PRAISE FOR MICHAEL S. GAZZANIGA'S

HU

"As wide-ranging as it is deep, andrtaining as it is informative, *Human* will please a diverse array of readers. [Gazzaniga] is adept at aiding even the scientifically unsophisticated to grasp his arguments about what separates humans from other animals."

—*Publishers Weekly* (starred review)

"[*Human*] is an intellectual romp through the cognitive neurosciences. . . . A rich testimony to the incredible accomplishments of the human brain in coming to understand itself."　　　　　—*New York Sun*

"Striking. . . . [Gazzaniga] convincingly claims advances in genetics, imaging and evolutionary psychology, and biology are converging to give us an arresting new picture of the human brain. . . . The sheer number of solid and intriguing studies Gazzaniga eloquently presents—including some from his own highly impressive body of work—allows readers to celebrate, with him, our unique ability to celebrate the world, to party like no other animal in it."　　　　　—*Forbes.com*

"In his own easy-to-read conversational style, Gazzaniga . . . takes off in search of what set humans apart from their predecessors. His entertaining tour includes some of the most lucid explanations of scientific concepts around as well as discursions into art, aesthetics, empathy, ethics, cyborgs, animals on trial, and what it would be like to date a chimp."

—*Scientific American*

"For any reader seeking a basic orientation in contemporary neuroscience, a category that includes students, *Human: The Science Behind What Makes Your Brain Unique* is a superb introduction. . . . The thoughtful reader will come away not only with many new insights but with a new

appreciation of our species and what neuroscience can contribute to an understanding of human nature." —*Nature Neuroscience*

"A savvy, witty guide to neuroscience today." —*Kirkus Reviews*

"Mike Gazzaniga is one of the founders of the field of cognitive neuroscience. The debate over the uniqueness of the human brain is not new, but *Human* conveys the excitement of new results in this field. His book is full of dazzling insights and written in an engaging style."
 —V. S. Ramachandran, MD, PhD, Center for Brain and Cognition, University of California–San Diego, and author of *Phantoms in the Brain* and *The Man with the Phantom Twin*

"This brilliant book reveals the secrets of humanity's special status. One reason humans are unique is because, as with this book, we seek to understand our own behavior. Among his many other contributions in *Human*, Gazzaniga reveals the mechanism by which understanding our behavior occurs, where in the brain it is located, and how it influences what we do." —Michael Posner, Professor Emeritus of Psychology, University of Oregon

© Joseph Mehling/Dartmouth College

About the Author

MICHAEL S. GAZZANIGA is the director of the University of California–Santa Barbara's SAGE Center for the Study of the Mind, as well as its Summer Institute in Cognitive Neuroscience. He directs the MacArthur Foundation Project on Law and Neuroscience, and is a member of the American Academy of Arts and Sciences and the Institute of Medicine of the National Academies. Dr. Gazzaniga is the author of *The Ethical Brain*, and he lives in California.

MICHAEL S. GAZZANIGA

AN ecco BOOK

HARPER PERENNIAL

NEW YORK • LONDON • TORONTO • SYDNEY • NEW DELHI • AUCKLAND

HUMAN

THE SCIENCE BEHIND
WHAT MAKES YOUR BRAIN UNIQUE

10/12/09
6 bg
$16.99

HARPER PERENNIAL

A hardcover edition of this book was published in 2008 by Ecco, an imprint of HarperCollins Publishers.

FIRST HARPER PERENNIAL EDITION PUBLISHED 2009.

Designed by Lovedog Studio

Library of Congress Cataloging-in-Publication Data is available upon request.

ISBN 978-0-06-089289-0

09 10 11 12 13 WBC/RRD 10 9 8 7 6 5 4 3 2 1

For Rebecca Ann Gazzaniga, M.D. . . .
the quintessential human
and everybody's favorite aunt

CONTENTS

PART 3
THE GLORY OF BEING HUMAN

PART 4
BEYOND CURRENT CONSTRAINTS

ACKNOWLEDGMENTS

This book started a long time ago. Its origins are probably somewhere in the J. Alfred Prufrock house at Caltech, where I had the privilege of being in graduate school. That is what we called The House, and it had several bedrooms, one of which was mine. I can tell you the inhabitants of the other bedrooms were all much smarter and wiser than I. Most were physicists, and all went on to great careers. They thought hard about hard problems and they cracked many of them.

What was enduring about the experience for a young neophyte like me were the aspirations of these bright men. Work on the hard problems. Work, work, work. And I did, and I have. Paradoxically, the problem I have spent my life examining is much harder than theirs, which in a phrase is, what is the deal with humans? Oddly, they were fascinated with my problem, and at the same time, I couldn't get to first base with the conceptual tools they used on a moment-by-moment basis to tackle their own problems. While I used to whip my housemate, the physicist Norman Dombey, in chess, I remain to this day not at all confident that I truly understand the second law of thermodynamics. In fact, I know I don't. Yet Norman seemed to understand everything.

The atmosphere was suffused with the pervasive belief that the objective of the meaningful life is to gain insight into its mysteries. That was what was so contagious. So, here I am trying to do it again, some forty-five years later. And yet, not by myself, not by a long shot. The issue is

trying to figure out what it means to be human. That is clear enough. So, to come out of the bullpen once more, I tapped into all the bright young students around me.

The journey started almost three years ago with my senior seminar during my last year at Dartmouth College. An extraordinary group of young men and women were assigned topics I knew I wanted to explore, and they all bellied up to the bar with insights and juice. We hacked away at it for two months or so, and it was all deeply illuminating. Two of the students caught the fever, and I am happy to report that they are off to careers in the science of the mind.

The following year, I taught my first class at the University of California, Santa Barbara, a university that doesn't apologize for being committed to research and scholarship. This was a class of dedicated graduate students, and they too deepened and added insights to the evolving story. Then a funny thing happened.

It was determined I had prostate cancer and needed surgery. Let me tell you, that is a bad hair day, even when you are bald! And yet I fell into terrific medical hands and came through it with a good prognosis. Still, I was swamped with work, and by luck, my sister Rebecca Gazzaniga, perhaps the finest person who ever graced this earth, was ready to try something new. She is a physician, a botanist, a painter, a chef, a traveler, and everyone's favorite aunt. And now I discover she is a science junkie, a writer and editor and collaborator. A star has been born. Without her help, this book would not exist.

I have attempted to become a mouthpiece for the vast talents of many people, both students and family. I do it with pride and joy, as I still remember that special imperative of the Prufrock house at Caltech: Think about the big problems. It is not that they are grave. They are challenging, inspiring, and enduring. See what you think.

HUMAN

PROLOGUE

I ALWAYS SMILE WHEN I HEAR GARRISON KEILLOR SAY, "BE well, do good work, and keep in touch." It is such a simple sentiment, yet so full of human complexity. Other apes don't have that sentiment. Think about it. Our species does like to wish people well, not harm. No one ever says, "Have a bad day" or "Do bad work," and keeping in touch is what the cell-phone industry has discovered all of us do, even when there is nothing going on.

There in one sentence Keillor captures humanness. A familiar cartoon with various captions makes its way around evolutionary biologists' circles. It shows an ape at one end of a line and then several intermediate early humans culminating in a tall human standing erect at the other end. We now know that the line isn't so direct, but the metaphor still works. We did evolve, and we are what we are through the forces of natural selection. And yet I would like to amend that cartoon. I see the human turning around with a knife in his hand and cutting his imaginary tether to the earlier versions, becoming liberated to do things no other animal comes close to doing.

We humans are special. All of us solve problems effortlessly and routinely. When we approach a screen door with our arms full of bags of groceries, we instantly know how to stick out our pinky and hook it around the door handle to open it. The human mind is so generative and so given to animation that we do things such as *map agency* (that is, we project

intent) onto almost anything—our pets, our old shoes, our cars, our world, our gods. It is as if we don't want to be alone up here at the top of the cognitive chain as the smartest things on earth. We want to see our dogs charm us and appeal to our emotions; we imagine that they too can have pity, love, hate, and all the rest. We are a big deal and we are a little scared about it.

Thousands of scientists and philosophers over hundreds of years have either recognized this uniqueness of ours or have denied it and looked for the antecedents of everything human in other animals. In recent years, clever scientists have found antecedents to all kinds of things that we had assumed were purely human constructions. We used to think that only humans had the ability to reflect on their own thoughts, which is called *metacognition*. Well, think again. Two psychologists at the University of Georgia have shown that rats also have this ability. It turns out that rats know what they don't know. Does that mean we should do away with our rat traps? I don't think so.

Everywhere I look I see tidbits of differences, and one can always say a particular tidbit can be found in others aspects of biological life. Ralph Greenspan, a very talented neuroscientist and geneticist at the Neuroscience Institute in La Jolla, California, studies, of all things, sleep in the fruit fly.

Someone had asked him at lunch one day, "Do flies sleep?" He quipped, "I don't know and I don't care." But then he got to thinking about it and realized that maybe he could learn something about the mysterious process of sleep, which has eluded understanding. The short version of this story is that flies do sleep, just as we do. More important, flies express the same genes during sleeping and waking hours that we do. Indeed, Greenspan's current research suggests that even protozoans sleep. Good grief!

The point is that most human activity can be related to antecedents in other animals. But to be swept away by such a fact is to miss the point of human experience. In the following chapters, we will comb through data about our brains, our minds, our social world, our feelings, our artistic endeavors, our capacity to confer agency, our consciousness, and our growing knowledge that our brain parts can be replaced with silicon parts. From this jaunt, one clear fact emerges. Although we are made up

of the same chemicals, with the same physiological reactions, we are very different from other animals. Just as gases can become liquids, which can become solids, phase shifts occur in evolution, shifts so large in their implications that it becomes almost impossible to think of them as having the same components. A foggy mist is made up of the same stuff as an iceberg. In a complex relationship with the environment, very similar substances with the same chemical structure can become quite different in their reality and form.

Indeed, I have decided that something like a phase shift has occurred in becoming human. There simply is no one thing that will ever account for our spectacular abilities, our aspirations, and our capacity to travel mentally in time to the almost infinite world beyond our present existence. Even though we have all of these connections with the biologic world from which we came, and we have in some instances similar mental structures, we are hugely different. While most of our genes and brain architecture are held in common with animals, there are always differences to be found. And while we can use lathes to mill fine jewelry, and chimpanzees can use stones to crack open nuts, the differences are light-years apart. And while the family dog may appear empathetic, no pet understands the difference between sorrow and pity.

A phase shift occurred, and it occurred as the consequence of many things changing in our brains and minds. This book is the story of our uniqueness and how we got here. Personally, I love our species, and always have. I have never found it necessary to lessen our success and domination of this universe. So let us start the journey of understanding why humans are special, and let's have some fun doing it.

A NOTE ON SOURCE DOCUMENTATION

The notes for this book were formatted according to the style documented in the Publication Manual of the American Psychological Association. At the time of this printing, the manual is in its fifth edition, and the APA format it details is a widely recognized standard for scientific writing in education and psychology.

Part I

THE
BASICS OF
HUMAN
LIFE

Chapter 1

ARE HUMAN BRAINS UNIQUE?

The brain is the organ that sets us apart from any other species. It is not the strength of our muscles or of our bones that makes us different, it is our brain.

—Pasko T. Rakic, "*Great Issues for Medicine in the Twenty-First Century*," Annals of the New York Academy of Sciences 882 (1999), p. 66.

THE GREAT PSYCHOLOGIST DAVID PREMACK ONCE LAMENTED, "Why is it that the [equally great] biologist E. O. Wilson can spot the difference between two different kinds of ants at a hundred yards, but can't see the difference between an ant and a human?" The quip underlines strong differences of opinion on the issue of human uniqueness. It seems that half of the scientific world sees the human animal as on a continuum with other animals, and others see a sharp break between animals and humans, see two distinct groups. The argument has been raging for years, and it surely won't be settled in the near future. After all, we humans are either lumpers or splitters. We either see the similarities or prefer to note the differences.

I hope to illuminate the issue from a particular perspective. I think it is rather empty to argue that because, say, social behavior exists in humans and in ants, there is nothing unique about human social behavior. Both the F-16 and the Piper Cub are planes, both obey the laws of physics, both can get you from place A to place B, but they are hugely different.

I want to begin by simply recognizing the huge differences between the human mind and brain and other minds and brains, seeing what structures, processes, and capacities are uniquely human.

It has always been a puzzle to me why so many neuroscientists become agitated when someone raises the question of whether or not there might be unique features to the human brain. Why is it that it is easy to accept that there are visible physical differences that make us unique, but to consider differences in our brains and how they work is so touchy? Recently, I asked a few neuroscientists the following question, "If you were recording electrical impulses from a slice of the hippocampus in a dish and you were not told if the slice came from a mouse, a monkey, or a human, would you be able to tell the difference? Put differently, is something unique about the human neuron? Would a future brain carpenter have to use that kind of neuron to build a human brain or would a monkey or mouse neuron do? Don't we all assume there is nothing unique about the neuron per se, that the special tricks of being human will come in the subtleties of the wiring diagram itself?"

The intensity of the response can be captured with just a couple of the replies. "A cell is a cell is a cell. It's a universal unit of processing that only scales in size between the bee and the human. If you scale appropriately a mouse, monkey, or human pyramidal cell you won't be able to say the difference even if you had Pythia to help you." So there! When we are studying the neurons of a mouse or an ant, we are studying mechanisms no different from a human neuron, period, end of story.

Here's another response: "There are differences in the types of neurons within a brain, and response properties of neurons within a brain. But across mammals—I think a neuron is a neuron. The inputs and outputs of that neuron (and synaptic composition) determine its function." Bang! Once again the physiology of the animal neuron is identical to that of a human. Without this assumption, it makes little sense to be studying these neurons so arduously. Of course there are similarities. But are there no differences?

Humans are unique. It is the how and the why that have been intriguing scientists, philosophers, and even lawyers for centuries. When we are trying to distinguish between animals and humans, controversies arise

and battles are fought over ideas and the meaning of data, and when the smoke clears, we are left with more information on which to build stronger, tighter theories. Interestingly, in this quest, it appears that many opposing ideas are proving to be partially correct.

Although it is obvious to everyone that humans are physically unique, it is also obvious that we differ from other animals in far more complex aspects. We create art, pasta Bolognese, and complex machines, and some of us understand quantum physics. We don't need a neuroscientist to tell us that our brains are calling the shots, but we do need one to explain how it is done. How unique are we, and how are we unique?

How the brain drives our thoughts and actions has remained elusive. Among the many unknowns is the great mystery of how a thought moves from the depths of the unconscious to become conscious. As methods for studying the brain have become more sophisticated, some mysteries are solved, but it seems that solving one mystery often leads to the creation of many more. Brain imaging studies have caused some commonly accepted tenets to come into question and others to be completely discounted. For example, the idea that the brain works as a generalist, processing all input information equally and in the same manner and then meshing it together, is less well accepted than it was even fifteen years ago. Brain imaging studies have revealed that specific parts of the brain are active for specific types of information. When you look at a tool (a man-made artifact created with a specific purpose in mind), your entire brain is not engaged in the problem of studying it; rather there is a specific area that is activated for tool inspection.

Findings in this realm lead to many questions. How many specific types of information are there, each with its own region? What is the specific information that activates each region? Why do we have specific regions for one type of activity and not another? And if we don't have a specific region for some type of information, what happens then? Although sophisticated imaging techniques can show us what part of the brain is involved with specific types of thoughts or actions, these scans tell us nothing of what is going on in that part of the brain. Today the cerebral cortex is thought to be "perhaps the most complex entity known to science."[1]

The brain is complicated enough on its own, but the sheer number of different disciplines* that are studying it has produced thousands of domains of information. It is a wonder that order can be put to the mountain of data. Words used in one discipline often carry different meanings in others. Findings can become distorted through poor or incorrect interpretation and become unfortunate foundations or inaccurate rebuttals of theories that may take decades to be questioned and reevaluated. Politicians or other public figures can oftentimes misinterpret or ignore findings to support a particular agenda or stifle politically inconvenient research altogether. There is no need to be dispirited, though! Scientists are like a dog with a bone. They keep gnawing away, and sense is being made.

Let's start on our quest into human uniqueness the way it has been done in the past—by just looking at that brain. Can its appearance tell us anything special?

BIG BRAINS AND BIG IDEAS?

Comparative neuroanatomy does what the name implies. It compares the brains of different species for size and structure. This is important, because in order to know what is unique in the human brain, or any other, for that matter, one needs to know how the various brains are alike and how they differ. This used to be an easy job and didn't take much in the way of equipment, maybe a good saw and a scale, which was about all that was available up until the middle of the nineteenth century. Then Charles Darwin published his *Origin of Species*, and the question of whether man had descended from apes was front and center. Comparative anatomy was in the limelight, and the brain was center stage.

Throughout the history of neuroscience, certain presumptions have

*Not only has the brain drawn the interest of anthropologists, psychologists, sociologists, philosophers, and politicians; it has intrigued biologists of all sorts (microbiologists, anatomists, biochemists, geneticists, paleobiologists, physiologists, evolutionary biologists, neurologists), chemists, pharmacologists, and computer engineers. More recently, even marketers and economists are jumping in.

been made. One of these is that the development of increased cognitive capacity is related to increased brain size over evolutionary time. This was the view held by Darwin, who wrote, "The difference between man and the higher animals, great as it is, is certainly one of degree and not of kind,"[2] and by his ally, neuroanatomist T. H. Huxley, who denied that humans had any unique brain features other than size.[3] The general acceptance of this notion, that all mammalian brains have the same components but that as the brain grew larger, its performance became more complex, led to the construction of the phylogenetic scale that some of us learned in school, with man sitting at the top of an evolutionary ladder, rather than out on the branch of a tree.[1] However, Ralph Holloway, now a professor of anthropology at Columbia University, disagreed. In the mid-1960s, he suggested that evolutionary changes in cognitive capacity are the result of brain reorganization rather than changes in size alone.[4] This disagreement about how the human brain differs from those of other animals, and indeed how the brains of other animals differ from each other—whether in quantity or in quality—continues.

Todd M. Preuss, a neuroscientist at Yerkes National Primate Research Center, points out why this disagreement is so controversial and why new discoveries of differences in connectivity have been considered "inconvenient."[1] Many generalizations about cortical organization have been based on the "quantity" assumption. It has led scientists to believe that findings using models of brain structure found in other mammals, such as rats and monkeys, can be extrapolated to humans. If this is not correct, there are repercussions that reverberate into many other fields, such as anthropology, psychology, paleontology, sociology, and beyond. Preuss advocates *comparative* studies of mammalian brains rather than using the brain of a rat, say, as a model for how a human brain functions but on a lesser scale. He and many others have found that, on the microscopic level, mammalian brains differ widely from one another.[5]

Is this assumption about quantity correct? It would appear not. Many mammals have larger brains than humans in terms of absolute brain size. The blue whale has a brain that is five times larger than a human brain.[6] Is it five times smarter? Doubtful. It has a larger body to

control and a simpler brain structure. Although Captain Ahab may have found a whale intellectually stimulating (albeit he was dealing with a sperm whale, whose brain is also larger than a human's), it has not been a universal experience. So perhaps proportional (allometric) brain size is important: That is the size of the brain compared to the size of the body, often called relative brain size. Calculating brain-size differences this way puts a whale in its place, with a brain size that is only .01 percent of its body weight, compared to a human brain, which is 2 percent of body weight. At the same time, consider the pocket mouse's brain, which is 10 percent of its body weight. In fact, in the early nineteenth century, Georges Cuvier, an anatomist, stated, "All things being equal, the small animals have proportionately larger brains."[6] As it turns out, proportional brain size increases predictably as body size decreases.

Human brains, however, are four to five times larger than would be expected for an average mammal of comparable size.[7] In fact, in the hominid (ape) line in general (from which humans have evolved), brain size has increased much faster than body size. This is not true for other groups of primates, and the human brain has rocketed in size after the divergence from chimpanzees.[8] Whereas a chimp's brain weighs about 400 grams, a human's brain is about 1,300 grams.[6] So we do have big brains. Is this what is unique and can explain our intellect?

Remember Neanderthals? *Homo neanderthalensis* had a body mass comparable to that of *Homo sapiens*,[9] but with a slightly larger cranial volume, measuring 1,520 cubic centimeters (cc) compared to the 1,340 cc typical of modern humans—so they too had a larger relative brain size than humans. Did they have a similar intelligence to humans? Neanderthals made tools and apparently imported raw materials from distant sites; they invented standardized techniques for making spears and tools[10] and about 50,000 years ago began to paint their bodies and inter their dead.[11] These activities are considered by many researchers to indicate some self-awareness and the beginnings of symbolic thought,[6] which is important because that is believed to be the essential component of human speech.[12] No one knows the extent of their speech capabilities, but what is clear is that Neanderthal material culture was not nearly as

complex as that of contemporaneous *Homo sapiens*.[13, 14] Although the bigger brain of the Neanderthals was not as capable of that of *Homo sapiens*, it was clearly more advanced than that of a chimp. The other problem with the big-brain theory is that *Homo sapiens'* brain size has *decreased* about 150 cc over the species' history, while their culture and social structures have become more complex. So perhaps relative brain size is important, but it is not the whole story, and since we are dealing with "perhaps the most complex entity known to science," that should not surprise us at all.

From my own perspective on this issue, I have never been taken with the brain-size argument. For the past forty-five years I have been studying split-brain patients. These are patients who have had the two hemispheres of the brain surgically separated in an effort to control their epilepsy. Following their surgery, the left brain can no longer communicate meaningfully with the right brain, thus isolating one from the other. In effect, a 1,340-gram interconnected brain has become a 670-gram brain. What happens to intelligence?

Well, not much. What one sees is the specialization that we humans have developed over years of evolutionary change. The left hemisphere is the smart half of the brain. It speaks, thinks, and generates hypotheses. The right brain does not and is a poor symbolic cousin to the left. It does, on the other hand, have some skills that remain superior to those on the left, especially in the domain of visual perception. Yet, for present purposes, the overarching point is that the left hemisphere remains as cognitively adept as it was before it was disconnected from the right brain, leaving its 670 grams in the dust. Smart brains are derived from more than mere size.

Before we leave the question of brain size, there is some exciting new information from the field of genetics. Genetics research is revolutionizing many fields of study, including neuroscience. For those of us who are natural selection fans, it seems reasonable to assume that the explosion in human brain size is the result of natural selection, which works through many mechanisms. Genes are functional regions on chromosomes (microscopic threadlike structures that are found in the nucleus of all cells and are the carriers of hereditary characteristics), and those regions

consist of DNA sequences.* Sometimes these sequences vary slightly, and as a result, the effect of that particular gene can vary in some way. These variant sequences are called *alleles*. Thus, a gene coding for flower color can vary in its DNA base pairs and result in a different flower color. When an allele has a highly important and positive effect on an organism such that it improves the organism's survival fitness or allows it to reproduce more, there is what is called a positive selection or directional selection for that allele. Natural selection would favor such a variant, and that particular allele would quickly become more common.

While not all genes' functions are known, there are many genes involved with the development of the human brain that are different from those of other mammals, and specifically from those of other primates.[†] During embryonic development, these genes are involved in determining how many neurons there will be, as well as how big the brain will be. There is not much difference among species in the genes that do routine "housekeeping" in the nervous system, which are those that are involved in the most basic cellular functions, such as metabolism and protein synthesis.[15] However, two genes have been identified that are specific regulators of brain size: microcephalin[16] and ASPM (the abnormal spindle-like microcephaly-associated gene).[‡] [17] These genes were discovered because

*Deoxyribonucleic acid, or DNA, is a double-stranded helical molecule with a backbone made up of sugars and phosphates. Each sugar has one of four types of bases attached to it: adenine (abbreviated A), cytosine (C), guanine (G), and thymine (T). These bases then attach to each other (A with T, C with G) and hold the helix together. It is the sequence of these bases that carries the genetic code.

† These include the genes named ASPM, microcephalin, CDK5RAP2, CENPJ, sonic hedgehog, APAF1, and CASP3.

‡ This is a fascinating gene story. Pakistan built the Mangla Dam in the 1960s on the Jhelum River to generate power and store water for irrigation. The lake that was created behind the dam flooded the valley, and 20,000 families lost their homes and fertile farms in the region of Mirpur in Kashmir. Many of these families moved to Yorkshire, England, where there was a shortage of skilled textile workers. Many years later, C. Geoffrey Woods, a physician and clinical geneticist from St James' University Hospital in Leeds, England, noticed that he was seeing several Pakistani families with children who had primary microcephaly. He began to study the DNA of the children with the affliction and their unaffected relatives, which led to the discovery of these two genes. The Mangla Dam was a controversial project at the time, and is once again.

a defect in them causes a problem that is passed on through birth to other family members. Defects in either of these genes lead to primary microcephaly, an autosomal recessive* neurodevelopmental disorder. Two principal features characterize this disorder: a markedly reduced head size that is the consequence of a small but architecturally normal brain, and nonprogressive mental retardation. The genes were named for the disease that they cause if they are defective.[†] It is the cerebral cortex (remember this point) that shows the greatest size reduction. In fact the brain size is so markedly decreased (three standard deviations below normal) that it is comparable in size to that of early hominids![18]

Recent research from the laboratory of Bruce Lahn, a professor of genetics at the University of Chicago and the Howard Hughes Medical Institute, has shown that both of these genes have undergone significant changes under the pressure of natural selection during the evolution of *Homo sapiens*. Microcephalin (without the defect) showed evidence of accelerated evolution along the entire primate lineage,[19] and ASPM (also without the defect) has evolved most rapidly after the divergence of humans and chimpanzees,[20] implicating these genes as the cause of the rapidly exploding brain size of our ancestors.

Accelerated evolution means what it sounds like. These genes were hot items that produced a characteristic that gave its owners an obvious competitive advantage. Whoever had them had more offspring, and the

The Pakistani government is currently trying to increase the size of the dam, displacing another 44,000–100,000 people. A short review of the detective work that went into the discovery of these two genes can be found in: A. Kumar, M. Markandaya, and S. C. Girimaji, "Primary microcephaly: Microcephalin and ASPM determine the size of the human brain," *Journal of Biosciences* 27 (2002): 629–32.

*Every person has two copies of every gene on non-sexed-linked chromosomes, one from the mother and one from the father. If a gene is *recessive,* in order for it to cause a visible or detectable characteristic, there must be a copy of it from both the mother and father. If there is only one copy, say from the mother, then the dominant gene from the father would determine the visible characteristic. Both parents have to be carriers of a recessive trait in order for a child to manifest it. If both parents are carriers, each child has a 25 percent chance of showing the recessive trait.

† If you are interested in the nomenclature of genes, check out this Web site: gene.ucl.ac.uk/nomenclature.

genes became dominant. Not resting on these findings, these researchers wondered if these genes could answer the question whether the human brain is continuing to evolve. It turns out that they could, and it is. The geneticists reasoned that if a gene has evolved adaptively in the making of the human species, like these genes that increase brain size, then it may still be doing so. How do you figure this out?

Scientists compared the genetic sequences of ethnically and geographically diverse people from around the world and found that the genes that code for the nervous system had some sequence differences (known as *polymorphisms*) among individuals. By analyzing human and chimpanzee polymorphism patterns and geographical distributions, using genetic probabilities and various other methods, they found evidence that some of these genes are experiencing ongoing positive selection in humans. They calculated that one genetic variant of microcephalin arose approximately 37,000 years ago, which coincides with the emergence of culturally modern humans, and it increased in frequency too rapidly to be compatible with random genetic drift or population migration. This suggests that it underwent positive selection.[21] An ASPM variant arose about 5,800 years ago, coincident with the spread of agriculture, cities, and the first record of written language. It, too, is found in such high frequencies in the population as to indicate strong positive selection.[22]

This all sounds promising. We've got the big brains. Some of those big brains have discovered at least some of the genes that code for the big brains, and the genes appear to have changed at key times in our evolution. Doesn't this mean they caused it all to happen and that they are what make us unique? If you think the answer is going to be found in the beginning of the first chapter, you are not using that big brain of yours. We don't know if the genetic changes caused the cultural changes or were synergistic,[23] and even if they did, what exactly is going on in those big brains and how is it happening? Is it happening only in ours or is it happening, but to a lesser extent, in our relatives the chimps?*

*We sit on a branch of an evolutionary tree, not on the top of a ladder. Chimpanzees are our closest living relatives and we have a common ancestor. Oftentimes in animal studies, comparisons are made with chimpanzees, because they are the animal most likely to share similar abilities.

BRAIN STRUCTURE

The structure of the brain can be looked at on three different levels: regions, cell types, and molecules. If you recall, I said that neuroanatomy used to be an easy job. The eminent experimental psychologist Karl Lashley once advised my mentor, Roger Sperry, "Don't teach. If you have to teach, teach neuroanatomy, because it never changes." Well, things have changed. Not only can sections of the brain be studied under the microscope with numerous different staining techniques that all reveal different information, but also a whole host of other chemical methods can be used, such as radioactive tracing, fluorescence, enzyme histochemical and immunohistochemical techniques, all sorts of scanners, and on and on. What is limiting now is actual material to study. Primate brains aren't easy to come by. Chimpanzees are on the endangered species list, gorilla and orangutan brains aren't any more abundant, and although there are an abundance of humans with brains, few seem to want to part with theirs. Many studies done on some species are invasive and terminal, not popular with *Homo sapiens*. Imaging studies are difficult to do on nonhuman species. It is so hard to get a gorilla to lie still. Even so, there are many tools, and even though huge amounts of information are being learned, not all that can be known is known. In fact, only a very small amount is known for sure. While this is great for neuroscientists' job security, the wide gaps in knowledge allow for speculation and differing opinions.

Brain Regions

What do we know about the evolution of the brain? Has the entire brain increased in size equally, or have only specific areas of it increased?

Some definitions will be helpful. The *cerebral cortex* is the outer portion of the brain, about the size of a large dish towel that is pleated and laid over the rest of the brain. It consists of six layers of nerve cells and the pathways that connect them. The enlargement of the cerebral cortex accounts for most of the difference in the size of the brain between humans and other primates. The cortex is highly interconnected. Of all brain connections, 75 percent are within the cortex; the other 25 percent

are input and output connections to other parts of the brain and nervous system.[6]

The *neocortex* is the evolutionarily newer region of the cerebral cortex and is where sensory perception, generation of motor commands, spatial reasoning, conscious thought, and, in us *Homo sapiens,* language take place. The neocortex is divided anatomically into four lobes—the frontal lobe and three posterior lobes—the parietal, the temporal, and the occipital. Everyone agrees that in primates, including humans, the neocortex is unusually large. The neocortex of a hedgehog is 16 percent of its brain by weight; in the Galago (a genus of small monkey) it is 46 percent; and in a chimpanzee, 76 percent. The neocortex in humans is even larger.[6]

What does it mean when part of the brain has enlarged? In proportional enlargement, all the parts are equally enlarged. If the brain is twice as large, every individual part of the brain is twice as large. In disproportionate enlargement, one part has enlarged more than the others. Usually, as brain regions change in size, their internal structure also changes, just like a business organization. You and your buddy build a new gizmo and sell a few of them. Once they become popular, you need to hire more people to make them, and then you need a secretary and a sales rep, and eventually you need specialists.

This also happens in the brain. As an area enlarges, it can produce subdivisions within a part of a structure that specializes in a particular activity. What is actually increasing when brain size increases is the number of neurons, but the size of the neurons is relatively constant among species. A neuron has connection capability to a limited number of other neurons. So although the number of neurons increases, they cannot increase the absolute number of connections each one makes. What tends to happen is that, as absolute brain size increases, the proportional connectivity decreases. Every neuron cannot connect to every other one. The human brain has billions of neurons that are organized into local circuits. If these circuits are stacked like a cake, they make up cortical regions; if they are bunched rather than stacked, they are called nuclei. Regions and nuclei are also interconnected to form systems. George Striedter[6] at the University of California at Irvine suggests that size-related changes in connectivity *may* limit how large brains can

become without being incoherent, and this may be the driving force be-hind evolutionary innovations that overcome this problem. Fewer dense connections force the brain to specialize, create local circuits, and auto-mate. In general, though, according to Terrence Deacon, professor of bi-ological anthropology and neuroscience at the University of California at Berkeley, the larger the area, the better connected it is.[24]

Now for the controversy: Is the neocortex evenly enlarged, or are some parts preferentially enlarged, and if so, which ones? Let's start with the occipital lobe, which contains, among other things, the primary visual, or striate, cortex. In chimps, it constitutes 5 percent of the entire neocortex, whereas in humans it constitutes 2 percent, which is less than would be expected. How to explain this? Did ours shrink, or did some other part of the neocortex enlarge? The striate cortex in fact is the exact size that it is predicted to be for an ape of our size. It appears then, that it is unlikely that it has shrunk; rather, some other parts of the cortex have expanded.[7] The controversy lies in which parts have ex-panded.

The frontal lobe, until recently, was thought to be proportionally larger in humans than other primates. Earlier investigations of this subject were based on studies done on nonprimates, for the most part on non-ape primates, and inconsistent nomenclature and landmarks for dif-ferent parts of the brain were used.[25] Then Katerina Semendeferi and colleagues[26] published a study in 1997 comparing the sizes by volume of the frontal lobes of ten living humans with those of fifteen postmortem great apes (six chimpanzees, three bonobos, two gorillas, four orangutans), four gibbons, and five monkeys (three rhesus, two cebus). This may seem like a small sample size, but in the world of comparative primate neuroanatomy it is quite large, and indeed included more samples than all previous studies. Their data concluded that although the absolute volume of the frontal lobe of humans was the greatest, the relative size of the frontal lobe across all the hominoids was similar. Thus they con-cluded that humans do not have a larger frontal lobe than expected for a primate with their brain size.

Why is this so important? The frontal lobe has much to do with the higher-functioning aspects of human behavior such as language and thought. If its relative size is no bigger in humans than in the other apes,

how can we explain the increased functioning, such as language? These researchers had four suggestions:

1. The region may have undergone a reorganization that includes enlargement of selected, but not all, cortical areas to the detriment of others.
2. The same neural circuits might be more richly interconnected within the frontal sectors themselves and between those sectors and other brain regions.
3. Subsectors of the frontal lobe might have undergone a modification of local circuitry.
4. Microscopic or macroscopic subsectors might have been added to the mix or dropped.[25]

Todd Preuss argues that even if you accept that the frontal lobes did not expand out of proportion to the rest of the cortex, a distinction should be made between the frontal and the *prefrontal* cortex. The prefrontal cortex is the anterior part of the frontal lobe. It is distinguished from the rest of the frontal cortex by having an additional layer of neurons* and is implicated in planning complex cognitive behaviors, in personality, in memory, and in aspects of language and social behavior. He suggests that the percentage of frontal to prefrontal cortex may have changed. Preuss provides evidence that suggests that the motor cortex portion of a human's frontal lobe is smaller than the chimp's, implying that an expansion of a different part of the human's frontal cortex occurred to account for no overall loss in lobe size.[1] In fact, Semendeferi[27] confirmed that area 10, in the lateral prefrontal cortex, is almost twice as large in humans as in apes. Area 10 is involved with memory and planning, cognitive flexibility, abstract thinking, initiating appropriate behavior and inhibiting inappropriate behavior, learning rules, and picking out relevant information from what is perceived through the senses. We will learn in later chapters that some of these abilities are much greater in humans, and some are unique.

Thomas Schoenemann and colleagues at the University of Pennsylvania

*This is called *internal granular layer IV*.

were interested in the relative amount of *white matter* in the prefrontal cortex.[28] The white matter lies beneath the cortex and is made up of nerve fibers connecting the cortex with the rest of the nervous system. They found that the prefrontal white matter was disproportionately larger in humans than other primates and concluded that this suggests a higher degree of connectivity in this part of the brain.

Connectivity is important. Supposing you were to set up an organization to locate a fugitive you suspected was driving across the country, what is the one thing you would need to have happen among all the law enforcement agencies that would be involved? Communication. It would do no good if the police in Louisiana knew to look for a blue Toyota and didn't tell anyone else, or a highway patrolman saw a suspicious car in El Paso going west, but didn't tell the patrol in New Mexico. With a lot of incoming information, the better the communication among investigators, the more effective the search will be.

This is also true of the prefrontal cortex. The more communication among its different parts, not only the faster it works, but the more flexible it is. What that means is that some information used for one task can be applied to something else. The more you know, the faster your brain works. Although we may share the same brain structures with the chimp, we get more bang out of our buck, and part of the reason may be the interconnections in the prefrontal cortex.

The prefrontal cortex is interesting in another way. Nonprimate mammals have two major regions of the prefrontal cortex, and primates have three. The original regions, which are present in other mammals and evolved earlier, are the orbital prefrontal region, which responds to external stimuli that are likely to be rewarding, and the anterior cingulate cortex, which processes information about the body's internal state. These two work together to contribute to the "emotional" aspects of decision making.[29] The new region tacked on to these is called the lateral or *granular prefrontal cortex,* and it is where area 10 is.

This new region is apparently unique to primates and is concerned mainly with the rational aspects of decision making, which are our conscious efforts to reach a decision. This region is densely *interconnected* with other regions that are larger in human brains—the posterior parietal cortex and the temporal lobe cortex—and outside the neocortex, it is

connected to several cell groups in the dorsal thalamus that are also disproportionately enlarged, the medial dorsal nucleus and the pulvinar. George Striedter suggests that what has enlarged is not a random group of areas and nuclei, but an entire circuit. He suggests that this circuit has made humans more flexible and capable of finding novel solutions to problems. Included in this circuit is the ability to inhibit automatic responses, necessary if one is to come up with novel responses.[6]

Leaving the frontal lobe, where most of the research has concentrated, we can't say much for the temporal and parietal lobes beyond that they are somewhat larger than expected, and they hold plenty of opportunities for PhD theses.

What about the rest of the brain? Is anything else enlarged? Well, the cerebellum is enlarged. The cerebellum is located posteriorly at the base of the brain, and it coordinates muscular activity. One part of the cerebellum, the dentate nucleus in particular, is larger than expected. This area receives input neurons from the lateral cerebellar cortex and sends output neurons to the cerebral cortex via the thalamus. (The thalamus sorts and directs sensory information arriving from other parts of the nervous system.) This is interesting because there is growing evidence that the cerebellum contributes to cognitive as well as motor function.

The Functional Story: Cortical Areas

Besides being divided into physical parts such as lobes, the brain is also divided into functional units called cortical areas, which also have specific locations. It's interesting that Franz Joseph Gall, a German physician, first came up with this idea in the early 1800s. It was known as the theory of phrenology and was later expanded by other phrenologists. Gall's good idea was that the brain is the organ of the mind and that different brain areas did specific jobs. However, it led to the bad ideas that one could read a person's personality and character from the size of their various brain regions, that the shape of the skull would accurately correspond to the shape of the brain (which it does not), and that the size of these regions could be determined by palpating the skull. Phrenologists would run their hands over a person's skull; some even used calipers to make measurements. From these observations,

they would predict the character of the individual. Phrenology was very popular and was used, among other things, to assess job applicants and to predict the characters of children. The trouble was, it didn't work. Gall's good idea does, though.

Cortical regions have neurons that share certain distinguishing properties, such as that they respond to certain types of stimuli, are involved in certain types of cognitive tasks, or have the same microanatomy.* For instance there are separate cortical areas that process the sensory input from the eyes (the primary visual cortex, located in the occipital lobe) and from the ears (the primary auditory cortex, located in the temporal lobe). If there is damage to a primary sensory area, one no longer has the awareness of the sensual perception. If the auditory cortex is damaged, one no longer has the awareness of having heard a sound but may still react to a sound. Other cortical areas, called association areas, integrate various types of information. There are also motor areas, which specialize in specific aspects of voluntary movement.

Cortical areas in the frontal lobe are involved with impulse control, decision making and judgment, language, memory, problem solving, sexual behavior, socialization, and spontaneity. The frontal lobe is the location of the brain's "executive," which plans, controls, and coordinates behavior and also controls voluntary movements of specific body parts, especially the hands.

What exactly is going on in the cortical areas of the parietal lobe is still a bit of a mystery, but they are involved with integrating sensory information from various parts of the body, with visual-spatial processing, and with the manipulation of objects. The primary auditory cortex, in the temporal lobe, is involved in hearing, and there are other areas involved with high-level auditory processing. In humans, areas in the left temporal lobe are specialized for language functions such as speech, language comprehension, naming things, and verbal memory. Prosody, or the rhythm of speech, is processed in the right temporal lobe. Areas in the ventral part of the temporal lobes also do some specific visual pro-

*Neurons are specialists. There is a wide variety in their shape, size, and electrochemical properties, depending upon what type of processing and transmission they are involved with.

cessing for faces, scenes, and object recognition. The medial parts are busy with memory for events, experiences, and facts. The hippocampi, which are evolutionarily ancient structures, are deep inside the temporal lobes and are thought to be involved in the process where short-term memory gets transferred to long-term memory and also spatial memory. The occipital lobe is involved with vision.

Since we can do so much more than those other apes, we definitely are going to find something unique here, don't you think? Primates have more cortical areas than other mammals. It has been found that they have nine or more premotor areas, the portions of the cortex that plan, select, and execute motor actions, whereas nonprimates have only two to four.[6] It is tempting to think that because we humans are higher functioning, we would have more cortical areas than other primates. Indeed, very recent evidence indicates that unique areas have been found in the visual cortex of the human brain. David Heeger at New York University has just discovered these new areas, which are not found in other primates.* For the most part, however, additional cortical areas have *not* been found in humans.

How could it be that we don't have more cortical areas? What about language and cogitation? And how about, well, writing concertos and painting the Sistine Chapel—and NASCAR, for goodness' sake? If chimps have the same cortical areas that we do, why aren't they doing the same things? Shouldn't our language area at least be different? The answer may lie in how these areas are structured. They may be wired differently.

As it turns out, while our search is getting more and more complicated, it is also getting more interesting. Besides the fact that there is no evidence that humans have radically more cortical areas than apes, there is increasing evidence that there are equivalent cortical areas in apes for human-specific functions. It appears that other primates, not just the great apes, also have cortical areas that correspond to our language areas and tool-use areas,[30] and that these areas are also lateralized, meaning that they are found predominately in one hemisphere rather than the other, just as they are in humans.[31, 32]

What has been found to be unique within the human brain is in an

*Personal communication.

area called the *planum temporale,* which all primates have. This is a component of Wernicke's area, the cortical area associated with language input, such as the comprehension of both written and spoken language.* The planum temporale is larger on the left side than the right side in humans, chimps, and rhesus monkeys, but it is microscopically unique in the left hemisphere of humans![33] Specifically what is different is that the cortical minicolumns of the planum temporale are larger and the area between the columns is wider on the left side of the human brain than on the right side, while in chimps and rhesus monkeys the columns and the intercolumnar spaces are the same size on both sides of the brain.

So what have we got so far? We have brains that are bigger than expected for an ape, we have a neocortex that is three times bigger than predicted for our body size, we have some areas of the neocortex and the cerebellum that are larger than expected, we have more white matter, which means we probably have more connections, and now we have some microscopic differences in cortical minicolumns, whatever those are.

The Brain Under a Microscope

Every time something is enlarged, it seems as if increased connectivity is involved. What are connections anyway? What are those columns? To answer that, we're going to the microscope. Remember that the cerebral cortex has six layers. These layers can be thought of as six sheets of neurons (impulse-conducting cells) stacked on top of each other. These sheets are not arranged haphazardly, but instead the individual neurons within a sheet line up with those in the sheets above and below to form *columns* (aka microcolumns or minicolumns) of cells that cross the sheets perpendicularly.[33, 34, 35, 36, 37] This might sound as though it ends up looking like a wall of bricks, but these bricks are not rectangular; they are neurons known as *pyramidal cells* because of their shape. They actually look like Hershey's Kisses with hairs (dendrites) sticking out from them

*The other cortical area involved with language is Broca's area, whose function is not fully delineated but is concerned with language output. A neural pathway called the *arcuate fasciculus* connects these two areas.

in all directions. The neurons that form these columns aren't just stacked on each other, but also form an elemental circuit and appear to function as a unit. It is widely accepted that neuronal columns are the fundamental processing unit within the cerebral cortex,[37, 38] and assembling multiple columns together creates complex circuits within the cortex.[39, 40]

The cortex is organized into columns in all mammals. Along with the size of the cerebral cortex, the associated number of columns within the cortex has historically been a major focus of evolutionary studies seeking to explain differences among species. Studies done at the close of the twentieth century have found that columnar cell numbers vary widely across mammalian species. Other studies have revealed that neurochemicals found within a column can also vary, not only across species but even across cortical locations within a species.[41, 42, 43, 44, 45, 46]

The connectional patterns of columns also vary. OK, so we have the six distinct layers, and they receive and send projections from and to specific sets of targets. The deepest cortical layers, the infragranular layers numbered V and VI, mature first during development (during gestation), and the neurons within these layers project primarily to targets outside the cortex. The most superficial layers, the supragranular layers (II and III), mature last,[46] projecting primarily to other locations within the cortex,[47, 48, 49] and they are thicker in primates than other species.[50] Several scientists have suggested that the supragranular layers, and the network of connections they form between cortical locations, participate heavily in higher cognitive functions. This is accomplished by linking motor, sensory, and association areas. These areas receive sensory inputs from high-order sensory systems, interpret them in the light of similar past experiences, and function in reasoning, judgment, emotions, verbalizing ideas, and storing memory.[50, 51] It is also suggested that the differential thickness of these layers may imply an unequal degree of connectivity,[49, 52] which could play a role in the cognitive and behavioral differences among various species.[43] For example: The average relative thickness of the supragranular layer in a rodent is 19 percent, while in a primate it is 46 percent.[53]

Let's put it another way. Picture this: Take the Hershey's Kisses with hairs sticking out from each of them and stack them on top of each other, and you have a minicolumn. Gather several stacks together in a bundle,

and these bundles are the cortical columns. Now take thousands of these bundles of Hershey's Kisses and pack them together. How much space they are going to take up and how they are arranged will depend on how thick each stack is, how dense the hairs are around each stack, how many individual stacks of Kisses are in a bundle, how tightly they are packed (which is also dependent on how the Kisses will wedge together), how many bundles you have, and how tall the bundles are. There are a lot of variables, and they all matter and ultimately are thought to contribute to our cognitive and behavioral abilities. What is determining how many Kisses we have?

The horizontal expansion of the cortical sheet (the dish towel) and alterations to the basic structure of cortical columns are likely determined early in fetal development by altering the number and timing of cell divisions that generate cortical neurons. Cortical neurogenesis can be divided into an early and a late period. The length of time and the number of cell cycles spent in the early period of cell division will ultimately determine the number of cortical columns that will be found in any given species.[54] The length of time and the number of cell cycles spent in the later period may determine the number of individual neurons within a cortical column. A higher number of early divisions will result in a larger cortical sheet (bigger dish towel), and a higher number of later divisions will result in a higher number of neurons within an individual column. The time spent generating neurons in a given species correlates highly with supragranular layer thickness[55]; thus, it is possible that changes to the absolute time of neurogenesis and the number of cell cycles that occur during neurogenesis dictate the pattern of the neuron sheets in a species, and the size of the supragranular layers. Changes in timing during the production of the neurons could produce dramatic changes in cortical structure.[56, 57, 58, 59] And what controls the timing? DNA. That is going to take us deep into the world of genetics, but we aren't going there yet.

The Areas of Specialization

Now that we know what minicolumns are, we are going to look at how this asymmetry of the columns found in the planum temporale (you almost forgot about that, didn't you?) relates to function and if it really has

anything to do with humans' being unique. The speech center is located in the left hemisphere's auditory cortex. Acoustic stimuli are received by the ear, where they are converted to electric impulses and sent to the primary auditory cortex, in both hemispheres. The auditory cortex is made up of several parts, each of which have a different structure and job. For instance some neurons in the auditory cortex are sensitive to various frequencies of sound and some to loudness. The number, location, and organization of these parts in the human auditory cortex are not fully understood. As far as speech is concerned, each hemisphere is concerned with different aspects. Wernicke's area in the left hemisphere recognizes distinctive parts of speech, and an area in the right auditory cortex recognizes prosody, the metrical structure of speech, which we will talk about in later chapters, and then sends this info to Wernicke's area.

We are now entering the realm of speculation. We know for sure that the human planum temporale (a component of Wernicke's area) is larger in the left hemisphere than the right, and the microscopic architecture is different on the left side compared to the right. The minicolumns are wider, and the spaces between them are greater, and this lateralized change in architecture is unique to humans. With the increased space between minicolumns, there is also an increase in the spread of the dendrites from the pyramidal cells (the hairs of the Hershey's Kisses), but the increase is not proportional to the increase in spacing. This results in a smaller number of minicolumns being interconnected than in the right hemisphere, and it has been proposed that this could indicate that there is a more elaborate and less redundant pattern of local processing architecture in this area in the left hemisphere. It may also indicate that there is an additional constituent in this space.[1] This scenario is different in the other auditory regions. There the dendritic spread of the pyramidal cells did compensate for the increased spacing (that is, the hairs on the Hershey's Kisses got longer and filled in the increased space between the stacks of Kisses).

The posterior language region also differs between the two hemispheres at the *macro*column level. The two hemispheres have equal-size areas of patchy interconnections, but the distance between the patches is greater in the left hemisphere, indicating that there are more inter-

connected macrocolumns in the left. It has been speculated that this pattern of interconnections is similar to that in the visual cortex, where interconnected macrocolumns that process similar types of information are also clustered together. Thus, perhaps the presence of greater connectivity in the posterior auditory system creates similarly functioning clusters that can analyze incoming information on a finer scale.[1]

So far, there is no direct evidence of hemispheric asymmetry in the connections between regions, owing to technical limitations in studying the long-distance connections of human brains, but there is some indirect evidence. The increased distance between the minicolumns could be caused partly by differences in the incoming and outgoing connections—either increases in numbers or size. There are consistent shape differences between the two hemispheres, and long- and short-range neurons are known to contribute to the shape of the brain's convolutions.

And one last thing: There is an increased number of extra-large pyramidal cells in the supragranular layer on the left side in the anterior and posterior language areas, as well as in the primary and secondary auditory locations. Many researchers have suggested that this is indicative of connectional asymmetries and may play a role in temporal processing, and that is a big deal.

We all know that timing is important. Just ask Steve Martin or Rita Rudner. The left hemisphere is better at processing temporal information. Because timing is essential to the comprehension of language, the human brain may require specialized connections to process it. It has even been suggested that the costs of a time delay in sending information across hemispheres has been the driving force in language lateralization.[60]

Lateralization and Connectivity

To be sure, the human brain is a bizarre device, set in place through natural selection for one main purpose—to make decisions that enhance reproductive success. That simple fact has many consequences and is at the heart of evolutionary biology. Once grasped, it helps the brain

scientist to understand a major phenomenon of human brain function—its ubiquitous lateral cerebral specialization. Nowhere else in the animal kingdom is there such rampant specialization of function. Why is this, and how did it come about?

Or, as Kevin Johnson, a friend of my sister's, put it, "So the brain is composed of two halves that need to interact to create a working mind. Now, if we assume that both brain and mind are the result of evolutionary forces, what is the adaptive advantage of a bicameral brain? What evolutionary force could possibly make such a wacky arrangement adaptive?" What emerges from my own split-brain research is a possible insight to these questions.

THE WACKY ARRANGEMENT

It may turn out that the oft-ignored corpus callosum, the fiber tract that is thought merely to exchange information between the two hemispheres, was the great enabler for establishing the human condition. The brains of other mammals, by contrast, reveal scant evidence for lateral specialization, except as rarely noted, for example, by my colleagues Charles Hamilton and Betty Vermeire while they were investigating the macaque monkey's ability to perceive faces.[61] In that study, they discovered a right-hemisphere superiority for the detection of monkey faces. Lateralization is present in birds, and the question of whether this was a shared solution throughout the phylogenetic tree or one that was independently developed is under investigation. We will be talking more about bird brains in a later chapter.

With the growing demand for cortical space, perhaps the forces of natural selection began to modify one hemisphere but not the other. Since the callosum exchanges information between the two hemispheres, mutational events could occur in one lateralized cortical area and leave the other mutation-free, thus continuing to provide the cortical function from the homologous area to the entire cognitive system. As these new functions develop, cortical regions that had been dedicated to other functions are likely to be co-opted. Because these functions are still supported by the other hemisphere, there is no overall loss of function. In short, the callosum allowed a no-cost extension; cortical

capacity could expand by reducing redundancy and extending its space for new cortical zones.

This proposal is offered against a backdrop of findings in cognitive neuroscience that strongly suggest how important local, short connections are for the proper maintenance and functioning of neural circuits.[62, 63] Long fiber systems are relevant, most likely for communicating the products of a computation, but short fibers are crucial for producing the computation in question. Does this mean that as the computational needs for specialization increase, there is pressure to sustain mutations that alter circuits close to a nascent site of activity?

One of the major facts emerging from split-brain research is that the left hemisphere has marked limitations in perceptual functions and the right hemisphere has even more prominent limitations in its cognitive functions. The model thus maintains that lateral specialization reflects the emergence of new skills and the retention of others. Natural selection allowed this odd state of affairs because the callosum integrated these developments in a functional system that only got better as a decision-making device.

Another aspect of this proposal can be seen when considering possible costs to the right hemisphere. It now appears that the developing child and the rhesus monkey have similar cognitive abilities.[64] It has been shown that many simple mental capacities, such as classification tasks, are possible in the monkey and in the twelve-month-old child. Yet many of these capacities are not evident in the right hemisphere of a split-brain subject.[65] It is as if the right hemisphere's attention-perception system has co-opted these capacities, just as the emerging language systems in the left hemisphere have co-opted its capacity for perception.

As the brain becomes more lateralized, one might predict that there would be an increase in local intrahemispheric circuitry and a reduction in interhemispheric circuitry. With local circuits becoming specialized and optimized for particular functions, the formerly bilateral brain need no longer keep identical processing systems tied together for all aspects of information processing. The communication that occurs between the two hemispheres can be reduced, as only the products of the processing centers need be communicated to the opposite half brain. Researchers from Yerkes Primate Center at Emory University have reported that there is a

differential expansion of cerebral white matter relative to the corpus callosum in primates.[66] Humans show a marked decrease in the rate of growth of the corpus callosum compared with intrahemispheric white matter.

The discovery of *mirror neurons* by Giacomo Rizzolatti, which we will talk about later, may also contribute to understanding how new abilities, exclusively human in nature, arose during cortical evolution. Neurons in the monkey's prefrontal lobe respond not only when the animal is going to grasp a piece of food but also when the human experimenter is about to grasp the same piece of food.[67] It would appear that circuits in the monkey brain make it possible for the monkey to represent the actions of others. Studies of the mirror neuron system in humans are revealing it to be much more extensive and involved than in monkeys. Rizzolatti[68] suggested that such a system might be the seed for a theory of a uniquely human modular mind.[69]

It is with this background, in which both developmental and evolutionary time come into play, that a dynamic cortical system establishes adaptations that become laterally specialized systems. The human brain is on its way to being a unique neural system.

Molecular and Genetic Dimensions

We are almost done with our tour through the brain, but remember, we still have to go one level smaller: molecules. We are ready to go to the land of genetics, and it is a happening place. In reality, everything that we have been talking about so far is the way it is because the DNA of that species has coded it to be that way. The ultimate uniqueness of the human brain is due to our unique DNA sequence. The successful sequencing of the human and chimpanzee genomes and the blossoming of the new field of comparative genomics are giving us tantalizing glimpses of the genetic bases of the differences in phenotypic specializations, that is, observable physical or biochemical traits. Before you get too complacent and think that we have most of the answers, let me share this quote with you: "The genomic changes after speciation and their biological consequences seem more complex than originally hypothesized."[70] Wouldn't you know it? We are going to look at one specific gene and just how complex a seemingly simple change can be.

GENETICS REVIEW

But first, we need to know a little bit more about what a gene is and what it does. A gene is a region of DNA that occupies a specific location on a chromosome.* Each gene is made up of a coding sequence of DNA that determines the structure of a protein, and a regulatory sequence that controls when and where the protein will be made. Genes govern both the structure and the metabolic function of the cells. When located in reproductive cells, they pass their information to the next generation. Each chromosome of each species has a definite number and arrangement of genes. Any alteration of the number or arrangement of the genes results in a mutation to the chromosome, but it does not necessarily affect the organism. Interestingly, very little of the DNA actually codes for proteins. Scattered along the chromosomes are larger sequences (about 98 percent of the total) of noncoding DNA, whose function is not understood. Now we can go on.

THE LANGUAGE GENE

Just like the story of microcephalin and ASPM, this one also starts in a clinic in England. Physicians there were treating a unique family (known as the KE family) in which many members suffered a severe speech and language disorder. They have extreme difficulties controlling complex, coordinated face and mouth movements. This impedes their speech, and they have a variety of problems with both spoken and written language, which includes difficulty understanding sentences with complex syntactical structure, defects in processing words according to grammatical rules, and a lower average IQ than nonaffected family members.[71] The

*As previously stated, a chromosome is a microscopic threadlike structure that is found in the nucleus of all cells and is the carrier of hereditary characteristics. It consists of a complex of proteins and DNA (which is a nucleic acid that contains the genetic instructions for the development of all cells). Each species has a certain number of chromosomes; a human has forty-six arranged in twenty-three pairs. The reproductive cells (gametes), however, have only twenty-three. Thus when fusion of a male and female gamete occurs, the fertilized egg (zygote) has one set of chromosomes from each parent.

family was referred to the Wellcome Trust Centre for Human Genetics in Oxford, where researchers, by looking at the family tree, found that the disorder was inherited in a simple fashion. Unlike other families with speech and language difficulties, inheritance of which was far more complicated, it turned out the disorder in the KE family was a defect in a single autosomal dominant gene.[72] That means that a person with the mutation has a 50 percent chance of passing it to offspring.

The hunt was on for the gene. It was narrowed down to a region on chromosome 7 containing between fifty and one hundred genes. Then, unlike Murphy's Law, there came a stroke of luck. An unrelated patient (CS) who had similar speech and language problems was referred to them. CS had a chromosomal abnormality called *translocation*. Large segments from the ends of two different chromosomes had broken off and had swapped positions. One of the chromosomes was chromosome 7, and the breakpoint spot was in the region of the chromosome that was implicated in the KE family's problems. The gene at that location on the KE chromosome 7 was analyzed and found to have a single base-pair mutation.[73] The base adenine was substituted for guanine. This base-pair mutation was not found in 364 normal control subjects. This mutation is predicted to result in a change in the protein that it codes, by causing a substitution for the amino acid arginine with histidine in the forkhead DNA binding domain of FOXP2 protein. The mutation of this gene, named FOXP2, caused the problem.

Why? How can one little change do so much damage? Take a deep breath. Blow it out slowly. OK, now you're ready. There are many different FOX genes. They are a big family of genes that code for proteins that have what is known as a forkhead-box (FOX) domain. The *forkhead box* is a string of eighty to a hundred amino acids forming a specific shape that binds to a specific area of DNA like a key fitting into a lock. Once coupled, the FOX proteins regulate the expression of target genes. The substitution of the amino acid histidine changed the shape of the FOXP2 protein, so that it could no longer bind to DNA; the key no longer fit the lock.

FOX proteins are a type of *transcription factor*. Oh no, what is that? Remember that a gene has a coding region and a regulatory region. The coding region is the recipe for the construction of protein. In order for the protein to be made, the recipe in the DNA sequence has to be copied

first into intermediary copies of messenger RNA (mRNA), which are the template for protein production, by a carefully controlled process called *transcription*. The regulatory region determines how many copies of mRNA are made, and thus the amount of protein. A transcription factor is a protein that binds to the regulatory region of other genes (notice that this is plural and can affect up to thousands of genes, not just one) and modulates their transcription levels. Those with the forkhead-binding domain are specific for particular DNA sequences, so they don't bind indiscriminately. The choice of targets may vary depending on the shape of the forkhead and on the cellular environment, and may either increase or decrease transcription. The absence of a transcription factor can affect an unknown and potentially large number of other genes. You can think of transcription factor as a switch that turns gene expression on or off for a specific number of genes. It could be a few, or it could be 2,500. If the forkhead protein cannot bind to the regulatory region of a strand of DNA, the switch to produce whatever that region codes for will not be turned on or off. Many forkheads are critical regulators of embryonic development that turn undifferentiated cells into specialized tissues and organs.

Back to FOXP2 protein: This transcription factor is known to affect tissues in the brain, lung, gut, heart,[74] and other locations in the adult. The mutation in the gene affected only the brain in the KE family. Remember that there are two copies of each chromosome, and the affected members of this family have one normal chromosome and one mutated one. It is postulated that reduced amounts of FOXP2 protein at specific stages of neurogenesis led to abnormalities in the neural structures that are important for language and speech[73] but that the amount of FOXP2 protein produced by the normal chromosome was sufficient for the development of the other tissues.

If the FOXP2 gene is so important in the development of language, is it unique to humans? This is complicated, and the complexity speaks to huge differences between talking about genes (genetics) and talking about the expression of genes (genomics). The FOXP2 gene is present in a broad range of mammals. The protein encoded for by the FOXP2 gene differs by only three amino acids between mouse and man. It has been found that two of those differences occurred after the divergence of the

human and chimpanzee lineages.[75] Thus humans do have a unique version of the FOXP2 gene that produces unique FOXP2 proteins. The two mutations in the human gene have changed the binding properties of the protein.[76] This can have a major effect on the expression of other genes. These two mutations are estimated to have occurred within the last two hundred thousand years[75] and have undergone accelerated evolution and positive selection. Whatever they do, they provided a competitive advantage. It is significant that this is the estimated time frame for the emergence of spoken language in humans.

Is this it? Is this the gene that codes for speech and language? Well, let me throw in another comparative study that identified ninety-one genes that are differentially expressed in the human cortex compared with chimps, of which 90 percent are upregulated, meaning that there are increased levels of expression in humans.[77] These genes have varying functions. Some are required for normal development of the nervous system, some are related to increased neuronal signaling and activity, some mediate increases in energy transport, and the functions of others are unknown. Most likely the FOXP2 gene is one of many changes on the pathway to language function, but what it provides is more questions. What is this gene doing? What other genes does it affect? Did the two-mutation difference between humans and chimps actually cause major changes in circuitry or muscular function, and if so, how?

And the story doesn't stop here. Pasko Rakic, perhaps the world's greatest neuroanatomist, has just described yet other new features of the developing human brain. In the summer of 2006, Rakic and his colleagues described new "predecessor cells" that appear prior to other cells underlying local neurogenesis.[78] There is no evidence at this time that such cells exist in other animals.

CONCLUSION

The historical and current social and scientific forces maintaining the notion that the only difference between an ape's brain and our own is one of size, which is to say number of neurons, have been overwhelm-

ing. And yet a dispassionate look at the data in front of us clearly shows that the human brain has many unique features. In fact, the scientific literature is full of examples that range from the level of gross anatomy to cellular anatomy to molecular structure. In short, as we build our case for the uniqueness of the human brain, we start on firm footing. Our brains are different in detail, so why should our minds not also be different?

Chapter 2

WOULD A CHIMP MAKE A GOOD DATE?

A brain is worth little without a tongue.

—French proverb

THERE ISN'T A HUMAN BEING ON EARTH WHO DOES NOT LOOK at his or her dog or cat—or old shoe, for that matter—without an irrational reverence and fondness. Nonhuman beings and objects take on humanness almost routinely, and we come to believe in such things as real and enduring. We grant them a kind of agency. "Of course my dog is smart," one hears. "My cat is psychic." "Old Nelly never once got stuck in the snow. She knows how to hug the road." The list is endless.

Our species has had a hard time drawing the line between us and them. In the Middle Ages, we used to have animal courts. If you can believe it, we put animals on trial and held them accountable for their actions. From 824 to 1845, in Europe, animals did not get off scot-free when they violated the laws of man, or perhaps, just disturbed his well-being. Just like common criminals, they too could be arrested and jailed (animal and human criminals would be incarcerated in the same prison), accused of wrongdoing, and have to stand trial. The court would appoint them a lawyer, who would represent them and defend them at a trial. A few lawyers became famous for their animal defenses. The accused animal, if found guilty, would then be punished. The punishment would often be retributive in nature, so that whatever the animal had done would be done to it.

In the case of a particular pig (during those times pigs ran freely

through towns, and were rather aggressive) that had attacked the face and pulled the arms off a small child, the punishment was the pig had its face mangled and its forelegs cut off, and then was hanged. Animals were punished because they were harmful. However, sometimes, if the animal was valuable, such as an ox or horse, its sentence would be ameliorated, or perhaps the animal would be given to the church. If the animal had been found guilty of "buggery" (sodomy), both it and the buggerer were put to death. If domestic animals had caused damages and were found guilty, their owners would be fined for not controlling them. There seems to have been some ambivalence as to whether an animal was fully responsible or whether its owner should also be considered responsible. Because animals were peers with humans in judicial proceedings, it was considered uncool to eat the bodies of any animals that were capitally punished (except among the thrifty Flemish, who would enjoy a good steak after a cow was hanged). Animals could also be tortured for confessions. If they didn't confess—and no one supposed they would—then their sentence could be lessened. You see, it was important to follow the law exactly, for if humans were tortured and didn't confess, then their sentence could also be changed. Many different types of domestic animals had their day in court: horses for throwing riders or causing carts to tip, dogs for biting, bulls for stampeding and injuring or goring someone, and pigs most commonly of all. These trials were held in civil courts.[1]

It is easy to see why we humans have struggled with our views of animals. As I mentioned, a feature of the human brain that is both ubiquitous and almost defining is how we reflexively build models in our minds about the intentions, feelings, and goals of others, including animals and objects. We can't help it. When one visits Rodney Brooks's artificial intelligence lab at MIT and sees his famous robot, Cog, it takes only a matter of seconds before agency of some kind is conferred on this hunk of steel and wires. Cog turns its head, tracks you around the room with its eyes, and bingo, Cog is a something, a somebody. If it is true for Cog, it is going to be true for Rover.

Veterinarians will tell you the same sort of grieving cycles that occur over humans do so over pets. Those remaining above the ground have a mental model of the deceased, and they must go through a process to put it at peace. I have carried out extensive animal primate research. One

quickly identified with each animal, noted its personality, its intelligence, and its cooperativeness. The research frequently required carrying out major neurosurgical procedures, and in some instances, major efforts were necessary for their postoperative care. I found each one taxing and troubling. When the animal survived and flourished after surgery, one's attachment was close indeed.

I can remember one such animal that I had taken a shine to, now some forty years ago. She needed some vitamins, and yet she hated the taste of the mixture. So I brought out a monkey's favorite delicacy—the banana. I injected the vitamin mixture into one end of the banana in hopes that she would chomp into it and get her vitamins incidentally to the tasty banana. It worked once. On day two—same plan, same preparation. This time Mozambique took the banana, looked at each end, noticed the end that had the vitamin mixture oozing out of it, broke the banana in two, threw the goopy end on the floor and ate the nonmedicated half! I couldn't believe my eyes, but I cheered her on.

The problem with this story is I can't be certain whether what I thought I saw as evidence of great mentation was really more than a chance event, overinterpreted by me and sort of lionized. Would I want to spend a lot of mental time with Mozambique? Indeed would I want to spend a lot of time with a chimp? This is where it starts to get serious and where hard work is needed to really know what it is we have in common with chimps. Of course, there is the flip side of the coin: Is our wanting to tack agency onto everything what makes us human?

A DATE WITH A CHIMP

Consider the following personal ads:

SFS (single female swinger) seeks strong male companionship. Age is unimportant. I'm a young, svelte, good-looking girl who *loves* to play. I love rambling in the woods, riding in your pickup truck (make it a late model with leather interior), hunting and camping trips, and hanging out with the locals. I love warm tropical nights you spend running your fingers through my hair. Moonlit dinners will have me eating out of your

hand, but don't try eating out of mine. I'm not one of those girls who always wants to discuss feelings, just rub me the right way and watch me respond. I'll be at the front door or over at the neighbor's when you get home from work, wearing only what nature gave me. Kiss me and I'm yours. Bring some friends over too. Call 555-xxxx and ask for Daisy.

Or,

SF seeks intelligent male for LTR (long-term relationship). I'm a young, svelte, good-looking girl with a good sense of humor, who *loves* to play piano, jog, and cook the delicious produce from my garden. I love long walks and talks in the woods, driving in your Porsche, and going to football games. I love to read by the campfire while you are hunting and fishing. I love going to museums, concerts, and art galleries. I love cozy, intimate winter nights spent lying by the fire with just you. Candlelight dinners in gourmet restaurants will have me eating out of your hand. Say the right thing, rub me the right way, don't forget my birthday, and watch me respond.

Which of the two ads do you relate to? A version of the first ad can be found on snopes.com, an "urban legends" reference page. It was supposedly placed in an Atlanta newspaper, listing a phone number that belonged to the Humane Society, which received 643 calls the first two days it was in print. Daisy was a black lab, not even a chimp. The Humane Society denied ever placing the ad.

How would these dates be different? What miscalculation would you have made if you found yourself facing a chimp at the door after responding to the first ad? Could you date a chimp? Would the two of you have any common ground?

COUSINS?

The physical differences and similarities between our closest relatives, the chimps, and us are, of course, quite noticeable. Just exactly what are we talking about when we say "closest relatives"? We often hear that we

share 98.6 percent of our total DNA nucleotide sequence with chimpan-zees. Yet, this figure is more than a little misleading. This does not mean that we share 98.6 percent of our genes with the chimps. The current estimate is that humans have 30,000 to 31,000 genes. What is generally not emphasized is that these 30,000 genes occupy a little more than 1.5 percent of the whole genome, the rest of the genome being noncoding.[2,3] Thus, the vast majority of the genome sits there—its function largely unknown.

With only 1.5 percent of human DNA coded for genes that are crucial in building a human, are the geneticists telling us 98.6 percent of the 1.5 percent is similar between the chimp and the human? No. Put differ-ently, how can only 1.4 percent of the DNA make such a huge differ-ence? The answer is clear. The relationship between a gene—a DNA sequence—and its ultimate function is not simple. Each gene can ex-press itself in many different ways, and the variation in expression can account for large differences in function.

Here is the abstract from *Nature* magazine on the report of the se-quencing of one chimpanzee chromosome:

Human-chimpanzee comparative genome research is essential for narrowing down genetic changes involved in the acquisition of unique human features, such as highly developed cognitive functions, biped-alism or the use of complex language. Here, we report the high-quality DNA sequence of 33.3 megabases of chimpanzee chromosome 22. By comparing the whole sequence with the human counterpart, chromosome 21, we found that 1.44% of the chromosome consists of single-base substitutions in addition to nearly 68,000 insertions or deletions. These differences are sufficient to generate changes in most of the proteins. Indeed, 83% of the 231 coding sequences, in-cluding functionally important genes, show differences at the amino acid sequence level. Furthermore, we demonstrate different expan-sion of particular subfamilies of retrotranspositions between the lin-eages, suggesting different impacts of retrotranspositions on human and chimpanzee evolution. The genomic changes after speciation and their biological consequences seem more complex than originally hypothesized.[4]

The great apes, which include orangutans, gorillas, chimpanzees, bonobos, and humans, all evolved from a common ancestor. The lineage that later evolved to become orangutans branched off about 15 million years ago (mya), and the gorillas 10 mya. It is estimated that somewhere between 5 and 7 mya, we shared a common ancestor with the chimpanzee. That is why that ape is assumed to be our closest living relative. For some reason, and it is often blamed on the climate, which may have caused a change in the food supply, there was a further split in our common line. One branch of the family stayed in the tropical forest, and the other branch stepped out into the open woodland. The branch that stayed in the forest resulted in the chimpanzees and later the bonobos (sometimes known as pygmy chimpanzees, although they are only slightly smaller). Bonobos branched from a common chimp ancestor about 1.5 to 3.0 mya. They occupy the tropical forests south of the Zaire River in central and western Africa, where there are no gorillas to compete for food, whereas the chimps live in the tropical forests north of the Zaire with gorillas. Because the tropical forest has always been home to the chimpanzees, they are called a conservative species. They have not had to adapt to many changes and thus, evolutionarily speaking, have not changed much since branching from our common ancestor.

Not so with the open-woodland branch that left the tropical forest to live on the savanna. They had to adapt to a radically different environment and thus went through many changes. After a few false starts and dead ends, they eventually evolved into *Homo sapiens*. Humans are the only surviving hominid from the line that split from the common ancestor with the chimps, but there were many that came before us. Lucy, for example, the fossil *Australopithecus afarensis* found by Donald Johanson in 1974, shocked the anthropological world because she was bipedal but did not have the big brain. Up until that time, it was thought that the big brain led to bipedalism.

In 1992, Tim White, from the University of California at Berkeley, found the oldest known hominid fossils. These were of a bipedal apelike animal that has been called *Ardipithecus ramidus* and is thought to have lived about 4.4 to 7.0 mya. Recent fossil findings in Ethiopia, again by Tim White, of *Australopithecus anamensis*, dated to 4.1 mya, suggest that

it may have been the descendant of *Ardipithecus* and the precursor of Lucy. Several different species arose from *Australopithecus*, including the beginning of our species, *Homo*. However, our development was not a straight shot from Lucy forward. There were eras when different species of *Homo* and *Australopithecus* existed at the same time.

PHYSICAL DIFFERENCES

Nonetheless, here we are, and the question once again is, how different are we? Now that we know that the seemingly small 1.5 percent difference in our genome means a lot, we can expect to find some big differences in our species.

First, is bipedalism unique? The Australians are shaking their heads: kangaroos. So although humans are not the only bipedal animals, bipedalism did set in motion a series of physical changes in the hominid line that distinguish us from chimps. We lost our opposable first toe and developed a foot that could carry our upright weight. This has also allowed us to wear Italian designer shoes, a unique behavior known only to humans. Chimpanzees still have an opposable first toe, which acts similarly to a thumb and is good for grasping branches but not for carrying upright weight. As we humans became bipedal, our legs straightened, unlike the bowed legs of a chimp. Our pelvis and hip joints changed their size, shape, and angle of connection. Our spine became curved into an S shape, as opposed to the straight spine of a chimp. The thoracic spinal foramen, the channel that the spinal cord travels through, has enlarged, and the point where the spinal cord enters the skull has moved forward to the middle of our cranium rather than the rear.

Robert Provine, at the University of Maryland, a researcher who studies laughter, postulates that bipedalism actually made speech mechanically possible. In apes walking on all fours, the lungs have to be fully inflated to provide the additional rigidity needed for the thorax to absorb the impact of the ground through the forelimbs while running. Bipedalism broke the link between breathing patterns and stride, and allowed the flexibility for regulating breathing and ultimately speech.[5]

Other speech-enabling changes occurred: Necks elongated, and the

tongue and pharynx dropped lower down into the throat. In chimps and other apes, the nasal passage is directly connected to the lungs. It is completely separate from the food route through the mouth and into the esophagus; this means that the other apes cannot choke on their food, but we can. We have a different system, a unique system, in which air and food share a common pathway in the back of the throat. We have developed a structure called the *epiglottis*, which closes off the pathway to the lungs when we swallow, and opens when we breathe. It is the anatomy of the pharynx, specifically the larynx, that makes it possible for us to utter the huge variations in sound that we can. We must have gained some survival advantage even though there is an increased risk of death by choking. Was it our increased ability to communicate?

Freeing Up the Forepaws

Once we were walking upright, we had free hands that could carry things, and our thumbs became extraordinary. Actually, our thumbs became unique. Chimps do have opposable thumbs, but they don't have the *range* of motion that our thumbs have, and that is key. We can arc our thumbs across to our baby fingers, known as ulnar opposition, but chimps cannot. This means we can pick up objects with the tips of our fingers rather than just the sides. We also have more sensitive fingertips, with thousands of nerves per square inch that send information to the brain. This has given us the ability to perform the finest motor-coordinated tasks not only of all the apes but also of all living creatures.

According to the current fossil evidence, it seems that our hands were up and functioning about two million years ago in *Homo habilis,* whose fossils were found in the Olduvai Gorge in Tanzania early in 1964, along with the first known hand-wrought tools. This was another shock for anthropologists at the time, because *Homo habilis* had a brain about half the size of ours. It had been thought that a bigger brain was needed for tool making. In fact, the arcing thumb was what allowed our ancestors to be able to grab objects and pound them together to make the first tools. Remember, tool making is not unique to humans. Chimps, crows, and dolphins have all been observed using sticks, grass, and sponges as tools. However none of them has made a Maserati, which is unique to humans.

The Pelvic Thing: Big Brains, Big Pelvis

The change in the size of the pelvis also had big repercussions. The birth canal became narrower and made birth much more difficult—even as brains, and thus heads, were becoming larger. A wider pelvis would have made bipedalism mechanically impossible. In the embryo, the skulls of primates form in plates that slide over the brain and do not coalesce until after birth. (Remember the soft spot in the baby's head you were warned not to touch?) This allows the skull to remain pliable enough to fit through the birth canal. Human babies are born very much less developed than other ape babies. In fact, in comparison to other apes, we are born one year prematurely, which is why human babies are so helpless and need to be cared for longer. The plates in our skulls don't fully join until about age thirty. Our brains are only 23 percent of their adult size at birth and continue to expand until adolescence.

While it appears that certain aspects of our brains may continue to grow throughout our lifetime, it is most likely not due to the addition of new neurons. Instead, it is more likely that the myelin sheaths that surround the neurons continue to grow. Francine Benes, a professor of psychiatry specializing in neuroscience at Harvard Medical School and director of the Harvard Brain Tissue Resource Center, has found that myelination of at least one part of the brain* continues into the sixth decade.[6] Myelination of an axon (nerve fiber) increases the propagation of the electrical signals from the cell body to the terminal area of the neuron. She postulates that these axons may play a role in the integration of emotional behaviors with the cognitive process, and that these functions may "grow" and mature throughout adult life. It is also interesting that there is a gender effect. There is increased myelin in females age six to twenty-nine, compared to males the same age.

As it turns out, our physical anatomy is important, and just how much it has affected the development of the brain, and thus our humanness, is unknown.† But let's get back to our date. What we are really concerned

*The superior medullary lamina in the parahippocampal gyrus.

†Try: Chip Walter, *Thumbs, Toes and Tears and Other Traits That Make Us Human* (New York: Walker, 2006), for a good read and a great evaluation of this subject.

about on a date beyond the physical—which in the land of sexual selection *is* a big deal—is just what makes him or her tick. What do we have in common and what is unbridgeable? Our guy is intelligent and curious. Is he well matched with a chimp?

MENTAL DIFFERENCES

In the descriptions of our prospective dates there are some major differences. Our chimp date cannot talk, never gained control over fire, doesn't cook, hasn't developed a culture of art, music, or literature, is not particularly generous, isn't monogamous, and doesn't grow food. However, she is attracted to a strong mate, is status conscious, is omnivorous, and likes to socialize, hunt, eat well, and have close contact with a mate. Let's look at these similarities and differences.

Do chimps share some of our intelligence? Is there a difference between human and animal intelligence? One could write an entire book on this issue, and many have. The field is nothing but controversial. Definitions of intelligence are commonly given from a human's point of view. For example, "Intelligence is a general mental capability that involves the ability to think abstractly, comprehend ideas and language, learn, plan, reason and solve problems."[7] But can one species' intelligence really be compared to another's? Perhaps a more useful definition of animal intelligence is that of Hubert Markl, former president of the Max Planck Society in Germany, who said it is "the ability to relate different unconnected pieces of information in new ways and to apply the results in an adaptive manner."[8]

Daniel Povinelli, director of the Cognitive Evolution Group and the Center for Child Studies at the University of Louisiana, addresses the problem by posing the animal intelligence question this way: "How does thinking differ across species?"[9] Or to put it another way: What kind of thinking was needed to allow a species to survive in the environments that it has successfully evolved in? Can you imagine a different way of thinking? It is difficult for us to imagine how to think other than how we do; thus it is difficult to conceive of the mental states of other species. It is hard enough understanding the mental states of our own species. Povinelli is concerned that

psychologists have become obsessed with establishing a psychological con-
tinuity between humans and other great apes, and so are looking only for
similarities. Indeed, he reminds us, "Evolution is real, and it produces diver-
sity."[10] Looking at the diversity of mental states instead of distorting "their
true nature by conceiving of their minds as smaller, duller, less talkative ver-
sions of our own"[9] would perhaps net us better information. John Holmes,
a trainer of border collies, stated, "A dog is not 'almost human' and I know of
no greater insult to the canine race than to describe it as such. The dog can
do many things which man cannot do, never could do and never will do."[11]
Indeed it is the differences that define a species and make it unique.

This presents a big problem that we face in studying chimpanzees'
mental states and behavior. How do we do it? We can watch them in the
wild: long arduous days just to get to where they live, followed by long,
arduous, mosquito-infested, humid days trailing after them and observ-
ing them. Or we can watch them in a laboratory, where few are equipped
to care for chimps, there are few chimps to experiment on, experimental
designs are limited, and chimps grow "sophisticated" as they become
familiar with the experimental milieu. The scientists who watch them in
the wild say that the laboratory is too artificial, that the chimps do not
behave normally there, and that they can be influenced by those running
the experiments. The laboratory scientists create a hypothesis and pre-
dictions, then design an experiment controlling for as many variables as
they can, and record and interpret the results. They say that those in the
field have no experimental control over the situations in which a behav-
ior is occurring and thus can't draw an accurate causal inference. Both
suffer from the fact that the interpretations are seen through the eyes of
humans, who are influenced by their own culture, politics, backgrounds,
religion, and theory of mind. Keeping these limitations in mind, we are
going to look at evidence and observations from both the lab and the
field, and see just how similar and different we are.

Theory of Mind

Humans have an innate ability to understand that other humans have
minds with different desires, intentions, beliefs, and mental states, and
we have the ability to form theories with some degree of accuracy about

what those desires, intentions, beliefs, and mental states are. It was first called *Theory of Mind* (TOM) by David Premack, whom we have already met in chapter 1, and his colleague Guy Woodruff in 1978. It was an ingenious insight. Another way to put it: It is the ability to observe behavior and then infer the unobservable mental state that is causing it. TOM is fully developed automatically in children by about age four to five, and there are signs that it is partially present before age two.[12, 13] It appears to be independent from IQ. Children and adults with autism have deficits in theory of mind and are impaired in their ability to reason about the mental states of others, yet their other cognitive abilities remain intact or increased.[14, 15] When looking at the behavior of other animals, our TOM causes us two problems. One is that we may get caught in the trap of seeing a certain animal behavior and with our TOM infer a human mental state in the animal, leading us to an inappropriate anthropomorphic conclusion. Alternatively, we may value our TOM ability to such a degree that it is a gold standard to which everything else is compared, leading us to think that man is completely separate from all other mammals. So do only humans have a theory of mind?

This is one of the major questions in chimpanzee research. Possessing a TOM is an important part of our abilities and has been argued to be uniquely human. To understand that other individuals have beliefs, desires, intentions, and needs affects how we act and react, whether out of sociability or for protection. When Premack and Woodruff coined the term TOM, they asked if chimps had it. There have been thirty years of experiments since that time, and the question has yet to be answered satisfactorily in the laboratory. In 1998, Cecelia M. Heyes from University College London did a review of all the experiments and observations that had been done up until that time on nonhuman primates and put them through a rigorous evaluation. These experiments studied motor imitation (the spontaneous copying of novel acts), self-recognition in a mirror, social relationships, role taking (the ability to adopt the viewpoint of another individual), deception, and perspective taking. (The last concerns the question whether seeing something translates into knowing it, i.e., is there an awareness that others see.) She came to the conclusion that in every case where nonhuman primate

behavior had been interpreted as a sign of theory of mind, it could instead have occurred either by chance or as a product of nonmentalistic processes.[16] She did not feel that the current procedures had proved or disproved TOM in chimps, although her arguments specifically about mirror self-recognition are not widely held. Now Povinelli and his colleague Jennifer Vonk have since reached the same conclusion.[17]

But nothing is simple in a field where so much is at stake. Michael Tomasello and his group at the Max Planck Institute for Evolutionary Anthropology in Leipzig, Germany, have drawn a different conclusion. "Although chimpanzees almost certainly do not understand other minds in the same way that humans do (e.g. they apparently do not understand beliefs) they do understand some psychological processes (e.g. seeing)."[18] They feel that chimpanzees have at least some components of TOM.

If I have a belief about your mental state, and you have one about mine, these are described as orders of intensionality. (*Intensionality* is used here, spelled with an *s*, as was the original practice, to refer specifically to the mental states associated with TOM. It is distinguished from *intentionality* with a *t*, which is a type of intensionality.) I know (1) that you know (2) that I know (3) that you want me to go to Paris (4) and that I want to. In a conversation about intensionality, fourth order is about as far as most people can grasp, but some can follow up to five or six orders, so I can throw in: and you know (5) I can't and I know (6) that you know it but keep coming up with reasons to go. Whew. As I said before, to what extent other apes have a theory of mind is still highly contested. It is accepted that they have first-order intensionality. Many researchers, but not all, believe that an individual who practices tactical deception has second-order intensionality. They think that in order to trick another individual, an animal has to believe that another animal believes something. Through the compilation of multiple observational studies, Richard Byrne and Andrew Whiten have shown that instances of tactical deception are extremely rare in prosimians* and New World monkeys, but are common among the socially advanced Old World monkeys and apes—especially chimps.[19]

Although not all researchers are satisfied by observational studies, many accept that nonhuman primates have second-order intensionality.

*The most distantly ancestral of the living primates.

Scientists at Tomasello's lab have shown in a series of experiments over the last few years that chimpanzees know what other chimps do and do not see, and can base their behavior accordingly. They will go after food that a more dominant chimp cannot see but will not go after food that the dominant one can see, and some subordinates even engage in strategic maneuvering, such as waiting or hiding, to obtain the food.[20] We will learn more about what chimps understand about seeing in chapter 5. Tomasello has also found that they understand some things about the intentions of others, specifically the difference between times when an experimenter is unwilling versus unable to give them food.[21] And chimps are more skillful at competitive tasks than those that involve cooperation,[22] but when they need to cooperate, they will choose a chimpanzee who was a better collaborator on the task in the past.[23]

Where the chimps have failed is in a false-belief task that children can do at four to five years old. This test has in the past been used to indicate the full development of theory of mind. However, more recently it has been realized that this is rather overstating the case. As Paul Bloom at Yale University and Tim German, when at the University of Essex, Colchester, United Kingdom, pointed out, there is more to theory of mind than the false-belief task, and there is more to the false-belief task than theory of mind.[24]

What is this task? It is classically called the Sally and Ann test. Nonverbally, it works like this: Sally hides a reward, such as food, in one of two identical containers while Ann watches, but the subject (the child or chimp) does not. Then the subject watches Ann place a marker on the container that she believes holds the food. The child or the chimp then picks a container to get the food. They both can do this successfully. Then, Sally hides the reward again as Ann watches but the subject does not. Then the subject sees Ann leave the room and while she is gone, watches Sally switch the containers. Ann then comes back into the room and marks the container that she believes the food is in (which of course is the wrong one). Sometime between the age of four and five, children understand that the container that Ann thinks has the food in it has been switched and that Ann doesn't know it. They understand that Ann has a false belief, and they will pick the correct container with the food, not the one that Ann has marked. However, the chimps and children with autism do not understand that Ann has a false belief, and will pick the container that she has marked.[25]

In the last couple of years, researchers are beginning to conclude that this test is too hard for kids under three years old. When different versions or a different type of test is done, even eighteen-month- to two-year-old children attend to mental states such as goals, perceptions, and beliefs to explain the behavior of others.[26]

What does this task actually show us? Why is there such a watershed change between three and five? What is going on in the brains of these kids that enables them to do what a chimp cannot?

Stand back or you'll get in the fray! Controversy abounds, and two different explanations are being batted around. One is that there is a conceptual change in the children's understanding of what beliefs really are as they get older: They gain a theoretical understanding of mental states,[27] perhaps a domain-general mechanism of theory formation.[28] In other words, the theory comes first, and from it concepts are derived. The other is that there is a modular theory of mind mechanism (ToMM) that gradually emerges on a reliable developmental schedule as the children get older.[29, 30]

In bringing up modules, I am getting ahead of myself a bit, but you are going to be hearing a lot about them soon. For now, think of a module as a hardwired (innate) mechanism that unconsciously directs you to think or act in a certain way, that directs your attention to such states as belief, desire, and pretense and then allows you to learn about these mental states.[31, 32] The proposal is that you are born with these concepts. The concepts came first; later, you form theories. The mechanism provides the child with a few choices of belief states, and then a secondary selection process (which is not modular and is able to be influenced by knowledge, circumstance, and experience) infers the underlying mental state that gave rise to the belief state.

For instance, a child would observe and pay attention to a behavior such as a person saying, "Hmmm." Then up pop the choices: "Well, . . . it could be she believes that the candy is in the box she marked with the X and it is true, or she believes that but it isn't true." But here is the catch: The choice "Well, she believes that and it is true" is the default choice. This choice is always supplied, is usually picked, and in general is correct. What people believe is usually true. But in some instances, others do have false beliefs, and you know it. In such unusual situations, the default should not be selected. In order not to pick this choice, to

succeed in the false-belief task, this choice must be inhibited, and there's the rub. This is what is so difficult for the very young and for our friends the chimps: inhibition. This theory also accounts for why we get better at attributing beliefs to others: Once we have inhibition under our belt, knowledge and experience help out.

Tomasello does not think that chimps have a full theory of mind, but he does hypothesize that chimpanzees "possess a social-cognitive schema enabling them to go a bit below the surface and discern something of the intentional structure of behavior and how perception influences it."[33] Dave Povinelli disputes this conclusion. He does not think that their similarity in behavior reflects a similarity in psychology. He offers his reinterpretation hypothesis, in which he suggests that the majority of the social behaviors that humans and other primates have in common emerged long before the human lineage evolved the psychological means of interpreting those behaviors in terms of second-order intentional states.[34]

The controversy goes on about consciousness shared with the chimp. What we share is minimal at best, according to Povinelli: "Key aspects of the data point toward the possibility that if chimpanzees do have a theory of mind, it must be radically different from our own." This leads us back to the question that he poses to begin with: How does thinking differ across species?

Povinelli has a further refinement to that question: "What are their mental states about?" Well, they most certainly are about living in the tropical forest. "It would stand to reason that the mental state of chimpanzees, first and foremost, must be concerned with the things most relevant to their natural ecology—remembering the location of fruit trees, keeping an eye out for predators, and keeping track of the alpha male." So far, this would be a good date to take camping. He goes on to suggest, "In contrast to humans, chimpanzees rely strictly upon observable features of others to forge their social concepts. If correct, it would mean that chimpanzees do not realize that there is more to others than their movements, facial expressions, and habits of behavior." In short, Povinelli believes that "for any given ability that humans and chimpanzees share in common, the two species would share a common set of psychological structures, which at the same time, humans would augment by relying upon a system or systems unique to the species."[9] We will talk more about TOM in other animals.

Another aspect of intelligence is being able to plan for the future. Besides doing TOM studies, Nicholas Mulcahy and Josep Call, also at the Max Planck Institute in Leipzig, have looked into whether other great apes can plan. Recently they published a study of five bonobos and five orangutans, finding that they did have the ability to save a suitable tool for future use.[35] In their study they first taught the subjects to use a tool to get a food reward from an apparatus in a test room. "Then we placed two suitable and six unsuitable tools in the test room but blocked subjects' access to the baited apparatus. After five minutes, subjects were ushered outside the test room into the waiting room, and the caretaker removed all objects left in the test room while subjects watched. One hour later subjects were allowed to return to the test room and were given access to the apparatus. Thus to solve the problem, subjects had to select a suitable tool from the test room, bring it to the waiting room, keep it there for one hour, and bring it back into the test room upon their return." The subjects took a tool with them 70 percent of the time. The researchers repeated the test but with a fourteen-hour delay, and the subjects did well again. Mulcahy and Call concluded that "these findings suggest that the precursor skills for planning for the future evolved in great apes before 14 million years ago, when all extant great ape species shared a common ancestor." Maybe our chimp date will plan ahead and make a reservation.

LANGUAGE

So your chimp date may not have much of a theory about you, and as a result, anything you might do with her will be sort of viewed as being without intention. Nonetheless, perhaps she has feelings about her own states of mind that she would like to tell you about. Speech, of course, is the faculty or act of expressing or describing thought, feelings, or perceptions by the articulation of words. But chimps can't speak. I can remember my friend Stanley Schachter at Columbia always lamenting, "How can Herb Terrace* become famous for showing chimps can't talk?" In

*Professor of psychology and director of the Primate Cognition Lab at Columbia University.

the end, they just don't have the anatomy to be able to articulate the kinds of sounds that are necessary, so talking per se is out. But that certainly doesn't mean they can't communicate.

Communication, quite simply, is the transfer of information by speech, signals, writing, or behavior. In the world of animal communication, it is more specifically defined by any behavior on the part of one animal that has an effect on the current or future behavior of another animal. An example of interspecies communication is when a rattlesnake shakes its rattle: It is a warning that it is going to strike. Of course, language is another type of communication. It is far more complicated in its origins and abilities, and so is its definition. In fact, the definition of language is constantly in a state of revision by linguists, to the consternation of researchers studying human language acquisition in chimps.

Sue Savage-Rumbaugh, a primatologist at Georgia State University who claims apes have a language capacity, vents her frustration: "First the linguists said we had to get our animals to use signs in a symbolic way if we wanted to say they learned language. OK, we did that, and then they said, 'No, that's not language, because you don't have syntax.' So we proved our apes could produce some combinations of signs, but the linguists said that wasn't enough syntax, or the right syntax. They'll never agree that we've done enough."[36]

Well, language is a system of abstract symbols and the grammar (rules) in which the symbols are manipulated. For instance the words *dog, chien,* and *cane* all mean "dog." The word doesn't sound like its meaning; it is just a sound that has come to represent "dog" in different languages. It is an abstract symbol. Language does not have to be spoken or written. It can be made with gestures, such as American Sign Language. What is complicated and always changing are opinions about the rules: what they involve and where they came from and what components, if any, of human language are unique.

Syntax is the pattern of formation of sentences or phrases that governs the way the words in a sentence come together. Human language can string phrases together indefinitely to produce an unlimited number of sentences that are all different and have never been said before. If you speak that particular language, you can understand them, because the

words are organized in a hierarchical and recursive way, not just randomly. So someone with human language can make a date for a certain time and place and give you directions about how and when to get there. "I'll meet you at noon in front of the museum that is by the bank" is different from "I'll meet you at noon in front of the bank that is by the museum." Which is also different from the nonsense "Bank in meet that you noon is museum by I'll front the of at." And why is it nonsense? It is not following the rules of grammar. If language had no syntax, we would just have a bunch of words that you would string together willy-nilly. You could get some rudimentary meaning across perhaps, but you might be unintentionally stood up. Bad for a date.

How did syntax develop? A species either has the ability to learn a language or it does not, and this ability was acquired through an evolutionary process of natural selection. If a species can learn language, then the individual is born with a sense for both symbolic representation and syntax. Of course, there are those who disagree with this theory, in two distinct ways. Some believe that language is not an innate ability but that the ability to learn it is learned. This does not refer to learning a specific language, but rather to the ability to learn any language. In other words, this view holds that an individual does not spontaneously utilize syntax and symbolic representation. Others disagree about the evolution of language. Cognitive linguists, proponents of the "continuity" theory, argue that mental traits are subject to the same forces of natural selection as biological traits. "Discontinuity" theory proponents argue that some elements of behavior and mental traits are qualitatively unique to a given species and share no evolutionary heritage with other living species or archaic species. Noam Chomsky, the distinguished linguist at MIT, proposes that human language is "discontinuous" in this sense.[37]

Remember that what we are concerned with is looking for what is unique to humans. Our language ability is often put on that list by others besides Chomsky. Can chimps communicate with language? This question is really asking whether nonhuman apes can communicate with a language taught to them by humans. Early efforts to teach language to chimps were first made by David Premack when he was at the University

of California at Santa Barbara. I know because the chimp that was being trained sort of had the office next to mine. Sarah was her name, and she was exceptionally bright. Indeed, she might have made tenure if she could ever have gotten the full story straight.

Premack moved on to the University of Pennsylvannia and kept trying. Others jumped into the fray, including Herbert Terrace of Columbia University. In 1979, Terrace published a skeptical account of his efforts to teach American Sign Language to a chimp whimsically named Nim Chimpsky. Nim was able to connect a sign to a meaning and could express simple thoughts, such as "give orange me give eat." However, Nim could not form new ideas by linking signs in ways he hadn't been taught; he didn't grasp syntax. Terrace also reviewed the reports of others' attempts to teach apes language and concluded the same thing: They aren't coming up with complex sentences.

This leaves us with Koko the gorilla, who supposedly was taught sign language by Penny Patterson. A problem presents itself when evaluating Koko's abilities. Patterson, the handler, is the only interpreter of the conversations, and as such, she is not objective. Stephen Anderson, a linguist at Yale, comments that although Patterson says she has kept systematic records, no one else has been able to study them, and that since 1982 all the information about Koko has come through the popular press and Internet chat sessions with Koko, Patterson acting as the interpreter and translator of her signs.[36]

This ambiguity in interpreting sign language is what led Sue Savage-Rumbaugh to use lexigrams, which are not ambiguous.[38] Savage-Rumbaugh has indeed the most tantalizing data and a serendipitous bonobo. She used an artificial symbol system of graphic designs called lexigrams on a computer keyboard.

She began teaching a female bonobo named Matata how to use the keyboard. The experimenters would press a lexigram key and point to the intended object or action. The computer would then say the word and the key would light up. Matata had a baby named Kanzi, who was too young at the time to be separated from his mother, so he sat in on the training sessions with Matata. Matata was not a good pupil, and after two years, she had not learned much. When Kanzi was about two and a

half years old, Matata was moved to a different facility, and Kanzi stepped into the spotlight. Although he had had no specific training, just by watching his mother's sessions he had learned how to use some of the lexigrams on the keyboard in a systematic way!

Savage-Rumbaugh decided to change tactics. Instead of doing the training sessions she had been using with Matata, she would just carry the keyboard around and use it during routine activities. What has Kanzi accomplished? Well, he can match pictures, objects, lexigrams, and spoken words. He freely uses the keyboard to ask for objects he wants and places he wants to go to. He can tell you where he intends to go, and then he goes there. He can generalize a specific reference: He uses the lexigram for *bread* to mean all breads, including tacos. He can listen to an informational statement and adjust what he is doing using the new information. This is what Sue was referring to when she said, "First the linguists said we had to get our animals to use signs in a symbolic way if we wanted to say they learned language." And she is right; Kanzi did.

Still, all of this begs the question of syntax. Stephen Anderson points out that both language production (the keyboard) and language recognition (spoken English) need to be evaluated.[36] Kanzi uses both keyboard and gesture, and sometimes combines the two to make a sequence. He will use a lexigram first to specify the action, such as "tickle," and then a pointing gesture to specify the agent—always in that order, even if he has to walk across the room to point to the lexigram first, and then return to indicate the agent. This is an arbitrary rule that Kanzi has developed on his own.* Anderson states that this does not yet satisfy the definition of syntax, in which the type of word (noun, verb, preposition, etc.), its meaning, and its role in the sentence (subject, object, conditional clause, etc.) all contribute to the meaning of the communication, not whether it is typed, gestured, spoken, or written.

Patricia Greenfield, a linguist at UCLA who studies language acquisition in children and has analyzed all of Savage-Rumbaugh's data, disagrees. She thinks that there is syntactical structure in Kanzi's multiword combinations.† For instance, he can recognize word order: He under-

*Kanzi, p. 161.
†Kanzi, p. 155.

stands the difference between "Make the doggie bite the snake" and "Make the snake bite the doggie," and he uses stuffed animals to demonstrate what the two mean. He can respond 70 percent of the time to unfamiliar sentences, such as "Squeeze the hot dog," given by vocal instruction from a concealed instructor. He is the first nonhuman to demonstrate either of these abilities.

Anderson remains unconvinced. He points out that when the understanding of a sentence depends upon a "grammatical word," such as a preposition, Kanzi's performance is poor. He seems to be unable to distinguish between *in*, *on*, or *next to*, and it is unclear if he understands conjunctions, such as *and*, *that*, and *which*. The obvious advantage that Kanzi has as a date is that you wouldn't be subjected to dangling participles or terminal prepositions, as in "Where are you going to be at?" At his current level, Kanzi has a grasp of words for visual objects and actions. Anderson concludes, "Kanzi can associate lexigrams and some spoken words with parts of complex concepts in his mind, but words that are solely grammatical in content can only be ignored, because he has no grammar in which they might play a role."[36] Although Kanzi is showing remarkable abilities, we must remember that after many years, his abilities are rudimentary.

We learned in the last chapter that there are many similarities in brain structure between humans and the other great apes, especially chimps, but we have bigger brains, more connectivity, and that FOXP2 gene, among other things. We've learned that our anatomy has changed a great deal since the divergence from a common ancestor, allowing us to become better at vocalization. Doesn't it make sense that part of the wiring was already in when we diverged from the common ancestor, and the chimp line made use of it in one way, whereas the multitude of changes that the hominid line underwent produced something else? Sue Savage-Rumbaugh states, "The significance of Kanzi's possession of certain elements of language is, however, enormous. As the ape brain is just one-third the size of the human brain, we should accept the detection of no more than a few elements of language as evidence of continuity."*

*Kanzi, p. 164.

Are other nonhuman primates communicating with each other? Is there natural language within other species? After all, as Povinelli reminds us, other species have evolved to communicate with each other, not with humans. Well, unfortunately, as Savage-Rumbaugh points out, Kanzi knows more about human language than humans know about bonobo language.[39]

COMMUNICATION AND POSSIBLE ORIGINS OF LANGUAGE

As I promised, we are now going to look at other types of communication. Language is but one type and clearly a bit shaky. Let's go to the forest and see what has been observed. Perhaps the best-known studies in intraspecies animal communication have been those done by Robert Seyfarth and Dorothy Cheney in Amboseli National Park in Kenya with vervet monkeys. They have found that vervet monkeys have different alarm calls for different predators: one for snakes, one for leopards, and one for predatory birds.[40] The response to a snake call is that the other vervet monkeys will stand up and look down; to the leopard call, they all scamper into the trees; and to the bird call, they go up against the trunks of trees and away from the exposed ends of the branches. It was thought until recently that animal vocalizations were exclusively emotional. However, a vervet does not always make an alarm call: He seldom makes it when he is alone and is more likely to make it when with kin than with non-kin. The calls are not an automatic emotional reaction.

Once again, it was David Premack who observed that it was possible for an affective communication system, even one based entirely on emotion, to become semantic (i.e., conveying information other than the emotion).[41] Even though a scream can be an emotional reaction, it can also convey other information. This was a much contested idea for twenty years, but Seyfarth and Cheney, after further investigation with the vervets, agreed with him: "Signalers and recipients, though linked in a communicative event, are nonetheless separate and dis-

tinct because the mechanisms that cause a signaler to vocalize do not in any way constrain a listener's ability to extract information from the call."[42] They explain that if a call is to provide information, it has to be specific: The same call can't be used for several different reasons. Also the call has to be informative, meaning that it is made whenever a specific situation arises.[43] Obviously there is information being given and understood. This could represent a mechanism of how language evolved.

However, Seyfarth and Cheney continue to point out that the most common function of human language is to influence the behavior of others by changing what they know, think, believe, or desire, but most evidence suggests that while animal vocalizations may result in a change, that is not their intention but is inadvertent. Vervet monkeys don't appear to attribute mental states to others. For example, infant vervets often give the eagle alarm call mistakenly for pigeons. Nearby adults will look up, but they don't give the alarm call themselves if they don't see an eagle. However, if the infant is the first to give an alarm call for a genuine predator, adults will sometimes look up and give a second alarm call, but not always. With the random pattern of repeating the infant's alarm call, the adults do not act as though they know that the infant is ignorant and just learning to spot predators, by validating all correct calls.[42]

There is similar data about wild chimpanzees, who do not appear to adjust their calls to inform ignorant individuals about their location or about food.[44, 45] A mother will hear her lost baby call, but she does not answer back. Meanwhile, in the laboratory, Povinelli has found that a trained chimp cannot teach another chimp to pull a rope for a food reward. In short, nonhuman primates do not seem to make calls or attempt to communicate because they perceive another individual is ignorant or needs information, as a human does. If chimps had a theory of mind, the mother might think: *I hear my baby call from a distance. He must not know where I am. I should make a call so he knows where I am.* Nevertheless, chimps and other primates may recognize the effect that their calls have on behavior: *I call in a certain way, and all my buddies run up into the trees.* This in no way negates the fact

that information is passed; it just may not have been the *intention* of the caller. So what does this all mean for our date? Well, vocal communication from the chimp's point of view may just be "It's all about me," which when you think about it isn't all that different from many human dates.

Chimps in the wild have been observed to communicate with a combination of glances, facial expressions, posturing, gesturing, grooming, and vocalization, just as Kanzi uses a combination of lexigrams and gestures. All these modes lead to interesting questions about the origins of language, which have yet to be answered. Has language evolved from hand gestures, a theory championed by Michael Corballis,[46] or a combination of hand gestures and facial movements, as postulated by Giacomo Rizzolatti and Michael Arbib?[47] Or did it evolve from vocalization alone? Or is the "big bang" theory of human language, postulated by Noam Chomsky, the correct one?

The speech center in humans is located in the left hemisphere. The left hemisphere controls the motor movements of the right side of the body. Chimpanzees exhibit preferential use of the right hand in gestural communication, especially when accompanied by a vocalization,[48] and baboons in captivity have been found to gesture primarily with their right hand.[49] There are many interesting studies of humans that show how hand gestures and language are connected. One study of twelve congenitally blind speakers found that they gestured as they spoke at the same rate as a group of sighted people, using the same range of gesture forms. The blind people would gesture while they spoke even when speaking to another blind person, which suggests that gestures are tightly coupled to the act of speaking.[50] Congenitally deaf people in isolated communities will develop their own fully communicative hand gesture language with syntax.[51]

Helen J. Neville and her colleagues at the University of Oregon have confirmed through functional magnetic resonance imaging (fMRI) studies that both Broca's and Wernicke's areas, the two main language-mediating areas in the left side of the brain that are activated when hearing people speak, are also activated in deaf signers while they watch sentences in ASL. However, when deaf subjects

read, they do not activate these regions.[52] It has also been observed that anterior lesions in the vicinity of Broca's area produce deficits in signing itself, but more posterior lesions produce deficits in the comprehension of signing. Neville also found that there was more activity in the right side of the brain in the deaf subjects than in the hearing people. This may be because of the spatial aspect of signing, mostly a right-hemisphere function. A similar thing is going on in the chimp's brain as it gestures.

Now we're going to Italy, a land famous for its hand gestures. Giacomo Rizzolatti, Leonardo Fogassi, and Vittorio Gallese, from the beautiful city of Parma, first discovered mirror neurons in the premotor area (area F5) of the brain of monkeys in 1996. These neurons fire when a monkey performs an action in which his hand or mouth interact with an object. They also fire when the monkey merely *sees* another monkey (or human experimenter) perform the same type of action. Thus they are called mirror neurons. They were later also found in another part of the monkey brain, the inferior parietal lobule.[53] It is generally accepted that the F5 region of the monkey brain shares the same ancestry as Broca's area in the human brain.[47] Broca's area in the human is thought to be the area for speech, and as we have seen above, for signing; the dorsal part of F5 in the monkey is an area for hand movements,[54, 55] and the ventral part is an area for mouth and larynx movement.[56, 57] Rizzolatti and Michael Arbib, director of the University of Southern California Brain Project, suggest that the mirror system was fundamental for the development of speech, and before speech for other forms of intentional communication,[47] such as facial expression and hand gestures. Do humans have these mirror neurons? There is a lot of evidence that we do.[58] The cortical areas active during action observation in humans match those active in the monkey. So there seems to be a fundamental mechanism for action recognition that is common to apes and humans.

Here is their proposal about language development: Individuals recognize actions made by others because the pattern of firing neurons made when observing an action is similar to the pattern produced to generate the action. So maybe the speech circuits in humans developed because

the precursor structure that later evolved into Broca's area had a mechanism for recognizing actions in others—and had to have this ability before language could evolve.

Huh? Rizzolatti and his buddies know they are walking on the wild side with this hypothesis, but let's see where they take us, because this is what neuroscience is all about. You find something interesting on the cellular level and try to connect it all the way to behavior. You propose a hypothesis, and then either it gets shot full of holes or it doesn't. As in many fields of science, the emotionally weak and the thin-skinned need not apply.

We have already seen that in the vervets there is a gap between recognizing actions and sending messages with communicative intent. How did this intent develop in humans? Normally, when an individual is watching an action or getting ready to perform an action, the premotor areas are on alert. There is a system of inhibition to prevent observers of an action from emitting a motor behavior that mimics it.[47] Otherwise we'd be playing follow the leader all the time. However, sometimes if the observed action is particularly interesting, there can be a brief lapse of inhibition and an involuntary response from the observer. This sets up a two-way street. The individual performing the action (the actor) will recognize a response in the observer, and the observer will see that his reaction caused a reaction in the actor. If the observer can control his mirror neuron system, then he can send a voluntary signal and thus begin a rudimentary dialogue of sorts. Voluntary control of the mirror neurons is the necessary foundation for the beginning of language. The ability to notice that one has actually given a signal and the ability to recognize that it caused a reaction did not necessarily arise at the same time. Each ability would have had great adaptive advantage and would have been selected for.

What action are they talking about? Was it facial or gestural? Remember that both F5 and Broca's area have the neural structures to control both. Speculating on the sequence of events that led to speech, Rizzolatti and Arbib guess that the first gestures used from individual to individual were orofacial. Jane Goodall states that long bouts of eye contact may accompany friendly interactions, and then describes one of many facial expressions: "There is one facial expression which, more

than any other has dramatic signal value—the full closed grin. When this expression suddenly appears, it is as though the whole face has been split by a gash of white teeth set in bright pink gums. It is often given silently, in response to an unexpected and frightening stimulus. When an individual turns to his companions with his face transfigured by this horrifying grin, it usually evokes an instant fear response in the beholders."[59]

Monkeys, apes, and humans still use orofacial gestures as their main natural way to communicate. The lip smacks and tongue smacks of monkeys persist in humans, where they form syllables in speech production. Did vocalization come next? Rizzolatti and Arbib don't think so. Remember when we talked about monkey and ape vocalization being a closed system? (See pages 61–62.) A manual system could have given more information. In a vocal system of limited anatomy, the only way to enhance an emotional vocalization of "Scream scream scream" telling you to be scared is to do it louder: "Be more scared." However, a manual gesture system could add information: "Scream scream scream" tells you to be scared and then a gesture to indicate a snake that is big and where it is. This type of behavior has been observed in chimps to a limited extent in the Ivory Coast: When traveling or encountering a neighboring group, the chimps combine a bark with drumming.[60]

Once this happened, an object or event described with a gesture could be associated with a vocalization that is not a scream but a short *ooo* or *aah*. If the same sound was used each time for the same meaning, a rudimentary vocabulary could have been started. In order for this new vocalization to develop into speech, it had to be skillfully controlled by more than just the old emotional vocal centers. The F5-like precursor—which already had mirror neurons, a control of orolaryngeal movements, and a link with the primary motor cortex—could have developed into Broca's area. Because an effective communication system would provide a survival advantage, eventually the evolutionary pressure to form more complex sounds, and the anatomy that could produce them, would be selected for. Manual gestures would lose their importance (except for Italians) and become an accessory to language, but they would still be able to function if need be, for sign language.

Consider this from Luigi Barzini in his book *The Italians*:

Often enough, a simple gesture, accompanied by suitable facial expressions, takes the place not of a few words, but of a whole and eloquent speech. This, for instance; imagine two gentlemen sitting at a café table. The first is explaining at great length. . . . "This continent of ours, Europe, old, decrepit Europe, all divided into different nations, each nation subdivided into provinces, each nation and each province living its own petty life, speaking its incomprehensible dialect, nurturing its ideas, prejudices, defects, hatreds. . . . Each of us gloating over the memories of the defeats inflicted by us on our neighbours and completely oblivious of the defeats our neighbours inflicted on us. How easy life would become if we were to fuse into one whole, Europa, the Christendom of old, the dream of Charlemagne, of Metternich, of many great men, and why not? The dream of Hitler too."

The second gentleman is listening patiently, looking intently at the first's face. At a certain moment, as if overwhelmed by the abundance of his friend's arguments or the facility of his optimism, he slowly lifts one hand, perpendicularly, in a straight line, from the table, as far as it will go, higher than his head. Meanwhile he utters only one sound, a prolonged "eeeeeh," like a sigh. His eyes never leave the other man's face. His expression is placid, slightly tired, vaguely incredulous. The mimicry means: "How quickly you rush to conclusions, my friend, how complicated your reasoning, how unreasonable your hopes, when we all know the world has always been the same and all bright solutions to our problems have in turn produced more and different problems, more serious and unbearable problems than the ones we were accustomed to."[61]

FEELING AND THE BRAIN

Back to our date. So far we've found that she can plan a little, communicate a little, but not with speech or the language skills that we use, probably doesn't think abstractly, and is mostly going to communicate only about her needs. What about feelings? Emotions?

The research into emotions, until recently, has gone through a period

of neglect. The exceptionally talented Joseph LeDoux, a former student of mine who is now at New York University, states that this happened for a couple of reasons. Since the 1950s, it was thought that the limbic system (which involves many brain structures) was responsible for creating emotions, but the more recent emergence of cognitive science has dominated research attention. Although he thinks that the limbic system concept does not adequately explain specific brain circuits of emotions, he does agree that emotions involve relatively primitive circuits that have been conserved throughout mammalian evolution.[62]

Emotion research had also suffered from the problem of subjectivity, whereas cognitive scientists have been able to show how the brain processes external stimuli (pain, for instance), without having to show how the conscious perceptual experiences come about. Most cognitive processes have been found to occur subconsciously, with only the end product reaching the conscious mind if at all. LeDoux continues, "Contrary to popular belief, conscious feelings are not required to produce emotional responses, which, like cognitive processes, involve unconscious processing mechanisms." To the extent that many of the systems that function nonconsciously in the human brain function similarly in the brains of other animals, there is considerable overlap among species in the nonconscious aspects of the self.[63]

One of the best-studied emotions is fear. What happens when you hear the rattle of a rattlesnake or catch a slithering movement in the grass? The sensory inputs go to the thalamus, a type of relay station. Then the impulses are sent to the processing areas in the cortex and relayed to the frontal cortex. There they are integrated with other higher mental processes and into the stream of consciousness; this is when a person becomes consciously aware of the information (there is a rattler!), has to decide to act (a rattlesnake is poisonous, I don't want it to bite me, I should move back), and put the action into gear (feet don't fail me now!). All this takes a while. It can take a second or two. But there is a shortcut that obviously is an advantage. It is through the amygdala, which sits under the thalamus and keeps track of everything that is streaming through. If it recognizes a pattern that was associated with danger in the past, it has a direct connection to the brainstem, which then activates

the fight-or-flight response and rings the alarm. You jump back before you realize why. This is more apparent when you have jumped back only to realize that it was not a snake. This faster pathway, the old fight-or-flight response, is present in other mammals. To what extent other emotions will be found to inhabit mutual pathways is not yet known, but it is now another hotbed of research.

Not only does it seem that we share at least some of the same unconscious emotions as our chimp date; observational studies in the wild are revealing that we may be more unconsciously apelike than we imagine. Let's go outside.

INTO THE TROPICAL FORESTS

Until January 7, 1974, scientists treated the remarkable violence of humanity as something uniquely ours. Then in Gombe National Park, Tanzania, Hillali Matama, the senior field assistant from Jane Goodall's research center in Gombe, observed for the first time a raiding party of chimps furtively entering the territory of another chimp group and killing a lone male who was quietly eating, and the subsequent systematic killing of the rest of the males in that rival group over the next three years. And the females? Two of the young females transferred into the raiding group, one watched her mother beaten to death by her new group, and four others disappeared. What was more shocking was that these groups had originally all been one community. More observations were recorded from other areas and observers. Toshisada Nishida's team in Tanzania's Mahale Mountains National Park (the only twenty-year chimp research program other than Goodall's) has seen violent charges toward strangers by border patrols and furious clashes between male parties from neighboring communities.

Since these first observations, two entire chimpanzee communities have been exterminated by their own kind. Other observers of nonhuman primates witnessed male gorillas and some monkey species killing infants, and male chimpanzees and orangutans raping females. As more field observations were recorded, we've learned that although infanticide is typical behavior in many species within every group of animals—birds,

fish, insects, rodents, and primates, practiced by males, females, and infants, depending upon the species—killing adults is not.

Richard Wrangham, professor of biological anthropology at Harvard, believes we can trace the origins of human violence, particularly male violence, to our origins as apes, and more specifically to our common ancestry with the chimp. In his book *Demonic Males*, he has a convincing argument.[64] He states that the most compelling set of facts that point to this conclusion is involved with the similarities of our two societies. "Very few animals live in patrilineal, male-bonded communities wherein females routinely reduce the risks of inbreeding by moving to neighboring groups to mate. And only two animal species are known to do so with a system of intense, male-initiated territorial aggression, including lethal raiding into neighboring communities in search of vulnerable enemies to attack and kill. Out of four thousand mammals and ten million or more other animal species, this suite of behaviors is known only among chimpanzees and humans."*

Wrangham reports that observational studies have found chimps to be patriarchal. Males are dominant, inherit territory, raid and kill their neighbors, and gain the spoils (not only increased foraging, but neighboring females), but they also are killed if they lose their territory. Females, however, gain a different advantage. They can remain in their territory and continue to forage by simply changing allegiance to the conquering band. They remain alive to reproduce again, whereas the male is killed. OK, so chimps are patrilineal, but what about humans?

Wrangham reviews the ethnographic records, studies of modern-day primitive peoples, and archaeological finds to show that humans are, and always have been, a patrilineal society, regardless of what some feminist organizations assert. (It is interesting to note that while I type this in my Microsoft Word program, the word *patrilineal* is underlined by the spell-check feature as having been spelled incorrectly, and the suggested spelling is for the word *matrilineal,* which is never underlined as having been spelled incorrectly.) It has been argued that this patriarchy is a cultural invention, but a new field of study, branded evolutionary feminism, views patriarchy as a part of human biology.

*Demonic Males, p. 24.

And lethal raiding? Wrangham postulates that there is the possibility that intergroup aggression has a common origin because it is unusual among other animals. Although human aggression is well known in the modern world, he also sees patterns of violence in current primitive cultures that are similar to the chimps' violence. One example is the Yanomami, an isolated cultural group of twenty thousand people living in the lowland forests of the Amazon basin, who are famous for intense warfare. They are subsistence farmers having plenty of food, and each community is made up of about ninety members. Men stay in the village of their birth, and the women change communities at marriage. The Yanomami do not fight over resources but most often over women. Thirty percent of Yanomami men die from violence. However, the violent raiders are rewarded. They are honored by their society and have two and a half times the number of wives as other men and three times the number of children. Lethal raiding among the Yanomamos gives the raiders genetic success.

"The conditions that make Yanomami society similar to that of chimps are their political independence and the fact that they have few material goods and no gold, valuable objects, or stores of food to fight over. In this stark world, some of the more familiar patterns of human warfare disappear. There are no pitched battles, no military alliances, no strategies focused on a prize, and no seizure of stored goods. What remain are the penetrating expeditions in search of a chance to attack, to kill a neighbor, and then to escape."* Thirty percent of male chimps die from aggression in Gombe National Park, the same percentage found in the Yanomami villages. Mortality rates from aggression in other primitive tribes are similar: in highland New Guinea, Australia, and the !Kung of the Kalahari. As Wrangham observes, hunter-gatherer societies don't fare any better under the microscope.

A handful of societies have managed to avoid outright war for extended periods. Switzerland is the best modern example. However, to retain their peace, as John McPhee writes in *La Place de la Concorde Suisse,* "There is scarcely a scene in Switzerland that is not ready to erupt in fire to repel an invasive war." The Swiss maintain the largest army per

*Demonic Males, p. 68–71.

capita in the world, enforce compulsory military service, bury live mines at critical bridges and passes, and keep deep caves carved into mountains stocked with enough medical supplies, food, water, and equipment to last the full army and some civilians a year or more. They also are isolated by the Alps.[65]

So, humans and chimps are patrilineal, and both humans and chimps have a history of lethal raiding. And it is well known that human males are more violent than females. Violent crime statistics from around the world reflect that. So agreeing on our similarities, let's hear why Wrangham thinks this happened. It boils down to the ecological version of economics; something called *cost-of-grouping* theory, which basically states that the size of the group depends on its resources. In an environment where food is seasonal or erratic, the party size will vary accordingly: more food, bigger parties; less food, smaller parties. Whether a group has to travel, or how far it has to travel, depends on what they eat. Some species have a food source that is abundant and stable, so their groups end up being stable (such as gorillas, who sit around and eat leaves all day). However, some species have evolved to eat high-quality, difficult-to-find foods that aren't always available, such as nuts, fruits, roots, and meat. Here we are like the chimps.

Bonobos, on the other hand, are different. They eat what the chimps eat but also the abundant leaves that gorillas eat, without the gorillas to compete with. They don't have to travel far to find food; they live on Easy Street. The type of food that we and the chimps eat has made males more dominant. Traveling to find food slows down the females, who carry and nurse the infants. The guys and the childless females can go farther and faster and get to the patch of food first, and then hang out together. They can afford to have larger parties. The advantage of moving around to find food with a variable party size gives a species flexibility and the ability to adapt to changing environments, but the disadvantage is that when the group becomes small, it is vulnerable to attack from a temporarily larger group. This is what Wrangham calls a party-gang species: species with coalitionary bonds (the males hanging out together) and variable party size.

What makes it possible for these species to kill, just as it is possible for some species to indulge in infanticide, is once again economic. It is

cheap to kill. The cost-to-benefit ratio is good. When you kill an infant, you don't really risk being injured yourself, so the cost is low. You gain either a food source or increased chance of mating with the female, because when her infant is dead, she will stop lactating and ovulate again. When you are in a gang against a weaker neighbor, once again the risk of injury is low. What do you gain? It weakens the neighbors, which is always good for the future, expands the food supply, and finds you mating once again.

But why are the males so aggressive? Has sexual selection selected for male aggression? Although they do not have large canine teeth, all apes can fight with their fists. Adapted for swinging in trees, the shoulder joint can rotate, and an ape's long arms and a balled-up fist can pack a punch that keeps opponents at bay. Fists can also grasp weapons. Chimps are known to throw rocks and branches. At puberty, both ape and human males develop increased upper body musculature and broad shoulders as the shoulder cartilage and muscle respond to increasing testosterone levels. But even though there is a physical ability to be aggressive, not all strong animals are.

What is going on in the brain department? We can grasp the idea that animals can't control their emotions or urges, but aren't humans able to control their aggression through cool reasoning? Well, it turns out that it isn't as simple as that. Antonio Damasio, head of the neurology department at the University of Southern California, has studied a group of patients who have all had damage to a particular location of the ventromedial part of the prefrontal cortex.* They all lack initiative, can't make a decision, and are unemotional. One patient whom he studied closely tested normally in intellectual ability, social sensitivity, and moral sense, and could devise appropriate solutions and foresee

*Lie with your arms at your sides and your palms facing up. The stomach side of your body is known as the ventral portion. The back side of your body is the dorsal portion. If you let your head relax and lean back, you will understand that the top of your brain is considered to be a continuation of the dorsal surface, and the ventral surface is the lower surface, deep inside the head. Thus the ventromedial prefrontal cortex is located where it sounds like it is: in the middle of the lower portion of the brain in front of the frontal lobes.

consequences to hypothetical problems, but he could never make a decision. Damasio concluded that this patient and other similar ones could not decide because they were unable to connect an emotional value to an option: Pure reason was not enough to make a decision. Reason made the list of options, but emotion made the choice.[66] We are going to talk about this in later chapters. What is important to know now is that even though we humans like to think of ourselves as being able to make non-emotional decisions, emotions play a part in all decisions.

Wrangham concludes that if emotion is the ultimate arbitrator of an action, the emotion that underlies aggression for both chimps and man is pride. He states that male chimps in their prime organize their whole lives around their rank. All decisions are guided by it, including when they get up in the morning, with whom they travel, whom they groom, and with whom they share food. All actions have the goal of becoming the alpha male. The difficulty of reaching this position causes aggression. With humans it is much the same. Wrangham quotes Samuel Johnson, who observed in the eighteenth century, "No two people can be half an hour together, but one shall acquire an evident superiority over the other." Just as today, men flaunt their status with expensive watches, cars, houses, women, and class-conscious societies.

Wrangham hypothesizes that pride "evolved during countless generations in which males who achieved high status were able to turn their social success into extra reproduction."* It is a legacy of sexual selection. Matt Ridley concludes his chapter about the nature of women in his book *The Red Queen*, "There has been no genetic change since we were hunter-gatherers, but deep in the mind of the modern man is a simple male hunter-gatherer rule: Strive to acquire power and use it to lure women who will bear heirs; strive to acquire wealth and use it to buy other men's wives who will bear bastards. It began with a man who shared a piece of prized fish or honey with an attractive neighbor's wife in exchange for a brief affair and continues with a pop star ushering a model into his Mercedes."[67]

So men and chimps are physically prepared for physical aggression

Demonic Males, p. 191.

and emotionally primed to achieve high status, but so are solitary orangutans, while humans and chimps are social. Pride accounts for social aggression also. Any group—whether it is a team, a religion, a sex, a business, or a country—can have a devoted following, but why? Is it the result of rational deliberation, or is it an innate response of an old ape brain?

Social psychologists have shown that group loyalty and hostility emerge with predictable ease. The process begins with groups' categorizing into Us and Them. It is called the *in-group–out-group bias* and is universal and ineradicable: French-speaking Canadians versus English-speaking Canadians, police versus FBI, Broncos fans versus everyone else, Stones fans versus Beatles fans. . . . This is to be expected in a species with a long history of intergroup aggression. Darwin wrote, "A tribe including many members who, from possessing in a high degree the spirit of patriotism, fidelity, obedience, courage and sympathy, were always ready to aid one another, and to sacrifice themselves for the common good, would be victorious over most other tribes, and this would be natural selection."* He wrote this to show how morality could emerge out of natural selection for solidarity. Wrangham also suggests that morality based on intragroup loyalty worked, in evolutionary history, because it made groups more effectively aggressive.

CONCLUSION

Sometimes looking at the family tree isn't always pretty, but it can explain many seemingly mysterious behaviors. Many a couple has come to grief because they ignored their prospective partner's family. In the case of our chimp date, we have a common ancestor; the families have diverged in many respects but still share many characteristics, as Richard Wrangham has pointed out. We have seen how the anatomy of our body has changed significantly and been the basis for changes that have led to many of our unique features. Bipedalism led to free hands and changed breathing patterns. Our arching and opposable thumbs have made it

*Quoted in *Demonic Males,* p. 196.

possible for us to develop the finest motor coordination of any species. Our unique larynx has allowed us to make the infinite number of sounds that we use for speech. Our mirror neuron system is far more extensive than has been found in other species, and we will see that it has far more ramifications than just language. Other changes have been going on in our brains, changes that allow us to understand to a far greater extent than our chimp relatives that others have thoughts, beliefs, and desires. Building on these differences, we will move to the next chapter and see where it takes us. I think a day spent with Kanzi would be very interesting, but for the long term, I prefer more culture. Make my date a *Homo sapiens*.

Part 2

NAVIGATING THE SOCIAL WORLD

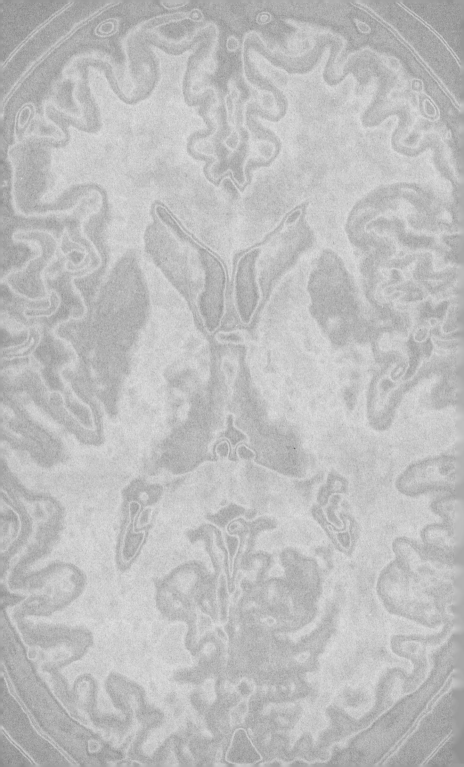

Chapter 3

BIG BRAINS AND EXPANDING SOCIAL RELATIONSHIPS

It is good to rub and polish our brain against that of others.

—*Michel de Montaigne*

IMAGINE: YOUR STOIC DAUGHTER COMPLAINS OF ACUTE AB-dominal pain while you are on vacation. You know that if she is complaining, then it is serious. You arrive at the ER with your wife and daughter, and the surgeon on duty, a total stranger, after a two-minute examination, says an emergency appendectomy is in order, *now*. You remember that a high-school buddy is a doctor in town, miraculously reach him on the phone, and get the reassurance that your daughter is in good hands. Everything is a go, and the surgeon is let into your new alliance. Old alliances are reestablished, new alliances are formed, and there is a successful surgery—followed by breaking of these fresh, fleeting alliances. The social mind is at work.

Imagine: You have signed on to take a guided trip to a rather adventurous locale, a place you would not attempt on your own. You are meeting with your group and guide the first morning. Glancing around at unfamiliar faces, you wonder, *What was I thinking?* However, two days later, you are clambering up a narrow winding path, trusting a person you have known for only forty-eight hours. Later you are having an interesting lunch conversation with a nearly complete stranger, and that evening you

are asked to join a small group for dinner. By the end of the week, the tour group you are in has divided itself into subgroups, which in turn have subgroups. The coalitions shift by the minute. The social mind is abuzz with ties being made and broken and, among other things, the phenomenon of human politics is apparent.

Forming and reforming social groups and alliances are what we do all the time. This is the big picture. And yet many experimental scientists like me have focused on pieces of the big picture. We have been struggling to grasp what may well be inherent fundamental cognitive skills that enable us to form categories, deal with quantity, or assemble piecemeal sensory input into wholly perceived sensations. We have not focused on what the human brain does best, what it seems built to do: think socially.

It is all about social process. Although we are highly skilled at categorizing people, animals, and things, we don't think about triangles and squares and red and blue. I don't look at the person walking down the street with a dog and think, "Well the head is a circle, the torso a triangle, and whoa, lookee there, four rectangular extremities, well, I guess I should say cylindrical, and then, well, we've got those ten cylindrical fingers . . . now for the dog." The fact is, we evolved with lots of other humans around, and developed brain capacity to monitor social behavior in large groups so that we may assess the value of cooperation, the risk of noncooperation, and so on. When one wakes up to this fact, that we are a bunch of party animals, not solitary hermits or mere perceptual data evaluators, suddenly a new question presents itself. If we are so social, how did that happen? Where did that come from? Were our ancestors social? How can natural selection result in group cooperation? Does natural selection work only to select for individual cognitive traits? Or does it work to select for group behavior as well?

This core issue grabbed the attention of Charles Darwin. While he pushed the view of the survival of the fittest, he was well aware of the seemingly paradoxical fact that many creatures make themselves less fit so the group may survive. In the worlds of bees and birds, this goes on all the time, and these phenomena have given rise to the view that natural selection must work on whole groups. Indeed, such mechanisms could

well serve as the cornerstone for the emergence of human social and ethical behavior.

That was all fine until the great evolutionary biologist George Williams put the idea of group selection to rest (for a while). In an interview, he recounted his insight that "natural selection works most effectively at the individual level, and adaptations that are produced are adaptive for those individuals, in competition with other individuals of the same population, rather than for any collective well-being."[1] Natural selection is not the mechanism at work on social processes and norms, which come into and out of existence so quickly. Individual selection also means that living organisms are not adapted to prevent the extinction of their own species. Organisms would be wily at preventing only their own personal extinction. Williams's "adaptationist" paradigm has dominated thinking in evolutionary biology for the past forty years.

Armed with Williams's analysis, Richard Dawkins, the evolutionary biologist who holds the Charles Simonyi Chair for the Public Understanding of Science at Oxford University, took it further and became the vanguard for the idea of the selfish gene. On reading the idea that natural selection works only on genes, one might argue that altruism and all other ideas that favor groups were incidental. It is easy to imagine that this sort of thinking was loathed by many, including the well-known paleontologist and evolutionary biologist Stephen J. Gould, who referred to the core belief that natural selection works only on genes as "Darwinian fundamentalism."

Dawkins had also built on the work done by William Hamilton in the early 1960s at the London School of Economics and the University College London, who had established a Darwinian view for altruism. Hamilton worked on kin selection, and was able to show by a simple mathematical formula ($C < R \times B$, where C is the cost to the actor, R is the genetic relatedness between the actor and the recipient, and B is the benefit to the recipient) that our human preference for altruism has a rationale using models of shared genes.[2] This implied a limited restraint on selfish competitive behavior and the possibility of limited self-sacrifices. If you were closely enough related, it would make genetic sense to help out a relative. He went on to suggest that such behavior supported general biological principles of social evolution. In short, Hamilton had given both Darwin and

the selfish-gene thinkers a unified way of comprehending the problem of altruism. He had worked out how fitness worked on individuals other than the actor. This became known as Hamilton's principle, and it is brilliant.

Still, not everyone is happy denying the role of group selection as a player in evolution. Although Dawkins, Williams, and other critics of group selection admit that natural selection can work on groups in principle, their stance is that selection pressures at the individual level are always stronger than those at the group level. Not all evolutionary biologists agree. David Sloan Wilson and Edward O. Wilson, in a review of the history of the rise and fall of group selection theory, conclude that the last forty years of research have provided new empirical evidence that supports the theory of group selection and its theoretical plausibility as an evolutionary force. "The problem is that for a social group to function as an adaptive unit, its members must do things for each other. Yet, these group-advantageous behaviors seldom maximize relative fitness within the social group. The solution according to Darwin is that natural selection takes place at more than one level of the biological hierarchy. Selfish individuals might out-compete altruists within groups, but internally altruistic groups out-compete selfish groups. This is the essential logic of what has become known as multilevel selection theory."[3] David Sloan Wilson suggests that group selection is not just a *significant* evolutionary force but can sometimes be the *dominating* evolutionary force. In a letter to eSkeptic, he writes: "It turns out that evolution takes place not only by small mutational change, but also by social groups and multi-species communities becoming so integrated that they become higher-level organisms in their own right."*

Although this is a highly controversial question, we can let the evolutionary biologists duke it out. Let us merely come away with the fact that our social behavior has biological origins.

The deep biological forces at work in producing our social mind will become evident as we consider how we got to this place. Even more tantalizing is the possibility that *all those social relationships we now worry about so intensely are merely by-products of behavior originally selected to avoid our being eaten by predators.* Natural selection mandated

*www.skeptic.com/eskeptic/07-07-04.html

us to be in groups in order to survive. Once there, we construct our "meaningful" as well as our "manipulative" social relationships, with our interpretive minds ever busy dealing with the stuff around us, most of which involves our fellow humans. While those human social relationships become central to our mental life, indeed become in many cases the raison d'être of our lives, it is all generated by a process secondary to the real reason we fall into social groups. We now think about others all the time because that is how we are built. Without all those others, without our alliances and coalitions, we die. It was true, as we shall see, for early humans. It is still true for us.

What would you think about if you were the only person on earth? Maybe your next meal? However, you wouldn't be thinking about who might help you get that meal or with whom you might share that meal. You might think about how to avoid being a meal yourself, but there would be no one to help you watch for predators.

We are social to the core. There is no way around the fact. Our big brains are there primarily to deal with social matters, not to see, to feel, or to cogitate about the second law of thermodynamics. We all can do these personal and more psychological actions. We can develop rich theories about our personality, but we do so as a result of functioning in the social world. All of that comes along after the fact. And the fact is, in order to survive and prosper, we had to become social. So, understanding how we got here requires reviewing evolutionary biology, and to understand the biology of our current social abilities, which include phenomena such as altruism, we need to remind ourselves how evolution works.

EVOLUTION, NATURAL SELECTION, AND THE PUSH TOWARD SOCIAL BEHAVIOR

Charles Darwin and Alfred Wallace* both observed that although species have a high potential for reproduction and populations should multiply exponentially, they don't. Except for occasional fluctuations, populations

*Wallace was the nineteenth century's leading expert on the geographical distribution of animal species. He independently came up with a theory of natural selection.

remain stable. After all, natural resources are limited and remain constant in a stable environment.* Thus more individuals are born than the resources can support, and this results in competition for those resources. Darwin and Wallace also observed that within each species, the individuals in the population vary. No two are exactly alike, and many of the traits that are variable are inherited. They concluded that the chances for survival weren't random, but varied with the heritable characteristics. According to the laws of natural selection, *for any characteristic to be selected in a competitive environment, it has to provide a survival advantage to the individual.* That advantage must manifest itself in a greater number of surviving offspring. The characteristic may allow the individual to be more successful at finding food (so he is stronger and healthier and hence can reproduce more and longer), at mating (so he will reproduce more), or at fighting off predators (so he will live longer and be able to reproduce more). These characteristics are coded for in the individual's genes and are passed on to the next generation. Thus, *genes that code for any behavior that increases reproductive success will become more prevalent in the population.*

Competitive pressures are affected by climate, geography, and other individual animals, both within the species and from different species. Changes in climate and geography, such as a volcanic eruption that also affects the climate, can cause changes in food resources, making them either more or less plentiful. Social competition arises within a species, either for food resources or sexual partners. Different species have evolved to deal with food competition in different ways. Some share and some don't.

One of the questions that puzzled Darwin about his theory was concerning altruistic behavior. It didn't make sense that an individual would share—would ever provide anything to another individual that would decrease its own reproductive success to the benefit of another's. Yet this happens frequently in species that live in groups. As I already mentioned, William Hamilton in 1964 came up with the theory of kin selec-

*Humans have not lived in a stable environment. Improved sanitation, better nutrition, widespread immunization, and access to modern medical care have decreased the death rate, while farming and food distribution have increased food supply.

tion, which explains this behavior. Altruistic behavior could evolve if the benefiting individuals were genetically related to the provider. Parents will sacrifice for their children, who share 50 percent of their DNA; individuals also share 50 percent of their DNA with their siblings; their grandchildren and their nieces and nephews share 25 percent of their DNA. Helping your close relatives survive and reproduce also passes your genes on to the next generation. It doesn't matter how the genes get passed, just so they do.

Kin selection does not explain all cases of altruism, however. Why would anyone do a favor for a friend? This question remained unanswered until Robert Trivers, professor of anthropology at Rutgers University, figured it out. If an individual does a favor for an unrelated individual and is sure it will be returned at a later date, then that could provide a survival advantage.[4] This presupposes several things, of course. One is that an individual can specifically recognize another individual and has the ability to remember that a favor was done. Another is that the two live in close enough contact that predictable occasions will arise to get repaid. They also have to be able to evaluate the cost of the favor and make sure that the one they get in return is of equal value. This is called *reciprocal altruism*, and it is very rare in the animal world.*

The difficulty arises because there is a time lag between when one individual performs a favor and when the second reciprocates. The time lag could allow for cheating. If the second individual is not reliable, it is not in the interest of the first to cooperate with him, and the possibility of a cooperative system falters. Species that practice reciprocal altruism also have mechanisms to identify cheaters,[5] otherwise the behavior would never have survived. As a consequence, strict Darwinian principles can help explain such phenomena as altruism. During the Enron fiasco, the cry was "Follow the money." In biology, follow the genes.

This leaves one further problem: The old question, why leave a tip at

*For a discussion, see J. R. Stevens and M. D. Hauser, "Why be nice? Psychological constraints on the evolution of cooperation," *Trends in Cognitive Science* 8 (2004): 60–65.

a restaurant that you will never return to? We will get to this question later, and it may have to be explained by group selection!

Sexual Selection and Social Groups

Some adaptations enhance success in reproductive competition. The classic example is the peacock's tail. Common sense would tell you that it could only be a hindrance towing a huge tail around. How could that possibly be adaptive? However, any bird that could survive with a big tail must surely be an attractive mate: strong and healthy and wily. That big tail is straight from Madison Avenue, a great advertisement campaign that pays off with more mates. The birds with the big tails have more offspring.

The peacock's tail confers an advantage for *sexual selection*, the term for the social dynamics involved in mate selection and reproduction. That tail is known as a *fitness indicator*. The higher the cost of a fitness indicator to the individual, the more reliable it is. It costs the peacock a lot of energy to carry around and maintain the big tail. He cannot counterfeit it; it is a reliable fitness indicator. A guy with a new Chevy may well have counterfeited his fitness indicator; he could have bought it with 0 percent financing, no credit, and a low monthly payment. However, a guy with a Lamborghini has an expensive, high-maintenance car that cannot be purchased without good credit, and it reliably indicates his resources. A Lamborghini is a good fitness indicator, but a Chevy is not.

Trivers also helped us realize that the underlying behavior of sexual selection all revolves around parental investment. *Parental investment* is "any investment by the parent in an individual offspring that increases the offspring's chance of surviving at the cost of the parent's ability to invest in other offspring."[6] Hence, in any species, the sex with the higher potential rate of reproduction is more concerned about mating as often as possible (to get as many of their genes into the next generation as possible), and the sex with the lower reproductive potential is more concerned about parental care, to make sure that the few offspring they have will survive.[7] In 95 percent of mammalian species, there is a large difference between males and females as to the efforts invested in mating

and parenting.[8] Females have limited reproductive time, due to pregnancy (internal gestation) and care of young offspring (lactating).[9] And we all know about males. They are ready to reproduce at a moment's notice.

The sex that has a higher parental investment and lower reproductive potential, usually the female, tends to be more fussy about mate selection.[10] They have more to lose by making a bad decision (less fit offspring that might not be able to reproduce themselves). Female choice of mating partners has influenced physical (the peacock's tail), behavioral, and social evolution in males. It intensifies both male-male competition for mating partners and female-female competition. Sexual selection can lead to "runaway sexual selection." This means the genes that are being selected for are also doing the selecting, setting up a positive feedback loop. Let me give you a simplified example of how this works.

Say you have a population of rabbits with short ears. Along with other characteristics, the trait for ear length is variable and heritable. The male rabbits have little parental investment; they mate as often as they can with whomever they can. Now, although they all have short ears, Rex's ears are a little longer than the others'. For some reason, a couple of the females have evolved a preference for longer ears, so they choose to mate with Rex. Their offspring are not only going to have longer ears but also will have the *preference* for longer ears. The traits have become genetically correlated when genes for different traits (long ears and the preference for long ears) end up in the same bodies. A positive feedback loop has been established. The more females who select for long ears, the more males and females there will be who have long ears as well as the preference for long ears. Runaway selection occurs.

Big Brains, Big Appetites, and the Hunt

The third factor in our drift toward being social seems to grow out of our need to nourish our ever-growing big brains. Hunting, herding, hiding, and hustling all lead to our social instincts and ultimately our domination. One way to compare brain sizes was used by David Geary, now professor of psychology at the University of Missouri, who has estimated

what is called the *encephalization quotient*, or EQ,[*] of various hominid species as a percentage of the EQ of modern humans.[†] He has shown that there is a relentless progression of increasing relative brain size during the evolution of hominids.[11] What caused this progression?

Traditional theories propose that ecological problems and problem solving have driven changes in the brain. Harry Jerrison, paleoanthropologist and emeritus professor of psychiatry at the University of California at Los Angeles, noted the brain sizes of predators and prey have increased back and forth in tit-for-tat fashion over the last sixty-five million years.[12] Because humans use tools for hunting (predation), it was assumed that production and use of tools were what was driving the increase in brain size. However, this theory didn't fit the facts.

Thomas Wynn, an anthropologist at the University of Colorado, states, "Most of the evolution of the human brain, the presumed anatomy of intelligence, had occurred prior to any evidence for technological sophistication and, as a consequence, it appears unlikely that technology itself played a central role in the evolution of this impressive human ability."[13] That is not to say that the ecology was not the early driving force for increased brain size, just that tool use was not.

Big brains are expensive and require more energy (food) than small ones, and there is evidence that early hominids did become more efficient at hunting and foraging and were thus able to occupy a wider range of ecologies.[‡] Anthropologists John Tooby and Irven Devore argue that hunting was very important in human evolution. As Steven Pinker puts it, "The key is to ask not what the mind can do for hunting, but what

[*]As I mentioned in the first chapter, one of the problems with looking at absolute brain size is that it increases with the overall size of the body and confuses cross-species comparisons of brain size. Encephalization quotient (EQ), developed by Harry Jerrison, controls for this problem by comparing brain size relative to that of an average mammal of the same body weight.

[†]He did this by taking the brain volumes that have been extrapolated from fossil hominid skulls and interpolating these with EQ estimates derived for modern-day humans by P. V. Tobias, emeritus professor of anatomy and human biology at the University of the Witwatersrand, Johannesburg, South Africa.

[‡]See the review in D. Geary, *The Origin of Mind* (American Psychological Association, Washington, DC, 2004).

hunting can do for the mind."[14] And what it can do is supply meat, a complete protein and a great source of energy for the greedy brain. Pinker points out that in the land of mammals, those that are carnivores have bigger relative brain sizes.

Richard Wrangham, our chimp man, thinks having meat was not enough; one had to be able to eat it efficiently. Although the diet of a chimpanzee contains about thirty percent monkey meat, it is very tough and it takes so long to chew that any advantage it might have in total calories is offset by the time it takes to eat. That is, an equivalent amount of time eating plants would have supplied the same number of calories. Wrangham not only spent many hours observing chimp behavior, he also sampled their cuisine, and he wasn't impressed. It was tough, fibrous, and very difficult to chew. He could not understand how any ape, eating the diet of a chimp—raw fruits, leaves, tubers, and monkey meat—could amass enough calories to supply the metabolically expensive big brain. Chimps spend almost half their waking hours chewing, interspersed with short periods of rest, which allow their stomachs to empty, but not enough time to go on extended hunts. There just wasn't enough time in the day to eat enough calories.

There also was another quandary. Chimps have big teeth and powerful jaws, as did the early Australopithecines and *Homo habilis*. *Homo erectus* was a different story. His jaws and teeth were smaller, while his brain was twice as large as his predecessor *Homo habilis*. What was he eating to get the calories to drive and maintain the brain expansion with those wimpy teeth and jaws? Not only that, *Homo erectus* had a smaller rib cage and abdomen, meaning that it could not hold as large of a digestive tract as *Homo habilis*. In fact modern man has a 60 percent shorter digestive tract than predicted for a great ape of our size.

Staring into the fire, Wrangham came up with a radical idea: those early humans were eating barbeque![15] Cooked food has several advantages over raw food.[16] It actually has more calories, and is softer, so you don't have to spend so much time and energy chewing: more calories, less time, less effort (not unlike the modern concept of fast food). In fact, the softer the food, the more calories there are available for growth, because it takes less energy to consume and digest it.[17, 18] Some anthropologists have objected to this theory because the oldest evidence for fire

that they have found is from 500,000 years ago, but there are some hints surfacing that fire was on the scene much earlier, maybe even 1.6 million years ago, just about the time that *Homo erectus* made his appearance. Wrangham suggests that *Homo sapiens* are biologically adapted to eat cooked food.[15] He thinks that cooking food drove the expansion of the brain by increasing calories and decreasing the amount of time it takes to ingest them. This freed up more time for hunting and socializing.

There are those, however, who think the story hinges on the fatty acids in the brain. The long-chain polyunsaturated fatty acid docosahexaenoic acid (DHA) was required for the expansion of the hominid cerebral cortex during the last one to two million years. Michael Crawford and co-workers at the Institute of Brain Chemistry and Human Nutrition, University of North London, think that because biosynthesis of DHA from its dietary precursor (alpha-linolenic acid, or LNA) is relatively inefficient, expansion of the human brain required a plentiful source of pre-formed docosahexaenoic acid.[19] The richest source of DHA is the marine food chain, while the savanna environment offers very little of it. Tropical freshwater fish and shellfish have long-chain polyunsaturated lipid ratios more similar to that of the human brain than any other food source known. Crawford concludes that *Homo sapiens* could not have evolved on the savannas but instead were holed up at the beach, gathering along the shoreline.[20] Nutrients gained in this manner contributed to increasing brain size and intelligence, which allowed our ancestors to forage and fish more effectively.[21]

But anthropologists Bryce Carlson and John Kingston at Emory University are not convinced. They do not think the biochemistry implies any such thing. They point out that the key premise of this perspective—that biosynthesis of DHA from LNA is not only *inefficient* but also *insufficient* for the growth and maturation of an encephalized brain—is not well supported. To the contrary, evidence suggests that consumption of LNA available in a wider variety of sources within a number of terrestrial ecosystems is *sufficient* for normal brain development and maintenance in modern humans and presumably our ancestors.[22]

By moving out into the more open landscapes—open woodlands, savannas, and grasslands—the early hominids not only had more animals to hunt, they also became more of a target for predators themselves.

There is a growing consensus that a major factor in developing larger brains was the banding together in social groups, which made hunting and gathering more efficient and also provided protection from other predators.[23]

There are two ways to outfox predators. One is to be bigger than they are, and the other is to be part of a larger group. (Gary Larsen, in a Far Side cartoon, presented a third method: All you need is a buddy who runs slower than you do.) The more individuals in the group, the more eyes are on the lookout. Predators have an attack range that depends on their speed and their style of killing. As long as you spot them and stay out of their range, you are fine. Also, if you have compatriots who will come to your aid when you are in trouble, a predator is less likely to attack. Herd animals are not known for the buddy system, but the social primates are. Individuals that banded together had a higher survival rate. And this brings us to social groups.

So three intertwined factors triggered the push toward our social mind: natural selection, sexual selection, and the consequences of needing more food to nourish our growing brains. Once social abilities became part of human brain architecture, other forces were unleashed, which in turn contributed to our growing brain size.

ORIGINS OF SOCIAL GROUPS

In 1966, Alison Jolly, a behavioral biologist trained in America and now at the University of Winchester in the United Kingdom, concluded a paper about lemur social behavior by stating, "Primate social life provided the evolutionary context of primate intelligence."[24] In 1976, Nicholas Humphrey, without knowledge of Jolly's paper, also concluded, "I argue that the higher intellectual faculties of primates have evolved as an adaptation to the complexities of social living."[25] He was suggesting that the ability to predict and manipulate another's behavior would give a survival advantage and would lead to increased mental complexity. Upon these and a few other papers, the theory of Machiavellian intelligence was hatched.

The hypothesis was first presented by Richard Byrne and Andrew

Whiten at the University of Saint Andrews, Scotland, and they suggested that the difference between primates and nonprimates is the complexity of their social skills: Living in complexly bonded social groups is more challenging than dealing with the physical world, and the cognitive demands of this social life selected for increases in brain size and function.[26] "Most monkeys and apes live in long-lasting groups, so that familiar conspecifics are major competitors for access to resources. This situation favours individuals that can offset the costs of competition by using manipulative tactics, and skillful manipulation depends on extensive social knowledge. Because competitive advantage operates relative to the ability of others in the population, an 'arms race' of increasing social skill results, which is eventually brought into equilibrium by the high metabolic cost of brain tissue."[23] Poor Machiavelli. Perhaps he was the ultimate sociologist, but his name has pejorative connotations, so the messenger was shot. The theory is now called the *social brain hypothesis.*

Another related hypothesis on increasing brain size was suggested by Richard Alexander, a professor of zoology at the University of Michigan. He focused on intergroup rather than intragroup competition and proposed that the main predator became other groups of hominids. This caused an arms race of strategizing and weapon invention: "Humans had in some unique fashion become so ecologically dominant that they in effect became their own principal hostile force of nature, explicitly in regard to evolutionary changes in the human psyche and social behavior."[27]

WHY IS SOCIAL GROUP SIZE LIMITED?

Support for some type of social component for the big brain has come most notably from the very clever anthropologist Robin Dunbar at the University of Liverpool. Each type of primate tends to have a social group size consistent with other members of the same species. Dunbar has correlated brain size with social group size in primates and apes, and found there are two different but parallel scales, one for apes and one for the other primates. Both show that the bigger the neocortex, the larger the social group. However, the apes required a bigger neocortex per

given group size than the other primates.[28] They seem to have to work harder to maintain their social relationships.

But why is social group size limited? Does it have something to do with our cognitive abilities? Dunbar proposes five cognitive abilities that could be limiting social group size: the ability to interpret visual information to recognize others, the memory for faces, the ability to remember who has a relationship with whom, the capacity to process emotional information, and the ability to manipulate information about a set of relationships. He maintains that it is the last cognitive skill, the one that deals with social issues, that underlies the limitation on group size. He points out that vision doesn't seem to be the problem, because the neocortex has continued to grow, whereas the visual cortex has not. Memory isn't the problem; people can remember more faces than their predicted cognitive group size. Emotion doesn't seem to be the problem; in fact there has been a reduction in the emotional centers of the brain. According to Dunbar, it is the ability to manipulate and coordinate information and social relationships that is limiting social group size. One can only handle a finite amount of manipulation and relationships!

Ways to measure social skill and social complexity have been hard to find. Currently five different aspects of social behavior have been correlated with neocortex size in primates. The first to be identified was social group size.[29, 30] Others are:

* Grooming clique size—the number of individuals with whom an animal can simultaneously maintain a cohesive intimate relationship that involves physical grooming.[31]
* The degree of social skill required in male mating strategy. This indicates that the advantages of individual male rank and power appear to be offset by social skill: You don't have to be the big cheese to get the girl; you can also get her by charm.[32]
* The frequency of tactical deception—the ability to manipulate others in the social group without the use of force.[23]
* The frequency of social play.[33]

Dunbar looked for ecological indices that might also correlate with brain size: the proportion of fruit in the diet, the home range size, day

journey length, and foraging style. There was no correlation between these and neocortex size. He concluded that most likely the increasing size of social groups was driven by the ecological problem of predator risk, and the pressures and complexities of living in the increasingly large social groups drove brain size expansion.[34] So we ended up with these big brains all because we didn't want to be the plat du jour? Let's look at these five social skills and see if any aspect of them is unique to humans.

SOCIAL GROUP SIZE FOR HUMANS

While the observed social group size of chimpanzees is 55, the social group size that Dunbar calculated from the neocortex size of humans is 150. How can that be, when we now live in huge cities, often with millions of people? However, think about it. Most of those people you never even have cause to interact with. Remember: Our ancestors were hunter-gatherers, and people didn't start to settle in one place until agriculture was developed about ten thousand years ago. Today the typical size of hunter-gatherer clans, related groups that gather together once a year for traditional ceremonies, is 150. This is also the size of traditional horticultural societies and modern-day Christmas card lists in personal address books.[35]

It turns out that 150 to 200 is the number of people who can be controlled without an organizational hierarchy. It is the basic number used in military units where personal loyalties and man-to-man contact keep order. Dunbar states that it is the upper limit of the size of modern business organizations that can be run informally.[36] It is the maximum number of people an individual can keep track of, whom he can have a social relationship with and would be willing to help with a favor.

SOCIAL GROOMING: THE ROLE OF GOSSIP

Gossiping has a bad reputation, but researchers who study gossip have not only found it to be universal,[37] they have found that it is beneficial, that it is the way we learn to live in society. Dunbar thinks gossip is the

human equivalent of social grooming in other primates (and remember, the size of the grooming group correlates with relative brain size). Physical grooming takes up much of a primate's time. The primates that spend the most time grooming are chimps, who do it up to 20 percent of the time.[38] At some point during the evolution of the hominids, as groups became larger, an individual would need to groom more and more other individuals in order to maintain relationships in the larger group. Grooming time would cut into the time that was needed to forage for food. This is when, Dunbar argues, language began to develop.[39] If language began to substitute for grooming, one could "groom," that is to say, gossip, while doing other things, such as foraging, traveling, and eating. This could be how talking with your mouth full began.

However, language can be a double-edged sword. The advantages of language are that you can groom several people at once (more efficient) and you can get and give information over a wider network. However, the disadvantage is that you are vulnerable to cheaters. With physical grooming, an individual invests high-quality personal time. That cannot be faked. With language, a new dimension has been added: liars. One can tell stories displaced in time, so their veracity is difficult to assess, and while grooming is done among a group, where it is visible and verifiable to all, gossiping can be done in private, and its veracity is not challenged. But language can also help you out with this problem. You may be warned by a friend about a previously bad experience with a certain individual. As a social group gets larger and more dispersed, cheaters or free riders become harder to keep track of. Gossip may have evolved partly as a way to control the slackers.[40, 41]

Various studies have found that, on the average, humans spend 80 percent of their waking time in the company of others. We average six to twelve hours per day in conversation, mostly one-on-one with known individuals.[42] What has been found out shouldn't come as any surprise to you. Nicholas Emler, a social psychologist at the London School of Economics, has studied the content of conversations and learned that 80 to 90 percent are about specific named and known individuals, which is to say, small talk. Impersonal topics, although they may involve personal opinions on art, literature, religion, politics, and so forth, form only a small part of the total. This is true not only about chance meetings in

the grocery store but also at universities and corporate lunches. You might think that the world's problems are being discussed and settled over power lunches, but it is really Bob's tee time, Bill's new Porsche, and the new secretary that are getting 90 percent of the air time. If you think this is an exaggerated statistic, then think about all those annoying cell phone conversations you have overheard. Have you ever heard anyone talking about Aristotle or quantum mechanics or Balzac at the table next to you or in the grocery line?

Other studies show that two-thirds of the content of conversations are self-disclosure. Of these, 11 percent are about states of mind (my mother-in-law is driving me nuts) or body (I really want that liposuction). The rest are about preferences ("I know it's weird, but I really like LA"), plans ("I am going to start exercising on Friday"), and the most talked about, doings ("I fired him yesterday"). In fact doings is the biggest category of conversations about others.[42] Gossip serves many purposes in society: It fosters relationships between gossip partners,[43] satisfies the need to belong and be accepted by a unique group,[37] elicits information,[44] builds reputations (both good and bad),[43] maintains and reinforces social norms,[45] and allows individuals to evaluate themselves through comparison with others. It may enhance status in a group, or it may just entertain.[46] Gossip allows people to express their opinions, ask advice, and express approval and disapproval.

Jonathan Haidt, a psychologist at the University of Virginia who studies happiness, writes that "Gossip is a policeman and a teacher. Without it, there would be chaos and ignorance."[47] It is not just women who gossip, although men like to call it "exchanging information" or "networking." The only time when men spend less time gossiping than women do is when women are present. Then more lofty subjects are discussed for about 15 to 20 percent of the time. The only difference between male and female gossip is that men spend two-thirds of the time talking about themselves ("and when I reeled that sucker in, I swear it weighed twenty-five pounds!"), whereas women spend only one-third of the time talking about themselves, and are more interested in others ("and the last time I saw her, I swear she had gained twenty-five pounds!").[48]

Beyond the content of conversations, Dunbar also discovered that conversation groups are not infinitely large but are usually self-limiting to

about four individuals. Think about the last party you went to. People drift in and out of conversation groups, but once you go over four people, they do tend to break up into two conversations. He says it may be coincidence, but he suggests a correlation with chimp grooming. If you take a conversation group of four persons, only one is talking and the other three are listening, or in chimp lingo, are being groomed. Chimps have to groom one-on-one, and their maximum social group size is 55. If we can groom three at a time, as indicated by conversation group size, then if you multiply our three grooming partners by 55, you get 165—close to our social group size that Dunbar calculated from the neocortex size of humans.

TACTICAL DECEPTION

In working the gossip mill, a person is involved not only in information exchange but perhaps in manipulation and deceit. He may be deceiving his gossip partners in essence because he isn't really talking with them to find out how they are doing; he may be mining information for his own purposes. He might even make something up so as to have more gossip to barter. These are two different issues. Let's start with exchange. I mentioned before, in order for reciprocal exchange to work, cheaters have to be identified. Otherwise, cheaters, who benefit without paying the cost, would eventually take over, and reciprocal exchange couldn't sustain itself.

Although there are cultural differences among groups of people, there are many universal behaviors.[49] As we have seen, we can trace some of these behaviors back to our common ancestor with the chimps and beyond, and some are qualitatively different. The field of evolutionary psychology attempts to explain mental traits, such as memory, perception, or language, as adaptations—products of natural or sexual selection. It looks at psychological mechanisms in the same way that biologists look at biological mechanisms.

Evolutionary psychology suggests that cognition has a functional structure that has a genetic basis, just like hearts, livers, and immune systems, and has evolved by natural or sexual selection. Like other

organs and tissues, these psychological adaptations are universally shared within a species, and they enhance survival and reproduction. Some traits are not controversial, such as vision, fear, memory, and motor control. Others are controversial but are becoming less so, such as language acquisition, incest avoidance, cheater detection, and sex-specific mating strategies. Evolutionary psychologists explain that a brain, at least in part, is made up of modules, which have developed specific functional purposes that are innate and have been selected for. Leda Cosmides, one of the first in this field, describes the search for these functions:

> When evolutionary psychologists refer to "the mind," they mean the set of information-processing devices, embodied in the human brain, that are responsible for all conscious and nonconscious mental activity, and that generate all behavior. What allows evolutionary psychologists to go beyond traditional approaches in studying the mind is that they make active use in their research of an often overlooked fact: That the programs comprising the human mind were designed by natural selection to solve the adaptive problems faced by our hunter-gatherer ancestors. It leads one to look for programs that are well-engineered for solving problems such as hunting, foraging for plant foods, courting mates, cooperating with kin, forming coalitions for mutual defense, avoiding predators, and so on. Our minds should have programs that make us good at solving these problems, whether or not they are important in the modern world.[50]

There are very practical reasons for looking at our behavior and abilities from an evolutionary standpoint. Cosmides points out:

> By understanding these programs, we can learn how to deal more effectively with evolutionarily novel circumstances. Consider, for example, that the only information available to hunter-gatherers about probability and risk was the frequency with which they encountered actual events. It looks like our "stone age mind" has programs designed to acquire and reason well about frequency data. Knowing

this, evolutionary psychologists are developing better ways of communicating complex modern data about statistics.

Let's say you have a positive mammogram. How likely is it that you actually have breast cancer? The typical way of presenting the relevant data—in percents—makes this difficult. If you said that 1% of women randomly screened have breast cancer, and all of these test positive, but there is a 3% false alarm rate, most people mistakenly think a positive mammogram means they have a 97% chance of having breast cancer. But let me give you the same information in absolute frequencies—an ecologically valid information format for a hunter-gatherer mind: Out of every 1000 women, 10 have breast cancer and test positive; 30 test positive but do not have breast cancer. So: out of every 1000 women, 40 will test positive, but only 10 of these will have breast cancer. This format makes it clear that, if you had a positive mammogram, your chance of having breast cancer is only 1 in 4 . . . that is, 25%, not 97%.[50]

Detecting Cheaters

Cosmides also came up with an experiment that she thinks demonstrates that the human mind has a special module designed to detect individuals who cheat in social exchange situations. She uses the Wason Test,* which asks you to look for potential violations of a conditional rule: if P, then Q. Many forms of this test have been devised to ascertain whether or not humans have specialized cognitive machinery for social exchange. Let's see how you do with it:

There are four cards on a table. Each card has a letter on one side and a number on the other. Currently you can see R, Q, 4, and 9. Turn over only those cards that you need to in order to prove whether the following rule is true or false: If a card has an R on one side, then it has a 4 on the other. Got it? What's your answer?

The answer is R and 9. OK, now try this one:

There are four people sitting at a table. One is sixteen, the second is

*P. C. Wason, "Reasoning about a rule," *Quarterly Journal of Experimental Psychology* A 20 (1968): 273–81.

twenty-one, the third is drinking Coke, and the fourth is drinking beer. Only those over twenty-one can drink beer legally. Who should the bouncer check to make sure the law isn't being broken? That one is easier isn't it? The answer is the sixteen-year-old and the beer drinker.

Cosmides has found that people have a hard time with the first type of question; only 5 to 30 percent of people get this one right, whereas with the second one, 65 to 80 percent of people get it right—not just at Stanford where she first tried it, but all over the world, from the French to the Shiwiar of the Ecuadorian Amazon, and not just adults, but three-year-olds as well. Whenever the content of a problem asks you to look for cheaters in a social exchange situation, people find it simple to solve, whereas if it is posed as a logic problem, it is more difficult to solve.[51]

After many more experiments across cultures and age groups, Cosmides has found in addition that cheater detection develops at an early age, operates regardless of experience and familiarity, and detects cheating but not *unintentional* violations. She thinks that this cheater detection ability is a component of a universal human nature, designed by natural selection to produce an evolutionarily stable strategy for conditional helping.

There is even neuroanatomical evidence. This comes from a patient, R.M., who has focal brain damage that has caused impairment in his cheater detection, but who has entirely normal reasoning on similar tasks that do not involve social exchange.[52] Cosmides says, "As humans, we take for granted the fact that we can help each other by trading goods and services. But most animals cannot engage in this kind of behavior—they lack the programs that make it possible. It seems to me that this human cognitive ability is one of the greatest engines of cooperation in the animal kingdom."[50]

We are not the only ones who can detect cheaters in social exchanges. It has been shown to exist to a limited degree in brown capuchin monkeys, in experiments done by Sarah Brosnan and Frans de Waal.[53] However, animals involved in reciprocal exchange make approximations. Humans want to be sure they are giving and getting the equivalent amount; approximations won't suffice. Indeed, Marc Hauser at Harvard University thinks that our mathematical abilities evolved with the emergence of social exchange systems.[54]

Cheating the Cheaters

Can you cheat the cheater detection system? Probably not, as Dan Chiappe, a psychologist at the University of Toronto, has found. He showed that in social contract situations, people rated cheaters more important to remember than cooperators, looked at cheaters longer, remembered their faces better, and were more likely to remember social contract information about them.[55]

When cheaters have been detected, there are two things that can be done with them: Either you avoid them, or you punish them. Isn't it easier just to avoid them? To punish a cheater costs the punisher time and effort. What's to be gained? Recently Pat Barclay, from Cornell University, has done a laboratory study showing that in games with repeated encounters, players who punish cheaters gain trust and respect and are thought of as being group focused. The benefits of this increase in good reputation (which, you remember, is a fitness indicator for sexual selection) can offset the costs of being a punisher, and could be a possible explanation for how the psychological mechanisms of altruistic behavior evolved.[56] Better not do anything that might lead to one of your competitors' getting a better rep. What a stroke of luck that you saw Don with that sophisticated-looking blonde at the racetrack. Everyone wonders what he does on his days off. That tidbit ought to be a hot commodity in the world of gossip exchange back at the office, but how will you know if what you get back is true? *If you can detect cheaters, does that mean you'll know if someone is lying?* Not really. That comes with reading facial expressions and body language. But I'm glad you brought that up because . . .

Intentional Deception

Although deception is known throughout the animal world, such as the piping plover that feigns injury to lead predators away from its nests,[57] intentional deception may be limited to the great apes.[58] And humans are the masters of deception. It is ubiquitous and begins in the morning when women put on makeup (to make themselves more beautiful or appear younger) and perfume (to mask their own odor). Women have been

using jewelry, hair color, and makeup for eons. One has only to cruise through the Egyptian section of the Louvre. Men are no strangers to deception either. They put on deodorant and brush their thin hair across their bald spots (as if that deceives anyone) or plop on their toupees and head out to their cars that they had to buy on credit.

Can you imagine a world where no one lied? It would be awful. Do you really want to know the answer to "Hi, how are you doing today?" Or hear "I've noticed that those five pounds that you've put on are all on your chin"? Lies are used for self-promotion in job interviews ("Sure, I know how to do that"), and when meeting new people ("This is your daughter? Isn't she the sweetest thing!" rather than Rodney Dangerfield's comment, "Now I know why tigers eat their young").[59] They're used when meeting potential mates ("Of course I'm a natural blonde").[60]

We not only lie to each other, we lie to ourselves. From 100 percent of high school students who rank themselves as having a higher-than-average ability to get along with others (a mathematical impossibility) to 93 percent of college professors who rank themselves above average at their work, self-deception is in play.[61] Or how about "I get plenty of exercise" and "My kid would never do that." To be a good liar, it helps not to know that you are lying or, in the case of psychopaths, not to care. In fact children are taught to lie by their parents ("Tell Grandma how much you love the lederhosen" and "Don't tell Sammy he is fat") and by teachers ("I don't care if you think Joe is dumb, it is not nice to say so").

How do we tell if someone is lying? Do we really want to know? And why *do* we lie to ourselves?

How Do We Tell If Someone Is Lying?

While gossiping and determining if we think the information we are getting is true, we also read facial expressions. Face perception is probably the most developed visual skill in humans and obviously plays a major role in social interactions. It has long been thought that face perception is mediated by a specialized system in the human brain, and we now know that different parts of the brain mediate different types of face perception. The pathways that perceive identity are different from those that perceive movement and expressions.

Beginning soon after birth, babies prefer to look at faces rather than other objects.[62] After the age of seven months, we begin to respond appropriately to specific expressions.[63] Thereafter, face perception provides tons of information that greases social interaction. From the visual appearance of faces, one can access information about another person's identity, background, age, gender, mood, interest level, and intentions. We can notice what they are looking at and check it out too, and also understand their speech better by lip-reading.[64]

We are not alone in the ability to recognize individual faces. Chimpanzees and rhesus monkeys are also able to do so.[64] Contrary to what has previously been observed, recent dissection has shown that chimpanzees and humans have a nearly identical facial anatomy[65] and a full range of facial expressions. Lisa Parr at Emory University has done some studies that demonstrate the ability of chimps to match photographic facial expressions with emotional scenes in videos.[66] So we share with the chimps two components of gossiping and social exchange—recognizing with whom we are dealing and being able to read emotions from facial expressions—but will that help us in recognizing liars? Well, there is a whole range of facial and body movements that are associated with deception, which brings us back to our man Machiavelli.

Paul Ekman, at the University of California, San Francisco, has done more for the study of facial expression than anyone else. It was a lonely business when he started his studies, because everyone else—except Darwin, of course, and an eighteenth-century French neurologist named Duchenne de Boulogne—had avoided the topic. Ekman, through years of research, has established that facial expressions are universal[67] and that there are specific expressions for specific emotions. When an individual is lying, the higher the stakes are, the more emotions (such as anxiety or fear) he is feeling.[68] These emotions are leaked to the face[69] and voice tone.[70] And here is one of the benefits of true self-deception: If you don't know you are lying, your facial expressions won't give you away.

Ekman has studied people's ability to detect liars, and it is pretty pathetic. Most people aren't very good at it, even though they may think they are (once again deceiving themselves). They perform at the same rate as chance guessing. However, he has found some professionals to be

good at it: Secret Service agents are the best, and next best are some psychotherapists. Out of twelve thousand people whom he has tested, he found only twenty who were naturally excellent lie detectors![71] One problem inherent in reading facial expressions is that one reads the emotion but does not necessarily understand the reason for the emotion and so misinterprets it. We will learn more about this in later chapters. You may realize that a person is scared and think it is because he is lying to you and is frightened that you will figure that out, but it could be that he is scared because he didn't lie and is being falsely accused and he thinks that you won't believe him.

Of course not all deception is nefarious. Out of politeness, people will often act as if they are enjoying themselves when they are not, such as complimenting you on the fish dish when in reality fish makes them gag. Or they are laughing at that really bad joke that you have already told too many times before. These are small-stakes lies without major repercussions.

People learn to manage their expressions, but Ekman has found microexpressions that result from trying to conceal emotions. Most people don't see them, but you can learn to spot them. Fabricated expressions can also be hard to spot. For instance, the false smile: There are two muscles principally involved in real smiling, the zygomaticus major, which pulls the corners of the mouth up, and the orbicularis oculi pars lateralis, which, along with pulling up the cheeks and causing crow's-feet, also pulls down the lateral border of the eyebrow. The orbicularis oculi muscle is not under voluntary control, so that in a fake smile the lateral border of the eyebrow does not depress, although a fully contracted zygomaticus can push the cheeks up to form crow's-feet.

If we are good at spotting cheaters in social exchange, why do we find it hard to spot liars? Lying has become prevalent in the population, so wouldn't mechanisms of detection have evolved? Ekman offers several explanations. First, he suggests that in the environment in which we evolved, lying wasn't as prevalent because there were fewer opportunities. People lived openly in groups. The lack of privacy would have made the chances of detection high, and discovery would have been made by direct observation of *behavior* rather than having to rely on judgments of *demeanor*. Second, uncovered lies would have re-

sulted in a bad reputation. Today, our environment is very different. Opportunities to lie abound, and we live behind closed doors. You can escape from a bad reputation, although it may be costly, by changing jobs, towns, countries, or spouses, and we haven't been prepared by evolution to detect lies from demeanor. So why haven't we *learned* how to detect them if we don't have the power innately? Perhaps because our parents teach us not to identify their lies, such as stories to cover up sexual activity and who knows what all. It may be that we also prefer not to catch liars, because being suspicious rather than trusting makes relationships difficult to establish and keep. Or we may want to be misled because we have a stake in not knowing the truth. The truth may set you free, but it may also set you free with four kids and no income. Often the reason is politeness: What we are told is all that the teller wants us to know, and we don't steal information that is not given to us.

But perhaps it is language, as it has evolved recently in humans, that is the problem. Understanding and interpreting language is a conscious process that involves much cognitive energy. If we are concentrating on what is being said, rather than letting visual perceptions and vocal clues register in our conscious brain, we may be lessening our detective powers. Gavin de Becker, in his book *The Gift of Fear*,[72] advises people to trust the phenomenon that he defines as "knowing without knowing why." He is an expert in predicting violent behavior, and he has found that most victims of violence have received warning signs without realizing it. Has our social training *taught* us not to detect deception? Do we reinterpret what we actually see? There is more work to be done.

Lying to Ourselves

Isn't lying to ourselves counterproductive? As the saying goes, if you can't trust yourself, then whom can you trust? Remember our cheater detector in social exchange? It pays to be cooperative, while being vigilant for cheaters. But you really don't have to be cooperative. You just have to *appear* cooperative. All you need is a good rep. You don't actually have to deserve it.

You mean being a hypocrite, right? Hypocrites make my blood boil.

Not so fast. Everyone (except for me, of course) is a hypocrite. It apparently is just easier to see from the outside than the inside. As we just learned, to pull this off, it helps not to consciously know that you are pulling a fast one, because then you will have less anxiety and thus less chance of getting busted.

Dan Batson at the University of Kansas has done a series of experiments[73, 74] with rather shocking results. Students were given the opportunity to assign themselves and another student (actually fictitious) to different tasks. One task was more desirable (the chance to earn raffle tickets). The other task had no chance to earn raffle tickets and was described as boring. The students were told that the other participant would think the assignment was made by chance. They were also told that most participants thought that flipping a coin was the fairest way to assign the tasks, and a coin was provided for participants to flip if they wished. After the experiment, virtually all participants said that either assigning the other participant the better task or using the coin flip was more moral. Yet only about half flipped the coin. Of the nonflippers, 80 to 90 percent assigned themselves the better task and, contrary to the laws of probability, the same was true among those who flipped the coin. The students who flipped the coin all rated themselves as being more moral than the nonflippers, even when they fiddled with the results.

This outcome was replicated in numerous studies, even when the coin was labeled to avoid ambiguities in the coin toss. Some participants flipped the coin to appear fair, yet still served self-interest by ignoring the results and giving the better task to themselves—and still rated themselves as being more moral for simply having tossed the coin! That is called moral hypocrisy. The results were duplicated even when the students were told that after their decision they would have to tell the other participant how they arrived at it. With one discrepancy, more flipped the coin (75 percent) and reported this was how they had made the decision; however, the percent of flippers who gave themselves the better task remained the same. Batson states, "The benefits to oneself of moral hypocrisy are obvious: One can reap the material rewards of acting selfishly and also garner the social and

self-rewards of being seen and seeing oneself as upstanding and moral."

Participants who had scored highly on various moral responsibility tests were more likely to flip the coin, yet among coin flippers, the high moral scorers were no less likely to assign themselves the better task than were those who scored low. Thus, those with a greater sense of *moral responsibility* did not show signs of greater *moral integrity*; they actually showed signs of greater hypocrisy! They were more likely to *appear* moral (flip the coin) but no more likely to actually *be* moral (allow the coin flip to determine the task assignment).

The only time participants stopped cheating with the coin flip (and they all did) was when they made their decision while sitting in front of a mirror. Apparently, having to face the discrepancy between one's stated moral standard to be fair versus unfairly ignoring the result of the coin flip was too much. Those who wished to appear moral had to actually be moral. Maybe we need more mirrors. That might help with the increasing obesity problem, too.

OK, so we lie to ourselves and have a difficult time spotting other liars. This isn't good news for your gossip exchange quest. You may need to take one of Paul Ekman's classes* on how to spot liars, but in the meantime, at least you can watch eyebrows and know that your coworkers aren't going to be good at spotting your lies, unless the high stakes at the office make you a little more anxious.

BACK TO THE BIG BRAIN AND MALE MATING STRATEGY

Geoffrey Miller, an evolutionary psychologist at the University of New Mexico, has a problem with language. No, he can talk just fine. He is concerned about why it evolved. Most speech appears to transfer useful information from the speaker to the listener, and it costs time and energy. It seems to be altruistic. What fitness benefit can be attained by giving another individual good information? Reviewing the original

*At www.ekmangrouptraining.com/.

argument of Richard Dawkins and John Krebs, Miller states, "Evolution cannot favor altruistic information-sharing any more than it can favor altruistic food-sharing. Therefore, most animals' signals must have evolved to manipulate the behavior of another animal for the signaler's own benefit."[75] And other animals have evolved to ignore them, because it didn't pay to listen to manipulators. Those who did are not ancestors.

There are a few signals that are given credence: those that are reliable. These are the ones that say, "I'm poisonous," "I'm faster than you," or "Don't even think about it, I'm stronger than you." Then there are the warnings from relatives, like "There's a leopard!" and the fitness indicators, like "Babe, have you seen my tail?" Miller concludes there are no credible models that can show evolution favors signals that carry any other kind of information, as long as there are incentives for deception. And when there is competition, there are always incentives for deception. Human language is a hotbed of deception because it can talk about other times and places when the listener was not present, such as: "The trout I caught yesterday was twenty-six inches." Or "I left you a gazelle leg in that tree over the hill. Oh, gee, it's gone? Musta been that lion." "It has only been driven by my grandmother to the store and back." And the infamous "I was working late at the office last night."

How could reliable information-sharing have evolved? By sharing information, the teller does not necessarily lose his benefits. In fact, information-sharing could have benefits through kin selection and reciprocal altruism. Although Miller admits that this is mostly right, and probably how language initially emerged, when he looks at the real behavior of people, it doesn't quite fit the predictions of kinship and reciprocity models. If you look at language as information, it brings more benefit to the listener than to the talker, so we should have evolved into great listeners and reluctant talkers. Instead of resenting the motormouth, or the self-absorbed talker, or the speaker who drones on for an extra fifteen minutes, we should be irritated with people who sit enthralled with what we say and make no effort to tell about themselves. Everyone has something to say, and in conversations people are oftentimes thinking about what they are going to say next rather than listening to the other person. Books on procedure have been written to make rules about who may talk when. We should have evolved huge ears and only a rudimentary speaking

apparatus to gather what we could, rather than the elaborate ability to speak language and the more rudimentary hearing that we have.

Considering this conundrum, Miller proposes that language's complexities evolved for verbal courtship. This solves the altruism problem by providing a sexual payoff for eloquent speaking by the male and the female. "Language complexity could have evolved through a combination of runaway sexual selection, mental biases in favor of well articulated thoughts, and fitness indicator effects."[75] Miller does not suggest that sexual selection accounts for the big brain in its entirety, just perhaps 10 percent.

A related theory has been presented by anthropologist Robbins Burling, who wondered why, when a rudimentary form of language was all that was needed for hunting, trade, and tool making, a more complex form emerged. He suggests that after language's initial emergence, its increasing complexity was the result of male orators competing for social status, the most eloquent gaining reproductive advantages. He lists evidence of this reproductive advantage from various societies, ranging from the Yanomami to India and ancient Greece. Although his theory largely addresses the question of leadership, he concludes, "We need our very best language for winning a lover."[76]

Hold on a minute. Are you saying that the big brain is for flirting? Does that mean that Frenchmen have the biggest brains?

It might. Get out the saws, we'll have to do a study.

Consider what is involved in human courtship. If you are having a random conversation with someone, that person may be mildly skeptical. However, with courtship the stakes are high. If you are successful, it may pay off with offspring. You have to bring out the big guns because your listener is going to be highly critical on all fronts. She will automatically evaluate whether it makes sense, conforms to what she knows and believes, is at all interesting or novel, and whether she can begin to infer intelligence, education, social savvy, status, knowledge, creativity, a sense of humor, personality, and character. "How about those Sox?" is not going to do it for her. Remember how long it took Bill Murray to get the courtship right in *Groundhog Day*?

Verbal courtship is not limited to the one-on-one encounter. Public speaking also advertises your charms and status, as does anything that improves your intellectual cachet. As Miller states, "Language puts minds

on public display, where sexual choice could see them clearly for the first time in evolutionary history."[75]

This is a little confusing. If guys are so good at talking, how come they have the reputation of not communicating? And if males are selected for their verbal courtship abilities, how come it is women who have the reputation for being big talkers? Well, remember that verbal courtship is a two-way street and is considered a fitness indicator. That means it is difficult and costly in terms of time and energy that could be spent in competition for survival resources. Once he has his mate, it doesn't pay the male to continue with the high-cost performance. Instead of talking his head off, he may get by with just a couple of sentences, unless sex is withheld, and then there may be a return of flowery speech. Women, however, have an incentive to continue their verbal courtship, because they want to keep the male around to help provide for their offspring.

SOCIAL PLAY AND BRAIN SIZE?

This is a hard one to figure out. What is the point of social play? It uses a lot of energy and time, to accomplish what? No one really knows the answer to this question, but there are many ideas being batted around. It is generally thought that most youthful animal play is practice. Practice in stalking, chasing, and fleeing, a way to buff up physically,[77, 78] develop motor and cognitive skills,[79] hone fighting skills,[80, 81] and become more physically adept at recovering from sudden shocks, such as loss of balance and falling over, and more emotionally adept at handling stressful situations.[82] Think about a pile of kittens. However, Elisabetta Palagi, from the University of Pisa, who has studied play behavior in bonobos and chimps, thinks the theories about play have focused too much on long-term rather than immediate benefits, and this focus may have limited the understanding of some of the adaptive significance of play. This could be especially true about play behavior in adults. Although play behavior is most common in young animals, in many species, like chimpanzees, bonobos, and humans, adults also play.

But why *do* adults do it? Why do they play when they no longer need to practice? In a study of the chimpanzee colony housed in the ZooParc

de Beauval in Saint-Aignan-sur-Cher, France—ten adults and nine immature chimps—she found that not only did the chimps groom each other the most just before chow time, but the adults and juveniles also played together the most just before chow time.[83] Chimps are competitive, and feeding time is stressful for them. Grooming stimulates the release of beta-endorphins.[84,85] Palagi thinks grooming and play may limit aggression and increase tolerance, a contribution toward conflict management during periods of high stress. This would be an immediate benefit rather than a long-term one, and would be beneficial to both youngsters and adults.

Humans take social play to greater heights than the chimps and bonobos. One more theory for adult play comes from Geoffrey Miller, our sexual selection expert. He suggests that the increased cost of play with age makes it a reliable indicator of youthfulness, energy, fertility, and fitness. "Well, he had his eye on that young filly, and all of sudden he is out windsurfing and playing tennis again. He is acting like a teenager." In fact, Miller says that the ability to invent and appreciate new ways of displaying physical fitness is a uniquely human ability, aka sports—the intersection of mind and physical strength.[75] Another universal: All cultures have them. As with other animals, human males play in competitive sports more than females. In order to prevent competitors from killing each other, and to determine who wins, sports have come up with rules, although you might not realize it when watching soccer matches. Monetary rewards are a recent invention. In the past, the only reward was status, but that was good enough. Winning at sports is a reliable fitness indicator, and the reward is attracting high-quality sexual partners.

CONCLUSION

The shift to becoming highly social is what the human is all about. Lots of animals have some degree of social organization but none revel in it the way we do. As our brain became larger so too did our social group size. Something triggered our interest in the other guy, in living and cooperating in groups. Richard Wrangham has a captivating theory about the role of cooking as being the facilitator of such a huge shift in primate

life. Other ideas include the need to fight off predators and to find food. Whatever the reason, others now argue that our higher intellectual skills arose as an adaptation to our newly evolved social needs. Understanding being social is fundamental to understanding the human condition.

With the importance of social groups now well understood, it is easy to see discussions emerge about whether or not natural selection might also work on groups versus individuals. It is a complex argument with much to say not only on both sides of the issue but also in the attempts to re-concile the question into theories that cover both sides. However these matters are finally settled and agreed to by all, here we are with big brains, living in social groups and better for it. As we move on, realizing our social nature is deeply rooted in our biology not simply in our cogni-tive theories about ourselves, we begin to see how the rest of our human equipment helps to guide us through the social maze.

Chapter 4

THE MORAL
COMPASS WITHIN

You have the morals of a rabbit, the character of a slug,
and the brain of a platypus.

—Cybill Shepherd, as Maddie in
the TV show Moonlighting, 1985

IF A MARTIAN WERE TO SHOW UP AND WATCH THE EVENING
news with you, there probably would be no limit to the number of martinis
he would need to believe that we humans are not inherently violent,
amoral, and without purpose. The news drones on. It might start at the
local police blotter, with the hit-and-runs, the stop-and-shop store holdups
and murders, the domestic abuse, and the shenanigans down at city hall,
then proceed to the beheadings in Iraq, the retaliation bombings by the
United States, the starvation in Africa, the AIDS epidemic, the plight of
illegal immigrants, and on and on. "Holy smokes," the Martian might say.
"Your species is bad news." Well, is it?

There are roughly six billion people on earth, and those six billion
people more or less get along. Does that mean *all* six billion get along? If
we assume only 1 percent are bad eggs in one way or another, that means
sixty million people are making trouble for the rest of us. That is a lot of
mischief, and if it is 5 percent, one can see there are three hundred mil-
lion troublemakers in the world. Material for the evening news is every-
where, and for some reason we want to know about the problems, not the
joys of the human condition.

We are left with the amazing fact that somehow at least 95 percent of us get along, and possess some kind of common mechanisms that guide us through the social morass or complexities of everyday life. I can remember the day my daughter and I found ourselves walking down a side street in Beijing. We had been guided to the wide boulevards by Tiananmen Square, and all seemed grand and proportionate. But as we took off down the side street to experience some local shopping, we were shocked by the density of people and by how we stood out in both height and demeanor. But we were also shocked by how quickly we all adapted, how the two of us became part of the social flow and milieu in a matter of minutes. Everything from simply crossing the street to buying an item all flowed easily and naturally. I have had more unnatural exchanges on Canal Street in New York than in Beijing.

As a species, we don't like to kill, cheat, steal, and be abusive. We go out of our way to assist in tragedies, emergencies, and the like. Indeed, emergency workers, such as search-and-rescue Park Rangers, have to be trained *not* to be heroes, not to take undue risks to save the lives of others. Soldiers have to get pumped up and be beside themselves to kill. Booze in the military is there not to relieve pain but to disinhibit, so horrendous acts can be carried out. So why are we basically a good bunch of animals?

We humans like to think of ourselves as rational beings. We like the idea that if we are presented with a problem, we can invent a list of solutions, pros and cons, evaluate each one, and then decide which is the best choice. After all, our rationality is what separates us from "being animals." But do we really decide upon a solution because it is the most rational? Why does your friend ask you, when you are presenting your list of choices, "What does your gut tell you?"

When we are presented with a moral decision, is it our rational self that comes forth and makes the decision, or is it our gut, our intuitive self, that first comes up with the judgment, and our rational self afterward tries to come up with the reasons? Do we have a set of moral beliefs that we base rational decisions on, and if so, where does it come from? Does it come intuitively from within, or consciously from outside us? Do we come off the assembly line with a standard set of moral instincts, or are they aftermarket add-ons?

The world's great philosophers have been arguing over these questions for centuries. Plato and Kant believed conscious rationality is behind our moral actions. Hume favored an immediate emotional feeling of right or wrong. Until recently, all one could do was bat these ideas around without any concrete evidence, but things have changed. With our current research techniques, we can answer many of these questions. In what follows, we are going to discover more about our intuitive selves and how they affect our moral decisions. We are going to see that we actually have hardwired ethical programming that has been selected for, and we will see what these ethical programs are concerned with. We are going to discover how our social world shapes them and turns some into virtues in one culture but not in another.

DO WE HAVE HARDWIRED ETHICAL PROGRAMMING?

To begin with, let me pose a moral dilemma to you, one that has been designed by researchers to demonstrate our intuitive moral judgment. Jonathon Haidt, the very clever psychologist at the University of Virginia whom we met in chapter 3, has come up with a provocative question he puts to his students:

Julie and Mark are sister and brother. They are traveling together in France on summer vacation from college. One night they are staying alone in a cabin near the beach. They decide that it would be interesting and fun if they tried making love. At the very least, it would be a new experience for each of them. Julie is already taking birth-control pills, but Mark uses a condom, too, just to be safe. They both enjoy making love, but they decide not to do it with each other again. They keep that night as a special secret, which makes them feel even closer to each other.[1]

The students are asked, was it OK for them to make love? The story was designed to call upon all of one's gut instincts and moral intuitions. Most people will say that it was wrong and disgusting. But Haidt knew that before he started his experiment. He wanted to dig deeper, to get to the root reasoning, if any, we all must use. So he urges his students on: "Tell me why. What does your rational brain say?" Not unexpectedly,

many answer that inbreeding could cause a deformed infant or that they could be hurt emotionally. But remember, they used two forms of birth control, so that is not the problem, and we already have been told that they weren't emotionally hurt but actually grew closer. Haidt tells us that eventually most students will say, "I don't know, I can't explain it, I just know it's wrong." But if it is wrong, and you can't explain why, is that a rational judgment or an intuitive one? Have we been taught a rational rule by our parents or culture or religion that it is morally wrong to have sex with your sibling because it may lead to birth defects, or is it hard-wired knowledge that we have a difficult time overruling with rational arguments?

Where did the incest taboo come from? Incest taboos are one of those human universals we talked about in the last chapter. All cultures have incest taboos. Edward Westermarck, in 1891, figured out how they develop. Because humans cannot recognize their siblings automatically, by sight, for example, he proposed that humans have evolved an innate mechanism whose function is to discourage incest. This mechanism operated by causing a person to be uninterested in or averse to having sex with those he had spent a lot of time with when a child.[2] This will work most times in preventing incest. This rule predicts that childhood friends and stepsiblings who were brought up together, as well as full siblings, would all be found not to marry.

Support for this idea has come from Israeli kibbutzim,[3] where unrelated children are brought up together. They form lifelong friendships but very rarely marry. More evidence for this theory is found in the ancient custom among some people in Taiwan called *shimpua* marriage, in which the family raises the future wife of their son from infancy. These marriages often result in no offspring, simply because the partners do not find each other sexually appealing.[4]

Debra Lieberman, an evolutionary psychologist at the University of Hawaii, expanded upon these findings.[5] She was interested not only in kin recognition as it related to incest and reciprocal altruism, but also in how personal incest taboos ("sex with *my* sibling is wrong") become generalized opposition ("incest is wrong for everyone"). Did this come from parents or society, or did it come spontaneously from within? She asked her subjects to fill out a family questionnaire, and then asked

them to rank from least morally wrong to most morally wrong a list of nineteen third-party acts that included sibling incest, child molestation, dope smoking, and murder. She found that there was only one variable that significantly predicted the degree of moral wrongness a subject ranked third-party sibling incest. This was the length of time spent under the same roof as a child and early adolescent with an opposite-sex sibling. The longer one lived in the same house with an opposite-sex sibling, the more morally wrong third-party incest was considered. It was not affected by relatedness (the sibling could have been adopted or a stepsibling); by parental, subject, or peer attitude toward sexual behavior; by sexual orientation; or by how long the parents had been married.

Why this is important to our current topic is that the moral attitude against incest in general was not increased by *learned* social or parental instruction, nor was it increased by the degree of relatedness to the sibling. It was increased only by the amount of time that the subject had actually spent living under the same roof with their sibling (related or otherwise) while being raised. This is not a rationally learned behavior and attitude that was taught to us by our parents or friends or religious teacher. If it were rational, then it would not apply to adopted siblings or to stepsiblings. It is a trait that has been selected because it worked in most situations to avoid producing offspring that were less healthy due to inbreeding and the expression of recessive genes. We got it at the factory.

But our conscious, rational brain does not know that all this is going on. Our conscious brain works on a "need to know" basis, and all it needs to know is that siblings are having sex and that is *bad*. When you are asked, "Why is it bad?" things get interesting. Now you are activating your conscious reasoning system—your interpreter, which doesn't know the above answer unless you have studied the literature on incest avoidance recently. No problem, reasons will come pouring out of your brain anyway!

This is pertinent to research that I have done on people who have had the connection (the corpus callosum) between the two hemispheres of their brains severed for medical reasons. What this does is isolate the right hemisphere from the speech center, which usually is in the left

hemisphere, so not only can't the right hemisphere communicate with the left hemisphere, it can't talk to anyone else either. With special equipment, you can tell the right hemisphere to do something by giving a visual command to one eye, such as "pick up a banana." The right hemisphere controls the motor movement on the left side of the body, so the left hand will pick up the banana. Then if you ask the person, "Why did you pick up the banana?" the left brain's speech center answers, but it doesn't know why the left hand picked up the banana, because the right hemisphere can't tell it that it read a command to do so. The left hemisphere gets the visual input that there is indeed a banana in the left hand. Does it say, "Gosh, I don't know?" Hardly! It will say, "I like bananas," or "I was hungry," or "I didn't want it to fall on the floor." I call this the interpreter module. The intuitive judgment comes out automatically, and when asked to explain, out pops the interpreter to make a rational explanation, keeping everything neat and tidy.

Another factor that we seem to understand intuitively is *intent* in social exchange. That means if someone doesn't reciprocate in a social exchange by accident, it is not recognized as cheating, but if someone intentionally does not reciprocate, it *is* recognized. Three- and four-year-old children will judge an action in a story of social exchange as being "naughty" if the behavior was on purpose, but not if it was done by accident.[6] Chimpanzees can judge intention; when someone is trying to grab some food for them but can't reach it, they don't get upset, but they will get upset when someone can reach it but won't.[7] Lawrence Fiddick, a lecturer in psychology at James Cook University, Townsville, Queensland, Australia, has shown that in detecting cheaters in social exchange, individuals detect intentional cheaters at a higher rate than accidental cheaters, whereas in precautionary contracts (such as "if you work with dogs, then you need a rabies vaccination"), intentional and unintentional cheaters are detected to an equal degree.[8] This ability was predicted by Fiddick, using his assumption that there are two separate innate circuits in the brain, one for social exchange, where it is beneficial not to detect accidental cheating, and a separate one for precautionary measures, where it would be more beneficial to detect all cheating. If all were logical in the brain, you would be able to detect cheaters equally in both circumstances, independent of intent.

IT'S NOT ALL RATIONAL

Further evidence that all is not rational conscious decision making began with a New Englander who lived in the 1800s. Phineas Gage was a railroad construction foreman who was hardworking, good at business, well mannered, civil, and respected. One September morning in 1848 he set off to work, not knowing he was about to have a textbook example of a bad day and become the most famous neurological trauma survivor. That morning, rocks were to be blasted with gunpowder to clear a path for the tracks. A hole was drilled into the rock and filled with gunpowder. A fuse was to be laid, covered with sand, and tamped down with a long iron rod, and then the charge was to be detonated. Unfortunately, Phineas must have been distracted, because he tamped down the gunpowder before the sand had been added, and the gunpowder exploded, blasting the tamping iron on a trajectory through Gage's head. It entered at the left cheek, passed through his eye socket, through portions of his frontal lobes and out the top of his skull, landing about twenty-five to thirty yards behind him.

This was no pixie-stick-sized rod. It was three feet seven inches long, weighed thirteen and a half pounds, and measured one and a quarter inches in diameter at one end, tapering over a distance of about one foot to a diameter of a quarter inch at the other. It can be seen at the medical museum at Harvard. It seems unbelievable, but Gage was unconscious for only about fifteen minutes and then was able to speak coherently and rationally! He was reported the next day by the local paper to be pain free.[9] Through the ministrations of his doctor, John Martyn Harlow, he survived the injury and subsequent infection, and was able to return home to Lebanon, New Hampshire, after two months, though it took much longer to recover his stamina.

Although this is story enough, it is not why he has become famous. Phineas Gage had changed. His memory and reason were the same, but his personality was light-years away from that of the affable man he had been. "He was now fitful, irreverent, and grossly profane, showing little deference for his fellows. He was also impatient and obstinate, yet capricious and vacillating, unable to settle on any of the plans he devised for

future action. His friends said he was 'No longer Gage.'"[10] He no longer acted in a socially acceptable way. There was some chunk of brain that had been damaged that caused this change, even though his reasoning and memory were unaffected.

More recently, Antonio Damasio and his colleagues have had a series of "Gage-like" patients with similar lesions (although as a result of surgery or trauma rather than tamping rods), and they all have something in common. They too are no longer themselves and have lost their ability to act in a socially accepted way. The first was a patient named Elliot,[11] who had a tumor removed from his frontal lobes. Before the surgery, he was a responsible husband, father, and employee. A few months later, his life was in shambles. He had to be prodded to get out of bed, he couldn't manage his time at work, he couldn't plan for the immediate or distant future, his finances were a mess, and his family had left him. He had seen several doctors who did not know what to make of him, because all the tests he had taken showed his brain was functioning well. He scored above average on intelligence tests, and when presented with problems, he could come up with well-thought-out lists of possible solutions. His sensory and motor skills were unchanged, as were conventional memory, speech, and language. However, Damasio noticed that he showed a flattened affect, that is, his emotions, both primary and social, were severely impaired.

Elliot could no longer function in a socially accepted way. He had a difficult time making appropriate decisions, and Damasio hypothesized that the reason was that he no longer had emotions. He proposed that before we make a decision, when an option presents itself, an emotional response is evoked. If it is a negative emotion, the option is eliminated from consideration before rational analysis begins. Damasio proposed that emotions play a major role in decision making, and that the fully rational brain is not a complete brain. These findings have contributed to a grand reevaluation of the contributions of emotions to the decision-making process. It turns out that no matter how many rational ideas a person is able to come up with, emotion is necessary to make the decision, and that includes deciding on moral dilemmas.

MAKING DECISIONS

People make decisions all day long. *Should I get up now or doze a while longer? What should I wear today? What should I have for breakfast? Should I exercise now or later?* So many decisions, you don't even realize you are making them. As you drive to work you are deciding when to put your foot on the accelerator, the brake, and perhaps the clutch. You are also adjusting your speed and your route to get to work on time, turning the radio dial, and perhaps talking on your cell phone. The interesting and scary thing is that your brain can think consciously about only one thing at a time. All those other decisions are being made automatically.

There are two types of automatic processes. Driving is an example of intentional (you have the intention of driving to work) and goal-directed (get to work on time) processes that have been learned over time until they become automatic; so is playing the piano or riding a bicycle. The second type is preconscious processing of perceptual events: You perceive a stimulus by seeing, hearing, smelling, or touching, and your brain processes it before your conscious mind is aware that you have perceived it. This takes place effortlessly and without intention or awareness. It turns out that what this automatic processing is doing is placing all your perceptions on a negative (the room is white, I don't like white) to positive (the room is brightly colored, I like bright colors) scale and biasing your decisions one way (something about this place isn't calling to me . . . let's keep looking) or the other (I bet this place is good, let's eat here). Your automatic processing is helping you to answer the evolutionarily significant question, "Should I approach or avoid?" This is called *affective priming*, and it affects your behavior. If I asked why you don't want to eat at the first place, you will give a reason, but it most likely won't be "I get a negative flash in a white room." It would more likely be "Oh, it just didn't look all that exciting."

John Bargh at New York University has placed volunteers in front of a computer screen and told them that he would flash words on the screen. They were to tap a key with their right hand if they thought it was a bad word (such as *vomit* or *tyrant*) or tap a key with their left hand if it was a

good word (such as *garden* or *love*). What they didn't know was that he was also flashing words on the screen for a hundredth of a second (too fast for them to consciously realize) before he would flash the word they were to judge. What happened was, if he flashed a negative word on the screen first, followed by a negative word the volunteer was aware of, the volunteer responded faster than if he had not been primed. If a good word was flashed after the negative word, he would take longer to tap the key, because more time was required to adjust from the subliminal negative impression.[12] Bargh has later shown that if he exposed subjects to words describing rude behavior and then instructed the subjects to tell someone in another room when they were done, they were more likely to interrupt that person to tell them (66 percent of participants) than if they had had no affective priming (38 percent), and they were less likely to interrupt if they had been primed with polite words (16 percent).[13]

Error management theory predicts that one should be biased toward committing errors that are less costly.[14] In thinking about evolution, one would postulate that those who survived were those who reacted more quickly, that is, automatically, to a negative cue, and a negativity bias should have been selected for. After all, it is more important to detect something that will hurt, kill, or make you sick than it is to react to seeing a bush with berries on it. There will always be another bush, but *not if you are killed by that lion.* Well, we do have a negativity bias! Big time. Subjects will pick angry faces out of a neutral crowd faster than happy faces.[15] One cockroach or worm will spoil a good plate of food, but a delicious meal sitting on top of a pile of worms will not make the worms edible. And extremely immoral acts have an almost indelible negative effect: Psychology undergraduate students were asked how many lives a person would have to save, each on individual occasions and each at risk to his or her own life, to be forgiven for the murder of one. Their median response was twenty-five.[16]

This negativity bias has been documented and reviewed by Paul Rozin and Edward Royzman at the University of Pennsylvania, who tell us that it appears to be ubiquitous in our lives. Negative stimuli raise blood pressure, cardiac output, and heart rate.[17] They grab our attention (newspapers thrive on bad news). We are better able to read negative than positive emotions in other people. The negativity bias affects our moods, our way of forming impressions of people, our search for the perfect (one tiny

smudge in a rare book will bring down its value), and our moral judgments. We even have a greater number of negative emotions, and we have more words for pain than for good sensations.[16]

Rozin and Royzman have suggested that the adaptive value of the negativity bias has four components:

1. Negative events are potent. You can be killed!
2. Negative events are complex. Should you run, fight, freeze, or hide?
3. Negative events can happen suddenly. There's a snake! There's a lion! And they need to be dealt with quickly—a good reason that faster automatic processing would have been selected for.
4. Negative events can be contagious—spoiled food, dead bodies, sick people.

Earlier, when we discussed emotions, we learned that incoming information passes first through the thalamus, then to the sensory processing areas, and then to the frontal cortex. However, there was a shortcut through the amygdala, which responds to patterns that were associated with danger in the past. The amygdala not only affects your motor system but also can change your thinking. Your quick emotional response of fear or disgust or anger to the threatening (negative) incoming information will color how you process further information. It concentrates your attention on the negative stimulus. You aren't thinking the mozzarella looks fresh, the basil is fragrant, the tomatoes are red and juicy; you are thinking, *Yuck, there is a greasy hair on my plate, and I am not going to eat this. In fact, I'm never eating here again.* This is our negativity bias.

There are some things that affect us in a positive manner, although there is no equivalent to the emergency status given to negative stimuli. One of these effects is with unconscious mimicry. Bargh and Tanya Chartrand have found that people who were assigned to do a task with a stranger were more likely to like the stranger, and find their interactions to be smoother, when the stranger copied their mannerisms. They also tended to mimic the mannerisms of the stranger without later being aware they had.[18] The researchers hypothesize that automatic mimicry increases liking and serves the purpose of facilitating social

interactions. When you first meet someone, you get an impression, and these first impressions are usually almost identical to ones formed with longer contact and observation.[19] In fact, different observers will have a remarkably similar rating of a stranger's personality, and that rating is in remarkable agreement with the stranger's self-rating of those personality traits.[20]

Mimicry is what makes a newborn baby copy his mother's expressions, sticking out his tongue when she does and smiling when she does. A related positive effect is that people tend to agree with others whom they like[21] (your friend tells you her neighbor is a jerk, so you will tend to agree), unless agreement leads to conflicts with what the person already knows (you know her neighbor personally and think she is nice). Even your physical position will unconsciously affect your bias. People like novel stimuli better if their arms are flexed (accepting) than if they are extended (pushing away).[22] In one study, half the subjects pulled a lever toward them if a word was positive, or pushed it away if it was negative, and the other half did the opposite. The subjects reacted faster to positive words if they were pulling the lever. Experimenters tried it again with just pushing for all words, or pulling for all words, and the reaction time was faster if the pushers saw a negative word than if they saw a positive word, and it was opposite for the pullers; their reaction was faster for the positive words.[23] All decisions we make are based on whether to approach or withdraw, including our moral decisions. If it is good, we approach; if it is bad, we withdraw; and these decisions are affected by the bias mechanisms, which in turn can elicit emotions that come as standard equipment from the baby factory.

THE NEUROBIOLOGY OF MORAL JUDGMENTS

Now try this scenario, known as the trolley dilemma:

A runaway trolley is headed for five people, who will be killed if it proceeds on its present course. The only way to save them is to hit a switch that will turn the trolley onto an alternate set of tracks where

it will kill one person instead of five. Should you turn the trolley in order to save five people at the expense of one?

If you are like most people, you will say yes, it is better to save five than one.

Now try this one:

As before, a trolley threatens to kill five people. You are standing next to a large stranger on a footbridge crossing above the tracks, between the oncoming trolley and five workmen on the tracks below. Pushing the large stranger off the bridge and onto the tracks below will stop the trolley. He will die if you do this, but the five workmen will not be killed. Should you save the five others by pushing this stranger to his death?[24]

Most people will answer no to this one. Why this dichotomy, when the actual numbers are no different in the two dilemmas? What is your interpreter saying now?

Joshua Greene, a philosopher-turned-neuroscientist at Harvard, thinks it is because the first scenario is more impersonal. You push a button and have no physical contact. The second one is personal. You actually have to physically push the stranger off. Greene looks to our evolutionary environment to solve this problem. Our ancestors lived in an environment of small social groups whose members were known to each other and whose dealings were regulated by emotions and were all on a personal level. It would then make sense that we should have evolved a hardwired emotional response to personal moral dilemmas, a response selected for survival or reproductive success. Indeed, when he used fMRI to look at areas in the brain that were being used in the above dilemmas, Greene found that with the personal dilemma, the brain areas associated with emotion and social cognition had increased activity. Dilemmas that were impersonal were not a part of the ancient environment, so when faced with the impersonal dilemma, the brain has no default reaction and has to resort to actual conscious thinking. With impersonal dilemmas, areas associated with abstract reasoning and problem solving showed increased activity.[25]

Marc Hauser, however, thinks there are too many other variables in these dilemmas to narrow it down to personal versus impersonal. The results can also be explained in terms of a philosophical principle that it is permissible to cause harm as a by-product of achieving a greater good, but not to *use* harm to achieve it[26]—which is to say, the means don't justify the ends. This is then discussing action based on intent. The intent in the first is to save as many as possible; the intent of the second is not to harm the innocent bystander.

Perhaps we can say it like this: Flipping the switch is emotionally neutral, neither good nor bad. So we get no help from intuitive bias or emotion; we then think about the problem rationally: One dying and saving five is better than five dying and saving one. In the second dilemma however, pushing an innocent person off a bridge is not emotionally neutral. It feels bad: Don't do it. Indeed, if you were the large person, the idea of jumping off the bridge yourself most likely would never even enter your head. Very bad. Jana Borg and colleagues, at Dartmouth College, decided to explore further. They found that the posterior superior temporal sulcus (STS) is used for the harder personal scenarios, and for the easy ones, the anterior STS. They postulate that the posterior STS may be used in thought-provoking, first-time scenarios, and the anterior portion may be more involved in previously resolved, more routine decisions.[27]

ACTION VERSUS NO ACTION

We began by observing that we can make a moral judgment quickly, automatically. Even though we may not be able to explain it logically, we will keep on trying. In incest avoidance, we saw an example of hard-wired behavior that we consider moral. In the trolley dilemma, we have seen that moral judgments are not completely rational. They depend on the circumstances (automatic bias, personal or impersonal situations). They depend on whether action or no action is required. They also depend on intent and emotions (Damasio's patient Elliot). We have found that some automatic pathways are learned over time (driving), and some are inherent (approach-avoidance with a negativity bias). The latter

can be affected by emotions, which also have been hardwired to varying degrees. Now we need to know a bit more about how the brain works.

It was thought in the past—and some still think so today, although their numbers are dwindling—that the brain is a general-purpose organ that can work on any problem with equal ability. If this were true, though, we should pick up molecular biology as easily as we learn to talk, and we definitely should not be able to figure out the great evolutionary psychologist Leda Cosmides' social-exchange questions better than we do logic questions. It appears our brains have neuronal circuits that have developed over evolutionary time that do indeed do specific jobs.

The concept of a brain with specialized circuits for specific problems is called the *modular brain theory*. I first wrote about this years ago in *The Social Brain*. It seemed logical, considering how most neuropsychological knowledge at the time emphasized how focal brain lesions produced discrete and specific deficits in patients. If a specific part of the brain is damaged, there are specific disorders of language, thought, perception, attention, and so on. And nowhere were such phenomena more dramatic than in split-brain patients, proving that the left side of the brain is specialized for one set of capacities and the right side for another kind.

More recently, the idea of modularity has been augmented by evolutionary psychologists. Cosmides and Tooby, for example, define modules as "units of mental processing that evolved in response to selection pressures." Yet, from considering the neurologic literature, it is clear that modules are not like isolated cubes stacked up neatly in the brain. Modern brain imaging studies have shown that the circuits for these modules can be widely scattered. And modules are defined by what they do with information, not by the information they receive (the input or stimulus that triggers them). Clearly, over evolutionary time, these modules evolved to react in specific ways to specific stimuli in the environment.

But our world has changed too fast for evolution to keep up with it. More types of information are going in, but the modules are still triggered in the same old ways. Although the range of stimuli is broader, their automatic responses still occur.

Furthermore, the brain is constrained. There are things it just cannot do, cannot learn, and cannot comprehend. For the same reason, a dog

cannot comprehend that, or why, you care so much about the Gucci shoes he just chewed up—after all, leather is leather—but he is getting the general feeling that maybe it was a bad move. There are some things the brain learns in just one try, and there are some things that take many attempts. The idea that the brain can't do everything is a hard concept, since it is difficult to conceive of things our brain can't grasp. Like, please explain the fourth dimension again, and that thing about time not being linear. The brain is basically lazy. It will do the least amount of work it can. Because using intuitive modules is easy and fast and requires the least amount of work, that is the default mode of the brain.

What is being proposed now by many researchers studying morals and ethics[1] is that we have modules that have evolved to deal with specific circumstances common to our hunter-gatherer ancestors. They lived in a social world made up of groups mostly of related people. Occasionally they met up with other bands of people, some more closely related than others, but they all needed to deal with the problems of survival, which included eating and not being eaten. Since this was a social world, the specific circumstances they often had to deal with involved other individuals, and some of these circumstances involved what we consider to be moral or ethical issues. These modules produce specific intuitive concepts that have allowed us to create the societies we live in.

ETHICAL MODULES: WHAT ARE THEY? WHERE DO THEY COME FROM?

The proposal is that a stimulus induces an automatic process of approval (approach) or disapproval (avoid), which may lead to a full-on emotional state. The emotional state produces a moral intuition that may motivate an individual to action. Reasoning about the judgment or action comes afterward, as the brain seeks a rational explanation for an automatic reaction it has no clue about. This includes moral judgments, which are not often the result of actual moral reasoning. Occasionally, however, the rational self does truly participate in the judgment process.

Marc Hauser points out that there are three possible scenarios for intuitive processes. At one end of the spectrum of opinion are those who

believe there are specific inborn moral rules: It is wrong to kill, steal, or cheat; it is good to help, be fair, and keep promises. On the opposite end of the argument, some maintain that we are born with no intuitions, just the proverbial blank slate, an ability to learn moral rules. Thus you could just as easily learn that cheating and incest are good and fairness is wrong. Then there is the middle position, which Hauser favors, believing we are born with some abstract moral rules and a preparedness to acquire others, just as we are born with a preparedness to acquire language. Thus our environment, our family, and our culture constrain and guide us to a particular moral system, as they do to a particular language.

From what we have seen so far, the middle path seems the most likely. To find where these abstract moral rules come from, Hauser looks at common behaviors we share with other social species, such as being territorial; having dominance strategies to protect territory; forming coalitions to garner food, space, and sex; and reciprocity. Social reciprocity, having been taken by humans to heights unheard of in the animal world, provides a treasure trove in the search for abstract moral rules. The specific circumstances needed for social reciprocity to exist, as shown by researchers in game theory, require not only that the cheaters be detected but also that they be punished. Otherwise, cheaters, who invest less but receive an equal benefit, will outcompete the noncheaters and take over. If cheaters take over, reciprocity crumbles. Humans have evolved two abilities that are necessary for *prolonged* reciprocal social exchange: the ability to inhibit actions over time (that is, delayed gratification) and punishment of cheaters in reciprocal exchange. These currently are on the short list of uniquely human capacities.[28]

Haidt and his colleague, Craig Joseph at Northwestern University, have come up with a list of universal moral modules* after comparing research on human universals, cultural differences in morality, and the precursors of morality in chimpanzees. Their findings also derive from the similar set of common behaviors that Hauser uses, but they add one class of abstract intuitions that are derived from the uniquely human

*They define modules as little bits of input-output programming, ways of enabling fast and automatic responses to specific environmental triggers.

emotion of disgust. Their five modules are reciprocity, suffering, hierarchy, boundaries between in-groups and out-groups (coalitions), and purity.[29, 30] Not everyone will agree on these, but as Haidt and Joseph point out, they cover the wide range of moral virtues, which they define as characteristics of a person who is considered morally praiseworthy. Their list encompasses moral concerns in the world's cultures, not just Western cultures.

All such lists provide us with avenues of study. They aren't by any means definitive. Virtues are not universal. They are what a specific society or culture values as morally good behavior that can be learned. Various cultures emphasize various aspects of the above five modules, and this is what drives cultural differences in morality. This is the part of Hauser's middle path that is influenced by society. Richard Shweder, an anthropologist at the University of Chicago, proposes three areas of moral concern: the ethic of autonomy, which is concerned with an individual's rights, freedoms, and welfare; the ethic of community, which is concerned with protecting families, communities, and nations; and the ethic of divinity, which is concerned about the spiritual self and physical and mental purity.[31] Haidt and Joseph favor a similar schema: They place the concern for suffering and reciprocity under the ethic of autonomy, the concern for hierarchy and coalitional boundaries under the ethic of community, and the concern for purity under the ethic of divinity.

I will address these separate modules, the input that activates them (the environmental trigger), the moral emotions that they elicit, and the moral intuition (the output) that results. As Damasio surmised, emotions are the catalyst, and they help us to explain why all is not rational in the world. Although on the surface it may seem that a fully rational world would be a better one, however, on just a quick look, we can nix that idea. For instance, the classical question in economics is why ever leave a tip in a restaurant that you will never go back to? That is not rational. Why not dump your sick husband or wife and get a healthy one? That would be more rational. Why spend public money on the severely handicapped, when they will rarely be able to repay it?

Haidt also makes the point that moral emotions aren't just for being nice. "There is more to morality than altruism and niceness. Emotions that motivate helping behavior are easy to label as moral emotions, but

emotions that lead to ostracism, shaming, and murderous vengeance are no less a part of our moral nature. The human social world is a miraculous and tenuous co-construction of its participants, and any emotion that leads people to care about that world, and to support, enforce, or improve its integrity should be considered a moral emotion, even when the actions taken are not 'nice.'"[32]

Oddly enough, Robert Frank, an economist, stepped into the world of the psychologists, philosophers, and the selfish gene. He suggests that moral sentiments are consistent with the selfish-gene theory. It can be to a selfish person's advantage to have moral sentiments that are visibly expressed by moral emotions, which predispose him not to cheat. Moral emotions, which are difficult to counterfeit, advertise that you have a conscience and would suffer uncomfortable feelings of guilt if a promise were broken. For instance, you know you can trust what the infallible blusher tells you. She cannot tell a lie without turning beet red. Humans are the only animal that blushes. Another visible sign of an emotion are tears. Humans are the only animal that cries. Although other animals have tear ducts, they produce tears only to keep the eye healthy. They do not produce tears with emotions.

Moral sentiments and emotions can be a commitment device that allows potential partners in trade or social exchange to get past the first round of exchange without cutting and running.[33] In short, they solve the commitment problem in personal relationships and in social exchange, which is: Why would anyone ever go into partnership with someone else in the first place? A rational person would never go into partnership with someone else because of the high probability that the other rational person would cheat, because if the opportunity presented itself, there would be no rational reason not to. How could you ever convince another rational person that you wouldn't cheat? It doesn't make sense not to.

Why would any rational person get married when they read the divorce rate or when they can have sex with innumerable others without the expense? Why would you ever start a business with someone? Why would you ever lend anyone money? Emotions solve the problem. Love and trust can lead to marriage, trust to partnerships. The fear of feeling guilt or shame prevents you from cheating, and you know (because of your theory

of mind) that your partner would also feel the same way. Anger and rage against a cheater is a deterrent. Possessing a theory of mind allows one to plan one's actions, taking into account how they will affect the beliefs and desires of another. If you cheat someone, they will get angry and retaliate. You don't want to feel the embarrassment when the other person finds out, nor do you want the retaliation, so you don't cheat.

One type of moral emotion, however, is not limited to a single module, as we will soon see. Here is an overview of the five moral modules most commonly postulated.

The Moral Modules

THE RECIPROCITY MODULE

Social exchange is the glue that holds societies together, and it is emotions that hold social exchange together. It is probable that many of the moral emotions arose in the context of reciprocal altruism and have precursors that can be seen in infants and other animals. If you recall, in order for social exchange to work, social contracts have to be made and honored. These take the form, *If I do this for you, then you will do an equal amount for me sometime in the future.* Robert Trivers, who helped us out in the previous chapter by explaining kin altruism, believes when looking at reciprocal altruism that emotions are what mediates between our intuitions and behavior. We will engage in reciprocity with those we trust, and we trust those who reciprocate. Individuals who didn't like being cheated and did something about it, and individuals who felt guilty if they cheated and didn't like that feeling, were the ones who were necessary to allow reciprocity to exist—by creating a society in which the honest would not be outcompeted by cheaters. Although there is evidence that reciprocity exists in a few other animals such as vampire bats and guppies, it exists only on a one-to-one basis. Humans will gossip and tell others who is a violator and who is trustworthy.

The moral emotions connected with reciprocity are sympathy, contempt, anger, guilt, shame, and gratitude. Sympathy can start the ball rolling by motivating an exchange. "Sure, I'll help you out." Anger urges you to punish cheaters; it is a reaction to unfairness and can motivate

revenge. Contempt is looking down on people who haven't pulled their weight or measured up to their self-proclaimed ideals, and feeling morally superior to them. Contempt for a person weakens other emotions, such as compassion, making future exchanges less likely. Gratitude results from the exchange but is also felt toward those who detect cheaters. The automatic processing of the reciprocity module is saying, *Pays his debts, cooperates, and punishes cheaters: good, approach,* or *Cheats: bad, avoid.* The virtues that have been derived from intuitive reciprocity are a sense of fairness, justice, trustworthiness, and patience. However, reciprocity is not built on an innate sense of fairness; it is built on an innate sense of reciprocity.

Two university professors sent Christmas cards to a list of people they didn't know. Surprisingly, they received return cards from most of those people, and most didn't even ask who they were.[34] Charity organizations have found that they can double their donations when they give a litte something along with their request for money, such as return-address stickers. Reciprocity is a strong instinct, but although fairness is a virtue that derives from it, it is not the master. Vernon L. Smith, a Nobel Prize winner in economics and currently professor of economics and law at George Mason University, has demonstrated this.[35, 36, 37] There is a research game called the ultimatum bargaining game. You give Dave a hundred dollars and tell him to share it with Al. Dave has to say beforehand how much he is going to give Al. If Al refuses the offer, neither gets anything. The rational offer would be to offer Al one dollar. Al should accept it because he comes out ahead. But people who are offered a low amount in these games do not accept the offer. It makes them mad and the punishment they dole out is to refuse it. Both sides lose.

Most people who play the ultimatum game offer fifty dollars. This would make you think that fairness is what is going on. However, in a group of college students, if you vary the game a bit so Dave has to earn his position by scoring in the top half of the class on a general knowledge test, and Al has to accept whatever he is offered (this is now known as the dictator game), behaviors change. Daves are less generous. They no longer offer half, as they had in the ultimatum game. If Dave thinks his identity is not known to Al, he is again less generous. If Daves think the experimenter doesn't know their identity, 70 percent of

them don't offer *any* money to Al in the dictator game. The results led Smith to conclude that it is as if the Daves don't think they'll be asked back if they are *known* not to play in a socially acceptable manner. Fairness is obviously not the motivation in these games, whereas opportunity is. Smith argues that the reason Daves act fairly in the original ultimatum game is that they are obsessed with reciprocity and want to maintain their personal reputation, but when their identity is not known or they have a higher status, fairness is not the issue.

Smith tweaked his game again by having Dave and Al play a *series* of games, not just one. Dave and Al can pass or take the cash on each turn, and the amount grows with each pass. Eventually, the game ends if neither has opted to take the cash by a certain point, and Dave gets the cash. If all were rational, Al should figure that he should take the cash on his last turn, and Dave should figure that Al will do that, so Dave should take it on his second-to-last turn, and so on and so on, so that the rational person should take the cash on his first opportunity. But the students don't. They let Dave take it on the last round, and hope for reciprocal generosity on the next round. This is Robert Frank's commitment model. Both parties know each other and are playing a series of games.

These studies have been extended to the world beyond college students. The games were played with fifteen small-scale societies on four continents and in New Guinea. Although the results were more widely varied (lowball offers were more readily accepted in some societies and not in others), the researchers concluded that in none of the societies did people play with a completely selfish behavior. How they played varied with how important local cooperation was and how dependent they were on marketing and trading goods. The individual player's personal economic status or demographic had no effect, and the play patterns pretty much resembled their everyday interactions.[38] The more the society engaged in reciprocal trade beyond their kinship ties, the more equitable the offers were.

THE SUFFERING MODULE

A concern for suffering, or a sensitivity to or a dislike of signs of physical pain in others, and a dislike for those who cause the pain, is a good adaptation for a mother raising an infant who has a long period of depen-

dency. Any adaptation that increases the offspring's chance of survival would have been selected for, and an ability to detect suffering in one's offspring fits this criterion. Sympathy, compassion, and empathy most likely have their distant origins in mimicry, which result in mother-offspring bonding and attachment, which in turn tend to increase survival of offspring. The virtues Haidt concludes societies derive from this intuitive ethic are compassion and kindness, but we could add righteous anger.

THE HIERARCHY MODULE

Hierarchy has to do with navigating in a social world where status matters. We evolved in social groups that were rife with dominance and status, both social and sexual. Our cousins the chimps are forever concerned about rank and dominance, and so are humans. Even in egalitarian societies, hierarchy exists in social status, work organizations, and sexual competition. No matter how egalitarian the society, some individuals will be more fit, more attractive, and thus ranked higher by the opposite sex. And somebody has to run the committee meetings, or chaos ensues. Intuitive behaviors that led to maneuvering this social web by being respectful to dominants or wielding power with aplomb would have been successful. We saw how the emotions of guilt and shame worked in social exchange, but they can also nudge one to act in a socially acceptable way, helping one navigate the hierarchical social world. Guilt is the belief that one has caused harm or suffering and can motivate helpful behavior, especially if one is caught in a reprehensible act, whereupon guilt becomes shame. Shame is violating a social norm knowing that someone is watching. It motivates one to hide or withdraw, which indicates that one understands the violation and is less likely to be attacked for committing it. Guilt and shame can be motivators for all the moral modules. Embarrassment is often felt around people of higher status. It motivates one to present oneself properly and show respect for those in authority, thus avoiding conflict with more powerful individuals, increasing the odds of survival. We learned in the last chapter that the reward for those who punished cheaters was increased status. Other emotions that are associated with hierarchy are

respect and awe, or resentment. Virtues based in hierarchy are respect, loyalty, and obedience.

THE IN-GROUP/OUT-GROUP COALITION MODULE

Coalitions are prevalent in chimpanzee society and among other social mammals, such as dolphins. They are endemic among humans, who organize themselves spontaneously into mutually exclusive groups. There are the sugar people and the salt people, farmers and herders, dog lovers and cat lovers. It is almost comic (if it didn't lead to so much tragedy) to look at an atlas of the world and see how many countries do not like their neighbors. Robert Kurzban, John Tooby, and Leda Cosmides have found evidence for a specialized module that codes for coalition recognition.[39] In an evolutionary world where kin groups live together, where hostile neighboring bands can be encountered, and where shifting power struggles erupt in social groups, it would be beneficial to be able to recognize patterns of cooperation, competition, and political allegiance. Visible markers that suggested who was allied with whom would be important. Arbitrary cues, such as skin color, accent, or manner of dress, would become significant only if they had predictive validity for coalitional membership. Otherwise they would be unimportant. The hunter-gatherer societies in which we evolved would rarely, if ever, have come into contact with groups of another race. They rarely moved more than a short distance. But race could be used as a coalition marker in the right circumstances because it is highly visible. In sociological tests in the past, people always categorized other people according to race, no matter what social context they presented.

To test if there might be a module that specialized in coalition recognition rather than race recognition, which did not make evolutionary sense, Kurzban, Tooby, and Cosmides created a social context in which race was not predictive of a cooperative alliance. They found this drastically decreased the extent to which subjects noticed race. They also demonstrated that any visual marker (they used shirt color) that is correlated with patterns of cooperation and alliance would be encoded, and in fact was encoded more strongly than race. It was only four minutes into their experiment when their subjects no longer noticed race. They

concluded that people are good at picking up on changing patterns of alliance, and this is why they can adapt to different social worlds, one where race was not the coalition predictor.

Various emotions can be aroused by coalition membership: compassion for other groups (by Shriners and walkathon participants, for example), contempt for other groups (nonsmokers' feelings for smokers), anger (by nonsmokers against smokers), guilt (for not supporting your group), shame (for betraying your group), embarrassment (for letting "the team" down), and gratitude (house owners to firemen). So this module would work: *Recognized as part of my group: good, approach; not part of my group: bad, avoid.* Coalition recognition has its roots in mimicry; like mannerisms generate a positive bias. Virtues that are spawned from in-group coalitions are trust, cooperation, self-sacrifice, loyalty, patriotism, and heroism.

THE PURITY MODULE

Purity has its roots in defending against disease: bacteria, fungi, and parasites—what Matt Ridley considers the competition.[40] Without their threatening presence, there is no need for gene recombination or sexual (versus asexual) reproduction. We wouldn't have to keep up with the Joneses, or in this case the *Escherichia coli* or the *Entamoeba histolytica,* which are constantly mutating to get better at attacking us so they can reproduce and survive. Disgust is the emotion that protects purity. Haidt suggests that the emotion of disgust arose when hominids became meat eaters. It appears to be a uniquely human emotion.[41] Obviously your dog doesn't feel it. Look what he eats. Disgust is only one of the four reasons that humans reject food, but we share the other three reasons with other animals: distaste, inappropriateness (a stick), and danger. Disgust implies the knowledge of the origins or the nature of food. Young infants will reject food that is bitter, but disgust doesn't appear until around age five. Haidt and his colleagues suggest that the emotion of disgust initially acted as a food rejection system, evidenced by its connection to nausea, concerns with contamination (contact with a disgusting substance), and facial expressions associated with it, which mostly use the nose and mouth. They refer to this as core disgust.

Initially, disgust would guard against disease transmitters, such as rotting corpses and carcasses, rotting fruit, feces, parasites, vomit, and the ill. Haidt suggests, "Human societies, however, need to reject many things, including sexual and social 'deviants.' Core disgust may have been preadapted as a rejection system, easily harnessed to other kinds of rejection."[41] Its purview expanded, and at some point disgust became more generalized to include aspects of appearance, bodily functions, and some activities, including overindulgence and some occupations, such as those having to do with corpses.

But if disgust evolved to serve these important adaptive functions— food selection and disease avoidance—then it is particularly surprising that the disgust response is almost totally lacking in young children. Indeed, young children will put almost anything into their mouths, including feces, and the full disgust response (including contamination sensitivity) is not in place until around the age of five to seven. Contamination sensitivity is also not found, so far as we know, in any non-human species.* Caution is therefore warranted in proposing that disgust is important for biological survival. The social functions of disgust . . . may be more important than its biological functions.[41]

Indeed when the researchers had people from many different countries list things that they found disgusting, they could be grouped into three general categories beyond that of core disgust. The first category was things that reminded people of their animal nature, including death, sex, hygiene, all body fluids except tears (which only humans have), and body envelope violations such as a missing part, deformity, or obesity. The next category consisted of things that were thought to risk interpersonal contamination, which turns out to be less a form of body product contamination (people were only slightly less reluctant to wear laundered clothes of another) than of contamination of their essence. People were

*In order to be afraid of contamination, one must be able to conceive of invisible entities and to understand that appearance is not necessarily reality.

more reluctant to wear the clothes of a murderer or of Adolph Hitler, than of a well-liked person. The majority of things listed as disgusting by people from India fell in this category. The last grouping was moral offenses. For American and Japanese subjects, the majority of disgusting things on their lists came from this category, although they were very different. Americans were disgusted at the violation of a person's rights and dignity, whereas Japanese were disgusted at violations to a person's place in society.

Disgust has a cultural component that varies among cultures, and children are coached as to what it includes. This module most likely had biological origins, which have widely expanded to include disgust that is not only elicited by food but now can even include the actions of others. Unconsciously this module would say, *Disgusting: dirty, bad, avoid; clean: good, approach.* I recently saw a sign that read, CLEAN HANDS MAKE GOOD FOOD. The purity module is alive and well in Santa Barbara.

Over the passage of time, religious and secular laws and rituals have been made regulating food and bodily functions, including hygiene, health, and diet. Once these laws are accepted, their violation results in a negative bias and a moral intuition. Other religious and moral concerns have been generalized to the purity of the mind and body. Many cultures make virtues of cleanliness, chastity, and purity.

Thalia Wheatley and Haidt[42] have run an experiment to see if they could affect moral judgments by increasing an emotion. They hypnotized two groups of people and told one group that whenever they read the word *that*, they would be disgusted, and told the other group they would be disgusted by the word *often*. Then they had them read stories that had either one or the other word in them. Each group found the moral stories with their hypnotically suggested word in it more disgusting. They even found that one-third of people will judge a story with no moral violation in it somewhat morally wrong. Schnall, Haidt, and Clore tried a different approach by asking subjects moral questions while seated either at a dirty desk strewn with used fast-food wrappers and tissues or at a clean desk. People who had tested at the upper end of the scale for "private body consciousness" (those who are more aware of their physical state) made more severe moral judgments when sitting at

the dirty desk. A take-home lesson from this is that if you have had a forbidden party at your parents' house while they are gone for the weekend, be sure the house is spotless when they get home, because if they find out about it and the house is dirty . . .

So if we all have these universal modules, why are cultures so different in their moral standards? Haidt and Joseph answer this question by looking at the link between our innate moral intuitions and the socially defined virtues. In Hauser's model, we have an innate preparedness to respond to the social world in particular constrained ways. That means some things are easier to learn than others, and some things can't be learned at all. Studies on animals have shown that some things can be taught with just one trial, others can take hundreds of trials, and some can never be learned. The classic example for humans is the fact that it is very easy to be taught to be afraid of snakes but nearly impossible to be taught to be afraid of flowers. Our fear module is prepared to learn about snakes, which were a danger in our ancestral environment, but not flowers, which weren't. When you ask children what they are afraid of, the answer is lions and tigers and monsters, but not cars, which are very much more likely to hurt them nowadays. Likewise, some virtues are easily learned, whereas others are not. It is easy to learn to punish cheaters; it is difficult to learn to forgive them.

Virtues are what the culture has defined as morally praiseworthy. Different cultures value the output of the moral modules differently. Different cultures will link more than one module together so they apply to broader stimuli. Hindus have linked purity to hierarchy and coalitions and come up with a caste system. Monarchies have done much the same and ended up with a class system, royals keeping their bloodlines pure within a hierarchy of nobility. Cultures may define the virtues elicited by the different modules differently. Fairness is considered a virtue, but with what as its basis—fairness based on need? Or fairness based on those who work harder? Or fairness based on equal distribution? And consider loyalty. Certain societies value loyalty to family whereas others value loyalty to peer groups or a hierarchical structure, such as a town or country. In some cultures there may be complex virtues derived from different modules that are linked together to create a super virtue such

as honor, derived from the hierarchy, reciprocity, and purity modules in most traditional cultures.[30]

THE RATIONAL PROCESS

With modules seemingly for almost everything, when does rational thinking kick in? Balzac marked the moment in *Modeste Mignon* with the statement "In love, what a woman mistakes for disgust is simply seeing clearly."[43] When this may happen is under debate at the current time. When are we motivated to think rationally? Well, we are motivated when we want to find the optimal solution. But what is the optimal solution? Is it the actual truth, or is it one that verifies how you see the world, or one that maintains your status and reputation?

Let us say you want the accurate actual truth unaffected by any bias you have. This is easier when moral interpretations are not at stake. For example, "I really want to know which medication is best for me, and I don't care how much it costs, where it came from, who makes it, how often I have to take it, or whether it is a pill, an injection, or a salve." That is a much less threatening question than "Is it OK to harvest organs from condemned felons?" The other condition is that we have enough time to think about it, so the automatic response doesn't kick in. On the spur of the moment, will you take one of the darling kittens being offered in front of the grocery store back to the apartment where you aren't allowed to have pets and your roommate is allergic to cat dander? Or do you go home and think about it? And of course, one has to have the cognitive ability to understand and use information that is pertinent.

Then again, even when we are trying to think rationally, we may not be. Research has shown that people will use the first argument that satisfies their opinion and then stop thinking. David Perkins, a Harvard psychologist, calls this the "makes sense" rule.[44] However, what people consider makes sense varies widely. It is the difference between anecdotal evidence (an isolated story that presumes a cause and effect) and factual evidence (a proven cause and effect.) For instance, a woman may believe birth control pills will make her sterile, because her aunt took birth control pills in the past, and now she can't get pregnant. Anecdotal

evidence, one story, was all she needed to support her opinion, and it made sense. However, she does not consider the possibility that her aunt may have been unable to get pregnant before she started taking the birth control pills, nor the possibility her aunt could have been infected with sexually transmitted bacteria, such as gonorrhea or chlamydia, that caused scarring in the Fallopian tubes—which in fact is the leading cause of infertility. She also does not know that using birth control pills will actually preserve her fertility better than nonhormonal methods (factual evidence). Predominantly, people use anecdotal evidence.[45, 46]

Try this example, one of many that Deanna Kuhn, a psychologist at Columbia University, used to investigate knowledge acquisition:

Which statement is stronger?
A. Why do teenagers start smoking? Smith says it's because they see ads that make smoking look attractive. A good-looking guy in neat clothes with a cigarette in his mouth is someone you would like to be like.
B. Why do teenagers start smoking? Jones says it's because they see ads that make smoking look attractive. When cigarette ads were banned from TV, smoking went down.

In a large group of students ranging from eighth grade to graduate school, few understood the differences between the two types of argument these represented, although the graduate students did the best. The first is anecdotal, and the second is factual. The implications of this are that even if a person seeks to make a rational judgment, most people don't use information in an analytical manner.[47]

Looking at our evolutionary environment, Haidt points out that if our moral judgment machinery were designed to always be accurate, the results could be disastrous if you occasionally sided with the enemy, against your friends and family.[1] He presents the social intuitionist model of moral reasoning. After the intuitive judgment and the post-hoc reasoning occur, Haidt suggests that there are four possible circumstances in which this intuitive judgment may be altered. The first two involve the social world either by reasoned (not necessarily rational) persuasion or by merely doing what everyone else is doing (again, not necessarily rational).

He suggests rational reasoning has an opportunity to bloom when an issue gets discussed with another person.

Remember those social groups I talked about in the last chapter, in relation to gossip? And what does gossip accomplish? It helps set standards of moral behavior in a community. And what does everyone love to gossip about? Juicy tidbits, and the juiciest of all are moral violations. That will turn a desultory conversation into a hot one. It's much more interesting to learn that Sally is having an affair with a married man than to hear that she is having a party. You can feel righteous yourself, and agree with your friend that married men are off-limits, but what if you don't agree with your friend? What if you know that the man is married to a gold digger who married him for his money, they have no children, their house is now partitioned in two—she is on one side having extravagant parties, and he is on the other spending his spare time managing the Web site for the local United Way—and they have no contact, except for her refusing to sign divorce papers? Can you two have a rational discussion of facts and leave with someone having changed his or her mind?

It depends on how strongly your emotions have kicked in on the case. We have already learned that people will tend to agree with people they like, so if the issue is neutral or of little consequence, or if an argument hasn't already arisen, then social persuasion can come into play. These persuasive arguments may or may not be rational, as we just learned. You will use anything you think will persuade the other to your viewpoint. If the two of you have really strong reactions, then don't waste your time. And of course, really strong reactions are what are at stake with moral issues. There is a reason for the adage of not talking about religion or politics over a meal. Strong emotions lead to arguments, which are disruptive to the taste buds and lead to indigestion.

As Robert Wright puts it in his book *The Moral Animal,* "By the time the arguing starts, the work has already been done." In steps the interpreter, and the bad news is, your interpreter is a lawyer. Wright describes the brain as a machine for winning arguments, not as a truth finder. "The brain is like a good lawyer: given any set of interests to defend, it sets about convincing the world of their moral and logical worth regardless of whether they in fact have any of either. Like a lawyer, the human brain wants victory, not truth; and, like a lawyer, it is sometimes

more admirable for skill than for virtue."[48] He points out that one would think that if we were rational creatures, then at some point, we should wonder at the probability of always being right. Come to think of it, if we were all rational creatures, wouldn't we all use pocket protectors?

Persuasion can come in the form of merely being in a group of people. How many times have you thought people act like sheep? For instance, my daughter related her experience at the San Diego train station the day before Thanksgiving. The train was late arriving, and when it was finally available for boarding, only one of the several doors to the platform was standing open. A long line of people formed at that door. She walked to one of the closed doors and pushed it open and stepped onto the train. Many studies have been done to illustrate how people are influenced by those around them. The creators of the TV show *Candid Camera* did some of their most hilarious skits with this in mind.

Solomon Asch, a pioneer of social psychology, did a classic experiment. He set up a room of eight subjects (seven of whom were "plants") and showed them a line. After concealing that line, he showed them another line that was obviously much longer. He asked each person in the room if one of the lines was longer than the other, but asked the real subject last. If the first seven people all said the lines were of equal length, the majority of test subjects agreed with them.[49] Social pressure made a person say something that was obviously incorrect.

Stanley Milgram was a student of Asch. After receiving his doctorate in social psychology, he did some shock experiments that were truly shocking. No persuasion was involved here, just obedience. He told his subjects he was researching the effects of punishment on learning. However, what he was really researching was obedience to an authority figure. He measured the willingness of his subjects to obey an authority figure, the researcher, who instructed them to perform acts that conflicted with their consciences. He told his subjects they were randomly assigned to play either a teacher or a student role. The subject, however, was always assigned the teacher role. Milgram told the teacher to administer an electric shock to the student (who, unbeknownst to the teacher, was an actor playing the part) every time the student got an answer wrong on a word-matching memory task, and to increase the shock for each mistake. The actor was not actually shocked but pretended to be.

The subject playing the teacher was told that real shocks were being given. The instrument panel on the shock machine read "slight shock" on one side of a dial and "severe shock" on the other, with numerical values from 0 to 30. Having previously asked people what they would do in such a circumstance, he expected most people would stop at a level of 9. However, he was quite wrong. The subjects continued shocking the student to an average intensity of 20 to 25, with or without prodding from the experimenter, even when the student was screaming or asking to leave. And 30 percent went to the highest-level shock even when the student was pretending to be listless or unconscious! If the teacher and student were in closer proximity, however, there was a 20 percent drop in obedience, suggesting that empathy encouraged disobedience.[50, 51]

This study has been replicated in many countries. Obedience to the instructions has been universal in several countries where the studies have been replicated, but among the countries, it varied from Germany, where 85 percent were willing to send the highest levels of shocks, to Australia, where it dropped to 40 percent. This is an interesting finding, considering that modern Australia was originally populated by prisoners, a rather disobedient gene pool! In the United States, 65 percent followed the instructions. That may be good news for traffic laws, but we know where blind obedience leads.

Haidt's third possible scenario in which rational judgment is most likely to be used is what he refers to as the reasoned judgment link. In this instance, a person logically reasons out a judgment and overrides his intuition. Haidt suggests that this happens only when the initial intuition is weak and the analytical capacity is high. Thus, if it is a low-profile case, in which there is no emotional investment or only a little, the lawyer might go on vacation. If you are lucky, a scientist[*52] covers for him—but don't count on it. If it is a high-profile issue, and the intuition is strong, an analytical mind can force logic on its owner, but he may end up with a dual attitude, with his intuition just below the surface. So just maybe, if it is a high-profile case, the scientist may sit in on the argument and later, while sipping a *digestivo,* nudge the lawyer to shut up already.

*The lawyer-scientist analogy was first used by Roy F. Baumeister and Leonard S. Newman.

The fourth possible scenario is the private reflection link. Here, a person may have no intuition at all about an issue, or might be mulling over the situation, when suddenly a new intuition hits her that may override the initial one. This can happen by imagining yourself on the other side of the issue. Then you are presented with two competing intuitions. However, as Haidt points out, is this really rational thinking? Aren't you right smack back in Damasio's lap needing an emotional bias to help you pick between the two?

MORAL BEHAVIOR

How much does all this matter? Does moral reasoning correlate with moral behavior? Do people who rationally evaluate moral behavior act in a more moral way? Apparently not exactly. There appear to be two variables that do correlate to moral behavior: intelligence and inhibition. Criminologists have found that criminal behavior is inversely related to intelligence, independent of race or social-economic class.[53] Augusto Blasi found that IQ was positively related to honesty.[54] In this context, inhibition basically refers to self-control or the ability to override an objective that your emotional system wants. You may want to sleep in, but you will get up to go to work.

Researchers headed by Walter Mischel, a psychologist at Columbia University, have been doing a very interesting long-term study on inhibition. They began with a study of preschoolers, using a food reward. One by one, children were seated at a table and asked which was better, one marshmallow or two. We all know what they answered. On the table were a marshmallow and a bell. The researcher (let's call her Jeanne) told the child (Tom) that she had to leave the room for a few minutes, and when she returned, he could have two marshmallows. However, if Tom wanted her to come back early, then he could ring the bell, but if he did that, she would give him only one marshmallow. Ten years later, the researchers sent questionnaires to the parents about their then adolescent children, and found that those who delayed eating the marshmallow longer in preschool were rated as more likely to exhibit self-control in frustrating situations, less likely to yield to temptation, more intelligent, and less

distractible when trying to concentrate, and they earned higher SAT scores.[55] The team continues to follow these people today.

How does self-control work? How does one say no to a tempting stimulus? Why did some of those kids wait until the researcher returned while staring at the marshmallow? In the adult world, why are some people able to refuse the Death by Chocolate cake on the dessert tray, or drive at the speed limit while everyone is passing them?

In order to explain how that aspect of willpower, "the ability to inhibit an impulsive response that undoes one's commitment," aka self-control, works, Walter Mischel and his colleague Janet Metcalfe proposed that there are two types of processing. One is "hot" and the other is "cool"; they involve neural systems that are distinct but still interact.[56] The hot emotional system is specialized for quick emotional processing. It responds to a trigger and makes use of the amygdala-based memory. This is the "go" system. The cool cognitive system is slower and is specialized for complex spatiotemporal and episodic representation and thought. The researchers call it the "know" system. Its neuronal basis is in the hippocampus and the frontal lobes. Does this sound familiar? In their theory, they stress that the interaction of these two systems is of critical importance to self-regulation and to decision making in regard to self-control. The cool system develops later in life and becomes increasingly active. How the two systems interact depends on age, stress (under increasing stress, the hot system takes over), and temperament. Studies have shown that criminal behavior decreases with age,[57] giving support to the idea that the cool system that increases self-control becomes more active with age.

MORALITY-FREE HUMANS: THE CASE OF THE PSYCHOPATH

What about psychopaths? Are they different from most criminals or just way worse? Psychopaths appear different on neuroimaging studies.[58] They have specific abnormalities that can be differentiated from simply antisocial individuals and normal individuals. This suggests that their amoral behavior is due to specific malformations of the cognitive structure of the brain. Psychopaths exhibit high intelligence and

rational thinking. They are not delusional. They know the rules of society and of moral behavior, but a moral precept is just a rule to them.[59] They don't understand that it is OK to suspend the societal rule "Do not eat with your hands at the table," but it is not OK to suspend the moral rule "Do not spit in the face of the person next to you at the table." They have a measurable decrease in ectodermal response to emotionally significant[60] and empathetic stimuli[61] compared with normal control subjects. They don't have the moral emotions of empathy, guilt, or shame. Although they do not show impulsive behavior in one sense, they do have a one-track mindedness that is not inhibited, which distinguishes them from normal individuals. It appears that they are born psychopaths.

PUTTING YOUR MONEY WHERE YOUR MOUTH IS

It has been hard to find any correlation between moral reasoning and proactive moral behavior, such as helping other people. In fact, in most recent studies, none has been found,[62, 63] except in one study done on young adults, in which there was a small correlation.[64] As one might predict based on what we have learned so far, moral behavior, as evidenced by helping others, is more correlated with emotion and self-control. Interestingly, Sam and Pearl Oliner, professors at Humboldt State University and founding directors of the Altruistic Personality and Prosocial Behavior Institute, studied moral exemplars by looking at European rescuers of Jews during the Holocaust.[65] Whereas 37 percent were empathically motivated (suffering module), 52 percent were primarily motivated by "expressing and strengthening their affiliations with their social groups" (coalition module), and only 11 percent were motivated by principled stands (rational thinking).

The Religion Assumption

Where does religion fit in with all of this? If we have these moral intuitions we are born with, what's up with religion? Good question. But you

have made an assumption. Haven't you assumed that morals came from religion and that religion is about morals? Religions have been around since the very beginnings of human culture, but in fact, only sometimes do they have anything to do with morality and the salvation of a soul. You might say "But my religion does, and it is true, and all the other ones are false." Why are you so special? Every other religion thinks the same thing. Think about the coalition in-group intuitive bias. Pascal Boyer, an anthropologist who studies the transmission of cultural knowledge at Washington University in Saint Louis, points out that it is a common temptation to search for the origin of religion in general human urges, such as the desire to define a moral system or explain natural phenomena. He attributes this to people's incorrect assumptions about religion and psychological urges. With our current research techniques, we are able to do better than just throw ideas about religion out into the wind; we can prove or disprove many of them. He has come up with a list of commonly posited reasons for the origins of religion, and he suggests a different viewpoint.[66]

Do not say . . .	But say . . .
Religion answers people's metaphysical questions.	Religious thoughts are typically activated when people deal with concrete situations (this crop, that disease, this new birth, this dead body, etc.).
Religion is about a transcendent God.	It is about a variety of agents: ghouls, ghosts, spirits, ancestors, gods, etc., in direct interaction with people.
Religion allays anxiety.	It generates as much anxiety as it allays: Vengeful ghosts, nasty spirits, and aggressive gods are as common as protective deities.
Religion was created at time t in human history.	There is no reason to think that the various kinds of thoughts we call "religious" all appeared in human cultures at the same time.

(continued)

Do not say . . .	But say . . .
Religion is about explaining natural phenomena.	Most religious explanations of natural phenomena actually explain little but produce salient mysteries.
Religion is about explaining mental phenomena (dreams, visions).	In places where religion is not invoked to explain them, such phenomena are not seen as intrinsically mystical or supernatural.
Religion is about morality and the salvation of the soul.	The notion of salvation is particular to a few doctrines (Christianity and doctrinal religions of Asia and the Middle East) and unheard of in most other traditions.
Religion creates social cohesion.	Religious commitment can (under some conditions) be used as a signal of coalitional affiliation, but coalitions create social fission (secession) as often as group integration.
Religious claims are irrefutable; that is why people believe them.	There are many irrefutable statements that no one believes; what makes some of them plausible to some people is what we need to explain.
Religion is irrational/ superstitious (therefore not worthy of study).	Commitment to imagined agents does not really relax or suspend ordinary mechanisms of belief formation; indeed it can provide important evidence for their functioning (and therefore should be studied attentively).

TABLE 1: Do's and Don'ts in the Study of Religion. From Pascal Boyer, "Religious thought and behavior as by-products of brain function," *Trends in Cognitive Sciences* 7, no. 3 (2003): 119–24.

When we talk about anything the brain believes or does, we have to go back to its structure and function. Religions are ubiquitous and thus are easy to acquire and transmit. They are tapping into modules that are used for nonreligious social activities but, as Marc Hauser said, are "prepared" to be used in other related ways. There is not just one part of the brain that is used in religious thought; there are many areas that come into play. People who are religious do not have a brain structure that atheists and agnostics do not have. But remember, the brain is also constrained. As Boyer puts it, there is a limited catalog of concepts; religion is not a domain where anything goes. For instance, in most religions, invisible dead souls are lurking somewhere, but invisible thyroid glands are not. Gods are either people, animals, or man-made objects with some ability beyond the normal, but otherwise they still conform to what we know about the world. A god has a theory of mind and may or may not have empathy, but a god would never be a pile of cow dung, for instance, or just a thumb.

People do not require the same standard of evidence for religion that they do for other aspects of their life. Why do people pick some parcels of incoming information and not others to use for their belief systems? What we have learned about bias and emotion should help us out with that. The analytical mind is rarely called in to help. Another interesting aspect has recently been teased out of some research subjects. What people *say* they believe and *believe* they believe, and what they *actually* believe, are two different things. Instead of the omnipresent, all-doing, all-knowing God that they say they believe in, when they are not focused on their beliefs, they use another concept of God that is humanlike. This God has serial attention (does only one thing at a time), a particular location, and a particular viewpoint.[67] Now that we know about the interpreter, why doesn't that surprise us?

Boyer says religions seem "natural" because "a variety of mental systems, functionally specialized for the treatment of particular (non-religious) domains of information, are activated by religious notions and norms, in such a way that these notions and norms become highly salient, easy to acquire, easy to remember and communicate, as well as intuitively plausible."[68] Let's look at our list of the moral intuitions and see how different aspects of religions can be seen as by-products of them.

SUFFERING

That one is easy. Many religions speak to the relief of suffering, or wallow in it, or even seek to ignore it.

RECIPROCITY

Easy again. Many natural and personal disasters are explained as God's or the gods' payback for bad behavior, that is, punishing cheaters. Also, the social exchange is ubiquitous in religion: "If you kill a bunch of innocent infidels, then you will go to paradise and have seventy virgins at your beck and call." Does that work for women, too? Or "If you renounce all physical desires, then you will be happy." Or "If I do this rain dance perfectly, then it will rain." Or "If you cure my disease, then I will never do such and such again."

HIERARCHY

Easy again. We can look at status. The person with the (appearance) of the highest morals is given higher status and more trust. Gandhi was known to have been quite successful with the women (status). Popes ruled vast stretches of Europe at one time (status, power, hierarchy). And how about the Ayatollah? Many religions are set up with a hierarchical structure; the most obvious is the Catholic Church, but it is not alone. Many Protestant religions, Islam, and Judaism all have hierarchical structures. Even in primitive societies, the witch doctors held places of esteem and power in their communities. The Greek, Roman, and Norse gods also had hierarchical structures, as do the Hindu gods. God is the big cheese, or there is a top god, like Zeus or Thor. You get the picture. The virtues of respect, loyalty, and obedience all morph over onto religious beliefs.

COALITIONS AND IN-GROUP/OUT-GROUP BIAS

Does anyone really need this spelled out? As in "My religion is right (in-group); your religion is wrong (out-group)"—just like soccer teams. Reli-

gion in its positive in-group form does create a community whose members help each other, as do many social groups, but in its extreme form it has been responsible for much of the killing in the history of the world. Even Buddhists are divided into rival sects.

PURITY

This too is obvious. "Uncontaminated food is good" has led to many religious food rituals and prohibitions. "Uncontaminated body is good" has led to certain sexual practices, or sex itself, being viewed as dirty and impure. How many primitive religions used virgins for sacrifice? We can start with the Aztecs and Incas and build. Women who have been raped are considered impure by the Muslim religion and are regularly murdered by their male relatives in the practice of "honor killing," a twisted combination of the purity and hierarchy modules. Buddhism has its "pure land" where all who call upon the Buddha will be guaranteed rebirth.

Has religion provided a survival advantage? Has it been selected for by evolution? Attempts to prove this have not been satisfactory because no one single characteristic has been found that generates religion, as we can see from Boyer's table. Natural selection, however, has been at work on the mental systems that religion uses or, as some think, parasitizes. Religions can be thought of as giant social groups with strong coalitions, often with hierarchical structures, and reciprocity based on notions of purity either of body, mind, or both. Giant social groups can have a survival advantage, whether they are based on religion or not. Ideology can strengthen coalitionary bonds, and that in itself can increase group survival. So are religions examples of group selection? This is a highly controversial question. D. S. Wilson points out that more is known about the evolution of the spots on a guppy than is known about the elements of religion.[69] This is a work in progress.

Can understanding how morality and religion came to be help us today? If we understand that our brain is a machine for hunter-gatherers in small groups, full of intuitive modules that react in certain ways, that it is not yet molded for huge societies, can that allow us to function better in our current world? It seems it can. Matt Ridley[70] gives the example

caused by the phenomenon known as the "tragedy of the commons," which was unfortunately misnamed by Garrett Hardin, a biologist. He apparently did not distinguish between open-access free-for-alls and communally owned property. The phenomenon should have been named the "tragedy of the free-for-alls." Land that is free for all is subject to cheaters in social exchange. An individual would think, "If everyone can fish, hunt, and graze livestock on this land, then I should get as much as I can now, because if I don't, someone else will, and there will be none left for me and my family."

However, Hardin used grazing commons as his free-for-all example. What he didn't know was that most grazing commons were not free-for-alls. They were carefully regulated community property. Ridley points out that free-for-alls and regulated commons are two very different things. "Carefully regulated" means that each member owns a right to something, such as fishing in a particular area, grazing a set number of animals, or having specific areas to graze. Now it is in the owner's interest to maintain that area, which makes it possible to set up a long-term social exchange: "If I graze only ten sheep and you graze only ten sheep, then we will not overgraze the common, and it will sustain us for a long period." Cheating no longer becomes attractive.

Unfortunately, this misunderstanding of what was happening in much communal property led many economists and environmentalists in the 1970s to conclude that the only way to solve the cheating problem (which didn't even exist in many communal setups) was to nationalize communal property. Instead of several patches of communally managed lands, one huge government-managed patch was created. This has resulted in fisheries being overfished, land being overgrazed, and wildlife being overhunted, because the fisheries, land, and wildlife became a free-for-all on a grand scale. There were not enough enforcers to detect the cheaters, and only fools wouldn't take all they could while they could.

Ridley explains that this has been a disaster for the wildlife of Africa, where most countries nationalized their lands in the 1960s and 1970s. The wildlife was now owned by the government, and although it still did the same damage to crops and competed for grazing, it was no longer a source of food or revenue—except for poachers. There was no motiva-

tion to protect it and every motivation to get rid of it. Officials in Zimbabwe, however, realized what was happening. They gave ownership of the wildlife back to the communities, and presto, the attitudes of the locals toward wildlife changed, and the animals became valuable and worth maintaining. The amount of private land owned by the villagers now devoted to wildlife has doubled.[70]

Elinor Ostrom, a political scientist who has studied well-managed local commons for years, has shown in the laboratory that groups, when allowed to communicate and develop their own methods of fining free riders, can manage communal resources almost perfectly.[71] And it turns out that those things that can be managed are those things that can be owned. We are territorial, just like chimps and many other animals. Thus, understanding our intuitive reciprocity and its constraints, and the fact that we are most comfortable in smallish groups, can lead to better management practices, better laws, and better governments. This is just like understanding that the plant you bought that came from the desert should not be watered as if it came from the tropics.

DO ANIMALS HAVE A MORAL SENSE?

Now this is an interesting question. Of course when we humans ask it, we are asking it from our own perspective, and the implied question is really Do animals have a moral sense *like ours*? I have just presented the case that many stimuli induce an automatic process of approval (approach) or disapproval (avoid), which may lead to a full-on emotional state. The emotional state produces a moral intuition that may motivate an individual to action. These moral intuitions have sprung from common behaviors we share with other social species, such as being territorial; having dominance strategies to protect territory; forming coalitions to garner food, space, and sex; and reciprocity. We share some aspects of this chain of events with other social species, and in fact we have the same emotional reactions, which we term moral, to some of the same inciting stimuli. We get angry at property violations or attacks on our coalition, just as chimps and dogs do. So in that sense, some animals have an

intuitive morality that is species-based, centered on their own social hierarchies and behaviors, and affected by the emotions that they possess.

The differences lie in the wider range and complexity of moral emotions that humans have, such as shame, guilt, embarrassment, disgust, contempt, empathy, and compassion, and in the behaviors these have contributed to. The most notable of these behaviors is prolonged reciprocal altruism, of which humans are the undisputed grand masters, but humans can also indulge in altruism and expect no reciprocity. I know that all you dog owners are now going to tell me that your dog feels shame when you walk into the house and see that he has just chewed your new shoes. But to feel shame, embarrassment, or guilt, which Haidt calls the self-conscious emotions, an animal must have self-awareness beyond recognizing his visible body and be conscious of that self-awareness. We are going to talk more about self-awareness and consciousness in chapter 8, but the short version for now is that the presence of this expanded sense of self in other animals has yet to be discovered. Your scowl at the sight of the gnawed Guccis and your terse comment are what your dog is reacting to. The alpha animal is angry. The moral emotions of shame and embarrassment have their animal roots in submissive behavior but have become more complex. You recognize this submissive cowering in your dog and call it shame, but that is a more complex emotion than it is feeling. Its emotion is fear of a swat or of getting dragged off the couch, not guilt or shame.

But in humans there is something going on in addition to more complex emotions and their repercussions: the post hoc need to interpret the moral judgment or behavior. The human brain alone seeks an explanation for the automatic reaction that it has no clue about. This is the unique interpretive function of the human brain in action. I suspect that this is also the point where humans put a value judgment on their actions: good behavior or bad. To what degree the value judgment may match the emotional approach/withdraw scale is an interesting question. There are the occasions, however, when the rational self becomes an earlier participant in the judgment and informs the behavior. We humans can inhibit our emotionally driven responses. Then the conscious, self-aware mind steps in, bellies up to the bar, and takes command. That is a uniquely human moment.

CONCLUSION

David Hume and Immanuel Kant were both right in a way. As the neurobiology of moral behavior becomes fleshed out, we shall see that some of our repugnance for killing, stealing, incest, and dozens of other actions is as much a result of our natural biology as are our sexual organs. At the same time, we will also realize that the thousands of customs that people generate to live in cooperation with each other are rules generated by the thousands of social interactions we have every day, week, month, and year of our lives. And all of this comes from (and for) the human mind and brain.

One could say most of our life is spent battling the conscious rational mind and the unconscious emotional system of our brain. At one level, we know that by experience. In politics, a good outcome happens when the rational choice is consonant with the emotions of the time. A lousy political decision occurs when a rational choice is made at a time when the emotions of the populace are at odds with the projected outcome. On a personal level, it can go a different way. A poor personal decision can be the product of a powerful emotion overriding a simple rational directive. For all of us, this battle is continuing and never seems to go away.

It is as if we are not yet comfortable with our rational, analytic mind. In terms of evolution, it is a new ability that we humans have recently come upon, and we appear to use sparingly. But, using our rational mind, we have come across other uniquely human traits: the emotion of disgust and a sensitivity to contamination, the moral emotions of guilt, shame, and embarassment, blushing, and crying. We have also found that religions are large social groups that have their foundation in the notion of purity of either mind or body, another uniquely human construct with its roots in the moral emotion of disgust. And the know-it-all interpreter is there, coming up with explanations for our unconscious moral intuitions and behaviors. And we have our analytical brain occasionally chiming in. Not only that, there is even more going on that we aren't conscious of. Stay tuned. . . .

Chapter 5

I FEEL
YOUR PAIN

If my heart could do my thinking, would my brain begin to
feel?

—*Van Morrison*

WHEN YOU SEE ME SMASH MY FINGER IN A CAR DOOR, DO
you wince as if it happened to you? How do you know the milk your
wife just sniffed is bad without her saying anything? Do you know
how a finalist for the women's gold medal gymnastic competition
feels when you see her miss a landing on the balance beam, fall, and
break her ankle? How is that different from when you see a mugger
running from his victim, trip in a pothole, fall down, and break *his*
ankle? Why can you read a novel and feel emotions engendered by
the story? They are just words on a page. Why can a travel brochure
make you smile?

If you can come up with some reasonable answers that satisfy you,
consider this one last phenomenon. Patient X, who has suffered a stroke,
has this condition. His eyes can still take in visual stimuli, but the pri-
mary part of his visual cortex has been destroyed. He is blind. He cannot
even distinguish light from dark. You can show him pictures of circles or
squares, or ask him to distinguish between photos of men or women, and
he has no idea what is in front of him. You can show him snarling animal
faces or calm animal faces, and he has nothing to say, but if you show him
pictures of angry or happy human faces, he, like some other patients with

this kind of brain lesion, can guess what the emotions are.[1] He has what has come to be called *blindsight*.

How do we recognize the emotional states of others? Is it a conscious appraisal, or is it automatic? There are a few schools of thought about this. One school holds that an individual uses her own version of psychology, which is either innate or learned, and infers the mental state of others from how they are acting and what they are doing, where they are and whom they are with, and how they have been in the past. This is called *theory theory*. The other school holds that one infers another's emotional state by deliberately and voluntarily attempting to simulate or replicate it in one's own mind—first pretending to be in the other's situation and seeing how that feels, then feeding that information to the decision-making process, and ending up with what one thinks the other is feeling. This is called *simulation theory*.[2] Both of these theories are volitional. You actually decide to evaluate the other's emotional state. Neither of them can explain patient X's ability to determine emotions.

In another form of the simulation theory, the simulation is not deliberate and voluntary but automatic and involuntary.[3] In other words, it just happens without your control or rational input. You perceive an emotional stimulus through your senses, and your body automatically responds to it by simulating the emotion, which your conscious mind can either recognize or not. This could help us explain patient X. And of course there is the combo theory, which is part theory theory and part simulation theory, part automatic and part volitional. A lot of the controversy, as usual, seems to be about how much is automatic, or voluntary, or a learned response. Because our social interactions are vastly important to being human, and because recognizing the states of mind, emotions, and intentions of others is necessary to interact, how this all comes about is extremely intriguing as well as controversial.

There is also the question of empathy, and understanding why some individuals use it selectively or lack it altogether. Other social animals share at least some of our capabilities, but is there something unique going on in our brains that allows us to have more complex interactions? Much evidence is accumulating that we automatically simulate the internal experiences of others, and that this simulation contributes to empathy and theory of mind. Is it all automatic, or does the conscious

brain contribute to such evaluations? Let's see what has been discovered so far.

VOLUNTARY SIMULATION: PHYSICAL IMITATION

About thirty years ago, the field of child development got a shock. Up until that time, it had been thought that when babies imitate a motor movement, it was *learned*. The theory was that the visual perception of a movement and the execution of the imitative movement by the motor system were independent of each other and controlled by different parts of the brain. Then a study of imitative behavior of young infants done by University of Washington psychologists Andrew Meltzoff and M. Keith Moore suggested perhaps the visual perception of a motor movement (such as tongue protrusion or lip smacking) and the production of the movement (actually copying the movement) were not separately acquired abilities but were linked somehow.[4] Since then, many independent studies[5] have shown that newborns from the age of forty-two minutes to seventy-two hours can imitate facial expressions accurately.[6, 7]

Think about it. One can only be amazed what the brain is doing when it is less than one hour old. It sees there is a face with a tongue sticking out, somehow knows it too has a face with a tongue under its command, decides it will imitate the action, finds the tongue in its long list of body parts, gives it a little test run, commands it to be stuck out—and out it goes. How does she know a tongue is a tongue? How does she know what neural system is in charge of the tongue, and how does she know how to move it? Why does she even bother doing it? Obviously, it was not learned by looking in a mirror, nor had anyone taught it to her. *The ability to imitate must be innate*.[8]

Imitation is the beginning of a baby's social interaction. Babies will imitate human actions, but not those of objects; they understand they are like other people.[9] The brain has specific neural circuits for identifying biological motion and inanimate object motion, along with specific circuits to identify faces and facial movement.[10] What can a baby do to enter the social world before it can sit up or control its head or talk? How

can she engage another person and form a social link? When you first hold a baby, what links her to you and you to her are her imitative actions. You stick out your tongue, she sticks out her tongue; you purse your lips, she purses her lips. She doesn't lie there like an object but responds in a way that you can relate to. In fact it has been shown that infants use imitation games to check the identity of persons, and do not use only their facial features.[11, 12]

After about three months of age, this type of imitation can no longer be elicited. Imitative abilities then develop that show that the infant understands the meaning of what is being copied: The imitative movements don't have to be exact but are directed toward a goal. The infant puts the sand in the bucket, but the fingers on the shovel don't have to be held in exactly the same way as the fingers of the person showing her how to use the shovel; the goal is getting the sand in the bucket. We have all seen how young children play when they are together, so it comes as no surprise that children aged eighteen to thirty months use imitation in their social exchanges, take turns between being the imitator and the imitatee, share topics, and in short, use imitation as communication.[13] Imitating others is a potent mechanism in learning and acculturation.[14]

Voluntary behavior imitation appears to be rare in the animal kingdom. No evidence of voluntary imitation by monkeys, regardless of how many years they have been trained,[15, 16] has been reported, except in one study in which imitative behavior was elicited in two Japanese monkeys who were so highly trained that they had learned to follow the eye gaze of a human.[17] So much for "monkey see, monkey do." To what extent voluntary imitation exists in other animals is controversial. It depends on the definition of imitation and how many other factors are involved, a few of which are whether the imitation is goal directed, exact, motivated, social, or learned.[18] It appears to exist to some degree in the great apes and some birds, and there is some evidence that it is present in cetaceans.[19] The fact that many people are watching for and testing for imitation in the animal world but have found little evidence of it, and the fact that when it has been found, it has been of limited scope, indicate that the ubiquitous and extensive imitation in the human world is very different.

INVOLUNTARY PHYSICAL IMITATION: MIMICRY

There is a difference between active imitation and what is known as mimicry, which is *nonconscious* imitation. In the last chapter, we learned a bit about nonconscious mimicry from the research done by John Bargh at New York University. People will unconsciously copy mannerisms of others, and not only will they not know they are doing it, but they will not consciously realize the other person even has a mannerism they could be mimicking. That is not all. We are virtual mimicking machines! People will not only mimic mannerisms but also unconsciously mimic the facial expressions, postures, vocal intonations, accents,[20] and even speech patterns and words of others.[21] How often have you noticed when you telephone a friend that their relative or their roommate who answers the phone sounds like your friend? Or how about all those married couples who start looking alike?

Our faces are our most prominent social feature, and they reflect our emotional states, but they also react to the emotional states of others. This can happen so fast that you are not aware of either the other person's expression or that you have had a reaction. In one experiment, subjects were shown thirty-millisecond exposures of happy, neutral, and angry faces. This is too fast for them to consciously realize that a face was seen. This image was immediately followed by pictures of neutral faces. Even though the exposure to happy and angry faces was unconscious, the subjects reacted with distinct facial muscle reactions that corresponded to the happy and angry faces. Their facial muscular activity was measured by electromyography. Both positive and negative emotional reactions were unconsciously evoked; this demonstrates that some emotional face-to-face communication occurs on an unconscious level.[22]

People will also mimic body movements during conversation. One researcher videotaped a series of sessions in which she told a group of subjects about how she had to duck to avoid being run into at a party and demonstrated by ducking to the right. The video revealed that as they were listening, the listeners mimicked her movements and had strongly tended to duck to the left—the mirror image of her movement.[23] Have

you ever noticed that your own speech pattern may change when you are visiting different parts of the country or other countries? Partners in conversations will tend to match each other in rhythm of speech, length of pauses, and likelihood of breaking silences.[24] All this is going on without your consciously willing it to happen. What's the point?

All this mimicking behavior greases the machinery of social interactions. Unconsciously, deep down in that automatic part of your brain, you form connections with, and you like, other people who are similar to you. Think how often you have said, "I liked her the second I met her!" or, "Just looking at him gave me the creeps!" Mimicry increases positive social behavior. Rick Van Baaren and colleagues at the University of Amsterdam have shown that individuals who have been mimicked are more helpful and generous not only toward their mimicker but also toward other people present than are nonmimicked individuals.[25] Thus, when you mimic someone, it becomes more likely that this person will behave positively not only toward you but also toward other people around you, by fostering empathy, liking, and smooth interactions.[26] This binding of people together through enhancing prosocial behavior may have adaptive value by acting as social glue that holds the group together[25] and fosters safety in numbers. These behavioral consequences provide suggestive support for an evolutionary explanation of mimicry.

However, it is difficult to *consciously* mimic someone. Once we resort to conscious voluntary imitative behavior, we are just too slow. The whole conscious pathway takes too long. Muhammad Ali, whose motto was "Float like a butterfly, sting like a bee," and who moved about as fast as anyone, took a minimum of 190 milliseconds to detect a light flash and another 40 milliseconds to begin his punch. In contrast, one study found that it took college students only 21 milliseconds to synchronize their movements unconsciously.[27] Consciously trying to mimic someone usually backfires, looks phony, and throws the communication out of sync.

A few years back, Charlotte Smylie and I were able to work out which hemispheres of the brain are involved in voluntary and involuntary commands.[28] Testing split-brain patients, we showed that while both hemispheres can respond to involuntary responses, only the left hemisphere can carry out voluntary responses. In addition, the left hemisphere uses

two different neurological systems to carry out the voluntary, as opposed to the involuntary, responses. This is abundantly apparent when studying Parkinson's disease. This disease strikes the neurological system that controls the involuntary spontaneous facial responses. As a result, people suffering from Parkinson's disease don't show the normal facial reactions when engaged in social interactions. They might actually be having a good time, but because of their "mask," no one knows it. Parkinson's patients talk about this with great despair.

This tells us that physical *action*, such as mimicking facial expressions, is closely linked to the visual *perception* of the face, and happens so quickly and automatically that it seems there must be some closely linked neuronal pathways. But what is behind the action? There is a smile or a sneer, but what does that imply? Does the other person actually feel the emotion of the mimicked facial expression? Does this mimicry help us figure that out?

EMOTIONAL MIMICRY?

If nonconscious automatic mimicry occurs with physical actions, does the same thing happen when observing emotional states? When I cut my finger, do you automatically copy how I am feeling and wince, or do you consciously reason it out? How about that shiver that you get up your spine? Do you consciously produce that, or is it an automatic response? If we automatically mimic a sad face (merely the physical action), do we actually feel sad, too? If we do feel the emotion, which comes first, the facial expression or the emotion? If we sense the emotion of the other, such as feeling sad, is it automatic? Or once we have the automatic sad face, do we consciously say to ourselves, "Gee, I seem to have this expression on my face that I remember I've had when I felt sad, and Sam has the same dang expression on his face, so I guess he must feel sad. I remember the last time I felt sad, and I didn't like that feeling and I bet he doesn't, either. Poor guy."

Do we consciously or unconsciously simulate the emotional states of others? If so, how do we do it, and how do we recognize which emotion it is? We need to be a bit careful here. I just casually threw in a word in

the last paragraph that I wonder if you even noticed: *feeling*. Antonio Damasio has made a point of separating the definitions of *emotion* and *feeling*. He defines a feeling as " the perception of a certain state of the body (the emotion) along with the perception of a certain mode of thinking and of thoughts with certain themes." Your body can respond to a stimulus with an automatic emotion, but not until your conscious brain recognizes it can you say you have a feeling. He emphasizes the point that the emotion is what causes the feeling, not the other way around. This is contrary to the way most people think the brain works.[29]

EMOTIONAL CONTAGION

Let's start with babies. How about when you go to the newborn nursery and all the babies are crying at once? Can it be that all of them are hungry and wet at the exact same time? No, not with all those nurses running around. Studies with newborns have shown that when they are exposed to the crying of another infant, a distress response is induced, and they will join in. However, when they hear their own cry that has been tape-recorded and played to them, or the cries of a baby several months older than they, or other random loud noises, a distress response is not induced, and they don't cry. The fact that babies are able to discriminate between their own cry and other infants' cries suggests that they have some innate understanding of the difference between themselves and others.[30, 31]

Is this a rudimentary expression of *emotional contagion*? That is the tendency to *automatically* mimic facial expressions, vocalizations, postures, and movements of another person and consequently to *converge emotionally* with them.[27] It certainly seems to be, because if it were just a response to crying or loud noises in general, the newborn should cry even when he hears his own recorded cries, not just the cries of others. It also does not support theory theory, because then we would have to suppose the baby is thinking like this: "Aidan, Liam, and Seamus are crying in the bassinets all around me, and I know when I cry it is because I am hungry, wet, or thirsty, which, of course, is uncomfortable. Well, I feel fine, though. My diapers are dry, I just ate, and I am ready for

a snooze. But those guys must be miserable, just listen to them. I think I'll show a little baby solidarity and make a stink too." Perhaps a bit too sophisticated for a three-hour-old, who has not yet developed the ability to consciously recognize that others have separate beliefs and emotions.

Now consider this situation: You are laughing with a friend when the phone rings and she answers it. You are feeling great, you're sitting in the warm spring sun enjoying a steamy cappuccino, but now you look over at your friend's face, and you know something is dreadfully wrong. In a second, you no longer feel great, but anxious. You have caught her mood in a single glance.

An interesting experiment done by Roland Neumann and Fritz Strack, psychologists at the University of Würzburg, Germany, demonstrates mood contagion. They were interested in finding out if a person who had no social motivation to interact with another person would still take on his mood. They also wanted to know if this was automatic or a result of taking the perspective of another. In order to figure this out, they had subjects listen to a tape recording of a rather dry philosophical text being read by an unknown person in a happy, sad, or neutral voice. Meanwhile, they also gave their research subjects a small physical task to do while they were listening. This was to divert their attention from the actual meaning of what was being read and the emotionality of the voice, so that wouldn't influence them. Then they were asked to read the same text out loud while they themselves were taped. The subjects not only automatically mimicked the tone of voice of the other person—happy, sad, or neutral—but what was even more interesting, they also took on the *mood* of the mimicked voice. They were also completely unable to recognize why they felt the way they did, and they hadn't realized that the voice they were mimicking had been happy or sad.[32] So although there never was nor would be an actual social interaction, and the text that they were reading was not emotionally charged, and their attention to its content had been diverted, they still automatically mimicked the vocal tone and felt the same mood as the voice had indicated the reader was feeling.

These researchers define an emotion as having two components—a mood, and knowledge of why the mood is being felt. Mood is defined as the experience component itself, without the knowledge.

Neumann and Strack then did one further experiment. Up until this point, they had diverted the attention of the subject so that she had not noticed that the person whose voice she had been listening to had expressed an emotion. In this last experiment, they asked half of the subjects to adopt the perspective of the reader, with the idea that the subject would then *consciously* recognize the emotional component of the voice. Afterward, the subjects who had been directed to take the reader's perspective were able to identify that they had *felt* the emotion of sadness or happiness.

Infants Take On the Mood of Their Mothers

Babies are affected by their depressed mothers. Studies of infant-mother pairs reveal that depressed mothers typically show flat affect, provide less stimulation, and respond less appropriately to their infant's actions. Their infants are less attentive, have fewer contented expressions, and are more fussy and less active[33, 34] than babies with mothers who are not depressed. These infants are physiologically aroused by interactions with their depressed mothers: They have stress reactions, which are revealed by elevated heart rate and cortisol levels.[35] They also appear to have a depressed mood, despite differences in the way their depressed mothers treated them.[36] Unfortunately, these interactions can have long-term effects on these children.

Of course, the phenomenon of mood contagion should not come as a complete surprise to us. We come out of the grocery store laughing and feeling good after listening to the banter of a funny cashier, or when a smiling stranger nods at us. Living with a depressed roommate or family member puts a cloud on the whole household. One depressed, angry, or negative dinner guest can ruin a party, whereas a group of simpatico guests will spell its success. Moods are subtle and can be affected by a word or a painting or music. With knowledge about mood contagion, we can increase the frequency of good moods by putting ourselves in places "infected" with good moods so we can catch them! Such places include comedy clubs, bustling restaurants, funny movies, parks with kids having fun and laughing, colorful rooms, and outdoor locales with beautiful scenery. So moods and emotions appear to be

automatically contagious. What is going on in the brain to make this happen?

Neural Mechanisms for Emotional Contagion?

Let's see if we can find out from neuroimaging studies how and why emotional contagion happens. Two emotional states that have been well studied in humans are disgust and pain—"yuck and ouch." These sound like excellent material for what we are interested in. Good thing there are psychology students! ("Hi, I'd like to volunteer for the disgusting experiment or, if that one is full, how about the pain one?")

One group of volunteers watched a film of someone sniffing different fragrances, either disgusting ones, pleasant ones, or neutral ones, while their brain was being scanned with fMRI. Then they each had their turn at sniffing the same range of fragrances. It turned out that the same areas of the brain, the left anterior insula and the right anterior cingulate cortex, were automatically activated, both during the observation of disgusted facial expressions in the video and while experiencing the emotion of disgust evoked by the unpleasant fragrance. This suggests that the understanding of the facial expressions of disgust in someone else involves the activation of the same part of the brain that normally is activated during the experience of that same emotion.

The insula is busy in other ways, too. It also responds to gustatory stimulation: not just disgusting fragrances but disgusting tastes. Electrically stimulating the anterior insula during neurosurgery results in nausea or the sensation of being about to vomit,[37] visceromotor activity (that queasy feeling you get), and unpleasant sensations in the throat and mouth.[38] So the anterior insula participates in transforming unpleasant sensory input, whether it is actual perception of the disgusting odor or flavor or merely observing someone else's facial reaction, into visceromotor reactions and the accompanying physical feeling one gets with the emotion of disgust.

So, at least for disgust, there is a common area in the brain that is activated for visually seeing the facial expression of the emotion in someone else, for one's own visceral response, and for feeling the emotion[39]—a tidy little brain package. The expression of disgust that you see on your

wife's face when she sniffs the sour milk activates your own disgust emotion. Luckily, you don't need to sniff it yourself. Obviously this has an evolutionary advantage. Your companion takes a bite of the rotting gazelle carcass and makes the disgust face. Now you don't have to test it. Interestingly, the same did not hold true for the pleasant fragrance. Pleasant fragrances activate the posterior right insula only, and we know we don't get the same visceromotor response.

Pain also appears to be a shared experience. In the movie *Marathon Man*, we all cringed at the dental torture scene. In our brains, there is an area that responds to both the observation of pain and the experience of pain. Volunteer couples were scanned with fMRI while one was being given a painful shock to the hand and the other was an observer. There are anatomical connections between regions that make up the pain system in the brain; these do not function independently but are highly interactive. However, there appears to be a separation between the sensory ("that hurts!") and emotional perceptions of pain, such as its anticipation and the anxiety that it produces ("I know it's going to hurt, oh, hurry up and get it over with, ohhh, when is it going to happen?"). What the scans showed was that *both* the observer and the recipient of pain had activity in the part of the brain that is active with the *emotional perception* of pain,* but only the recipient had activity in the area that is active with the sensory experience,†[40] which is a good thing. You wouldn't want the paramedic himself to need to be anesthetized while he was stabilizing your broken femur, but you do want him to be gentle with your painful leg: You want him to realize it hurts but not to feel it himself to the point of inaction.

Clearly, whether you anticipate the pain for yourself or another, the same area in the brain is used. Looking at pictures of humans in painful situations also activates brain activity in the area that is active in the emotional appraisal of pain,‡ but not the area that is active with the

*The rostral anterior cingulate cortex, the bilateral anterior insula, the brain stem, and the cerebellum.

†The posterior insula, the secondary somatosensory cortex, the sensorimotor cortex, and the caudal anterior cingulate.

‡The anterior cingulate, the anterior insula, the cerebellum, and to a lesser extent the thalamus.

actual sensation of pain.[41] There is evidence the same neurons mediate the emotional appraisal of both personal and vicarious pain. In rare cases, patients who have had portions of their cingulate removed have had testing of neurons under local anesthesia with microelectrodes. This has shown that the same neuron in the anterior cingulate fired upon experiencing a painful stimulus and also while anticipating or observing one.[42] This indicates that the observation of an emotion in someone else can result in brain activity that matches the experience of the emotion, to a certain degree, automatically.

These findings have very interesting implications for the emotion of empathy. Without going into a long discussion of the definition of empathy, we can at least agree that it implies being able to detect accurately the emotional information being transmitted by another person, being conscious of it, *and caring about it*. To care about another's state is an altruistic behavior, but it cannot occur without good information. If I cannot accurately detect your emotion, if I think that you are disgusted when in fact you are in pain, I will react to you inappropriately, perhaps handing you a Compazine suppository instead of Advil.

Tania Singer and colleagues at the University College London, who did the pain research with the couples, wondered, as you may too, if observers who had higher pain-related brain activity were more empathetic. So they gave the couples a standardized test that rates emotional empathy and empathetic concern. Indeed, the individuals who scored higher on general empathy scales did show stronger brain activity in the portions of the brain that were active when they perceived their partner as being in pain. There was also a correlation between how empathetic one rated oneself and how much activity there was in the anterior rostral zone of the cingulate, an area near the center of the brain. Also in the second study, when people looked at pictures of painful situations, the activity in the anterior cingulate was strongly correlated with their ratings of the others' pain. The more activity, the higher they rated the pain, suggesting that the activity of this brain region varies according to subjects' reactivity to the pain of others.

The work on disgust and pain suggests that the simulation of these emotions is automatic. The question remains whether the simulation of the emotion comes first and then the automatic physical mimicry follows,

or the automatic mimicry is followed by the emotion. When you see your wife's face after she sniffs the sour milk, do you automatically copy her expression, and then feel the disgust, or do you see her facial expression of disgust, feel disgust yourself, and then automatically make the disgust face? The chicken-and-egg problem continues to be unresolved in this particular case.

PHYSIOLOGICAL SIMULATION

When you feel a negative emotion, such as fear, anger, or pain, you also get a physiological response, just as babies have a stress response to hearing other newborns crying or when interacting with a depressed mother. Your heart races and you may sweat or get the shiver up your back, and so forth. In fact, you get a different set of physiological responses with each different emotion.[43, 44] They are emotion-specific. Would your physiological response to an observed situation be able to predict how accurately you interpreted the emotion of the other person? If your physiological response were more similar to the other person's, would you be better at judging her emotion?

That is what Robert Levenson and colleagues at the University of California, Berkeley, demonstrated happens for negative emotions. They measured five physiological variables* in subjects as they watched four separate videotaped conversations between married couples. These same measurements had been taken of the couples as they were having the conversations. Throughout the conversations, the subjects assessed what they thought the husband or the wife was feeling. The subjects whose autonomic physiological responses more closely simulated those of the person they were observing did indeed interpret his or her *negative* emotions more accurately. This did not hold true for positive emotions. These results suggest a relation between physiological linkage (how closely one simulates the physiological response) and rating accuracy for negative emotions. The researchers suggest that empathetic subjects (i.e.,

*Heart rate, skin conductance, pulse transmission time to the finger, finger pulse amplitude, and somatic activity.

those who are most accurate in rating the negative emotions of targets) would be most likely to experience the same negative emotions. These negative emotions would produce similar patterns of autonomic activation in both subject and target, thus resulting in high levels of physiological linkage.[45] The other question this presents is, "Do people who are more sensitive to their physiological responses have more intense emotional feelings? If I am acutely aware (conscious) that my heart is beating faster and I am sweating, am I more anxious or scared than someone who doesn't notice? If I pay more *attention* to my physiological responses, am I more empathetic to others?"

Hugo Critchley and colleagues at Brighton and Sussex Medical School, England, provided the answer to this question and also found out a little bonus information.[46] They gave a group of people a questionnaire that rated symptoms of anxiety, depression, and positive and negative emotional experience. None of the subjects scored in the range necessary for a diagnosis of either depression or anxiety. Then they were scanned with fMRI while judging whether an auditory feedback signal, a repeated musical note, was synchronous with their heartbeat or not. This measured their *attention* to a physiological process—their heartbeat. They were also asked to listen to a series of notes and distinguish which one was a different tone. This was to test their *perception,* how well they could distinguish differences in sensory input. This separates how intensely one feels a pain (perception) from how intensely one focuses on it (attention).

The researchers also measured the size of the activated brain regions. They found that activity in the right anterior insular and opercular cortex predicted subjects' accuracy in detecting (attention) their heartbeat. And the size of that particular portion of the brain itself mattered! The larger it was, the more accurate the person was at detecting their internal physiological state, and these same people also had higher self-ratings of body awareness. However, not everyone who had rated themselves high in body awareness was actually good at detecting their heartbeat. This was that old problem of people thinking they are better at something than they are. With one exception, those who were actually good at detecting their heartbeat were only those with a greater volume of that particular brain area: big right anterior insula, more body self-awareness,

more empathy. The exception was that subjects who had scored higher in past negative emotional experiences also had increased accuracy in detecting their heartbeat.

These findings indicate that the right anterior insula is involved with visceral responses that can be recognized (which we already learned from the disgust experiments) and that recognizing these responses can lead to subjective feelings. Some people are better at recognizing these internal signals than others. Some people are just born that way with a larger insula, but also some have acquired the ability by having had more negative experiences in their past. These results may explain why some people are more aware of their feelings than others.[47]

PAIRED DEFICITS

The above findings, coupled with the findings that increased neural activity associated with the emotional component of pain increases empathy, make one wonder: If one can't feel an emotion (no brain activity, no physiological response), can one recognize it in someone else? This questions one of the main tenets of simulation theory—that we simulate the other person's state of mind and then, from our own personal experience of that state of mind, we predict how the other is feeling or what his behavior will be. Is this true? Are there paired deficits? If a person has a lesion in their insula, do they neither feel nor recognize disgust? If nothing disgusts me, can I recognize disgust in you? What if there is a lesion in the amygdala, what does that do? If we look at people who have a brain lesion that affects a particular emotion, does it change their ability to detect that emotion in another?

These paired deficits have indeed been shown to exist. Andrew Calder and colleagues at Cambridge University tested a patient with Huntington's disease who had damage to his insula and putamen. They hypothesized that because the insula has been shown in neuroimaging studies to be involved with the emotion of disgust, their patient should be limited in his ability to recognize disgust in others and also should have less of a disgust reaction himself. This turned out to be true. He didn't recognize disgust from facial signals or from verbal signals, such

as retching, and he was less disgusted than controls by disgust-provoking scenarios.[48]

Ralph Adolphs and colleagues at Caltech and the University of Iowa had a patient with a rare bilateral insula lesion. He was unable to recognize disgust in facial expressions, actions, descriptions of actions, or pictures of disgusting things. When he was told a story about a person vomiting, then asked how that person would feel, he said they would be "hungry" and "delighted." After observing someone act out vomiting unpalatable food, he said, "Delicious food was being enjoyed." He could not recognize disgust in others, nor did he appear to feel the emotion of disgust. He is reported to eat indiscriminately, including items that are not edible, and he "fails to show any disgust to food-related stimuli, such as pictures of food covered with cockroaches."[49] Remember from the last chapter that disgust appears to be a uniquely human emotion.

Now back to the amygdala. We just learned that the amygdala is part of the pain system, but we have seen in a previous chapter that it is also concerned with fear. Adolphs and his team have found that people with *right* hemisphere lesions to their amygdala have impaired recognition of various negative facial expressions, including fear, anger, and sadness, but people with lesions to the *left* hemisphere amygdala are able to recognize these expressions. Amygdala lesions did not affect the ability to recognize happy expressions.[50] Patients with bilateral lesions of the amygdala (although it is the damage to the right side that is causing the problem) appear to have selective impairment in interpreting fearful expressions.[50, 51, 52] In a group of nine patients with bilateral amygdala damage (there are very few people with lesions like this), although they intellectually understood what should be a frightening situation (a car coming at them, confronting a violent person, illness and death), they could not recognize fear in the facial expressions of others.[53] In a different study, a patient with bilateral amygdala damage did not recognize fear in the facial expressions, emotional sounds, or posture of others. His own everyday experience of both the emotions of anger (an emotion he had no problem in recognizing in others) and fear were reduced, compared with neurologically normal controls. His low fear level allowed him to engage in such activities as jaguar hunting in the Amazon River basin and hunting while hanging from a helicopter in Siberia.[54] These

patients have shown us that not perceiving the emotion and not feeling the emotion are linked, and they suggest that a neural lesion preventing one from feeling or simulating an emotion may also prevent one from recognizing it in others.

And what about patient X, the blind stroke victim who can guess emotional facial expressions? When he was scanned with fMRI while doing so, his right amygdala became active.[1] Remember when we learned about the fast-track pathway for fear, whereby incoming information goes to the thalamus and then straight to the amygdala? That is what is happening with patient X. The visual stimuli can still go to the amygdala even if the connection to the visual cortex has been disrupted, and the amygdala still does its job. The amygdala is not connected to the speech center. It does not tell the speech center, "I just saw a really scared face," so patient X can guess that the photo being presented to him is of a scared person. Instead, the amygdala creates a feeling. Patient X is automatically simulating a feeling; then he can guess the expression based on how he is feeling. He did not need the conscious brain to recognize the emotion!

All this talk about activating areas in the brain is actually referring to the fact that a neurochemical process is going on in that region. Another way to investigate emotion recognition is to artificially block an emotion with a drug that suppresses it, and then see if the subject can recognize the emotion in someone else. This was done in a study of anger recognition. One form of human aggression occurs over disputes about property or dominance, and it is associated with the facial expression of anger. Your neighbor thinks the strip of property between your driveways is his; you think it is yours. He gets mad when he sees you have dug it up and planted roses, so he digs them up. You get mad.

Andrew Lawrence, Trevor Robbins, and colleagues at Cambridge postulated that a separate neural system might have evolved specifically to recognize and respond to this specific threat or challenge. In many animals, it has been shown that increased attention to these types of aggressive encounters is associated with the body producing increased levels of the neurotransmitter dopamine. If an animal is given a drug that blocks the action of dopamine, this impairs the reactions to these types of encounters but does not affect its locomotion—so if it

doesn't react to an aggressive act, you know it isn't because it can't move. You could still chainsaw your neighbor's prize sycamore tree that drops leaves all over your lawn, but you don't. They wondered if blocking the dopamine would not only decrease the *reaction* to anger expressions but also decrease the *recognition* of anger expressions.

This is indeed what happened. "Why, Fred, by golly, you seem to have dug up my roses. What about those Sox anyway?" Even more interesting, there was no effect on the ability to recognize all other emotions. "By the way, your wife is looking at you with a rather disgusted expression, what's up with her?" The implications of a distinct system for the processing of specific emotional signals (e.g., fear, disgust, and anger) support psycho-evolutionary approaches to emotion. They suggest that distinct systems may have evolved for these negative emotions in order to detect and co-ordinate flexible responses to different ecological threats or challenges.[55]

DO OTHER ANIMALS SIMULATE BEHAVIOR AND EMOTIONS?

There is evidence for a similar type of automatic emotional simulation in nonhuman primates. Emotional mimicry has been identified in the lab with monkeys. And just as with humans, damage to the amygdala in macaque monkeys results in monkeys with reduced fear and aggression and increased submissiveness.[56] They were tamer and abnormally friendly. If these monkeys also simulated emotions, and the amygdala has a role in their emotion of fear similar to its role in humans, then you would expect that parts of their amygdala would be active when they viewed another individual with a fearful expression. Single-neuron studies have shown that this occurs. Emotional contagion is evident in monkeys. It has also been shown in rats and pigeons. So emotional contagion is not unique to humans. Many researchers think it is the foundation stone necessary for the more highly evolved emotion of empathy, which requires consciousness and altruistic caring.

The question as to whether empathy is a uniquely human emotion, or whether other animals share it, is actively being researched, with parti-

sans in both camps. Everyone agrees that the extent of human empathy far surpasses its extent in other animals. Studies have shown that rats that have been trained to press a bar for food will stop pressing it if another visible rat gets a shock when the lever is pressed.[57] Various permutations of such tests have been done, but the basic question remains. Does the rat stop pressing the bar because of altruistic, empathetic impulses, or does he stop because the experience of seeing another rat being shocked is unpleasant? The difference is between a response to a visually perceived unpleasantness versus all that constitutes empathy: theory of mind, self-awareness, and altruism. This dilemma also plagues other studies that have been done with rhesus monkeys. Tests have yet to be designed that convincingly tease these two responses apart.

Another avenue of exploration is chimpanzee yawning. In a group of chimps, one-third will yawn while watching videos of other chimps yawning.[58] Some 40 to 60 percent of people will yawn while watching videos of yawning. I am yawning right now. It has been suggested that contagious yawning may be a primitive form of empathy. Steve Platec and colleagues suggest that, rather than just being an imitative action, it uses parts of the brain that are associated with theory of mind and self-awareness.[59] He found that people who were more susceptible to contagious yawning also could identify their own face faster and do better on theory-of-mind tasks. He has evidence from neural imaging that supports this idea.[60] Humans' empathetic behavior far surpasses contagious yawning, of course. It is no surprise that we have discovered some foundational behavior in the chimps, but so far, evidence for the altruistic, conscious empathy that humans possess is elusive in other animals.

MIRROR NEURONS AGAIN

How does the brain link observation of a facial expression with the action of copying it? How does it link facial expressions with particular emotions? You may already have started to wonder about those mirror neurons again. Those puppies are important! The first concrete evidence that perhaps there was a neural link between observation and imitation of an action was the discovery of mirror neurons, which we talked about

in chapters 1 and 2. If you recall, the same premotor neurons fired both when a macaque monkey observed others manipulating an object, such as by grasping, tearing, or holding it, and when it executed the action itself. Mirror neurons for hearing have also been found in monkeys, so that the sound of an action in the dark, such as ripping paper, activates both these auditory mirror neurons and the action neurons for the action of ripping paper.[61]

We already have learned that since that time, several studies have shown the existence of a similar mirror system in humans. For instance, a group of subjects were studied with an fMRI scanner, either while they merely watched a finger being lifted, or while they watched and then copied the movement. The same cortical network in the premotor cortex was active in both conditions, just watching, or watching and doing, but it was more active in the second condition.[62] In humans, the mirror system is not restricted to hand movements but has areas that correspond to movements all over the body. There is also a difference when there is an object involved in the action. Whenever an object is the target of action, another area of the brain (the parietal lobe) is also involved. A specific area will be active if a hand is using an object, such as lifting a cup, and a different area will be active if the mouth is acting on an object, perhaps sucking on a straw.[63] It is not possible to locate individual mirror neurons in humans as it is in the monkey, owing to the type of testing procedures. However, mirror neuron *systems* have been found in several areas of the human brain.

There is a distinct difference, however, between the mirror neurons in the monkey and the systems we humans have. The mirror neurons in the monkey fire only when there is goal-directed action, such as when they see a hand grasp an ice cream cone and move it to the mouth, which happened to be the case when the first mirror neurons were seen firing (although it was actually a gelato). In humans, however, the mirror system fires even when there is no goal.[64] A hand randomly waving in the air will cause the system to activate. This may explain why, although monkeys have mirror neurons, there is very limited imitation. The monkey's mirror system is tuned to the goal and does not code all the details of the action leading to the goal.[65]

The prefrontal lobe also plays an important role in imitation,[66] and humans, with their larger prefrontal cortex, may just have the advantage over monkeys by being able to build more complex motor patterns. We can watch someone play a guitar chord, and copy it movement for movement. We can take dance lessons and imitate our instructor as he sambas across the floor. A monkey would understand only that we went to the other side of the room, not that gyrating was necessary. The fact that monkeys have a less complex system helps us understand the evolutionary development of the mirror neuron system. Giacomo Rizzolatti and Vittorio Gallese originally proposed that the function of the mirror neuron system was to *understand* action (I understand that a cup is being lifted to the mouth). This action understanding is present in both monkeys and humans. However, in humans, the mirror neuron system is capable of doing much more. Are humans unique because they are the only animal that can samba?

What all are the mirror systems involved in? As we saw above, they are involved with immediately copying actions. It has also been found that they are involved with understanding *why* the action is being done, its *intention*.[67] I understand that a cup is being lifted to the mouth (the action understanding of the goal) to see how its contents taste (the intention behind the action). The same action is coded differently if it is associated with different intentions, thereby predicting the likely future unobserved action. In monkeys, a different set of mirror neurons activates if food is grabbed to be lifted to the mouth, or to be put in a cup. (I understand that the food is being grabbed to be eaten versus being grabbed to be put in a cup.) Not only do you understand someone is grabbing a candy bar, you understand she is going to eat it or put it in her purse or throw it out or, if you're lucky, hand it to you.

Are there mirror neurons for understanding emotion, too, or are they just for physical actions? The findings that we discussed above of the paired deficits in feeling and recognizing disgust and pain are suggestive that there are mirror systems located in the insula, which, as in action understanding, are involved with emotion observation and with understanding mediated through the visceromotor response.[68] The theory that mirror neurons are involved in emotion observation and understanding

(which contributes to social skills) has led two groups of researchers* to suggest that some of the symptoms of autism may be caused by a defect in the mirror-neuron system. These symptoms include lack of social skills, lack of empathy, poor imitation, and language deficits. Although Rizzolatti used electrodes to study mirror neurons in monkeys, researchers in San Diego have come up with a way to test for mirror neurons in humans without using electrodes.[69]

One of the components of EEGs, the mu waves, are blocked when a person makes a voluntary muscle movement and also when one watches the same action. The University of California, San Diego, group decided to see if EEGs could monitor mirror-neuron activity. They studied ten children with high-functioning autism and found they did suppress mu waves when they performed an action, just as normal children did, but unlike normal children, they *did not* suppress the mu waves when they observed an action. Their mirror system was deficient.

Another study[70] was done at UCLA, where children (both normal and with autistic spectrum disorder, ASD) were scanned using fMRI while either observing or imitating emotional facial expressions. Because individuals with ASD often show deficits in understanding the emotional states of others, it was predicted that dysfunction in the mirror-neuron system (MNS) should be manifest both when these individuals imitate emotional expressions and when they observe emotions displayed by others. This prediction proved correct. Moreover, the degree of reduction in neural activity correlates with the severity of deficit in social skills. The less activity, the less socially skilled they were.

The two sets of children use different neural systems when imitating facial expressions. The normal children use a mirroring neural mechanism in the right hemisphere that links with the limbic system via the insula. However, this mirroring mechanism is not engaged in children with ASD, who adopt a different strategy. They increase their visual and motor attention, using a pathway that does not go through the limbic system and the insula. The internally felt emotion of the imitated facial expression regulated by the insula is probably not experienced. These

*Villayanur Ramachandran's group at the University of California, San Diego, and Andrew Whiten's group at the University of St. Andrews, Scotland.

researchers suggest that because both adults and normally developing children show increased MNS activity even when simply observing an emotional expression, this is more proof that the mirroring mechanism may underlie the remarkable ability to read others' emotional states from facial expressions. The lack of MNS activity in children with ASD strongly supports the theory that dysfunction in the mirror-neuron system may be at the core of the social deficits observed in autism. However, there are many nonsocial attention skills that are also impaired in autism; they may not be involved with the mirror-neuron system.

It is currently unknown if animals other than primates have mirror-neuron systems, but it is being checked out. However, just as Clint Eastwood said, "A man's got to know his limitations."[71] We need to understand the limitations of the mirror neurons. They do not *generate* actions.

So far we have seen that specific emotions are associated with activity in specific parts of the brain, and specific physiological responses and specific movements of the facial muscles result in specific expressions. When we perceive another individual exhibiting some type of mood or emotion, we automatically mimic it, both physiologically and physically, and psychologically to some extent. If there is some abnormality in the brain structure that normally supports the response, then both the ability to experience the emotion and the ability to recognize it in others are affected. We have a mirror system that understands actions and the intentions of actions, and it is also involved with learning through imitation and emotion recognition. This is Emotion Recognition 1—elementary emotion recognition. It seems as though we have built up a good case for some type of simulation going on from one person to the next.

MORE THAN AUTOMATIC?

Even though this analysis looks reasonable, there is a wrench in the machinery. People who have Möbius syndrome (congenital facial paralysis due to the absence or underdevelopment of the cranial nerves that supply the facial muscles) can successfully identify emotions in the faces of others, even though they are not able to physically mimic facial expressions.[72] This may not be a problem if our understanding of emotions is

via the mirror neurons. They may still fire, even though the motor system is not functioning.

Another wrench is a recent study on subjects who have a congenital inability to feel pain (CIP). From facial expressions, these people are able to recognize and rate the pain that others feel just as well as normal controls, even though they themselves feel none. If, however, they are presented with video clips in the absence of visible or audible pain-related behavior, CIP patients rate the pain as lower, and they have less aversive emotional responses, compared with control subjects.

One additional interesting finding is that pain judgments in CIP patients are strongly related to individual differences in emotional empathy, and this correlation is not found in control subjects. The authors of this study suggest that personal experience of pain is not necessarily required for perceiving and feeling empathy for another's pain, although it might be greatly underestimated when there are no emotional cues.[73] However, in both cases, the patients with Möbius syndrome and CIP have had long-standing deficits. Their ability to recognize emotions in others may have been *consciously learned* over the years via a different pathway than that in normal subjects. The authors note that the parents of some CIP patients may resort to miming facial expressions of pain to make their child understand that a particular stimulus might damage his body.

We have learned that watching or hearing other individuals in pain activates some of the cortical areas known to be involved in the emotional component of self-pain experience, such as the anterior cingulate cortex and the anterior insula. In contrast with the neural mechanism for actually feeling pain, mirror matching of the emotional aspect of another's pain might be preserved in CIP patients. Thus they could detect suffering in others from emotional cues such as facial pain expressions. At the end of this study, one-third of the patients said that they found it difficult to estimate the pain experienced by injured individuals without seeing their face or hearing them cry. Scanning these patients during these emotional recognition tasks to see what neural areas are being used would be interesting, as well as timing their responses compared to those of normal subjects. Is it a slower conscious pathway that is used, or is it a fast automatic one?

Another finding that indicates automatic simulation is not all that is going on came from a study done by Ursula Hess and Silvie Blairy at the University of Colorado. They found that the occurrence of mimicry did not correlate with the accuracy in facial emotional recognition.[74] This study used facial expressions that were not exaggerated but were thought to be more like those one usually experiences. So even though facial mimicry did occur, it did not correlate with the accurate diagnosis of the emotion being felt by the observed person. Other studies have shown that people do not mimic the faces of those with whom they are in competition[75] or of politicians with whom they do not agree.[76] Is some inhibitory ability going on? It seems there must be, otherwise we would start crying in the baby nursery with all the newborns. Is some voluntary cognition involved?

I THINK, THEREFORE I CAN REAPPRAISE

Indeed we can change our emotion and the way we feel by the way we think. One way this is accomplished is by reappraisal. This is what happened to Modeste Mignon, our fictional example in the last chapter. "In love, what a woman mistakes for disgust is simply seeing clearly." After a reappraisal of her lover's character, she goes from love to disgust.[77] A car cuts in front of you and zooms down the street. It makes you angry. As your blood pressure starts to rise, all of a sudden you remember when you did the same thing on a terrifying drive to the emergency room. Next to you was your child whimpering in pain with a dislocated shoulder hanging at his side. Your anger dissipates in a second, your blood pressure drops, and now you feel concern as you realize the hospital is down the road.

Conscious reappraisal of an emotion has been investigated in a brain imaging study where participants were presented with photos showing negative but somewhat ambiguous emotional situations, such as a woman crying outside of a church. While being scanned, the subjects were then asked to reappraise the situation in a more positive way. The thought was that reappraisal draws attention to the emotion one is feeling and requires

a *voluntary* cognitive assessment. After reappraisal, such as imagining that the woman was shedding tears of joy after a wedding, versus their initial impression of a funeral scene, the participants reported being less negatively affected. The scanning results showed that during reappraisal, there was decreased activity in regions concerned with emotional processing, and activation in regions that are essential for memory, cognitive control, and self-monitoring.[78] Reappraisal can modulate emotion and simulation. Another interesting finding was that the left hemisphere was more active in reappraisal. It is theorized that perhaps this may be because participants reported having "talked" themselves into reappraisal strategies, and the speech center is in the left hemisphere. Another possible explanation is that the left hemisphere is known to be associated with evaluating positive emotions in general.[79] People who show a higher resting activity of the left hemisphere have more resistance to depression, which may be because of their cognitive ability to decrease negative emotional processing.

SUPPRESSION

Another way simulation can be affected is through suppression, that is, voluntarily not showing any sign of an emotion. Parents often do this when they don't laugh at their child's funny but inappropriate social behavior (pulling off her dirty diapers in the pool), although it can be difficult. In a review of research on emotional regulation,[80] James Gross of Stanford University explains that suppression requires one to continually monitor one's expressions (that smile might just pop back up) and correct them (if it does). This is using your conscious neural circuits, which we have learned are limited, and it takes your conscious attention away from the social interaction. This leaves you with less ability to process the interaction and can affect your memory of it. This is different from when you reappraise a situation and you no longer actually feel the emotion, so there is no need to monitor to make sure it doesn't show. (Pulling off her dirty diapers in the swimming pool actually isn't funny, it is disgusting: There is no chance of the smile creeping back.)

Suppression and reappraisal have different emotional, physiological,

and behavioral consequences. Suppression does not decrease the emotional experience of negative behavior; you still have the emotion, you just don't express it. When the car cuts you off in traffic, you may not scowl at the driver and ram his bumper, but you are still angry. This is unlike reappraisal, when you realized the other driver might need the hospital services and you no longer felt the emotion of anger. However, suppression can decrease the emotional experience of *positive* behavior. Great, that is par for the course. You try to suppress bad emotions, and not only doesn't it get rid of them, but now you don't feel the good ones as well. Nor does suppression change the physiological responses. You still get all the increased cardiovascular activity. You may be hiding your anger, disgust, or fear, but you're still making your heart work overtime and wearing it out that much sooner. However, reappraisal *can* change the physiological response; it can decrease the stress of a stressing situation. If you can change your attitude about a negative stimulus so that it is no longer negative, then you won't be borrowing unnecessarily from your cardiovascular bank account.

How does this affect simulation? The interesting consequence of suppressing emotional expressions is that it hides important signals that would otherwise be available to the other person in a social situation. She is talking to old stone face, has no clue how he is feeling, and so can't respond to him appropriately. And lord knows he isn't going to respond to her. She has just told him her funniest story, and he is looking at her as if she should never have graduated from elementary school. She reminds herself to put him on the "do not invite" list, to spare her friends this trying social interaction. And how about old stone face? His social interactions will be limited, for no doubt she is not the only one to avoid him.

Researchers studying suppression with James Gross made a prediction: Because one needs to monitor oneself while suppressing an emotion to be sure the expression isn't popping up visibly or vocally, then one may be distracted from actually responding to the other's emotional cues. This could have negative social consequences. If a person is focused on himself, there is less conscious focus available for another person. The guy trying to act macho all the time has to suppress any tender expressions that may be trying to erupt. He has less available brain

capacity to be paying attention to anyone interacting with him. Gross and his colleagues also thought that since reappraisal isn't so cognitively taxing, it should have more positive social consequences.

They set out to test this theory by asking unacquainted women to watch an upsetting film and then discuss it afterward. One woman in each couple had been asked to do one of three things. She was to suppress her reactions to the film (as a macho guy may do: "I'm tough, those gory pictures mean nothing to me"), or reappraise ("Those pictures are awful, but it is only a movie, and that is really ketchup"), or interact naturally with her conversation partner. The other woman did not know that any instructions had been given to her partner. Their physiological responses were measured during the conversations.

Positive expressions of emotion ("That is so great!! I'm so excited for you!") and emotional responsiveness ("Oh brother, that must drive you crazy; it would me!") are key elements in social support, which decreases stress.[81] The researchers figured if this social support was absent, then there should be a big difference in the physiological responses to the conversations among the group of the uninformed partners. This proved true. The conversation partners of the women who had been told to suppress had greater increases of blood pressure than the women whose partners either acted naturally or had reappraised the film.[82] Interacting with people who express little positive emotion and who are unresponsive to emotional cues actually increases the cardiovascular activity in their social partners.[80] So if you hang out with someone who suppresses his expressions of emotion, it not only makes *his* blood pressure go up, it makes *yours* go up too.

Things are getting a little more complicated now. It seems that we have gone beyond a world of emotional contagion, where simulation is a reflexive automatic response to facial expressions or other emotional stimuli, and entered into the world where the conscious brain plays a role. Here you are able to use your memory, the knowledge you have gained from past experiences, and what you know about the other person as part of your input. This leads us to one more simulation ability we have, one that is most probably unique. We can simulate an emotion with only abstract input.

IMAGINATION

I can e-mail you and tell you I cut off part of my finger using a router saw, and without seeing my face or hearing my voice, you can imagine how I felt. Just the printed words can stimulate you to simulate my emotion. You may wince as you read the description of the accident, get that shiver up your spine. You can also read a novel about fictitious characters and still be emotionally involved with them. Some of the scenes from a Tom Wolfe novel are perfect reminders of this. The icehouse scene from *The Man in Full* was so anxiety provoking I had to put it down for fifteen minutes. So imagining a situation can stimulate one to simulate an emotion.[83] It can be entertaining in itself to watch the facial expressions and posture of people as they are reading a book. Fear, anger, or pleasure can be deduced. Sherlock Holmes was a master at this, as he would watch Watson read the paper. In fact, words associated with pain cause areas in the brain that are associated with the subjective component of pain to activate.[84] Imagination works in physical actions too. Pianists who played music on a silent keyboard activated the same part of their brain* as when they simply imagined playing the same music.[85]

Imagination allows you to go beyond the data you have at hand. When the Olympic athlete fell and broke her ankle, we see the facial expression of pain, but our imagination supplies us with all the years of hard work and sacrifice involved, the dashed dreams, the embarrassment, the shame of letting down the team, the knowledge that the injury may affect her future performance, and we feel great empathy for her. When we see the mugger break his ankle, we also see the facial expression of pain, but we imagine the person he attacked lying injured and frightened on the street, and we get angry and no longer feel empathy for his pain, but satisfaction that the perp is getting his due.

Imagination is what helps us reappraise a situation. The auditory input may say that a woman is laughing down the hall, but imagination can put her in a job interview with that dweeb in the next office, and you know she is faking it. She is not laughing because she is happy. Imagination also

*The fronto-parietal network.

allows us to time-travel. We can go into the future and back to the past. An event may be long in the past, but I can replay it in my imagination from memory. I can simulate the experience of my former self and reexperience the memory. I can even reappraise that emotion from my current perspective. I can remember the embarrassment I felt at getting a D on a test and feel it again to the point of flushing, and then I can think with satisfaction that it motivated me to study more, and I ended up with an A. I can remember how I felt driving in a Fiat just before noon on a roundabout in Rome, horns honking, traffic snarled; my anxiety and heart rate can increase, and I can decide never to rent a car there again. I can remember how I felt sipping a Campari while sitting in the sunny Piazza Navona with my wonderful wife—and decide to go back, but take a taxi to get there.

Likewise I can project into the future. I can use my past experience of an emotion and apply it to future circumstances. I can imagine how I would feel, for example, standing at the open aircraft door with a parachute on my back (terror, which I have felt in the past and did not enjoy) and decide I can bypass this adventure. Neural activity associated with feeling an emotion can be seen while just imagining that the emotion will happen in the future. Elizabeth Phelps, a neuroscientist at New York University, did a brain imaging study in which she told her volunteer subjects they would be viewing a series of shapes and that every time they would see a blue square, they would receive a mild shock. Even though they never were given a shock, every time a blue square was presented, their amygdala was activated.[86] Just the imagination of the shock caused the circuit to light up. After watching a scary movie, you may hear a creak in your house in the middle of the night and imagine the presence of an intruder. Your heart rate increases, the blood starts pounding in your ears, and you can get a full-fledged fear reaction. For the rest of her life, Janet Leigh said she had problems taking a shower after filming the movie *Psycho*. Her imagination continued to work.

Can other animals time-travel? Hold on! We are going to talk about this in chapter 8.

Imagination is a deliberate process. It takes simulation beyond the automatic in some circumstances and uses a conscious component. It allows us to plan how we will act in the future and anticipate how others will act. It saves us wear and tear. I don't have to go up in the airplane,

only then to decide I'm not going to jump; I can figure that out in my living room. I can also figure out that my daughter won't want a gift certificate for a jump either, but my brother would, except he would also want to fly the plane. Imagination allows us to simulate our past emotions and learn from those experiences, and project how others may feel or act in the same situation. This ability is critical for social learning. When we do this, however, we are using another one of our many abilities that we take for granted—the ability to distinguish the difference between others and ourselves.

SELF-AWARENESS

Observing actions and emotions in others can activate the same neural areas in our own brains, yet we are able to distinguish between "me" and "you." How does this happen? If the same neural areas are activated when I see you are disgusted as when I am disgusted, how can I tell whether it is you or I? I imagine your toupee slipping off as you give an important televised lecture; I can simulate your embarrassment and feel it myself, but know that it was you I was imagining and not I. It seems there must be specific neural circuits to distinguish between the self and others. Moreover, the self is both physical and psychological. And yes, there are mechanisms in the brain for distinguishing the physical me, both from another and from the psychological me.

Studies of perspective taking, or imagining yourself in another's place, have been fruitful in separating the neural networks of self and other. Perspective taking emerges at about eighteen months in human infants, though not to the same extent as in an adult. That is when a child will offer you the type of food that you indicate with a smile that you like (perhaps broccoli) versus what they like but which you reacted to with a disgusted face (cookies).[87] We are not necessarily good at perspective taking, however, nor do we always do it. I would find the choice of broccoli distinctly odd myself, and I might overrule the evidence of your facial expression in favor of my much more sensible preference, and give you the cookie anyway. Obvious examples are all those really bad Christmas presents that you have received. "Why would anyone in his right

mind think I wanted or would like this?" must run through thousands of brains on Christmas morning behind forced (conscious) smiles. At least now you know you can check the lateral eyebrows, to see if they have depressed, to spot those fakers.

People tend to think that others know and believe what they know and believe[88] and also tend to overestimate the knowledge of others.[89] This is most likely what is happening when you start talking about your theory of recursion in linguistics to normal people and they get that dazed look on their faces. You've assumed they'd be interested. It seems our default mode in regard to others is biased toward our own perspective. That is why it can be so difficult to talk to people who are specialists in fields you have no clue about. They assume you know much of what they themselves know. "Ah, run that hedge fund deal by me again?" If you are asked how another would feel in a situation involving bodily needs, such as hunger, fatigue, or thirst, your prediction is largely based on how you would feel. I assume when other people feel hungry, they feel the same thing I do—that aching, gnawing feeling in the stomach. This apparently is not true. I found this out in a discussion with some friends: Some feel jittery, some get head-aches, some get cranky, some have no feelings in their gut at all.

This self-centered perception can lead to errors in social judgment other than bringing up recursion at cocktail parties. "He should have called me by now. I would have called him. He must not care about me." But as University of Chicago psychologist Jean Decety and University of Washington psychologist Philip Jackson point out, it goes well with sim-ulation theory, which states that we understand and predict the behavior and mental states of others by using our own mental resources. By imag-ining we were in their situation, we use our own knowledge as our de-fault base to understand others.[26] However, for social success, we need to be able to separate ourselves from the other. (He didn't call because he forgot his cell phone, he's on a business trip in China, the time differ-ence is crazy, and he is exhausted.) Decety and colleagues emphasize that one needs mental flexibility to flip back and forth between perspec-tives: We need to be able to inhibit our own perspective to take the other's perspective. Regulation (or inhibition) of our own perspective is what allows flexibility to take the other's perspective. It has been suggested that errors in assessing another's perspective are a failure of

suppressing one's own,[90] which is why your husband gave you a new barbecue instead of jewelry for your birthday, and why you gave him the beautiful blue dress shirt instead of the XVR800 series PKJ super-beyond-reason subwoofer. This ability to regulate gradually develops in children and is not fully apparent until about age four. The cognitive control involved has been linked to the development of theory of mind, which emerges at the same age, as well as to the maturation of the prefrontal cortex. So what is going on in the brain when we switch from our own perspective to another's?

One way to figure this out is to see which areas are activated in taking one's own perspective, and which are activated in taking another's perspective. Any commonly activated areas are subtracted. What is left activated in either situation is what is unique to that perspective. Perrine Ruby and Decety have done a series of neural imaging studies while subjects take either their own perspective or another's on tasks in the motor domain (imaging using a shovel or razor), the conceptual domain (medical students imaging what a layperson would say about various statements, such as "There are more births when the moon is full," versus what they would say), and the emotional domain (imaging either yourself or your mother talking about someone and then realizing that the person is right behind you).[91, 92, 93] They have found that, apart from the shared neural network between self and other, when one takes another's perspective, there is significant activation in the right inferior parietal cortex and the ventromedial prefrontal cortex, which includes the frontopolar cortex and the gyrus rectus. Other studies have had similar results. The somatosensory cortex is activated only when one takes one's own perspective.

The junction of the right inferior parietal cortex with the posterior temporal cortex plays a critical role in the distinction between one's own actions and another's. Called the *temporoparietal junction* (TPJ), it is a busy place, integrating input from many different parts of the brain, including the lateral and posterior thalamus; the visual, auditory, somesthetic and limbic areas; and reciprocal connections with the prefrontal cortex and the temporal lobes. Various other studies have thrown in bits of evidence that this area plays a part in differentiating self from other. Studies of the out-of-body experience (OBE), a third-person perspective of oneself, have been fruitful.

One interesting case is that of a woman who was being evaluated for epilepsy treatment at the University Hospital of Geneva. Her physicians were trying to locate the focus of her seizures but were unable to do so with brain imaging. The next step was to do surgery, but they needed to locate the focus first. Under local anesthesia (the brain itself feels no pain), subdural electrodes were implanted to record seizures, and focal electrical stimulation was used to identify the cortical locus of the seizures. With focal electrical stimulation of the brain's right angular gyrus (located in the parietal lobe), she had repeated out-of-body experiences. With stimulation to one particular area, the patient reported, "I see myself lying in bed, from above, but I only see my legs and lower trunk."[94]

Since then, Olaf Blanke and Shahar Arzy[95] have done a review of all such phenomena, collating evidence from neurology, cognitive neuroscience, and neuroimaging. They suggest that OBEs are related to a failure to integrate multisensory information from one's own body at the temporoparietal junction. They speculate that this failure at the TPJ leads to disruption of what the self experiences and thinks. This can cause illusions of reduplication, self-location, perspective, and agency that are experienced as an OBE. Another particular area along the TPJ is involved specifically in reasoning about the contents of another person's mind,[96] an ability that requires differentiating self from other.

The other part of the brain that is active when taking another's perspective is the ventral prefrontal cortex, also called the frontal polar (or frontopola) cortex. Damage to this region in childhood can result in impaired perspective-taking ability.[97] This area is thought to be the source of the inhibition that allows one to move from self-perspective to other perspective. Damasio's group has given moral tests to adults who have had injuries to this area in childhood. Their answers were excessively egocentric, as was their behavior. They exhibited a lack of self-perspective inhibition and did not take the other's perspective. People who acquire these types of lesions as adults (for example, Phineas Gage), rather than as children, can compensate for them better. This suggests that the neural systems that had been impaired at an early age were critical for the acquisition of social knowledge.[98]

Additional studies have shown that the somatosensory cortex, the

part of the brain with specific areas that correlate with sensation to specific parts of the body, is activated when a situation is simulated from one's own perspective. Subjects were asked to view pictures of hands or feet in neutral or painful positions and imagine the pain from either their own or another's perspective. Both perspectives had activation in the emotional affective pain area, but only the subjects taking a personal perspective had activation of their somatosensory cortex. They also had higher pain ratings and faster response times, and activated the pain pathways to a greater extent.*[99] Ruby and Decety speculate that the activation of the somatosensory cortex with the personal perspective contributes to separating the two perspectives: "If I feel it, it is me (I feel, so I am), it cannot be the other."[93]

Interestingly, the regions that were active in third-person perspective taking were the same regions that are active in various theory-of-mind tasks.† If we are consciously taking the other's perspective and are assuming the other is like us, then simulating how we would feel in their situation will most likely lead to an accurate appraisal of the other's state. However, if we are taking the perspective of a person who is very different from us, then simulating our own state will be less useful. Does our brain use different substrates when we assume that the other is like us and when we think he is different? A new study has shown this to be so.[100] When we take the perspective of a similar person, a region of the ventral medial prefrontal cortex (mPFC) linked to self-referential thought is activated, whereas mentalizing about a dissimilar other engages a more dorsal subregion of the mPFC.

The overlapping neural activations between judgments of self and similar others take us back to the simulation theory of social cognition, according to which we use knowledge about ourselves to infer the mental states of others. This use of a different substrate to think about unlike

*Specifically, there was activation in the somatosensory cortex, the anterior cingulate cortex, and the bilateral insula. The subjects taking another's perspective had increased activation in the posterior cingulate, the right temporoparietal junction, and the right insula only, with no activation of the somatosensory cortex.

†The medial prefrontal cortex, the left temporoparieto-occipital junction, and the left temporal pole.

others has interesting implications, especially as to how we think about in-group and out-group individuals. When we think about people in our own group, we assume they are like us, and we predict their behavior from simulating what we would do or feel in the same situation. This may explain Sam and Pearl Oliner's finding that 52 percent of the rescuers of Jews during the Holocost were primarily motivated by "expressing and strengthening their affiliations with their social groups." However, when thinking of a person in the out-group, a process different from simulation may occur. Sociological studies have shown people think that unlike others feel neither the same emotions nor the same depth of emotion,[101] and they will project their own goals and preferences on similar others but less so on dissimilar ones.[102] This perhaps can explain the dehumanizing that can occur such as between prison guards and prisoners, between neighboring countries, and between religious groups. Although this distinguishing between groups can be the source of inhumane treatment, it can also be helpful if you understand how the brain works. People do differ. Not everyone is like you. Assuming they are can cause problems. Popular psychology literature about the differences between the sexes, such as *Men Are from Mars, Women Are from Venus*, puts men and women in two different groups. This actually may be helpful for our anxious woman awaiting a phone call. Perhaps if she realized that men's and women's behaviors differ in some areas, then she would not try to predict his behavior from her perspective.

CAN ANIMALS TAKE ANOTHER'S PERSPECTIVE?

Is perspective taking uniquely human? Are we the only animals that can stand back and look at the world through another's eyes? Such an ability implies self-awareness, which we are also going to talk more about in relation to other animals in chapter 8. This has been a controversial question, but a new way of studying the question (a new perspective) is indicating that primates are able to do this in certain situations. Brian Hare and colleagues at the Max Planck Institute in Leipzig have shown that chimpanzees can take the *visual* perspective of another when in competition for

food.*[103] It may be that previous studies looking for theory-of-mind capacities in primates using helping tasks were looking in the wrong place. As we have learned before, chimpanzees perform most skillfully in *competitive* cognitive tasks. The researchers took advantage of this characteristic and pitted the chimps against a human (let's call him Sam) who moved prized food items out of the chimps' reach when they attempted to grab them. The chimps could approach Sam from behind an opaque barrier or could approach from a direction in which Sam was either looking or not looking. The chimpanzees spontaneously avoided food Sam was watching, as indicated by gaze direction. Instead they approached food he was not watching, even when most of his body was oriented toward and was within reach of the food. Also, the chimps preferred to approach food behind opaque barriers while refraining from approaching it from behind transparent barriers. When the chimps initially walked away from the food, if Sam was able to see them, they always used an indirect route before approaching behind the barrier. However, if the barriers prevented Sam from seeing them move away from the food, or if there was no hidden route back to the food, the chimps did not use indirect routes to distance themselves. The researchers point out that this indirect approach behavior is striking, because it suggests the possibility that the subjects not only understood that it was important to be hidden from their competitor's view while approaching contested food, but that they also understood that in some cases it was useful to hide their attempt to hide.

The chimps were able to take another's visual perspective, understand what the other could see, and actively manipulate the situation in a competitive environment. This study also provides some of the strongest evidence that chimpanzees are capable of intentional deception, at least where food is concerned in a competitive situation. Intentional deception is manipulating what another believes to be true. However, as we have seen in a previous chapter, chimps are unable to solve the false-belief task that children are able to do at the age of four. Understanding what others see is not the same as being able to understand or manipulate their *psychological* state, but these findings do lead inevitably to

*See videos at http://email.eva.mpg.de/~hare/video.htm.

more questions. They up the ante on the abilities of chimps in regard to theory of mind. Hare suggests that we also need to determine whether chimps understand what others hear. Do they avoid making loud noises, as has been observed in the wild,[104, 105, 106] to intentionally manipulate a situation, and do they make false cries to intentionally deceive others? It is unclear if chimps can take another's psychological perspective, but there are indications that they can, to some degree. Lisa Parr's research that showed that chimps could match the emotion shown in a video scene, such as that of a chimp receiving an injection, with a photograph of a equivalent emotional facial expression indicates an emotional awareness that may be a precursor to our more advanced psychological perspective-taking ability.[107]

After these results were obtained, another research group decided to use the competitive task situation to test rhesus monkeys to see if they understood that *seeing* leads to *knowing*. All previous laboratory testing of monkeys for TOM tasks has had negative results. These researchers also set up a situation in which the monkeys would be in competition with an experimenter for food. First they tested whether monkeys took into account the direction of an experimenter's gaze when trying to steal food. They did—they stole it from an experimenter whose back was turned or whose head was averted. With even more discernment, they stole it from one who had averted his eyes but not turned his head, or from one whose eyes were covered but not from one whose mouth was covered.[108]

They then wondered if a monkey would know that a researcher who hasn't *seen* where food was wouldn't *know* where it was. In this experiment, there were two platforms with a grape on each. The monkey could see both grapes. The experimenter put the grapes on the platforms and then sat down behind a barrier so he could no longer see them. The platforms were rigged so that one would tilt and the grape would roll down a ramp but the experimenter could not see this happen. The monkeys would immediately grab that grape, but not the one whose position the experimenter knew about. When they changed the situation so that the experimenter could still see both grapes, the monkeys approached either grape randomly. Their results indicated that rhesus monkeys do understand that seeing leads to knowing. The monkeys understood what the

experimenter could see and what he could or could not know as a result of what he could see. For the first time, researchers believe that rhesus monkeys do have some capacity for theory-of-mind reasoning, and it seems to be most available in competitive situations.[109]

Another social animal is man's best friend, the dog. Scientists have not spent much time studying dogs, except for Darwin, of course. Recently, however, dogs have surpassed Rodney Dangerfield and have been getting some respect. The study of dogs has been hindered by the view they are an "artificial" species. Realizing that dogs have adapted to their niche (living as domesticated animals) for at least the last 15,000 years or so (although DNA evidence suggests as far back as 100,000 years), as have other "natural" species adapted to their particular niche, makes comparative investigations into their social cognition more fruitful.[110] Dogs have some humanlike social skills chimps do not have[111] and have coevolved with humans for thousands of years. These social skills are not learned but are innate, and are different from those of their ancestral wolf relatives. Dogs understand what humans see and will drop a returned ball in front of a human, not to his back if he has turned around. Dogs will beg for food from humans whose head and eyes are visible, rather than someone whose head is covered by a bucket, something that chimps do not spontaneously do. Dogs will not approach forbidden food when they are behind a barrier and the food is in front of a window that a human can see through. They understand that the human can see the food, even though they can't see the human. Dogs do not need competition to cooperate. Dogs will find hidden food that humans are pointing to, even if the human is walking away from the food. Chimps themselves do not point, nor do they understand the intention of it as dogs do. This may be because of the lack of cooperation in chimps.

What effects has domestication brought about? In 1959, Dr. Dmitry Belyaev began domesticating foxes in Siberia, selecting for only a single criterion: whether they exhibited fearless and nonaggressive behavior toward humans. In other words, he selected for *inhibition* of fear and aggression. By-products of this selection process have included many morphological variations that are seen in domestic dogs, such as floppy ears, upturned tail, and piebald colorations like that in border collies. There are also behavioral changes, including prolonged reproductive

season, and physiological changes, interestingly including higher serot-
onin levels in the female (known to decrease some types of aggressive
behavior) and altered sex hormone levels, resulting in bigger litters. The
levels of many of the chemicals in the brain that regulate stress and ag-
gressive behavior have been altered.[112] Correlating Belyaev's work with
the domestication of the dog, it has been suggested that the social skills
of dogs may have developed as a by-product, and first appeared after
systems mediating the inhibition of fear and aggression developed. In-
terestingly, this has led to the proposition that the social behavior of
great apes is constrained by their temperament—their inability to co-
operate and their intense competitiveness, which are now becoming
more recognized.

Perhaps the human temperament might be necessary for the evolu-
tion of more complex forms of social cognition. Perhaps it is the ability to
inhibit self-perspective that is deficient in other nonhuman primates and
has constrained their cooperation. Hare and Tomasello suggest that the
evolution of the human temperament might have preceded the evolution
of our more complex forms of social cognition. It would have done us no
good to have a highly sophisticated ability to read the minds of others if
we didn't share in cooperative goals. They flirt with a hypothesis that an
important first step in the evolution of modern human societies was a
kind of self-domestication that selected for systems that controlled emo-
tional reactivity. According to this idea, individuals in a group would
either ostracize or kill overaggressive or despotic others.[111] This is an in-
teresting proposition, and when considered with the proposition of mul-
tilevel group selection, it could result in a social group that is cooperative
but willing to punish cheaters.

These studies on animal perspective taking are indicating that we
do share social cognitive abilities with other primates and other social
animals. This should come as no surprise. What is surprising is the
extent of *our* sociability. We share the capacity for emotional conta-
gion, mimicry, perspective taking, and limitations on self-awareness
to some degree. We share mirror-neuron systems; however, ours have
greater capability and are more extensive. We can voluntarily imitate
intricate movements, an ability that does not exist in other primates.

CONCLUSION

People are capable of voluntarily, deliberately switching from one *abstract* perspective to another with easy flexibility. We can manipulate what emotions we are simulating by imagination alone. Different perspectives can lead to simulating different emotions. This can be done without the presence of any immediately available physical stimulus. We can transfer emotional knowledge with abstract tools, such as language or music, through books, songs, e-mails, and conversations. We can listen to George Gershwin's *An American in Paris* and feel excitement and the nostalgia of homesickness. We can feel sadness as we read Hugo's *Les Misérables,* and laugh uncontrollably as we read about Dave Barry turning forty. This ability allows us to learn about the world without having to experience it all firsthand ourselves. We don't have to learn things the hard way. I can tell you how an audience reacted to a joke last night and you can learn whether that joke is a good one to use (you do not have to experience the embarrassing silence or snickers). You can tell your friend that taking the bus from El Paso to Tierra del Fuego was an interesting but grueling trip, and recommend Tahiti for his honeymoon instead: Your friend can learn from your experience and save his marriage. These abilities to simulate emotions from language and imagination, to alter our simulations by using perspective, and to project ourselves into the future and past enrich our social world and make our simulations more powerful and complex than those of other species.

THE GLORY OF BEING HUMAN

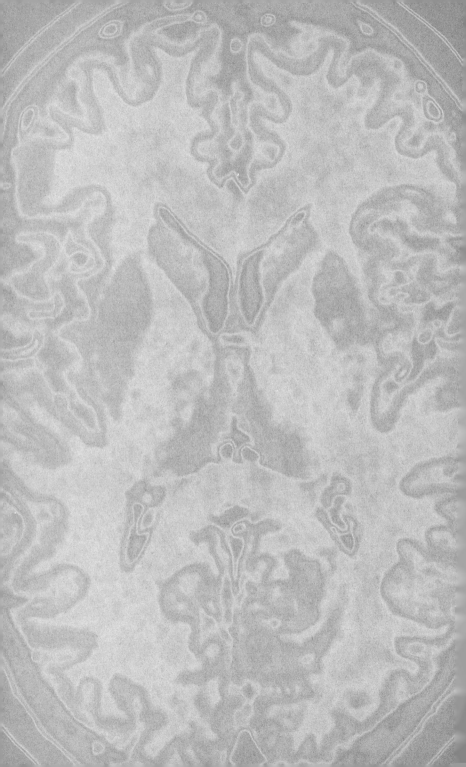

Chapter 6

WHAT'S UP WITH THE ARTS?

A man who works with his hands is a laborer; a man who works with his hands and his brain is a craftsman; but a man who works with his hands and his brain and his heart is an artist.

—*Louis Nizer*

HOW CAN YOU EXPLAIN THE ARTS? ARE HUMANS THE ONLY artists? Since we are products of natural selection, what possible evolutionary advantage did they bestow on us? Would a lion pause and think twice about eating your ancestor if he had done a quick little rendition of "Shuffle Off to Buffalo" in a pair of cobra skin shoes with coconut shell taps? Would a neighboring tribe's army crawling through the brush exclaim to themselves upon seeing your camp, "Look at how aesthetically placed those logs are! And the fire pit is simply spectacular! What are we thinking? We could not possibly consider knocking out these creative people and taking their leg o' impala roasting on the spit!"

Or maybe art is like the peacock's tail. "Bruno makes the cutest carving instruments out of bones. All the other guys are just a bunch of Neanderthals, but Bruno, he is an artist. I think I'll mate with him."

Or is it all about status? "Bruno has the biggest knife collection of anyone. In fact he has a knife made by Gormox. I know, I know, Gormox's knives don't cut anything, and they are misshapen, but there are very few of them around!"

Or perhaps Bruno is curling up for his afternoon siesta when he catches a glimpse out of the corner of his eye of a snake peeking out at him. He remembers the bedtime story his father had told him about some guy who had seen a poisonous snake, and he had feigned sleep, and just as the snake was . . . he grabbed it and slammed it against the ground. As he skinned it with his cute knife and thought about some new taps, he considered, "Hmmmm. Maybe those stories weren't just to put me to sleep after all."

Or was he the first charming Frenchman? "Oh, my petite, slither with me through this cave just around the corner in Lascaux and let me show you my etchings." Or was art a gift to the gods? "If I can get this dance down right, we will be sure to have plenty of good hunting and great weather. I better not screw up and hip when I should hop. That will wreck everything."

And what about those intoxicating rhythms? Did the tribe that danced together bond better than the tribe who were out of sync? Were they better able to coordinate their hunting? Did the beat of drums work as an aphrodisiac? Was Pavarotti any different from a songbird attracting a mate? Is Mick Jagger another example of a peacock's tail, or is there more to the story? Are the arts uniquely human?

Explaining the arts is a conundrum. A superficial consideration would place the arts in the position of frosting on the cake. After everything else is accounted for, then we can think about art. After we create the functional, is the aesthetic merely the extra? "I've built a chair and now I can sit down. Hmmm, it sure looks boring, maybe I should add a pillow for a splash of color." After the rent, groceries, clothes, gas, car, insurance, utilities, retirement account, and taxes are taken care of, if there is any left over, then maybe you can consider a movie, a concert, painting, dance lessons, or a theatrical production. But is that really their place? Perhaps the arts are more important. Maybe they aren't the frosting on the cake; maybe they are the baking soda, or the sugar. Maybe they are so much a part of us that once again we take them for granted. Perhaps the aesthetic quality of things is more basic to our sensibilities than we realize, and we ignore it at our peril. Does it belong to the great unconscious part of our brain we are learning more and more about to our amazement? When did art evolve? Is there any

evidence of it in other animals or our ancestors? Was it necessary for big brains to develop first for art to appear, or did it contribute to their development?

Obviously many forms of art are unique to humans. Gorillas don't play the sax, chimps don't write plays. Can other animals appreciate art? Will a chimp gaze at the sunset or be enraptured by Rachmaninoff? Does your dog dig the Stones? Do we, as humans need art? Does it help develop our brains? Are piano lessons just as important as history class? Should we be spending more money on our children's art education? Should we consider it not frosting, the last thing we spend money on, but a baseline budget item?

Many of these questions are just beginning to be addressed. We will start with a look at what art is. Then we'll see what is known of the beginning of art and what it can tell us about the brains that created it. We'll see what the evolutionary psychologists have to say, and then see what recent neuroimaging studies have revealed.

WHAT IS ART, ANYWAY?

Can we even define art? One of art's mysteries is brought to our attention by the oft-said phrase "Beauty is in the eye of the beholder"—or the ear. We can both go to an art gallery, and one of us may have been enraptured while the other of us thinks we've seen a hack job. We may have heard the mumbled comment, "And she calls this art? I call it garbage." We can go to a concert, and one of us will think the music sublime, and the other may be on edge and have to get up and leave. One of us may walk into a room and feel warm and relaxed and find it beautiful, while the other may find it tedious and boring, whispering, "His taste is all in his mouth!" We know instantly whether we like a painting or not. It "appeals" to us or it doesn't.

Art is one of those human universals. All cultures have some form of it, whether it is painting, dance, story, song, or other forms. We can look at a painting or listen to a symphony or watch a dance recital and understand consciously how much time and effort went into the production, how much practice and education were (or perhaps were not) involved, and

appreciate it, but that does not mean we like it. How can we define something about which we have no consensus? On the other hand, don't we *all* gaze up at a starry desert sky and think it is beautiful? Don't we all find a babbling brook lovely?

Ellen Dissanayake, an affiliate professor in the school of music at the University of Washington, points out, "The present-day Western concept of art is a mess."[1] She comments that our notion of art is peculiar to our place and time, and modern aesthetics comes from philosophers who had no knowledge of prehistoric art, or of the widespread presence of art around the world in its many forms, or that we had evolved biologically. Steven Pinker, who has penetrating ideas on just about everything, reminds us that the arts engage not only the psychology of aesthetics but also the psychology of status. In order to understand the arts the two need to be separated, and this is what hasn't been done throughout many of the long windbag discussions about art in the past. The psychology of status plays a major role in what is considered Art. Just like an expensive house and a Lamborghini, an original Picasso on the wall has no utilitarian value but indicates that you have money to burn. Pinker says, "Thorstein Veblen's and Quentin Bell's analyses of taste and fashion, in which an elite's conspicuous displays of consumption, leisure, and outrage are emulated by the rabble, sending the elite off in search of new inimitable displays, nicely explain the otherwise inexplicable oddities of the arts."[2]

Once the fashion, architecture, music, etc., is accepted by the seething masses, it is no longer elite and may no longer be considered art with a capital A. Thus, it is impossible to define art if both aspects of its psychology are left entwined, because the accepted definition is constantly changing. However, if we can separate the two, then we can deal with the aesthetic aspect of art. Both Pinker and Dissanayake include in their category of art the common and not just the rarefied products. Your kitchen plates can be as aesthetically pleasing to you as a painting. Aesthetics has little to do with the monetary value of art. In the world of Art, however, it may be beautiful, but if it is a copy, it is worthless.

Pinker goes on to point out that the psychological response to the status aspect of Art is a forbidden topic among art academicians and intellectuals. To them, it is OK to be ignorant of the sciences and math, even though

such knowledge would be beneficial to health choices. However, to prefer Wayne Newton to Mozart, or to be ignorant of some obscure reference, is as shocking as wearing your boxers (only) to a black-tie dinner. Your choice in art, your personal preference and knowledge about a leisure time activity, is used by another to make a value judgment about your character. The same does not usually happen in a discussion of hammers or chromosomes. How status became enmeshed in art is one question, and why we find something aesthetically pleasing is another.

BEAUTY AND ART

There are those who will argue that beauty has nothing to do with art. It must be because they have not separated the two different psychological responses. You don't hear, "That is the ugliest painting I've ever seen. Let's put it in the dining room." But while looking at the same awful thing in the gallery, you may hear, "This is Blah Blah's latest painting, and his last one was purchased by the Getty. I think I'll get this for our New York apartment." Camilo Cela-Conde, director of the Laboratory of Human Systematics and professor at the University of Islas Baleares, Spain, quotes the philosopher Oswald Hanfling as saying, "People who visit galleries, read poetry and so on, do it, after all, looking for beauty."[3] Symphony orchestras don't survive by having this response: "It says here in the Sunday review that this symphony is the most dissonant and jarring piece of music that the critic has ever heard, and he likens it to fingernails scratching on a blackboard. Well that sounds great! Let's go." We are going to be interested in finding out if there is a universal sense of aesthetics or beauty. Pinker asks: "What is it about the mind that lets people take pleasure in shapes and colors and sounds and jokes and stories and myths?"[2]

One dictionary definition of art is: "Human effort to imitate, supplement, alter, or counteract the work of nature. The conscious production or arrangement of sounds, colors, forms, or other elements in a manner that affects the sense of beauty, specifically the production of the beautiful in a graphic or plastic medium."[4] Nancy Aiken of Ohio University breaks art down into four components:

1. the artist who makes the work
2. the work itself
3. the observer of the work, and
4. the value the observer places on the work.[5]

The *American Heritage College Dictionary* gives four definitions of aesthetics. We are going to consider them one by one. The first definition is: "The branch of philosophy that deals with the nature and expression of beauty, as in the fine arts. In Kantian philosophy, the branch of metaphysics concerned with the laws of perception." We've got philosophers talking about what is beautiful, and they have been talking for centuries. The philosophical discussion starts with Plato's theory that beauty is independent of the observer (although it needs an observer). If something is beautiful, it just is; no one's opinions are necessary. A couple of millennia later, we have Kant, who was concerned with the aesthetic value to the perceiver: Beauty is in the eye of the beholder. Beauty is then a judgment.

Neuroscience can at least study Kant's theories about perception and aesthetic judgments.[6] So we have the stimulus (the object or artist or piece of music) and the sensual perception of the stimulus. Next comes our emotional response to the perception of the stimulus, which brings us to the second definition of aesthetics: "The study of the psychological responses to beauty and artistic experiences."

The study of psychological responses to beauty has actually been rather sparse. Research in aesthetics has suffered the same fate as research into emotion. The behaviorists and the cognitivists have neglected it, and surprisingly, it has also been neglected by the more recent emotion theorists.[7] It has been suggested that this neglect has been due to a failure to identify aesthetics as either cognition or an emotion, or even as both: It is an orphan child in the land of psychology. Aesthetics is a special class of experience, neither a type of response nor an emotion, but a modus operandi of "knowing about" the world. It is sensation with an attached positive or negative evaluation. Does this sound familiar? It is like the approach—don't approach information given to the brain before it had language. In fact, I recently heard this statement: "I like that kitchen, but I can't tell you why. I guess you have to break it down

and examine its components to figure it out."* After the emotional reaction, we get a judgment tempered by either an unconscious (hardwired) or conscious (conditioned by culture, upbringing, education, and inclination) idea of whether we think the input is beautiful.

And that takes us to the third definition of aesthetics: "A conception of what is artistically valid or beautiful." Donald Norman of Northwestern University suggests that there are three separate levels of beauty. The *surface beauty,* which is the immediate visceral reaction, is biologically determined and is consistent in people throughout the world. Then there is *beauty in operation or behavior* (how that beamer handles on the autobahn). Last is the *beauty in depth, in meaning, and implication,* which Norman calls reflective. Reflective beauty is conscious and is influenced by the individual's culture, education, memory, and experience—everything that goes into you as a person.[8] Thus there are two different types of aesthetic judgment, one visceral and automatic, the other conscious and contemplative.

And finally we arrive at the fourth definition of aesthetics: "An artistically beautiful or pleasing appearance." Nicholas Humphrey[†] tackles the question of beauty from the perceptual end by attempting to define the particular perceptual quality that things of beauty have in common. He proceeds by searching for the essence of beauty in the relations formed between the perceived elements. We can listen to a melody and think it is beautiful, but we don't think a B-flat is beautiful by itself, and an A is beautiful, and so on. It is the combination, the relations among the different notes, that are beautiful. But this doesn't really help us out all that much. Sure, we can say the relation is beautiful, but what relations are important? Why are they important? Why isn't an endless trill of B-flat and A beautiful, whereas a quick little flourish of it in the right spot is?

Humphrey calls on the poet Gerard Manley Hopkins. Hopkins defined beauty as likeness tempered with difference. Humphrey goes on to

*Maureen Gazzaniga.

†Humphrey said, "I argue that the higher intellectual faculties of primates have evolved as an adaptation to the complexities of social living." N. K. Humphrey, The social function of intellect. In P. P. G. Bateson and R. A. Hinde (eds.), *Growing Points in Ethnology* (Cambridge: Cambridge University Press, 1976).

build a hypothesis that "aesthetic preferences stem from a predisposition among animals and men to seek out experiences through which they may learn to classify the objects in the world about them. Beautiful 'structures' in nature or in art are those which facilitate the task of classification by presenting evidence of the 'taxonomic' relations between things in a way which is informative and easy to grasp."[9] Humphrey is hinting that our ability to make aesthetic judgments is fundamental to learning.

In the nineteenth century, Gerard Manley Hopkins didn't have neuroscience to help him out, nor did Plato in his day. But things have changed and gotten more interesting. Psychologists Rolf Reber, Norbert Schwarz, and Piotr Winkielman, from the University of Bergen, Norway, the University of Michigan, and the University of California, San Diego, respectively, tackle the question of beauty through neural processing. They propose that beauty, as defined by aesthetic pleasure, is a function of the perceiver's processing dynamics. The more fluently perceivers can mentally process an object, the more positive their aesthetic response. This theory has four assumptions:

1. Some objects are processed more easily than others because they contain certain features the brain is hardwired to process, which it does quickly, such as symmetry. (These are features we will run into later.) But the ease of processing can also be influenced by perceptual or conceptual priming.
2. When we perceive something we process easily, we get a positive feeling.
3. This positive feeling contributes to our value judgment as to whether something is pleasing or not, unless we question the informational value of this input.
4. The impact of the fluency is moderated by your expectations or what you attribute it to. If you go shopping at Nordstrom and enjoy the piano playing while you are shopping, you are in a positive mood. Then, when you see a red purse you like, you are more likely to buy it because of this positive mood. However, before we enter the store, I might tell you, "Don't let the piano playing go to your head. They just do that to put you in a

good mood so you'll buy more." Then when you see that purse, you will be more conscious about deciding whether you like it or not.

However, even though there are hardwired preferences due to ease of processing, different experiences can increase processing fluency in novel areas, and new neural connections can be made, all of which will affect aesthetic judgment.[10] Your processing fluency can be enhanced by experience. The first time you see a new architectural style, you may not like it, but after you have seen it several times, it begins to "grow on you." The beauty of this theory is that it can account for many different findings that have been puzzling. I will return to it a bit later.

Hopkins broke down the aesthetic judgment of a "beautiful" object into its perceptual and its visual or auditory components, then analyzed what he thought were factors contributing toward making his judgment, implying that these would be universal rules. Reber, Schwarz, and Winkielman assume there are some things that are innately easy to process. Norman thinks that the immediate reaction we get to surface beauty is biologically determined. Can science tell us whether there are in fact universal guidelines for aesthetic preferences that are hardwired in our brains?

Are There Universal Components to Aesthetic Judgments?

Do we share some universal preferences for certain components of aesthetic preference with other animals? If so, when did these preferences get channeled into the actual production of art? Can the past help us? Can we pinpoint when art first appeared? I won't keep you in suspense. That answer is no. The point at which our ancestors first perceived a stimulus and made a value judgment that it was beautiful is probably always going to be unknown to us. When did the first primate look up at the sunset and find it magnificent? Did this happen before we diverged from our common ancestor or afterward? Is there any evidence chimpanzees have aesthetic sensibilities? Chimpanzees will have an emotional

reaction to some natural phenomena. Jane Goodall describes a waterfall in Gombe National Park where she has observed chimps on several different occasions. After they arrive there, they do a wild dance, which involves rhythmically swaying from foot to foot, and then they sit and watch the water as it falls.[11] What is going on in the chimpanzees' brains is unknown. Are they excited, just as a child is excited to go to the beach? Do they feel the emotion of awe? Are they making an aesthetic judgment? ("I like this" does not necessarily translate to "I think this is beautiful.") Can they even make aesthetic judgments?

Artistic Chimps?

Some chimpanzees, especially when young, when given pencils or paints have become engrossed in using them, to the point of ignoring favorite foods and turning their backs on other chimps while working on a design. Chimps familiar with drawing have begged for supplies when they see their caretaker in possession of them and have thrown tantrums when stopped while painting. One untamed chimp named Alpha refused to draw with a pointed stick and would reject pencils with dull points. Obviously, some chimps like to draw and are a bit fussy about the results. Chimps also stayed within the boundaries of their paper, and one chimp would mark the corners before starting.[12] A series of three paintings by a male chimp named Congo recently sold at auction for twelve thousand pounds.[13]

Desmond Morris, who studied Congo primarily, as well as the works of other primate drawers and painters, could identify six common principles in both chimpanzee and human art. It was a self-rewarding activity, there was compositional control, there were variations in line and in theme, there was optimum heterogeneity and universal imagery.[12] Just as the art of children and untrained human adults across cultures is very similar in its imagery and appearance, the chimpanzee drawings and paintings also were similar to each other. Morris attributes universal imagery in human art partly to similarities in muscular movements of the body and to the constraints of the visual system. As an artist is trained, he gains more control over his musculature, and with practice, Morris suggests, a third influence becomes more pronounced—the psychological factor.

However, Congo was not a supreme colorist, as his paintings may suggest. If left alone with the paints, he would mix them all together until he had made brown and then would use that. He was handed brushes that had been preloaded with paint, and when that color was used up, he was handed another color. In order that the researchers might study the calligraphy of the strokes, one color was allowed to dry before another color was given to him, so that the colors and strokes would not blend. If left to his own devices, he would not allow one color to dry but would slap on the next, and the colors and strokes would become muddy. Although he would signal when he was done with a drawing, he would frequently draw on top of it if it was given to him at another time. After completing a drawing or painting, he was no longer interested in it. He wouldn't just look at it for pleasure. The drawing and painting sessions were very short, never lasting more than a few minutes per picture, presenting the question of whether the end of the picture was an aesthetic judgment or simply the end of his attention span, especially since he would draw on top of it at a different session. Interestingly, he would try various techniques, such as urinating on a painting and swishing the urine around and later using dripped water on a painting for the same effect. He tried using his grooming brush and fingernails on the paints also. Novelty was important. None of the chimpanzees that Morris studied created a recognizable pictorial image.

In discussing compositional control, Morris cites a study done by Professor Bernhard Rensch in Germany, who wondered if animals had pattern preferences. He tested four inquisitive species: two monkey species, capuchin monkeys (*Cebus*) and guenon monkeys (*Ceropithecus*), and two bird species, jackdaws and crows. He presented a series of cards with either regular rhythmic patterns or irregular markings.

After several hundred tests, Rensch found that all four species would pick up the regular patterns more frequently. He concluded: "When choosing between different black patterns on white cardboards the monkey preferred geometrical, i.e. more regular patterns, to irregular ones. It is very probable that the steadiness of the course of a line, the radial or bilateral symmetry and repetition of equal components in a pattern (rhythm) were decisive for the preference. . . . Both species of birds preferred the more regular, more symmetrical or rhythmical patterns. In

most cases the percentage of preference was statistically significant. Probably this preference is caused by the better 'complexibility,' i.e. the easier comprehensibility of symmetrical and rhythmical repetitions of the same components (Rekurrenzlust)."* Morris points out that the vital elements—symmetry, repetition, steadiness, rhythm—are the basic factors that appeal to the eye in selecting a pattern, but they also appear in the production of patterns. There is a "positive reaction to order rather than chaos, organization rather than confusion." We can see from these studies that there is a preference in numerous species for specific types of visual patterns, the same preferences that humans show. It seems that there is a biological basis to the preference for some of the components of pictorial images.

EARLIEST HUMAN ART

In order to look for the origins of artistic endeavors in our direct ancestors, we need to look at what archaeological artifacts can tell us. Obviously we will never know when the first melody was strung together and hummed merely for enjoyment. Much of decorative art is likewise ephemeral, being in the form of feathers, wood, paint, and clay. We can explore this question only by looking at artifacts that have survived: stashes of dyes, tools, shell and bone beads, and rock art, such as can be seen in the caves of southern France and the wilds of Australia. We will discuss music a bit later on.

The question of whether stone tools were a creative endeavor has spurred some controversy. Stone hand axes have been found with remains of *Homo erectus* dated from 1.4 million years ago,[14] and examples have been found dating until about 128,000 years ago. Although chimpanzees sometimes will use a stone as a tool to crack open nuts, and even may carry a particular stone from one tree to another, they have never yet been observed in the wild intentionally flaking a stone to *make* a tool.[15] The basic design of the early hand ax and its production technique remained stable over many thousands of years and across a

*The Biology of Art, p. 161.

wide geography. The axes appear to have been flaked along the path of least resistance. They show a limited degree of imposed form, rather than an imagined plan in mind. Later examples began being modified with more pleasing symmetries, distinctive twisting patterns, and different length-to-width ratios. It continues to be debated whether stone hand axes represent only a mimetic ability[16] or are the early products of a developing creative imagination.

British archaeologist Steven Mithen suggests that to fashion an ax out of a random shape of stone may indicate the presence of creativity.[15] But we aren't exactly concerned with creativity, which can produce articles of only functional quality, but with art, aesthetic appeal. Ellen Dissanayake points out that some of the hand axes made by *Homo erectus* were made of pudding stone (conglomerate), which most people would call beautiful, rather than flint, which was more abundant and easier to use. This suggests they may have had an interest in its appearance. Later axes made by early *Homo sapiens,* dated at 250,000 years ago, incorporated fossils centrally (symmetrically!) displayed in their carving. Some have been examined under an electron microscope and have been shown never to have been used.[1] Perhaps they were retained just for their aesthetic appeal. Although there is this evidence of some artistic sensibility, it appears to have been limited.

Researchers interested in the origins of human art are of two camps. Some believe there was an explosive event, some sudden and major change in human abilities and creativity that occurred about 30,000 to 40,000 years ago; others believe it was a more gradual process with roots extending back millions of years. We will leave this argument to those so inclined and will take from it the one thing that is agreed upon. There is evidence of decorative hand axes, beads, and ocher powders dating thousands of years before this period, but the overwhelming number of artifacts that have been found have their origins in the last 40,000 years. There *was* an explosion of artistic and creative activity that included cave paintings and engravings found from Australia to Europe, as many as ten thousand sculpted and engraved objects made from ivory, bone, antler, stone, wood, and clay found across Europe to Siberia, and sophisticated tools, such as sewing needles, oil lamps, harpoons, spear throwers, drills, and rope.

Many archaeologists conclude that this explosion of creativity represents a fundamental evolutionary event in the *Homo sapiens* lineage.[17] Something changed in our brain that expanded its earlier creative abilities, something unique to *Homo sapiens.* Remember from chapter 1 the genetic variant of microcephalin that arose approximately 37,000 years ago? Suddenly, about 40,000 years ago, when life could not have been easy street—with infectious diseases, hunting mishaps, shorter life spans, and no convenience stores, Prada, or Armani—anatomically modern *Homo sapiens,* in an unprecedented burst of creative and aesthetic activity, began painting pictures, wearing jewelry, and coming up with a host of new useful items. Why were they doing this, and what can this tell us about our brains?

Evolutionary Theories About the Origins of Art

Charles Darwin considered the aesthetic sense an intellectual faculty that was the result of natural selection. Nobody else thought much about this until Ellen Dissanayake came along. She proposed that art is a *biological* behavior! She based this on several observations. To begin with, song, dance, storytelling, and painting are universal in all cultures. In most societies, art is an integral part of most human activities and consumes a large portion of available resources. For example, the men of the Owerri tribe in Nigeria who build and paint ceremonial houses don't have to participate in their day jobs for up to two years. Arts give pleasure: Our motivation system seeks them out because they reward us by making us feel good. Young children spontaneously engage in dancing, drawing, and singing. Like Darwin, Dissanayake proposes that the behavior of creating art has evolved through natural selection and that the fundamental behavioral tendency that lies behind the arts is what she calls "making special."

Making something special implies intent, and the intent is to distinguish an object or action from the ordinary by appealing to the emotions through the rhythms and textures and colors that it employs. Dissanayake thinks that "making special" is a behavior that increases group cohesiveness and thus would provide a survival advantage. A cohesive group in turn could increase individual survival. She suggests that in the

past, the realm where one would want to make something out of the ordinary had to do with magic or the supernatural world, in the form of rituals, not as it is done today for a purely aesthetic motive.

Whatever one calls art, one is acknowledging that it is special in some way. Using "making special" as the major motivation of art as a behavior, one can include many behaviors and leave out the value judgments of whether it is "good art." We no longer need to think of art as being done for its own sake, which makes it easier to explain in an evolutionary context. Although many people have suggested that art's origins arose from a single motivation, such as body ornamentation, a creative impulse, relief of boredom, or communication, Dissanayake proposes that it is composed of many parts—manipulation, perception, emotion, symbolism, and cognition—and arose alongside other human characteristics, such as tool making, the need for order, language, category formation, symbol formation, self-consciousness, creating culture, sociality, and adaptability. She proposes that the creation of art in terms of human evolution was "to facilitate or sugarcoat socially important behavior, especially ceremonies, in which group values often of a sacred or spiritual nature were expressed and transmitted."*

Geoffrey Miller, who, as you may remember, studies sexual selection, thinks that the arts are the result of sexual selection. He suggests that creative individuals had higher reproductive success. He proposes that the arts are like the peacock's tail—a fitness indicator. The more intricate, complex, and extravagant an artwork was, the greater the skill that was required to produce it, and the less functional it was for survival, the better it would be as a fitness indicator. Such a work says, "I am so good at finding food and shelter that I can spend half my time doing something that has no visible survival value! Pick me to mate with and you will have some dynamite offspring who are as capable as I." Miller states, "the peacock's tail, the nightingale's song, the bowerbird's nest, the butterfly's wing, the Irish elk's antlers, the baboon's rump, and the first three Led Zeppelin albums"[18] were all examples of sexually selected fitness indicators. I guess he wasn't as impressed with "Stairway to Heaven," on *Led Zeppelin IV,* as others were.

*What Is Art For? p. 167.

Steven Pinker is not so sure that the arts have an adaptive function at all but thinks rather they are a by-product of the brain's other functions. He points out that the reasons on which Dissanayake bases her premise that the arts serve an adaptive function—they are present in most cultures, use a lot of resources, and are pleasurable—can also be said of recreational drug use, which is hardly what one would call adaptive.

From the evolutionary psychologist's point of view, the brain is motivated by needs that served biological fitness in our ancestral environment, such as food, sex and successful reproduction, safety and predator awareness, friendship, and status. When goals are attained, the body rewards us with a pleasure sensation. We hunted and caught the gazelle, we are now munching away at it, and we get a pleasurable sensation. The human brain also has the ability to understand cause and effect and uses that to attain some goals. "If I hunt the gazelle and kill it, I will have something to eat" (and unconsciously will be rewarded with a pleasure sensation). Pinker thinks that the brain has put that together and figured out that it can get the pleasure sensation without all the hard work of actually attaining a goal. One way of doing this is taking recreational drugs; another way is through the senses that were designed to give off pleasure signals when they came across a fitness-enhancing sensation. Thus we get a pleasure signal when we eat something sweet and full of fat, a jelly doughnut for instance.

In our ancestral environment, it would have been fitness-enhancing to have a motivation to find and eat sweet food (ripe fruit) and fats, because they were hard to find and were good for survival. However, we know where that road leads today, when food is abundant. We are still motivated by the pleasure that we feel when we eat sweets and fats, although it is no longer adaptive to have such a strong motivation that is difficult to deny. Recreational drugs can also elicit a pleasurable feeling without having to do the work of attaining a goal. Listening to music gives us pleasure but doesn't appear to enhance fitness . . . or does it? Pinker, however, does not have a closed mind. He is listening to John Tooby and Leda Cosmides, directors of the Center for Evolutionary Psychology at the University of California, Santa Barabara. They have another idea, and he is looking interested.

Something Odd Is Going On

Tooby and Cosmides originally were also of the opinion that the arts were a by-product, but now they don't think that theory answers all the questions. They state, "Almost all the phenomena that are central to the humanities are puzzling anomalies from an evolutionary perspective."[19] Especially odd is what they call the *attraction to the fictional experience,* whether it is in a story, a drama, a painting, or other products of the imagination. If these phenomena didn't exist cross-culturally (involvement with fictional, imaginary worlds is another one of those human universals), no evolutionary psychologist would have predicted them.

Another item in the list of odd phenomena is that the involvement with imaginative arts is self-rewarding without an *obvious* functional payoff. Why do people sit around and watch sitcoms or read novels or listen to stories? Is it just a waste of time? Are they just a bunch of lazy couch potatoes? Why does the brain contain reward systems that make fictional experiences enjoyable? Why would we rather read a mystery story on a rainy afternoon than the repair manual for our car, which could prove more useful? And why, when we read a story or watch a movie, do some of our psychological responses kick in but not others? Why will we react emotionally but not physically? The movie may scare us, but we don't run out of the theater. If we are scared, why don't we run? Why hasn't that unconscious reaction kicked in, as it would if we saw a snake? However, we may remember the movie and act on the memory: We may not close the shower door after seeing *Psycho.* It seems that humans have a specialized system that allows us to enter imaginary worlds.

The neural machinery that permits this play in imaginary worlds can be selectively impaired. Children with autism have severely limited imagination, which suggests that it is a specialized subsystem, not a product of general intelligence, which usually is normal in autism. In children, pretend play begins to appear at about eighteen months, the same time that they begin to understand the existence of other minds. How is an infant able to understand that a banana is something he can eat, but can also be a faux telephone? No one takes him aside one day and says, "Son, a banana is a piece of food, but because it is shaped like a telephone

receiver, we can pretend . . . wait a minute, *pretend* is what I am trying to explain, ah, we can substitute a banana for a telephone receiver, it won't really work, but if we want to play, I mean. . . ." How does the child understand faux anything? How does he know what is real and what isn't?

Separating Pretense from Reality

Alan Leslie of Rutgers University proposed a special cognitive system that separates pretense from reality: a decoupling mechanism. He wrote: "The perceiving, thinking organism ought, as far as possible, to get things right. Yet pretense flies in the face of this fundamental principle. In pretense we deliberately distort reality. How odd then that this ability is not the sober culmination of intellectual development but instead makes its appearance playfully and precociously at the very beginning of childhood."[20] Tooby and Cosmides conclude that the fact we have adaptations that prevent the mistaking of fact and fiction, and that there seems to be a reward system that allows us to enjoy fiction, implies that there is a *benefit* to the fictional experience. Good news for the authors of fiction! What could it be?

In order to navigate the world successfully, one needs accurate information. Survival depends on it. People in general should prefer to read nonfiction rather than fiction, but instead, they would rather watch a fictional movie than a documentary; they prefer to read a historical novel rather than a history book. However, when we really do want accurate information, we go to the encyclopedia rather than to Danielle Steele.

Enhancing Fitness

Why do we have this appetite for the imaginary? To answer this question and the question of why we evolved aesthetic reactions, Tooby and Cosmides remind us that fitness-enhancing adaptive changes can be made in three ways. They can be made to the external world, with actions or appearances that increase sexual encounters (à la Miller's sexual selection theory). These changes include cooperation (Dissanayake's theory) and other mutual behaviors, like aggressive defense, habitat selection, and feeding your infant. Adaptive changes can also be made so as to in-

crease the fitness of the body, such as the pleasure reward for eating sugar and fat, vomiting to get rid of toxic food, and sleeping. Last, changes can be made to the brain. Fitness-enhancing changes to the brain include capacities for play and learning. And here is where Tooby and Cosmides think our search should concentrate.

> We think that the task of organizing the brain both physically and informationally, over the course of the lifespan, is the most demanding adaptive problem posed by human development. Building the brain, and readying each of its adaptations to perform its function as well as possible is, we believe, a vastly underrated adaptive problem. We think that there is an entire suite of developmental adaptations that have evolved to solve these adaptive problems, and that the possible existence of many of these adaptations has gone largely unexamined. Thus, in addition to world-targeted and body-targeted aesthetics, there is a complex realm of brain-targeted aesthetics as well.[19]

Do aesthetic experiences make our brains work better? Did Humphrey hit it on the head? Was he right when he hinted that aesthetics was fundamental to learning?

We are born with brains that have a lot of hardwired systems, but unlike computers, the more software you load into them and the more internal connections that are forged, the faster and better they work. For instance, we have language systems ready to learn a language, but the specific language is not encoded. The hardware is there, but the software isn't. Some of the information necessary for the development of the adaptation of language is economically stored in the external world; you have to input it. The genome does not have to be so complex if reliable information can be stored in the outside world. This is true not only for language but also for parts of the visual system and other systems. Tooby and Cosmides believe that we may have aesthetic motivations that have evolved to serve as a guidance system to prod us to seek, detect, and experience different aspects of the world, which will help our adaptations reach their full capacities. We get rewarded with a pleasurable feeling when we do this.

With this in mind, the two researchers suggest that a neurocognitive adaptation may have two modes. One is a functional mode. Once it is up and running, it does what it has been designed to do. The functional mode of the language system is speaking. The other mode is an organizational mode, which is what builds the adaptation and assembles what is necessary for the functional mode to start working, as when a baby babbles to develop its language system. The organizational mode is necessary to produce the functional mode. The famous example of not stimulating the organizational mode is Victor of Aveyron (François Truffaut's *L'Enfant Sauvage*), the young boy who was found living alone in the wilds of France in 1797. Three years later, at the estimated age of twelve, he allowed himself to be cared for by other humans. However, he was never able to learn language beyond a couple of words. It is now understood that in order to learn to speak, one must be exposed to language at an early age. There appears to be a critical period in which one must be exposed to a particular stimulus. Critical periods of learning are also documented in birds. A young chaffinch must hear an adult singing before it sexually matures, or it will never properly learn the highly intricate song.[21]

Critical periods have been identified to construct other adaptations, such as binocular vision. The critical period for the development of a human child's binocular vision is thought to be between one and three years of age.[22] The organizational mode of each different adaptation is expected to have a different aesthetic component. In this way, Tooby and Cosmides explain that aesthetically driven behavior only seems to be nonutilitarian because we are analyzing it from the aspect of changes adaptive to the *external* world, not to the *internal* world of the brain. We see some nonutilitarian behavior, such as dancing, but we don't see how that affects the development of the brain. "Natural selection, a relentless but devious task-master, seduces you into devoting your free time to these improving activities by making them gratifying." It is fun—that is, it feels good—to dance, so we do it. This happens when the external price is not too great and we are not concerned with competing for food, sex, and shelter. These circumstances are most often present when we are children.

Tooby and Cosmides' conclusion is a most important aspect of this

discussion: "The payoff on such investments is *greater earlier in the life-cycle*, when competing opportunities are lower, the adaptations less well developed, and the individual can expect to benefit over a longer subsequent lifespan from her investment in increased neuro-cognitive organization. For this reason we expect that children should live according to behaviorally imperative aesthetic sensibilities in an aesthetics-drenched world, although their standards of the fun and the beautiful will be somewhat different from our own." It is interesting to note that the male chimpanzees, as they matured and started to vie for mates and social position, were less inclined to paint.[12] The external costs were becoming too great.

Tooby and Cosmides' answer to the nature-versus-nurture argument, which really should be put to bed, is that we have genes that code for certain adaptations (nature), but in order to realize their full potential, certain exterior conditions need to be met (nurture). "Innate ideas (and motivations) are incomplete ideas. . . . Our evolved inheritance is very rich compared to a blank slate, but very impoverished compared to a fully realized person." They think the arts are not frosting but baking soda.

The two go on to propose an evolutionary theory of beauty, which they concede is not very informative. "A human should find something beautiful because it exhibits cues which, in the environment in which humans evolved, signaled that it would have been advantageous to pay sustained sensory attention to it, in the absence of instrumental reasons for doing so. This includes everything from members of the opposite sex to game animals to the exhibition by others of intricate skills. . . . However, the class of beautiful entities is immense and heterogeneous, with no other unifying principle except that our evolved psychological architecture is designed to motivate sustained attention to them through making the experience intrinsically rewarding." They don't believe there is a general prescription for beauty, but there are several subsets that have strict principles that differ for different applications, such as sexual attractiveness, and landscape.

An example they use is that many natural phenomena are considered beautiful, such as a starry night, natural landscapes, the pattering of rain, and running water. As we sit in the chaise longue on a warm

evening, or lean back from the campfire and gaze up at the desert sky (where we can actually see the stars), or lean back in our chair while gazing up at a leafy plane tree and listening to a fountain's burble in a square in Aix-en-Provence, what we experience is the pleasure (emotionally positive response) of relaxed attention. But why is it relaxed? They think this is caused by an organizational mode adaptation that provides us with an innate program for these invariable phenomena. We unconsciously know what they should sound or look like. They are the default mode, and they are aesthetically pleasing. They are used as test patterns against which actual perceptions are compared. The scene agrees with the innate principle of babbling brook and leafy green tree. It is when a stimulus varies from the programmed default that increased attention is aroused. When the birds and frogs stop chirping, when the stars disappear, and when the babble becomes a roar, our attention becomes focused.

So what does this all have to do with our attraction to fictional experience? Tooby and Cosmides suggest that it increases the opportunities in which adaptation-organizing experiences can occur: nurture building on nature. Pretend play, such as hide-and-seek, can develop skills that are better learned in a play situation than when they may need to be actually used. It would be fitness enhancing to learn to hide or run from a predator, or stalk and search for food, before one actually needs to do it for survival. If you recall, one thing that is correlated with brain size is amount of play. We discussed play in terms of practice for real life, stress reduction, and sexual selection, but not in terms of imagination. From having read the fictional story about the boy who cried wolf when we were children, we can remember what happened to him in the story and not have to learn that lesson the hard way in real life. The more fictional stories we hear, the more circumstances we become familiar with, without having to actually experience them. If we do run across the same circumstances in life, then we will have a wealth of background info to draw from. "This same thing happened to Sally in that movie. What did she do? Oh yeah . . . that worked out pretty well, I think I'll try that." It is interesting to note that throughout world literature, there appears to be a limited number of scenarios, and they are all related to evolutionary concerns, such as protection from predators, parental investment, proper

relationships with kin and non-kin, and mate selection, to name a few, and all fiction draws on these.[23]

Becoming Mentally Flexible

The core ability that enables us to use all this fictional information is the decoupling device separating pretense from reality in our brains, which Leslie proposed. This device appears to be uniquely human. Tooby and Cosmides comment that humans are radically different from other species in the amount of *contingently true information* we use. We can categorize information as always true, true only on Thursdays, true only when told by a related person, true if done before winter, true if you are talking about orange trees but not plum trees, used to be true but isn't now, true in the mountains but not in the desert, true about lions but not about gazelles, true when Josh is talking about Sarah but not about Gabby, etc. *Our ability to use contingently true information is unique.* Our brains store not just absolute facts but information that may be true only temporarily or locally or to a specific individual. And we can break information down into component parts and keep this info stored and separated from other info. We can mix and match info from different times, places, and input types, and we can make inferences based on the source. This allows us to separate fact from fiction, and also to know that the store is open every day in the summer but not in the winter. This has allowed us to be very flexible and adapt to different environments.

Joseph Carroll, an English professor at the University of Missouri interested in Darwinian theory, points out:

> To the modern human mind, alone among all minds in the animal kingdom, the world does not present itself as a series of rigidly defined stimuli releasing a narrow repertory of stereotyped behaviors. It presents itself as a vast and perplexing array of percepts and contingent possibilities. The human mind is free to organize the elements of its perception in an infinitely diverse array of combinatorial possibilities. And most of those potential forms of organization, like most major mutations, would be fatal. Freedom is the key to human success, and it is also an invitation to disaster. This is the insight that

governs E. O. Wilson's penetrating explanation for the adaptive function of the arts. "There was not enough time for human heredity to cope with the vastness of new contingent possibilities revealed by high intelligence. . . . The arts filled the gap."[24]

So the arts may be useful as a form of learning. As Humphrey suggested, they help us categorize, they increase our predictive power, and they help us react well in different situations—and thus as Tooby and Cosmides suggest, they do contribute to survival.

AND WHAT ABOUT BEAUTY? IT'S BIOLOGIC, BABY!

It boils down to this: What people find beautiful is not arbitrary or random but has evolved over millions of years of hominid sensory, perceptual, and cognitive development. Sensations and perceptions that have adaptive value (i.e., that enhance safety, survival, and reproduction) often become aesthetically preferred. What evidence do we have for this? To begin with, remember that every decision is funneled through the approach-or-withdraw module in the brain: Is it safe or not? And these decisions happen fast.

You'll recall that people have an instantaneous reaction, using what Jonathan Haidt calls the like-o-meter.[25] For instance, people will judge whether they like or dislike a Web page in 0.5 seconds, and the stronger their evaluation the faster it happens.[26] What is it that influences how our like-o-meter reacts? What are the physical elements in a visual or auditory stimulus that make one like it, dislike it, or respond fearfully to it?

More is known about the visual system than about other systems. There seem to be certain elements that can be extracted from an image extremely quickly. A preference for symmetry has been shown to exist cross-culturally,[27, 28] and has also been found in other animals, as I have mentioned earlier. It also plays a role in mate selection. Symmetry is associated with mating success or sexual attractiveness in many species, including humans.[29] For example, symmetry in both sexes is associated

with increased genetic, physical, and mental health.[30] Men with symmetrical features have greater facial attractiveness[31] and lower metabolic rates,[32] attract a greater number of sexual partners, have sex at an earlier age,[33] and have more extra-pair copulations.[34] In women, asymmetry is correlated with increased health risks,[35] while symmetry is associated with higher fertility [32, 36, 37] and facial attractiveness.[38] Ovulating women are more attracted to the body scent of symmetrical men, and symmetrical men are more muscular and active.[39] The voices of both men and women with greater bilateral symmetry were rated as more attractive by members of both sexes than those with asymmetrical traits.[40] Symmetry seems to be an important indicator of genetic quality and attractiveness for potential mates of both sexes. It seems the preference for symmetry has its roots in biology and sexual selection. Reber, Schwarz, and Winkielman suggest that it is not symmetry per se that is preferred, but the fact that it has less information and is easier to process.[10]

It also appears that when one is judging the attractiveness of human faces, beauty is not all in the eye of the beholder. Faces judged attractive in one culture are also judged attractive by other cultures.[41, 42] This makes sense if biologically relevant characteristics are revealed by attractiveness.

Babies as young as six months old prefer to look at attractive (as judged by adults' preferences) faces. This effect is independent of race, gender, and age; it indicates an innate sense of what a human judges to be attractive.[43] Women with more attractive, healthy, feminine faces have higher estrogen levels and thus reproduce better.[44] Sexual selection has provided an aesthetic concept for facial attractiveness.

People also like curved objects better than angular ones. Researchers correctly predicted that emotionally neutral objects with primarily pointed features and sharp angles would be less well liked than corresponding objects with curved features (e.g., a guitar with a sharp-angled contour compared to a guitar with a curved contour). The rationale for this prediction was that sharp transitions in a contour might convey a sense of threat, on either a conscious or a nonconscious level, and would trigger a negative bias.[45] Or is it because curves are processed more easily?

Humans easily make aesthetic judgments about shapes. Richard Latto

coined the term *aesthetic primitive* to suggest that a shape or form is aesthetically pleasing because it is more effectively and more easily processed, due to the processing properties of the human visual system.[46] To find evidence for this, he investigated a phenomenon known as the oblique effect, which he attributes to Joseph Jastrow, who first described it in 1892.[47] Observers with normal vision are better at perceiving, discriminating, and manipulating horizontal and vertical lines than oblique ones. He wondered, if people are better at perceiving them, do they like them better? Apparently so: Latto found that humans prefer pictures whose component lines are verticals and horizontals rather than oblique angles.[48]

People recognize objects faster when there is high contrast between an object and its background. Contrast makes identification easier. Objects are more easily processed with higher contrast. People also like higher-contrast pictures. Is this because they process them more easily or because of the contrast per se? If stimuli are presented quickly, people prefer the high contrast, but if they are given more time to decide, the preference weakens. Reber, Schwarz, and Winkielman have found that contrast influenced aesthetic judgments only at short exposure times. If someone is given more time to process a picture, then the ease of processing is no longer a factor in the decision,[10] so it is not the objective factor of contrast that caused the earlier decision, but the fluency of the processing.

We also appear to have an innate preference for natural landscapes. When comparing urban landscapes, people prefer those that contain some vegetation.[49, 50] Hospital patients with views of outside trees feel better, recover faster, and require less pain medication than those looking out on a brick wall.[51] What is really interesting is that we have a preference for particular *types* of landscapes. People always prefer to have water in their landscapes, but when this variable is excluded, there is yet another preference. When shown a series of photographs of five natural landscapes—tropical rain forest, temperate deciduous forest, coniferous forest, savanna, and desert—the youngest subjects (those in the third and fifth grades) picked the savanna as a preferred landscape. Older subjects equally preferred those landscapes with which they were familiar, as well as the savanna.[52] People were happier viewing scenes

with trees rather than inanimate objects, and also preferred the shapes of trees with spreading canopies, similar to those found on the African savanna, rather than rounded or columnar ones. This was true even of people who were raised in areas where round or columnar trees were dominant.[53]

Gordon Orians, an emeritus professor of ecology at the University of Washington, formulated the savanna hypothesis. He proposed that human aesthetic responses to trees with spreading forms would be based on innate knowledge (of our ancestral habitat) of the shapes of trees that would be associated with productive human habitats in our ancestral landscapes.[54]

What is it about natural landscapes that attract the brain? Can you say fractals? Nature's patterns are not the simple shapes we learned in geometry class. Trees are not triangles, and clouds are not rectangles. We learned to find the areas of squares and circles and triangles, and the volumes of cubes and cones and spheres. That was Euclidian geometry, and this is a whole other ball of wax. We did not learn to find the area of a tree's branches or the volume of a cloud (luckily). Nature's forms are more complex.

Many natural objects have what is known as fractal* geometry, consisting of patterns that recur at increasing magnification. Mountains, clouds, coastlines, rivers with all their tributaries, and branching trees all have fractal geometry, as do our circulatory system and our lungs. For instance, we can see the veins on a leaflet, then the leaflets that make up a leaf and the leaves on a branch and the branches that make up a tree. If I gave you an empty piece of paper and asked you to draw a branching tree on it, how could you describe to me how dense the branching is that you drew? Well, there is a measurement called D. The empty paper would have a D of 1. A completely blackened paper would have a D of 2. Somewhere in between

*Natural (nonmathematical) definition: A geometric figure or natural object that combines the following characteristics: (a) its parts have the same form or structure as the whole, except that they are at a different scale and may be slightly deformed; (b) its form is extremely irregular or fragmented, and remains so, whatever the scale of examination; (c) it contains "distinct elements" whose scales are very varied and cover a large range. From the *Mandelbrot Set Glossary and Encyclopedia,* Robert P. Munafo, Creative Communications, 1987–2006.

is the amount of branching you drew. When you show people fractal versus nonfractal patterns, 95 percent of people prefer fractal patterns.[55] Humans generally prefer scenes with a D (fractal density) of 1.3 and low complexity,[56, 57] and they have a lower stress response when observing them.[58, 59] This may explain why hospital patients improve faster in a "room with a view." They look out and see a natural fractal pattern of 1.3 D. This preference for fractal patterns with a D of 1.3 extends from natural scenes to art and photography,[60] independent of gender and cultural background.[61]

Richard Taylor, a physicist at the University of Oregon, wondered if the eye is aesthetically "tuned" to the fractals surrounding us in nature.[62] Is it some property of the visual system that makes us prefer fractals of specific dimensions? How does it discern them in complex scenes? Taylor knew two things about eyes. One was that the eye fixates predominately on the borders of objects while examining a scene, and the other was that the edge contours play a dominant role in the perception of fractals. Putting those two facts together, he figured the tuning might be through silhouettes. His group has found that people like skyline scenes with fractal values of 1.3![63] He suggests that it might not be merely that people like natural scenes but that they like any scenes with the right fractal value. Gerard Manly Hopkins's "likeness tempered with difference" actually has a specific D number. If this is so, then designing architecture and objects with this fractal value would make them more pleasing to the human psyche and perhaps lead to less stressful urban landscapes.

So there is plenty of evidence that there are some hardwired processes that are influencing our preferences and our visceral reactions. But we all know that some of our aesthetic preferences have changed as we have gotten older or perhaps studied some form of art. We didn't like opera, but now we do. We didn't like Asian art, but now we do. We didn't like Andy Warhol, and we still don't. We used to like colonial furniture, and now we don't. Our preferences evolve over time. What causes them to change?

The fluency theory of Reber and his colleagues suggests that the various preferences described above are things our brains have evolved to process quickly, and when we process something quickly, we get a positive

response. We process the fractal D 1.3 quickly and get a positive reaction. They have been able to measure this. Positive emotional responses increase activity over the zygomaticus major, or smiling muscle, in our faces. This response can be measured with electromyography. When we see something that our brain processes with high fluency, we actually get increased activity in this muscle way before a judgment about it is made. We get a little positive priming action for the judgment we are about to make. They have shown that this positive emotional response then contributes to the aesthetic judgment, "Yes, that's good, I like it." So the basis for our aesthetic judgment is not the fluency alone, but fluency coupled with the positive response that one feels when something is processed quickly.[10] This means that what we like is the process, not the stimulus. Plato was wrong, beauty is not independent of the observer. It can also explain why, if someone tells you, "You aren't going to like this!" before you process it, the negative bias may overwhelm the positive one you would have received on your own.

We like things that are familiar. We have all had the experience of not really liking something the first time we have seen it or heard it, but over time it has "grown on us." We increase our processing fluency with increased exposure. The liking of familiar things and wariness of the new obviously can be adaptive. In exposing ourselves to the unfamiliar, our memory, learning, and culture are involved. They are supplying past data about what we are exposed to, or forging new neural connections to accommodate new information, or speeding up the processing of recently novel stimuli. This is another type of fluency besides perception. This is conceptual fluency: the meaning of a stimulus. Sometimes more complex stimuli are necessary to convey meaning. This is what Donald Norman was referring to as beauty in depth, in meaning and implication—reflective beauty.

Neural Correlates of Beauty

What is going on in the brain when it observes aesthetically pleasing sights? Hideaki Kawabata and Semir Zeki at University College London had some university students with no specific art education look at three hundred different paintings, then rank on a scale of 1 to 10 whether

they were ugly, neutral, or beautiful. Different subjects picked different paintings, and some paintings that were in the beautiful category for one person were in the ugly category for another. Then a few days later, each student had an fMRI scan while looking at the pictures she or he had ranked most beautiful, most ugly, and neutral. By having the students themselves decide the categories before the viewing, Kawabata and Zeki could scan them knowing whether the student thought it an aesthetically pleasing painting or not.

They postulated that because beauty and ugliness were extremes of a continuum, instead of separate areas of the brain functioning for the two different judgments, it was just as likely that there might be a difference in the intensity of an activation of the same areas. They found when subjects were viewing the paintings, the orbitofrontal cortex, which is known to be engaged during the perception of rewarding stimuli, was active, and it was more active when viewing a beautiful painting. The motor cortex was also active, becoming more active when viewing an ugly painting, as it is with other unpleasant stimuli, such as transgressions of social norms, and with fearful stimuli, including scary voices and faces, and anger.[6] This makes sense when we remember that we are directly wired to be best and fastest at avoiding danger, which our emotions categorize as unpleasant or negative.

However, in Kawabata and Zeki's experiment, the aesthetic judgment had already been made. It seems more likely that what they learned was what areas were used after the judgment had been made. Camilo Cela-Conde and his group wondered whether part of the prefrontal cortex, the most evolutionarily advanced part of the human brain, was active in the actual aesthetic judgment. They were curious about the fact that there was a great proliferation of art about 35,000 years ago, and wondered if this had anything to do with changes in the prefrontal cortex. They designed their study differently than Kawabata and Zeki. They had some people look at pictures of artwork of different styles, and photographs of different landscapes both natural and urban, and scanned their brains as they were doing so. If subjects found the picture beautiful, they raised their finger. Because the experiment was set up in this way, these subjects were also deciding what they thought was beautiful, but deciding it while being scanned.

By watching what areas of the brain were being used over a period of time, Cela-Conde and his colleagues could track the input from the visual system and see where it went. Cool, huh? They were able to confirm what others had found about the visual system, that it indeed has different stages in the processing of forms and that there was activation beyond the visual system in the prefrontal cortex. The dorsolateral prefrontal cortex (dlPFC) is known to be critical for the monitoring of events in the working memory and, along with the cingulated cortex, is known to be active in decision making. In this case, the cingulated cortex was active in deciding between beautiful and not beautiful, but the dlPFC was active only when the decision was "beautiful." They also found that when something was judged beautiful, there was more activity in the left hemisphere. This activation of the prefrontal cortex in deciding that something is beautiful supports the hypothesis that a change in the prefrontal cortex allowed artistic profusion in anatomically modern *Homo sapiens,* and to a limited extent in Neanderthals.

They also suggest that because the left hemisphere was more active in aesthetic judgments, cerebral dominance may have a role.[3]

It seems that when something is deemed beautiful, we have more than an emotional reaction. Other parts of our brain are engaged, parts that are more evolved in us than in other species. We should be glad that our dogs don't have the same aesthetic sense. If they were influenced by beauty, there might not be that unconditional love thing with them. We might have to get out of our paint-streaked jeans, get a haircut, or put on makeup for them to wag their tails. We might have to go on a diet.

WHAT ABOUT MUSIC?

Marc Hauser at Harvard and Josh McDermott at MIT, among many others, classify music as a uniquely human endeavor.[64] Only humans compose music, learn to play musical instruments, and then play them together in cooperative (usually) ensembles, bands, and orchestras. None of the other great apes create music or sing. Too bad, or *Greystoke: the Legend of Tarzan* could have been a musical. That means that our common ancestor didn't sing.

What about birdcalls? They certainly sound like music. Hauser and McDermott say birdsong is a different kettle of fish. Birds sing only in certain contexts: mating and territorial defense. Singing is done primarily by males, and its sole function is for communication. This also seems to be true of whales. It is not done for pure enjoyment. Apparently, birds don't sing alone in the shower. And birds don't change their scales or the key in which they sing. There are no telephone-line quartets tweeting harmonies in the bird world. You see a canyon wren; you hear the descending call of a canyon wren. A canyon wren doesn't all of a sudden change its song from the key of C to A-sharp minor and add a little rhumba beat at the end.

Songbirds are a bit more variable. Some songbird species can mimic and learn the calls of other species and may splice parts of one call with another, although they prefer the calls of their own species.[65] There are, however, limitations of various kinds with different species of birds, and no bird species is equally able to acquire new songs at any time of its life. There are sensitive periods when they are able to learn songs more readily.

It is interesting to consider, however, that just as birds have constraints on their auditory systems and what and when they sing, and on when and how they learn and remember their songs, so we too have constraints on our auditory system, on what we consider pleasing music, and on when and how we learn to play and remember it—and we may share some of these constraints with other animals. Comparative studies of these constraints are just beginning.

However, there is something unique going on in our brains that has picked up the tempo, so to speak. We compose new music, play it, and listen to it not just to attract chicks, pay the bills, or impress our friends. We can pick up the fiddle and fire off a tune when we are alone, just for the sheer pleasure of it. Inventing and playing music uses all our cognitive machinery, as anyone knows who has learned to play. It is not an easy assignment. Perception, learning and memory, attention, motor action, emotion, abstraction, and theory of mind are all harnessed into action. Music is another one of those human universals.[66, 67, 68] Every culture in the present and in the past has had some form of music. People like to boogie. Perhaps the oldest musical instrument that has been

found is a fragment of a bone flute made from the femur of the now-extinct European bear. It was excavated in 1995 by paleontologist Ivan Turk in a Neanderthal burial mound in Divje Babe, Slovenia. Whether this is truly a flute is controversial. It has been determined to be around 50,000 years old. In all likelihood, there were probably drums from earlier dates that were made of materials that have not been preserved.[69] To the consternation of those who attribute the tonal octave to relatively recent western music, still playable 9,000-year-old flutes have been found in Jiahu, China. These flutes sound tonal scales, one of them an octave.[70]

We Are All Musicians

The adaptive theories of music have explanations similar to the ones we heard for visual art. Steven Pinker ruffled feathers, as only he can do, a few years ago when he wrote that he suspected that music was auditory cheesecake and that perhaps it had no adaptive purpose but was a by-product of other functions.[2] Cheesecake? Many disagree with his conclusion and think music serves an adaptive function. Like the other arts, perhaps it has been sexually selected to attract mates (the arguably adaptable Mick Jagger effect) and to signal mate quality, as the sexual-selection advocate, Geoffrey Miller, suggests.[18] Or maybe it acted as a social bonding system, much like language, that synchronized mood and perhaps prepared the group to act in unison, thus binding coalitions and groups.[69, 71] But if these were true, why would anyone play music when they were alone? Research on this topic is in its infancy, and there is no widely accepted concept.

Once again, Darwin had something to say. He suspected that music may originally have been adaptive as a form of communication, a protolanguage, that later was replaced by language. If that was true, music now is a "fossil" of a former adaptation. Tecumseh Fitch, a linguist from University of St. Andrews, Scotland, following Darwin's reasoning, suggests that that would put music in a subtle category of former adaptations having a biologically grounded cognitive domain that are currently being used not as originally selected for but not in a completely different manner either.[72]

Speech shares many features with music and also with primate vo-
calizations, such as pitch, timbre, rhythm, and changes in volume and
frequency. These are all things that we are good at identifying even with-
out musical training. You may think that you don't know anything about
these aspects of music, but if I ask you to sing your favorite song, you will
be able to do it pretty well. In fact, when Dan Levitin, a former rock-and-
roll music producer turned neuroscientist and now a professor at McGill
University, asked students to sing their favorite song, they easily repro-
duced the pitch and tempo of songs.[73, 74] If I play a note on a piano and
the same note on a violin, you will be able to tell which is which. That
means that you can recognize the timbre of the note. In fact, you knew
all that stuff when you were a baby.

Sandra Trehub, who studies the developmental origins of music in
infants at the University of Toronto, summarizes findings that babies
from at least six months old have relative pitch: They can recognize a
melody even if it is played in a different key.[75] The only time any other
mammal has demonstrated relative pitch was in one experiment done on
only two rhesus monkeys.[76] But they weren't as good as babies. They
could recognize melodies played an octave apart as being the same, but
not if they were played in different keys or in an atonal scale. Babies also
recognize melodies if they are played at different tempos. This is not
because they can't tell the difference between them; they are very dis-
criminating. They can differentiate between semitones in a scale,
changes in the timbre, tempo, meter, and grouping of notes, and dura-
tion. They can tell consonance from dissonance from the age of two
months, and they prefer consonance and harmonic music to dissonant.*
This does not appear to be culturally engendered, but that has been dif-
ficult to prove. Babies who have never heard any form of music are rare.
Even fetuses respond to music with changes of heart rate.[77]

Music has proven to be a difficult research topic because it has all
those components I have already mentioned: pitch, timbre, meter,
rhythm, harmony, melody, loudness, and tempo. These are part of musical
syntax and are also part of verbal syntax.

*The researchers suggest that babies have these preferences even earlier, but the
researchers have as yet been unable to figure out how to test them any younger.

Have you ever tried to speak a foreign language? Trying to be social with a bus driver in Italy on a rainy day, I asked, "Dov'e il sole?" a short and simple sentence. He looked at me puzzled. I thought to myself, *I know I have the words right. He must just be perverse in not recognizing them.* But then I thought about all the times someone has said something to me in English with a foreign cadence and I haven't been able to understand him or her. The words were correct, but the emphasis was on the wrong syllables, or the wrong word in the sentence was emphasized, or the words ran together incorrectly. I realized I had pronounced *sole* with the accent on the second syllable, as if I were saying *soleil* in French, rather than on the first syllable. Think of the sentence "Sunday was a lovely day for sailing," but say it as if it were written "Sun daywas, a love lyday forsai ling." Your companion would look puzzled too. Prosody is the musical cues of language: melody, meter, rhythm, and timbre. Prosody helps delineate the word and phrase boundaries. Some languages are very melodic, like Italian. Some languages, such as Chinese, are tonal, which means that the same word means different things just by varying the pitch. Some researchers think that the brain, at least at an early age, treats language as a special case of music.[78]

We know that music can convey emotion, just as some animal calls can. However, music can convey meaning other than emotion.[79] It can actually prime you for the recognition of words. There is a way to measure with an EEG how semantically similar the brain recognizes words to be. Just as when a person is presented with a sentence such as "The sky is blue," and then recognizes the word *color* afterward as being more closely related than the word *billboard,* a certain passage of music will prime you to afterward recognize certain words as being more semantically related to the music than others. For example, after hearing musical notes that sound like a clap of thunder, you would find the word *thunder* more related than the word *pencil.* In fact, when words were presented that the composer, by his own admission, was trying to convey, such as *stitch* (as in sewing), they were actually the words that the listener found to be related. Many musical sounds are universally recognized to convey certain meanings. Like language, music has phrase structure and recursion. You can create an endless variety of musical

phrases by putting together different notes and groups of notes. Just as humans are easily able to assemble phrases into an infinite number of meaningful sentences, we are able to structure and process multiple musical phrases. It appears that humans are the only animals with the ability to do this both verbally and musically.[80]

Music and language also share some of the same neural areas. Dan Levitin, working with Vinod Menon at Stanford, has found two regions of the frontal lobe* that are closely associated with the processing of language and are also active when listening to classical music with no accompanying song. They speculate that this area is used to process stimuli that evolve over time, not only words but musical notes.[81] Other researchers have found that if you hear a chord that is not "right," something your brain does not expect to hear, an area in your right frontal cortex† is activated, as well as the area that corresponds to that area in the left frontal cortex, which is thought of as the language network.‡[82, 83] This corresponding area in the left hemisphere is also activated when you hear a phrase structure that is wrong, such as "dog walked park he." These areas appear to be sensitive to violations in expected structure, and in the left hemisphere there is an overlap between music and language processing.

Just as we like to hear a good story or look at a starry sky, we also play music because we like to hear it. What do we like to hear? As I mentioned before, we like consonance, and, though you might freak out when I tell you this, there is another fractal thing going on with music. Scaling noise is a type of sound whose quality is unaffected by how fast it is played. White noise is the simplest example. It is monotonous at any play speed. It is at one end of the spectrum of scaling noise; it is made up of completely random frequencies. At the other end is noise that is completely predictable, like a dripping faucet. In the middle is noise with what is known as 1/f spectra; it is partially random and partially predictable. The amplitude and pitch fluctuations of natural sounds, such as

*The pars orbitalis region (Brodmann area 47) of the left inferior frontal cortex and its right hemisphere counterpart.

†Brodmann area 44, the inferior lateral cortex.

‡Broca's area and the posterior temporal regions.

running water, rain, and wind, often exhibit 1/f spectra.[84, 85] In other words, large, abrupt changes in pitch or loudness occur less frequently in nature than gentle, gradual fluctuations. Most music falls into the same range of 1/f spectra.[84] Furthermore, human listeners reportedly prefer 1/f-spectra melodies to melodies with faster or slower changes in pitch and loudness. Many auditory cortical neurons are tuned to the dynamical properties of the natural acoustic environment,[86] which could explain why stimuli with naturalistic amplitude spectra are processed dramatically better than other stimuli.[87] Back to the old fluency in processing theory: We process it more easily, so we end up liking it. It's pretty interesting that both our auditory system and our visual system have this built-in preference for natural landscapes and sounds. It's also interesting that one of the dictionary definitions for art was the human effort to imitate nature.

So we are listening to some music, and it puts us in a good mood. At least the Stones do. But sometimes it makes us sad. And what about that music in *Jaws*? That made us tense. Music can actually elicit emotions.[88] In fact, you can get so emotional that you get a physiologic reaction, such as the chill down your spine and changes in your heart rate.[89] But even more interesting, you can block that reaction by getting injected with the drug nalaxone,[90] which blocks the binding of opioid receptors. It is well established the body produces a natural high by releasing its own opioid when we listen to music that we like. Nalaxone, the same drug that is given to someone who has overdosed on heroin and makes it to the ER on time, will also block the binding of the natural opiates that your body produces. The first hints of what was going on in the brain came from scans done on musicians[91] as they listened to music that gave them the "chills." The same brain structures* were activated that are active in response to other euphoria-inducing activities, such as eating food (fats and sugars), sex, and downing so-called recreational drugs.

Menon and Levitin were able to do more-specific scans with nonmusicians and found that the hypothalamus was activated (which modulates heart rate, respiration, and the "chills"), as were specific neural

*Including ventral striatum, midbrain, amygdala, orbitofrontal cortex, and ventral medial prefrontal cortex.

areas that are crucial for reward processing. They also found evidence for a correlation between dopamine release and the response to pleasant music. This is a big finding. Dopamine is known to regulate opioid transmission, and increased levels are theorized to cause positive affect.[92] This release of dopamine also happens as a reward when one drinks water and eats food, and also is the reinforcing effect of addictive drugs. Is music rewarded because it too is a survival-related stimulus? Or is it auditory cheesecake, just another recreational drug? This question has not yet been answered, but one thing is for sure: Music does increase positive affect, just as some visual stimuli do.

Increasing positive affect is a good thing, whether it is from auditory, visual, or any other sensory experience. Being in a good mood increases cognitive flexibility and facilitates creative problem solving in many different settings. It has been shown to increase verbal fluency. People with a positive affect widen category groups by finding more similarities between objects, people, or social groups, enabling a socially distinct out-group to be placed into a broader mutual in-group—"Well, I know he is a Lakers fan, but at least he loves to fish!" This results in less conflict. Having a positive affect makes tasks seem more rich and interesting. Interesting tasks make work more rewarding and induce people to find improved outcomes in problem solving. A good mood stimulates you to seek variety in safe pursuits, making you more inventive on dates. It just makes you a more pleasant and less rigid person to be around. This in itself would have adaptive potential.

Does Music Affect Our Thinking Abilities?

Spatial abilities are used to create, think of, remember, and change visual images in one's mind. For instance, looking at a two-dimensional map and being able to visualize its information in three dimensions to find one's way around in a city uses spatial ability. A few years ago, there was a suggestion that listening to certain classical music would increase your spatial abilities.[93] It became dubbed the Mozart effect. However, it proved difficult to confirm, and later studies revealed that it wasn't listening to classical music or Mozart per se that made you smarter, but rather listening to music you prefer puts you in a better

mood. When you are in a good mood, you are aroused, and this can lead to enhanced performance on a variety of tests of cognitive ability. Arousal stimuli aren't limited to music. One can be aroused by other preferred stimuli, such as a licking a glob of Nutella off your finger, or drinking a cup of coffee.[94]

Moreover, listening to music and actually taking music lessons are two different things in terms of their effect on the brain. Glenn Schellenberg, at the University of Toronto, has found in a randomly assigned group of six-year-old children who received keyboard lessons, voice lessons, drama lessons, or no lessons that music lessons in childhood are associated with small but long-lasting increases in IQ. (He incidentally found that drama lessons enhance social behavior but not IQ.) This increase was not affected by family income or parents' education, nor was it seen with other types of extracurricular studies. Learning music made you a little bit smarter. You can safely bet that these findings have sparked a great deal of interest. Proof of training in one field that generalizes to others has been hard to find.

In a detailed review of transfer effects, the ability to transfer knowledge gained in one context to another very similar context (near transfer) or dissimilar context (far transfer), Steve Ceci and colleagues[95] found little evidence in a century's worth of previous studies for far transfer. Although there is little evidence for it, there is widespread belief that far transfer occurs, and this belief is central to Western concepts of education. Schellenberg points out that the goals of formal education are not just to build skills in reading, writing, and arithmetic but to develop the capacity for reasoning and critical thinking. His data that reveal music lessons increase IQ are a rare example of far transfer and might actually contribute to this process.[96] Should we be putting band and music lessons back in school programs instead of trimming them from the budgets? Do we know what music training does for the brain? We know a little but not exactly why it may increase IQ.

We know that musicians are using many skills at one time. They are seeing notes that are written and translating them to a special motor activity that has a time line. This involves both hands and in some cases the legs and feet, the mouth, and the lungs. Musicians use intonation and timing to imply emotion, they may transpose music to different

keys, and they may improvise melodies and harmonies. Long passages are committed to memory. Musicians often sing and play at the same time. Certain brain regions in musicians are bigger than in nonmusicians. It is not known if this is due to learning to play an instrument or if children who choose to learn an instrument have neural differences to begin with, but there is much evidence to suggest that learning causes these changes. There are also greater differences in the size of certain brain regions in those who began musical training at an earlier age. For instance, violin players have a larger region for the fingers of their left hand, the effect being smaller for the thumb, which is not used to an equal extent, and the overall increase is greater in violinists who started their training at a younger age.[97] There are also corresponding size differences that correlate with the intensity of musical training throughout life. Professional musicians (keyboard players) have more gray matter volume in motor, auditory, and visual-spatial brain regions compared with amateur musicians and nonmusicians.[98] These and other similar studies suggest that musical training can increase the size of certain neural structures. There are also suggestions that along with increases of IQ, it enhances verbal memory (you'll be able to remember jokes better), motor ability (you'll be a better dancer), visual-spatial abilities (you'll be better at juggling), the ability to copy geometric figures, and possibly mathematical ability.

Helen Neville's group at the University of Oregon is currently investigating the old chicken-and-egg question: Does music *cause* improvements in cognition, or are people with strong cognitive skills more likely to make the effort to learn music? Learning music requires focused attention, abstract and relational thinking, and what is known as executive control in the brain. Do the kids who study music already have these abilities, or does learning music develop them?

Neville and her colleagues are testing groups of children aged three to five recruited from a Head Start program. Their preliminary findings are that the children in each of the music/arts groups have more significant gains in language and preliterary skills than the gains made by children in the regular Head Start group. Children who received music/arts training also displayed significant gains in attention, visual-spatial skills, and numeracy. Children in the attention-training intervention displayed a

similar pattern. If these results hold up, they suggest that training in music and the arts does improve language, attention, visual-spatial, and numeracy skills.[99]

Improving attention is also important. One aspect of attention, executive attention, concerns the mechanisms for self-regulation of cognition and emotion, such as concentration and impulse control. Being able to control emotional impulses can be lifesaving in panic situations.* How well this works is partly under genetic control, but Michael Posner and colleagues at the University of Oregon wondered if home and school environments could also exert an influence, as they do for other cognitive networks. This group has found that children aged four to six who participated in attention-training tasks improved their emotional control.[100] This improvement was equal to that garnered over the passage of developmental time. They suggest that the immature system can be trained to function in a more mature way and also argue that the effect of attention training extends to more general skills, such as those measured by intelligence tests.†

Currently a group from Boston[101] is running a long-term study with the other chicken-and-egg problem of brain size. Do children who choose to participate in musical training (piano or string instruments) show neural differences prior to training compared to a control group of children not seeking music lessons? They are also testing whether the music students have innately superior visual-spatial, verbal, or motor skills. Their third aim is to see if a test measuring musical perception before their training began correlates with any of the cognitive, motor, or neural outcomes associated with music training. Their initial screening showed there was no difference in the groups of children before beginning musical training. After the first fourteen months of study, preliminary results

*For a fun read, try: Laurence Gonzales, *Deep Survival* (New York: W. W. Norton, 2003).

†Effortful control is a highly heritable quality associated with the DAT1 gene. There is a long form and a short form of DAT1. In this study, researchers also found that children who had two copies of the long form had more effortful control, less difficulty resolving conflicts, and were less extroverted. The children who had both the long and the short forms had greater improvements in their attention with training, suggesting that targeted training may be beneficial.

in five- to seven-year-old children suggest that cognitive and brain effects from instrumental music training can be found. So far, these effects are small and are in areas that control fine motor skills and melodic discrimination.[102]

Another researcher, John Jonides, at the University of Michigan, has been testing musicians to see if they have better memories. It appears that they do, both long- and short-term memory in both visual and verbal tests. They are currently in the process of seeing if there is a close relationship between musical training, musical skill, and memory.[103]

For years, many people have thought musicians have greater mathematical skills. I would bet if you asked people on the street what cognitive advantage playing music gave to a person, this would be a very common answer. However, evidence for this is sketchy. Elizabeth Spelke is in the midst of testing mathematical abilities and music training in several different age groups. She has four different age groups: five to ten years, eight to thirteen, thirteen to eighteen, and adults. Preliminary results from those aged eight to thirteen show a significant advantage in geometric representation for the music-trained children; other results are pending.

CONCLUSION

It seems that Tooby and Cosmides are right when they suggest that children should be immersed in an aesthetically pleasing environment. But children are not the only ones to benefit. Whether you are sitting in a mountain meadow or catching alpine glow along the Seine, looking at a Bonnard or your own latest handiwork, listening to Beethoven or Neil Young, watching *Swan Lake* or showing your kids how to tango, reading Dickens or telling your own tall tale, art can put a smile on your face. We may be smiling because our cocky brain is pleased with itself, because it is fluently processing a stimulus, but you don't need to tell the artist that. The benefits to the individual and society from positive affect alone suggest that the world is a happier place if it is beautiful. I think the French figured this out a while back.

The creation of art is new to the world of animals. It is now being

recognized that this uniquely human contribution is firmly based in our biology. We share some perceptual processing abilities with other animals, and therefore we may even share what we call aesthetic preferences. But something more is going on in the human brain—something that has allowed us to engage in pretense, as Alan Leslie suggests, some connectivity change that has allowed us to decouple the true from the imaginary and, as Tooby and Cosmides suggest, to use contingently true information. This unique ability has enabled us to be very flexible and adaptable to different environments, to break out of the rigid behavioral patterns that other animals are subject to. Our imaginative ability allowed one of us thousands of years ago to look at a wall of an empty cave in France and decide to spruce it up with a little fresco, another to tell the story of the odyssey of Ulysses, another to look at a chunk of marble and see *David* trapped inside, and another to look at a strip of bay-front property and envision the Sydney Opera House. What caused this connectivity change is unknown. Was it due to a change in the prefrontal cortex as a result of some small genetic mutation, or was it a more gradual process? No one knows. Did the increasing lateralization of brain function that we will read about in chapter 8 contribute to it? Maybe.

Chapter 7

WE ALL ACT LIKE DUALISTS: THE CONVERTER FUNCTION

The centermost processes of the brain with which consciousness is presumably associated are simply not understood. They are so far beyond our comprehension that no one I know of has been able to imagine their nature.

—Roger W. Sperry, quoted by Denis Brian in
Genius Talk: Conversations with
Nobel Scientists and Other Luminaries

IN THE PERSONAL ADS IN THE DATING COLUMNS, WHEN PEOple will describe themselves or the type of person they are looking for, there might be a quick physical description such as "tall, brown eyes, brown hair, thin, athletic," but then the writer will launch into "humorous, clever, intelligent, and happy male looking for witty, charming, intelligent, caring, generous female," or something similar. These descriptions don't seem odd. It *would* seem odd if there were no description of the personality or character of either party, but instead the physical description continued, "I have a 5 percent greater amount of gray matter than average, and my left planum temporale is larger than most. I have spent years increasing my intercerebral connectivity, to the point where my latest scan rather

stunned the radiographers. I am looking for someone with a large cerebel-lum and hippocampus, and a well-connected amygdala. Please do not re-spond if you have had any prefrontal lobe injuries."

Although perhaps some specialists could guess the characteristics that such a brain might endow on its person, it is not how we think about others. If you are talking with a friend and tell him about your son, you don't start with his physical description. You may say what a great kid he is and what his interests are and whether he likes school or sports. Sure, you will probably pull out his picture, but the conversation is not dead without it. You are talking about what makes him *him*. If you merely said, "Ah, let's see, he has blond hair and is about four eleven now, and he burns easily," that would not tell us much about him except that he should use sunblock, and you would likely get some speculative looks.

There seem to be two parts of a person, the physical person (the body, including the brain), and then that other part, the part that makes you *you* and me *me*—the essence. Some call this the soul or spirit; others call it the mind. Together, these make up the classic mind/body duo. Phi-losophers have been discussing and arguing for literally thousands of years whether the mind and body are one entity or are separate, with Descartes topping the charts championing the latter position. Dualism is the belief that people are more than just bodies. This idea comes so easily to us that we even believe it about other animals, especially our pets and any animal we consider cute.

But you know what? We are not going to talk about whether the mind and body *are* the same or separate in *reality*. We are going to talk about why most people *believe* they are separate and why even people who don't believe they are separate *act* as if they are separate. Why do we think of a person as being more than just a body? Maybe in a conscious intellectual way, you can grasp the idea that you are just a bunch of at-oms and chemical reactions, but in everyday life, that is not how you in-teract. If someone cuts in front of you on the freeway, you don't think, *Gee, what an influx of catecholamines in that chunk of cells in front of me!* No, you think, *What makes him think he is so important that he should get in front of me? What a jerk.* And if you are standing on the rim of the Grand Canyon looking over the edge and get a rush of catecholamines yourself, you don't say, *Whoa, I've got some palpitations going on. Great*

catecholamine surge. No, the chemical change produces a feeling that your brain is compelled to explain situationally. It takes into account all the input, and then interprets the feeling and comes up with, *Standing on the edge here makes me nervous.*

What happens in every instance of human life? We somehow reflexively convert raw input, such as what we experience and see and feel, into another level of organization. In physical terms, it is like a phase shift, like going from solid to liquid to gas. Each state has its rules, its references, its reality. So too for the work of the brain. Mental states come with the brain, whether you want them or not. Our converter takes the input and delivers it to a new organization. Our chore in this chapter and also in the next is to try to understand the converter functions, the system that makes us all dualists.

Of course, we immediately want to know, Are we the only dualists? Is your cat a dualist? Does your cat think that you are more than his person who feeds him? Does he separate the you that he sees and smells and hears and licks and scratches and bites to some incorporeal *you*?

We are going to probe how the human brain forms beliefs, and what makes the belief that we have a mind that is separate from the body so easy to latch on to. The systems our brain uses to form beliefs and the way our brain forms the belief that we are dual are both central to the understanding of what makes us unique.

As we have seen with other systems, belief formation comes in two flavors. Neuropsychologist Justin Barrett calls these two systems reflective and nonreflective.[1] Nonreflective beliefs are fast and automatic. Sound familiar? These are such common thoughts that you may not even classify them as beliefs. You are sitting at the kitchen table having breakfast, still half asleep. You knock your knife onto the floor. Do you believe the knife felt pain? Could the knife have just as easily hit the ceiling or passed through the floor into the ground under the house? How about the floor; will it bleed? After you pick up the knife, wash it off, and put it in the drawer, do you think it will mate with the other knives? Will there be twice as many knives in the drawer in a few days? No. You don't believe any of that, and you don't even have to think about those questions to give me an answer, even though you may never have thought about any of them before.

As you stare out the window at breakfast without your glasses on, you

see something about the size of a softball come down out of the sky, land on the tree branch, and start making a tweeting noise. Do you believe it is breathing? Do you believe it gets hungry? Do you think it mates? Do you believe one day it will die? Sure you do. Your brain has classified these two different items into two different categories. One was "a thing" and the other was "It's *alive!*" Then your brain automatically inferred an entire list of properties that belong to each category, beginning with "object, not alive" and "object, alive, animal." This makes life much easier for us.

You wouldn't want to have to consciously go through a whole list of properties every time you came across something you hadn't seen before and have to learn them each time. You would never get out of Home Depot. None of us would be here, because our ancestor would have been transfixed, staring at the lion and running down a list of alternatives still figuring out what it was that was flying through the air toward his throat. Your brain has used its detection devices to figure out the categories your perceptions fall into. You have an entire detective agency working in your brain, made up of an object detection device, an animal identifier, an artifact identifier, and a "face detector," all of which answer the question, Who or what is that? You also have an agency detection device, the detective that answers the question, What or who done it? You also have profilers working. Once the detective devices identify the culprit, the profilers infer information about it and describe it. Barrett calls these profilers an animal describer, an object describer, a living thing describer, and an agent describer (also known as TOM). Each of these detectives and profilers has some hardwired knowledge, and as you learn and experience the world, this knowledge gets enhanced. All of these devices are part of the converter function that leads to our moving things from one level or state into the personal psychological state. How such devices actually work is not altogether clear, and we will talk more about that in chapter 8. For now, let's see what is hardwired.

INTUITIVE BIOLOGY

Humans are natural-born taxonomists. We like to name and categorize all sorts of objects that surround us, and our brain automatically does

this. A good rule of thumb is, if a way of thinking comes easily to us, we probably have some cognitive mechanism that is set up to think in that way. Cognitive anthropologist Scott Atran from the University of Michigan provides evidence that in every human society people intuitively think about plants and animals in the same special ways,[2] which are different from how we think about objects, such as rocks or stars or chairs. An animate object is different from an inanimate object. The intuition that bestows animacy on an object is the hardwired knowledge that animate objects have, as Steven Pinker so wonderfully refers to it, "an internal and renewable source of oomph."[3] We classify plants and animals into species-like groups and infer that each species has an underlying causal nature, or *essence,* which is responsible for its appearance and behavior.

This essence is the *nonperceptual* attributes that make a wolf a wolf, even if it is in sheep's clothing—for appearance is not always reality. We know that a horse is still a horse, even if you paint zebra stripes on it. This belief or intuition is already present in preschool children. These kids will tell you that if you change the innards, those invisible parts of dog, it no longer is a dog, but if you change its appearance, it still is; and once you're born something, such as a cow, you will develop the nature and behavior of that animal, no matter if you were raised by pigs and never saw another cow.[4] These classification systems have a hierarchy. There are groups within groups: A mallard is a specific type of duck, which is a specific type of bird. The classification provides a framework for making inferences about the properties of the category.[5] Some of the inferences are innate, some are learned. You tell me it's a bird, I infer it has feathers and can fly. You tell me it's a duck, I infer it has feathers, flies, quacks, and swims, and I may even infer that its name is Donald. You tell me it's a mallard, and I infer all that, plus the fact that it will be in my backyard in March. Intuitive biology refers to this way our brains categorize living things.

Harvard researchers Alfonso Caramazza and Jennifer Shelton claim that there are domain-specific knowledge systems for animate and inanimate categories that have distinct neural mechanisms. Indeed, there are patients with brain damage who are very poor at recognizing animals but not man-made artifacts, and vice versa.[6] If you have a lesion in one

spot, you can't tell a tiger from an Airedale, and if it is in another spot, the telephone becomes a mysterious object. There are even people with brain lesions that make them specifically unable to recognize fruit.

How do these systems work and come about? If an organism repeatedly comes across the same situation, any individual that evolves a mechanism to understand or predict the results of the situation is going to have a survival advantage. These domain-specific knowledge systems aren't actually the knowledge itself, but systems that make you pay attention to particular aspects of situations that will increase your specific knowledge. Just how specific and what type of information is encoded are not the same for every system, and there are different opinions on how it is differentiated.

Clark Barrett and Pascal Boyer suggest that the animal identification system may be a bit more specific than the object system, especially for predators as opposed to prey animals.[7] Within the domain of living things, there may be quite specific detectors for certain classes of dangerous animals that were common in many environments, such as snakes, and perhaps even big cats. A stable set of visual clues may be encoded in the brain, clues that make you pay attention to such things as sharp teeth, forward-facing eyes, body size and shape, and aspects of biological motion that are used as input to identify them.[8] You don't have innate knowledge that a tiger is a tiger, but you may have innate knowledge that when you see a large stalking animal with forward-facing eyes and sharp teeth, it is a predator. Once you see a tiger, then you pop that into the predator category along with whatever else you have already added.

This domain specificity for predators is not limited to humans. Richard Coss and colleagues at the University of California, Davis, have studied some squirrels that had been raised in isolation with no previous exposure to snakes. When exposed to snakes for the first time, they evaded them but did not evade other novel objects. They concluded that these squirrels have an innate wariness of snakes. In fact, these researchers have been able to document that it takes ten thousand years of snake-free living for this "snake template" to disappear from populations.[9] I am pretty sure I have a big fat snake template.

Dan Blumstein and colleagues at UCLA have studied a group of

tammar wallabies living on Kangaroo Island, off the coast of Australia, that have been naturally isolated from all predators for the last 9,500 years. They presented these wallabies with stuffed predators that were evolutionarily novel (ones their ancestors had never faced—a fox or cat), as well as a model of their evolutionary, though now extinct, predator (no stuffed ones being available). The wallabies responded to the sight of both types: They stopped foraging and became more vigilant.[10] They did not have these reactions to the control items. They were reacting to some visual cue that these stuffed or model predators exhibited, not to any behavior. Thus, it is possible for highly domain-specific mechanisms to exist, in this case for identification, ones that do not require prior experience or social context to work. These mechanisms are innate and hardwired. We share some with other animals, certain animals have some that we don't have, and some are uniquely human.

Studying babies helps us identify what knowledge is hardwired in humans. In a previous chapter, we learned that babies have categorizing domain-specific neural pathways to identify human faces and also to register biological motion.[11] There are a couple of other aspects of motion that interest babies from about nine months of age and aid in identifying animate motion. Babies understand when an object reacts to a distant event. For instance, if something falls, whatever else moves that it did not contact is animate.[12] They also expect an animate object to move toward a goal in a rational way.[13] So if an object has to hop over an obstacle to get to a goal, they expect it *not* to hop if the obstacle is removed. Infants have even been shown to have specific expectations about what objects that are chasing or evading will do.[14] These studies are all evidence that young infants have innate abilities to distinguish animate from inanimate objects. So, once an object is observed with any of these perceptual characteristics, the detective device surmises that it's ALIVE, and the brain automatically places it in the alive category and then infers a list of properties. The more life experience you have, the more you add to the list of properties that you infer. If none of these characteristics are observed, it will be placed in the inanimate category, and a different set of properties will be inferred. This is where the profilers come in.

Infers properties? Yes! Automatically the brain bestows on the animate object some properties common to things that are alive. Then the

object may be further categorized as an animal or even more specifically as a human or a predator, and even more properties are inferred. Barrett and Boyer summarize the features of these inference systems for us,[7] and some of their properties have specific bearing on our topic.

1. Each of the different domains deals with a different type of problem and has specific ways of handling information. Each has a specific input format, a specific way it infers information, and a specific output form. For instance, most psychologists will agree that humans have a special system to recognize human faces. The input format for face recognition is concerned with the overall arrangement and the relations of the parts to each other, rather than with specific parts. The input pattern that your brain looks for automatically consists of two brightly contrasted points (eyes) and a central opening (mouth) below. When the input format is not this way, for instance if you turn a picture upside down, faces are harder to recognize.

2. Just because there is a specialized domain for a specific problem, the domain does not necessarily correspond to reality. We see faces as the important aspect of a person because we have a system that pays particular attention to them. But are they really important? Not all animals have this system and see human faces as important. Neither now nor in the evolutionary environment would an impala need to know whether it was Pierre, Chuck, or Vinnie who was chasing it, or even that they are human; all it needs to know is that a predator is chasing it.

 The reality may be that there are fourteen different predator species that it needs to recognize, but it may recognize them all as only one species: an animal with eyes facing forward that runs. We could have evolved with a foot-recognition system instead, and it would be feet that we would gaze at lovingly and think were important. All you would have to do to be incognito would be to put on a pair of boots. The system does not necessarily recognize objects as wholes, but notices aspects of the object. For the face, there is a system to identify the person and a different system to identify their mood.

One problem is that if there is an ambiguous aspect of an object, the system may infer the wrong information. There are two darkly contrasting points and a central opening over there in the dark. "Yikes! There is someone in those bushes!" No, it turns out to be a hubcap with holes in it. Another problem is that the system may infer scientifically incorrect information, although it is information that is mostly correct and has worked well enough so that it has been selected for. The system that identifies plants assumes that plants don't move of their own volition. Some plants do, but they are rare, so it doesn't affect the accuracy much. It is important for us to note, however, that the human brain does not divide living and nonliving things up the same way that a scientist would, based on verifiable information.

3. It is through the process of evolutionary selection that the specific system has arisen, so we need to keep in mind what the original function of the design was, because . . .

4. We may use a domain in ways other than the one it was selected for. For instance, our ears have evolved because they captured sound waves, which improved hearing, but we now also hang glasses from them. Bipedal locomotion was selected for because it gave some survival advantage in finding food and shelter, but we also use it for salsa dancing. The proper evolutionary use of a domain may be quite different from its current use.

5. You (and every other animal) can learn and infer only what your brain is programmed to be able to do. We cannot learn to hear sound frequencies beyond the range of our hearing, because our systems are not programmed to be able to. We can learn to speak because we have a domain that is ready to learn language. We cannot consciously feel what our brains are doing when they are performing unconscious processes. We can see three dimensionally even though a two-dimensional pattern falls onto our retina, because we have a specialized visual system that fills in the visual blanks. So where animals are concerned, because we have a brain that is predisposed to species-specific taxonomy, we are able to use all the incoming information, such as shape, color, sounds, motion, and behavior, to infer similarities and differences.

6. Different domains learn things in different ways and have different developmental schedules, so optimal learning takes place at specific times in development. We have seen that there is an optimal time in development to learn language. We will be talking about our intuitive knowledge of physics. This develops earlier in babies than a fully developed intuitive psychology. It develops earlier than children can speak, so we have had to figure out how to find this out without resorting to language.

7. Genetic influence continues throughout the life of an organism. It doesn't stop at birth, and there are specific pathways that development follows, which are genetically encoded. All children everywhere follow the same general developmental time schedule, though there can be individual differences. Even if you are really really, really smart, you still don't learn to speak when you are three months old.

8. In order to develop these systems, a normal environment is needed to input the proper stimuli. In order to learn to speak, one needs to hear others speak, just as songbirds need to hear other songbirds sing before they can sing. In order to develop proper vision, one needs visual input and can't be raised in the dark.

9. These systems that infer information for survival and fitness are most likely interconnected, so that more than one area of the brain is activated when they are employed.

Children from the age of three already infer that something that falls into the animate category has some essence that makes it what it is and does not change. When shown pictures of slowly transforming animals, such as a porcupine turning into a cactus, children will put their foot down at some point and tell you that it doesn't matter what you do to it, it is still a porcupine. Susan Gelman[15] and her students at the University of Michigan wondered if this is information that has been explained to them or if it is innate knowledge. They analyzed thousands of mother-child conversations about "animals" and "things," conversations from several families that occurred over a period of several months. The insides

of something, what made it tick, and its origins were rarely discussed, and if they were, the discussion usually involved things, not animals. Children are born believing in essences; it is not something they are taught. Nine-month-old babies also already believe in the essence of objects. If you present them with a small box that makes a sound when you touch it in a particular place, they expect all identical small boxes to possess the same quality. Three-year-old children will go a step further and infer that *similar* boxes have the same quality, even if they are not exactly the same.

Using these examples, Yale psychologist Paul Bloom, in his fascinating book *Descartes' Baby*,[16] tells us that children are natural believers in *essentialism*, the philosophical theory that a thing perceivable to the senses can have an embodied unobservable essence that is real. Bloom says essentialism in some form shows up in all cultures. This essence may take the form of DNA or a gift from God or your astrological sign or, as a Yoruba farmer will tell you, a "structure from heaven." Bloom considers essentialism an adaptive way to think about the natural world. Biologically, animals are similar because of a shared evolutionary history. Although appearance has some relevance as to what group an animal is in, more reliable indicators are deeper. So this inference that animals have an essence that does not change, even when the physical features do, has validity and ratifies the innate dualism in children. The converter is at work.

Do other animals have a concept of essences? Jennifer Vonk and Daniel Povinelli don't think so.[17] After reviewing studies that have been done to tease out how animals categorize entities as either same or different, they have concluded that all findings so far can be explained by other animals' using solely perceivable traits: appearance, behavioral patterns, odor, sound, and touch. For other animals, appearance is reality.

When you start trying to design experiments to separate perceivable relationships from unobservable relationships, you realize it is quite difficult, and you begin to understand that perceivable relationships will do quite well most of the time. In fact, they have proven to be very difficult to distinguish, and Vonk and Povinelli don't think there is any good

evidence that animals use more than perceivable characteristics. Their interpretation of the current findings is that pigeons and monkeys can perceive first-order relationships: They have a concept that two things that share common perceptual characteristics are the same. The researchers emphasize that the key word here is *perceive,* just as the Kangaroo Island wallabies perceived that the stuffed fox and cat were things they should be concerned about, because they shared perceptual features that put them in the to-be-avoided class. Would a wallaby have been fooled by sheep's clothing? If all other perceivable clues were eliminated, such as odor, type of movement and behavior, and sound, and the fox kept his mouth shut and wore a mask, probably. And you might have been, too. But foxes don't actually dress up in sheep's clothing.

Appearances are good enough in the animal world unless the animals are dealing with humans. Let's just throw in an anecdotal tale. Apparently mountain lions can be fooled! This from the California Department of Fish and Game Web site: "One incident involved a turkey hunter who was camouflaged and calling for turkeys when a mountain lion approached from behind. Immediately after the mountain lion confronted the hunter and realized that the hunter was not a turkey, the lion ran away. This is not judged to be an attack on a human. Every indication suggests that if the hunter had not been camouflaged and calling like a turkey, the mountain lion would have avoided him."

Understanding second-order relations means that one understands that the relationship between *these* two items is the same as the relationship between *those* two items. Remember your verbal SATs? The analogy section? How well did you do with those? There is evidence that the great apes are capable of understanding some second-order relationships, but as yet there is no evidence that they can do so with information other than what is observable. Even in chimpanzee social relationships, such as dominance or emotional relationships like love or attachment, all can be explained by observable phenomena. If this doesn't make sense to you, then explain how you know that someone loves you. "Well, he kisses me good-bye every morning." Perceivable. "He calls me from work every day." Perceivable. "She goes out of her way to do nice things for me." Ah, perceivable. "She tells me she loves me." Ah, that would be a ditto. Vonk and

Povinelli point out that we may *define* love as feelings, an inward manifestation, but we describe its visible outward manifestations. You can't actually feel another's feelings, you infer them through *perception*, the observation of their actions and facial expressions. We advise our friends in the throes of infatuation, "Actions speak louder than words." Your dog is loyal to the audible, visible, sniffable you, not the essence of you.

INTUITIVE PHYSICS

We also have an intuitive knowledge of physics, although your physics grades may not reflect it. Remember that the intuitive systems make us pay special attention to things that have been helpful in survival. To survive, you didn't really need an intuitive system to help you understand quantum mechanics or the fact that the earth is however many billions of years old. It is not so easy to grasp these concepts, and some of us never do. However, when you knocked the knife off the table at breakfast, there were many aspects of physics you did unconsciously take into account. You knew it would fall to the floor. You knew it would still be there when you leaned over to pick it up. You knew it would be directly beneath you and didn't fly into the living room. You knew it would still be a knife, that it had not morphed into a spoon or a lump of metal. You also knew it wouldn't pass through the solid floor and end up under the house. Was all this knowledge learned through experience, or was it innate? Just as you understand these things, very young infants already understand these same aspects of the physical world.

How do we know? What if, instead of falling onto the floor, the knife had flown up to the ceiling? You would have been surprised. In fact, you would have stared up at that knife. Babies will do the same thing if they see something unexpected. They will stare.

Babies expect objects to conform to a set of rules, and when they don't, they will stare at them. By five months of age, babies expect objects to be permanent. They don't just disappear when put out of sight.[18] In a number of experiments, Elizabeth Spelke at Harvard and Renée Baillargeon at the University of Illinois have studied for years what babies know about physics. They have shown that infants expect objects to

be cohesive and to stay in one piece rather than spontaneously break apart if you pull on them. They also expect them to keep the same shape if they pass behind a screen and reemerge. For example, a ball shouldn't turn into a cupcake. They expect things to move along continuous paths and not to travel across gaps in space. And they make assumptions about partially hidden shapes. They also expect an object not to move on its own without something touching it, and to be solid and not to pass through another object.[19, 20] How do we know this isn't learned knowledge? Because babies everywhere know the same stuff at the same age no matter what they have been exposed to.

Babies do not understand everything about physical objects, however. It takes them a while to understand the full implications of gravity. They understand that an object can't just be suspended in midair, but not until they are a year old do they understand that an object must have support under its center of gravity or it will fall.[21] This is why the sippy cup was invented. Of course not all physical knowledge is innate. There is plenty that needs to be learned, and some adults never learn some of it, hence your physics grade. To what extent other animals share our intuitive physics is not yet known. As Marc Hauser says in his book *Wild Minds*, it seems inconceivable animals would not understand object permanence. There would be no prey animals left if they didn't understand that the predator that walked behind the bush is still there and didn't disappear into thin air. However, there are some major differences in what we understand about physics and what other animals understand, and in how we use the information.

Povinelli and Vonk,[17] having reviewed what is known about the physical knowledge of nonhuman primates, suggest that although it is clear they can reason from observed events to resulting causes, they do not appreciate the causal forces that underlie their observations. For instance, if they understood the cause of gravity, instead of knowing only by observation that fruit will fall to the ground, then they should also understand that if they were reaching for something and dragged it across an open void, then it too would fall into the void. They can't figure this out. They don't understand force. They understand that objects touch each other, which is observable, but they don't get the idea that in order for one object to move another, some force has to be transferred: A cup needs to be

sitting *on top* of a tablecloth when the cloth is pulled in order for the cup to move; it can't just be touching the tablecloth. They just don't get it. This contrasts with two- and three-year-olds, who do get it. Children will prioritize the cause of simple events by an unobservable feature (the transfer of force) over an observable feature (for instance, proximity).[22] It has been proposed[23, 24, 25] that humans are unique in their ability to *reason* about causal forces. Sure, some animals understand that an apple will fall off a tree, but humans are the only animal that can reason about the invisible cause—gravity—and how it works. Not that we all do.

Our object taxonomy for physical objects, man-made artifacts in particular, works differently than our biological taxonomy. Artifacts are classified mostly by function or intentional function,[26] and are not hierarchically classified like plants and animals. When something is classified as a man-made artifact, different inferences are made about it than about a living thing. It gets a different profile. In fact the identification and profiling systems can get even more specific. Motor regions of the brain activate when tools are the objects[27] and when the artifact is manipulable,[28] but not with man-made objects in general. We infer all the above physical properties, but not the properties we infer for living things, except in special circumstances.

After the detective device has answered What or who is that? or Who or what did that? the information is sent to the describers, which infer all the properties of what has been identified. So back at breakfast when you looked out the window and saw the flitting, softball-size what-or-who-is-that, the object detective identified it as a physical object with a definite border rather than something formless, and, wait a minute . . . the object has initiated its own motion, a biological-type motion, so the detective device signals, "It's *alive!*" The animal identifier chimes in with "Ah, it's a bird." Once it has been identified, the animal describer infers that it has all the properties of its class: It would have all the physical properties of an object in space, plus those of an animal and those of a bird. This all happens automatically, even if you have never seen that specific animal before. If the detective device says it's a *who* as opposed to a *what* problem, and identifies the quarry, then the agent describer or TOM is engaged. This is another area of intuitive knowledge, known as intuitive psychology, which also contributes to our nonreflective beliefs.

INTUITIVE PSYCHOLOGY

We use our theory-of-mind system (our intuitive understanding that others have invisible states—beliefs, desires, intentions, and goals—and that these can cause behaviors and events) to ascribe these same characteristics not only to other humans but also to the animate category in general, even though other animates do not possess it to the same degree humans do. (Sometimes it can also get sloppily slapped onto objects.) This is why it is so easy to think of our pets and other animals as having thoughts and beliefs like our own and why anthropomorphism is so easy to resort to. This is also why it can be so hard for humans to accept that their psychology is unique. We are wired to think otherwise. We are wired to think animate objects have TOM. We think other animals, especially ones most similar to us, think as we do. Our intuitive psychology does not limit the extent of TOM in other animals. In fact, when presented with films of geometric shapes moving in ways that suggest intention or goal-directed behavior (moving in ways that an animal would move), people will even attribute desires and intentions to geometric figures.[29] Yes, other animals have desires and goals, but they are shaped by a body and a brain that has answered survival and fitness problems with different solutions. We are not all hooked up the same.

Anthropomorphism is not the only common type of thinking that has roots in TOM. If your biology teacher chastised you for that, perhaps you also had a big red mark for teleological thinking—explaining facts of nature as a result of intelligent design or purpose. You were in trouble in biology class if you said giraffes have a long neck so they can eat the leaves of tall trees, that is, their neck was *designed* to reach the high leaves.* However, this may actually be a default mode of thinking that is fully developed between ages four and five.

*Because it is so easy for people to think teleologically, grasping how natural selection works can be difficult. The long neck was not specifically designed. It just so happened that ancestral giraffes that had longer necks were able to eat more food, which increased their fitness, their ability to survive, and their reproduction. Giraffes with longer necks outcompeted giraffes with shorter necks.

Whereas both adults and children will resort to teleological explanations for biological processes, such as that lungs are for breathing, children resort to teleological thinking for more diverse situations than adults do. They have a bias to treat objects and behaviors of all kinds as existing for a designed purpose.[30, 31, 32] They will extend this reasoning to natural objects and will say clouds are there to rain, mountains are there so you can go for a hike, and tigers exist for zoos.

The origins of teleological thinking are still being hashed out. There are three proposals. Either it is innate, or it comes from understanding that man-made objects are designed for a purpose,[33] or it derives from the understanding of rational action that babies exhibit and thus may be a precursor of TOM.[34]

Teleological thinking explains a phenomenon by invoking an intended design. However, the fact we are even trying to *explain* an effect having been *caused* by something is also most probably a unique ability. Other animals do understand that certain things are linked to other things in a causal manner. Your dog may learn that chewing your Gucci shoes causes the effect of getting a swat, or yelled at, and he may learn that chewing his bone does not cause that effect. However, as we discussed with intuitive physics, there is no clear evidence that other animals form concepts about imperceptible things. Your dog doesn't understand that the unperceivable cause of the swat was the cost of the shoes or your notions of dog obedience. Vonk and Povinelli[17] have proposed that the human ability to reason about unobservable entities and processes goes beyond causal physical forces and includes the psychological realm. This reasoning about unobservables can then be used to predict and explain events or psychological states. Thus, once full-blown TOM developed, it greatly enhanced the ability to predict behavior beyond just observable phenomena. One could predict the behavior of another animal by inferring its psychological state.

While other animals and humans use observables to predict, it may be that humans alone also try to explain.[35] Only one experiment so far has addressed this notion. Chimps and preschool children were given some blocks that they were to stand on a platform covered with an irregular mat. In the first experiment, among the blocks was one sham block that had had its ends beveled so it could not stand up. In the second experiment, the blocks were visibly identical (all L-shaped) and all

of the same weight, but the sham block had been weighted so that it could not stand up on its long axis. In the first experiment, both the children and the chimps examined the visibly different block. However, in the second experiment, in which the difference between the blocks was not visibly perceptible, 61 percent of the children investigated the sham block to figure out why it couldn't stand up, but none of the chimps did.[36]

Sometimes our predilection for explaining the cause of things or behaviors with teleological thinking runs amuck. One of the reasons is that the agency-detection device is rather zealous. Barrett calls it hyperactive. It likes to drum up business, so it finds animate suspects even when there are none. When you hear a sound in the middle of the night, the question that first comes to mind is Who is that? rather than What is that? When you see a wispy something moving in the dark, Who is that? comes to mind because the detective device is not modern and up-to-date. The detective device was forged many thousands of years ago before there were inanimate objects that could move or make noise on their own. To first consider a potential danger as animate is adaptive. It worked most of the time. Those who did it survived and passed their genes to us.* Sometimes blunders are made, but they usually aren't much of a problem. We realize the wispy something is a towel someone left hanging in the tree, and the noise is the house creaking as the temperature cools.

The hyperactive detective device, combined with our need to explain and teleological thinking, is the basis of creationism. To explain why we exist, the hyperactive detection device says there must be a Who involved.

*This comes from error-management theory (EMT): "Decision-making adaptations have evolved through natural or sexual selection to commit predictable errors. Whenever there exists a recurrent cost asymmetry between two types of errors over the period of time in which selection fashions adaptations, they should be biased toward committing errors that are less costly. Because it is exceedingly unlikely that the two types of errors are ever identical in the recurrent costs associated with them, EMT predicts that human psychology will contain decision rules biased toward committing one type of error over another." M. Haselton and D. M. Buss, "Error management theory: a new perspective on biases in cross-sex mindreading," *Journal of Personality and Social Psychology* 78 (2000): 81–91.

Teleological reasoning says there must be an intentional design. The cause must be the desires and intentions and behavior of the Who. Thus we were designed by a Who.

All of this is reminiscent of what the left-brain interpreter would do, which it has been demonstrated to do in other settings. In the next chapter, we will see it become hyperactive in cases of neurologic disease when it produces seemingly bizarre stories of causality, given the bad information it receives. The interpreter and the theory-of-mind modules seem to be close cousins.

Povinelli has suggested that TOM was "grafted" onto already existing cognitive systems for reasoning about perceivable behavior, thus allowing humans to reinterpret already existing, complicated social behavior with the additional ability to think about mental states.[37] TOM did not replace already existing systems and is not necessarily always resorted to. The key point to this idea is that it expects humans and their nearest living relatives, the great apes, especially chimps, to behave similarly, because being able to predict behavior by observation had evolved before TOM. These systems for reasoning about behavior were already highly sophisticated and complex, and they became closely connected to the TOM system. However, just because other animals may have some of the same behaviors that we do, inferring from this that they have the same cognitive system may not be correct. Also, just because we have a system to seek out cause from unobservables does not mean we use it all the time. It is unknown when our concepts about unobservables are activated and to what extent they inform human behavior. It is possible that in many situations they are not activated at all. It is also evident that not everyone possesses the ability to use TOM to the same extent.

We will see in a moment that oftentimes we can come to the same conclusions whether we use our TOM or not.

OTHER DOMAINS PUT IN THEIR TWO CENTS

More-specialized domains come into play in specific circumstances when the profiler doesn't provide enough information, and many of these

are involved in social interactions. Some of these systems also act like statisticians and predict human behavior or guide it under specific circumstances. We have already talked about how some of these systems are active for social exchange, precautionary exchange, and the many moral intuitions that we have. There are probably umpteen others, including one for math. Babies expect there to be two Mickeys behind a screen when they see one go behind it, and then one more.[38] Plus we have memory and our past experience to draw on. So now there is quite a bit of information available.

So at breakfast you gaze out the window and see an object move toward you and then bend and straighten and move away from you. Your detective device has identified it as human, and even more specifically identified it as your neighbor Luigi. Your animal describer tells you all Luigi's properties, including TOM. Could you and your dog predict Luigi's behavior correctly without taking TOM into account? If Luigi has been your neighbor for a few months, then when you see him, you also remember that he came out yesterday morning and picked up the paper, and the morning before that he did the same thing. You could actually predict his behavior without even using your TOM. Your dog also has seen Luigi come out each morning and bend over and pick up the paper. Everything looks the same as yesterday; your dog predicts the same behavior. Now try the same scenario using your TOM. Both you and your dog see the newspaper and see the front door open with Luigi on the threshold. Now you have an edge on your dog. Your profiler has inferred that Luigi has TOM. You know he has desires, and you can use your intuitive psychology to predict (just as if you were he) that one of those desires is to read the paper. Yep, there he goes. But that was no different from what you and your dog predicted without TOM. TOM is an embellishment that is called in especially in human social interactions, for which we sometimes use it to predict behavior. But its most important function allows you to understand that that hunk of cells over there has unobservable beliefs and desires, just as you do, which are motivating it. The information has been automatically converted to give another status or state to Luigi.

Intuitive psychology is a separate domain from intuitive biology and physics. This is important, because a desire or a belief doesn't get tagged

with physical properties, such as "has gravity" or "is solid," or with bio-logical properties, such as "eats" or "has sex" or, most important, "dies." When Luigi comes out for his paper, do you believe his desire is purple? Do you believe that it will fall out of his head when he leans over to pick up the paper? Do you believe that his desire is going to eat breakfast? No. You don't believe any of that. Do you believe that his desire can pass through walls? Do you believe his desire can disappear into thin air? Do you believe that his desire can die? Does that mean it stops breathing? Now your responses may not be so quick. Your intuitive mechanisms are getting all flustered.

THE GREAT DIVIDE

The divide between the domains is apparent in autism, in which the lack of social understanding is a prominent feature, but it can also be associated with impairments in imagination and communication. Children with autism rarely engage in imaginative playing, and many do not speak at all. It is thought that individuals with autism suffer from "mind-blindness." They are blind to the understanding that other individuals have desires, beliefs, goals, and intentions—that they have a mind. Autistic children do not possess a theory of mind; they lack an intuitive psychology. This lack of intuitive psychology is what makes social inter-actions so difficult. Instead of automatically knowing that when you smile you are happy, or that your furrowed brow indicates displeasure, they have to learn and memorize what these expressions indicate and consciously apply the lesson each time they see one. This lack of under-standing also explains other characteristics of children with autism, such as not pointing things out or looking to their parents for guidance. If they don't understand that others have a mind, then there is no reason to show them something or look to them for advice. You don't point the dust out to your broom or ask your dictionary for advice.

When shown the films mentioned above, of the geometric figures exhibiting intentional action, autistic subjects merely give a physical description and do not ascribe intentions to them. The researchers give an example that is so demonstrative of the difference, I will repeat it here.

The first is a response from a normally developing adolescent describing the forms in the film: "What happened was that the larger triangle—which was like a *bigger kid* or a *bully*—and he had *isolated* himself from everything else until two *new kids* come along and the *little one* was a bit more *shy, scared,* and the smaller triangle more like *stood up for himself* and *protected the little one.* The big triangle got *jealous* of them, came out, and *started to pick on the smaller triangle.* The little triangle *got upset* and *said* like, 'What's up? Why are you doing this?'"

Contrast that response with the following from an autistic adolescent: "The big triangle went into the rectangle. There were a small triangle and a circle. The big triangle went out. The shapes bounce off each other. The small circle went inside the rectangle. The big triangle was in the box with the circle. The small triangle and the circle went around each other a few times. They were kind of oscillating around each other, maybe because of a magnetic field. After that, they go off the screen. *The big triangle turned like a star—like a Star of David*—and broke the rectangle."[39]

Instead of bestowing social relationships on the geometric figures in the film, the autistic children described solely physical relationships. Multiple MRI studies have been done in order to understand how the brain is different in autistic individuals. Of importance to our discussion is that when autistic individuals looked at faces, the activity was significantly lower down in a region of the brain called the fusiform gyrus, widely accepted to be specialized for the perception of faces.[40, 41] The autistic groups showed greater activation in adjacent regions of the temporal cortex that are usually associated with objects. Indeed autistic children often treat other people as objects. Other people can be terrifying to autistic individuals because they do not act like objects; they move and do things that are unpredictable according to their nonreflective intuitive beliefs of how objects should act.

DUALITY OF EXPERIENCE

Paul Bloom, who contends people are natural-born dualists, states that in individuals who do not have autism, this processing of object

understanding separate from social and psychological understanding is what gives rise to our "duality of experience." Objects, the material, physical things of the world, are treated separately and differently from the nonvisible psychological states of goals, beliefs, intentions, and desires. Different inferences are made. Part of that physical world is what you can look down and see: your body, that physical biological object that eats and sleeps and walks and has sex and dies. But the psychological part is not visible; it does not have an obvious physical substance and is subject to different processing and inferences. It is not a physical biological object subject to that same array of inferences. You have a nonreflective intuitive belief that the body and its conscious essence are separate.

This intuitive belief in separateness allows you to be able to consider all sorts of situations without getting a brain ache, as you would if I started to explain quantum physics. When Susie says, "If I could just be a fly on the wall in that office for an hour!" you immediately know she wants to be a physical fly but retain her own mind. The fly would not only have a desire and intention, it would have *her* desire and goal and intention to listen to what was being said. You can easily separate her physical self from her mind and put her mind into the fly. A real fly would have no such state, but the idea is easy to comprehend. You also don't hear someone saying, "If I could just be a wall for an hour!" because it is less likely for your intuitive psychology to assign an inanimate object, a wall, the ability to have desires and goals.

Because you can mentally separate the physical body from the invisible essence of a person, you can conceive that either one could exist separately. The physical body without the essence is a zombie, a robot; the invisible essence without the body is the soul or spirit. We can conceive of other essences or invisible agents without a physical body that have desires or intentions, such as ghosts, spirits, angels, demons or the devil, and gods or God. It would follow from Povinelli's reasoning, then, if animals cannot form concepts of imperceptible entities or processes, if they do not possess a full TOM, then they cannot be dualists nor entertain the notion of spirits of any sort. These are uniquely human qualities. But what about the stories of elephants visiting their dead relatives? Doesn't that mean that they have some notions of essences?

ARE WE THE ONLY DUALISTS?

The search for evidence of dualism in the animal world has centered on how a species treats their dead. Humans attach great importance to dead bodies, and their observable ritualistic behavior associated with the dead is visual indication of dualism at work. Although Neanderthals occasionally buried their dead, Cro-Magnons (the first anatomically modern *Homo sapiens* who appeared in Europe, about forty thousand years ago) regularly and elaborately did, interring with them material objects. This indicates a belief in an afterlife where such items were assumed to be useful.[42] A belief in an afterlife assumes that there is a difference between the physical body that is buried in the ground and what continues to live on. The Cro-Magnons were dualists.

So, do other animals show an elaborate response to their dead relatives or companions? Most animals do not. Lions appear to be practical. They may briefly sniff or lick the body of a recently dead buddy, and then tuck in to it for a quick meal. Chimps may have longer interactions with a dead social partner, but they abandon the body once it starts getting a little whiffy.[43] However, elephants have been observed to behave quite differently. Cynthia Moss, who started the Amboseli Elephant Research Project at Amboseli National Park in Kenya, has studied African elephant family structure, life cycle, and behavior. In her book *Elephant Memories,* she wrote:

> Unlike other animals, elephants recognize one of their own carcasses or skeletons . . . when they come upon an elephant carcass they stop and become quiet and yet tense in a different way from anything I have seen in other situations. First they reach their trunks toward the body to smell it, and then they approach slowly and cautiously and begin to touch the bones . . . they run their trunk tips along the tusks and lower jaw and feel in all the crevices and hollows in the skull. I would guess they are trying to recognize the individual.

Although the reports of elephant graveyards had been exposed as myths,[43] Moss and other researchers suggested that they visited the dead bones of their relatives.[44]

But did they? Did they visit or recognize dead individuals? Karen McComb and Lucy Baker, from the University of Sussex, United Kingdom, joined Moss to study this question experimentally. In one experiment, they set out an elephant skull, a piece of ivory, and a piece of wood. They found the elephants were very interested in the ivory, and were also somewhat interested in the elephant skull, but not the wood. In another experiment, the researchers found that they were more interested in an elephant skull than in the skull of a buffalo or a rhino. In their last experiment, they found that the elephants showed no preference for the skull of their own matriarch over the skulls of matriarchs from other clans.[43] What does this tell us? It tells us that elephants are very interested in ivory and are more interested in the bones of their own species than those of others, but not specifically the bones of a relative. What the significance of this preference is, both evolutionarily and behaviorally, is currently unknown, but it cannot be taken for evidence that elephants have an interest in their conspecifics beyond the physical. Whether there are other species that practice a similar behavior still needs to be checked out.

REFLECTIVE BELIEFS

After all this incoming information from the senses has been selectively picked apart and processed by various intuitive systems and your memory, *some* of it comes bubbling into your conscious mind. How that happens is still the big mystery. Once the info hits the conscious mind, the interpreter comes in—Mr. Know-it-all, who puts the info together and makes sense out of it. All this detecting, profiling, and predicting is done automatically. It is quick and fast, and usually correct. However, it is not *always* correct. Sometimes the detective gets it wrong—for instance, when you hear the rustle in the bushes and jump because your "who or what did that?" detective goofed and told you it was an animal that caused the noise instead of the wind. That's OK. It is better to be fast and sometimes wrong than slow and mostly right. Or maybe your detective goofed and identified your computer as alive because it did something all by itself (that you couldn't possibly have caused) and so

your profiler gave it theory of mind. Now you believe that it has desires causing its behavior, and the interpreter has to make sense of this, so it comes up with: Your computer is out to get you! All this is your automatic nonreflective belief system at work, fed by information from different domains.

But just because you can *imagine* something does not mean it is true. You can imagine a unicorn, a satyr, and a talking mouse. Just because you *believe* something does not mean that it is true. Just because you believe or imagine that the mind and body are separate does not mean they are. So, what happens now when I pose a problem to you that challenges your nonreflective beliefs? If you believe that the mind and body are separate, that you have a soul that is more than just your brain cells and chemicals, then how do you explain personality changes, consciousness changes, or any of the changes that occur with brain lesions? What about Phineas Gage, who after his brain injury was described as no longer the same person? His essence was different because of a physical change in his brain. Now you have to think this over and decide if you are going to change your mind or not.

Reflective beliefs are different and are probably what most people mean when they say they believe something. Reflective beliefs make up opinions and preferences. They are not fast and automatic but are conscious and take time to form, and may or may not agree with nonreflective beliefs. After you weigh the information, look at the evidence, and consider the pros and cons, you come to a decision whether to believe something or not. Yeah, sure, we learned in chapter 4 just how far in depth most people will go in this endeavor and how difficult it is to form rational judgments. Reflective beliefs are the same. Just as with moral judgments, they too are usually arrived at with a minimum of reflection. Both reflective and nonreflective beliefs can be either true or false, and may or may not be provable or justifiable.

The interesting difference between these two types of belief systems is how to tell which is in effect. Usually, if the automatic nonreflective, nonconscious belief system is in effect, you can tell by the person's behavior, whereas the best evidence for a conscious belief system is verbal statements, which may or may not be consistent with his or her behavior. You still walk faster by the cemetery at night even though you say you

don't believe in ghosts. You still act as if we are talking to a mind rather than a bunch of cells and chemicals, even if you think there is no difference between a brain and a mind, a body and a soul.

Barrett tells us how nonreflective beliefs affect reflective ones. To begin with, nonreflective beliefs are the default mode. If you have never been presented with a situation in which you must question your nonreflective belief, then that is what you will believe. It is not until you learn about Venus flytraps that you will change your intuitive belief that plants are not carnivorous, and it is not until you learn about the sensitive plant that you will change your belief that plants don't move on their own. Your intuitive beliefs are best guesses. These two types of plants are rare, so your best guess that plants aren't carnivores and don't move will serve you well. This is much easier than holding a piece of ham in front of every new plant you see to determine if it is a carnivore.

Next, the better a reflective belief merges with a nonreflective belief, the more plausible it seems, the more intuitive and the easier to learn or accept. If I tell you a table is a solid object that doesn't move, that accords with your intuitive beliefs about objects that are not alive. That is easy to believe. However, if a physicist tells you that no objects are solid but are just a bunch of atoms moving around, that is difficult to believe. Just as when arriving at moral judgments, if the reflective belief verifies how you already see the world, it is more readily accepted. The other way that nonreflective beliefs influence reflective ones is that they shape memory and experience. When you form a memory, first you have perceived something. Zip, the perception gets funneled through your detectives and profilers, all picking out and editing the info. The interpreter puts it all together in a summary that makes sense and files it away in memory. It has already been edited by your nonreflective belief system, and you are now calling on it as true information to use for forming a reflective belief. This information may be totally wrong, and is the same as using anecdotal evidence to form a moral judgment in which you may attribute the wrong cause to the effect. Not only that, once you form a reflective belief based on this information, then that reflective belief, if it meshes with another reflective belief, will be even stronger or will supply strength for another reflective belief.

If my friend tells me she is afraid of heights and asks me if I am, in order to answer I may remember standing at the edge of the Grand Canyon and getting the catecholamine rush that gave me a feeling of fear. My brain interpreted this feeling as being caused by standing on the rim of the canyon, but its actual cause was the catecholamine rush. In fact, it may not have been standing on the rim that gave me the rush; it may have been a memory of falling off a ladder that occurred to me as I leaned out over the canyon. The actual reason for the rush is not what you become aware of; it is your brain's interpretation of the rush. It may not be the correct interpretation, but it will fit the circumstances. Now you have a false belief. You think the feeling of fear was caused by standing on the rim of the canyon. This false belief can now be used in the future when you consciously reflect about heights. You will remember that you were scared standing there, and this memory may cause you to stay away from high places and form the reflective belief that you are afraid of heights.

Reflective beliefs need more time. If I force you to respond to a question within a few seconds, you will be more likely to respond with your nonreflective belief.[45]

So in the rare event when we are being "deep" because a default non-reflective belief hasn't presented itself, or for some reason we are questioning an automatic belief, and we actually are spending time pondering to form what we so blithely think of as an informed belief, much of the information that we use from memories and past experience is highly colored by our nonreflective intuitive beliefs, and some of it can be wrong. It is very difficult to separate the intuitive from the verifiable, even though that is what we think we are doing. It would be like doing a math problem that involves several steps, and getting the first step's answer wrong but being quite sure it was correct, and using it to complete the rest of the problem. And don't forget how emotion gets to be part of the process. What a mess!

Luckily, the whole process has been refined to enhance fitness and survival, and usually it gets things right enough, but not always. Or I should say it got things right enough in the evolutionary environment. To separate the verifiable from the nonverifiable is a *conscious*, tedious process that most people are unwilling or unable to do. It takes energy and

perseverance and training. It can be counterintuitive. It is called analytical thinking. It is not common and is difficult to do. It can even be expensive. It is what science is all about. It is uniquely human.

So we have this generally well-run system that sometimes makes errors, and these errors can lead to some mistaken beliefs. As the old adage goes, "Actions speak louder than words." Our actions tend to reflect our automatic intuitive thinking or beliefs. We are dualists because our brain processes have been selected over time to organize the world in specific categories and assign different properties to these categories. It just so happens we ourselves fall into two separate categories whose properties are different. We are animate objects, which are subject to the physical laws of animate objects, but we also have nonperceptual psychological properties not subject to physical laws. No problem! We'll take a little of this and a little of that and voilà: a physical biological body and an unobservable psychological essence, two things in one. As Descartes would have said, *"Pas de probléme!"*

CONCLUSION

We have seen that both we and other animals share some highly domain-specific abilities, such as spooking at snakes and recognizing other predator animals. We also share some of our intuitive physics with other animals, such as object permanence and gravity, and as we have seen in previous chapters, some rudimentary intuitive psychology (TOM). However, species differ in their domain specificities. Unlike other animals, we humans have an expanded intuitive understanding of physics. We understand that there are invisible forces. Current evidence suggests that we are the only animals that reason about unobservable forces. We alone form concepts about imperceptible things and try to *explain* an effect as having been caused by something. We also use these same abilities of reasoning about and explaining imperceptible things in the biological and psychological arenas. We understand that other living things have an invisible essence that is independent of their appearance, although we may get carried away with just what this essence is. This questioning and reasoning about imperceptible forces is a

hugely significant ability. It certainly sparked the curiosity that, when coupled with conscious analytical thinking, has been the cornerstone of science, but that same curiosity has led to other, less rigorous ways of explaining imperceptible forces, such as myths, junk science, and urban legends.

Chapter 8

IS ANYBODY THERE?

> As the brain changes are continuous, so do all these consciousnesses melt into each other like dissolving views. Properly they are but one protracted consciousness, one unbroken stream.
>
> —*William James*, The Principles of Psychology, *1890*

EVER SINCE MY DAYS IN COLLEGE, I HAVE PUZZLED OVER THE problem of conscious awareness. This isn't a story about college bull sessions dealing with the meaning of life. This is a story about my being fascinated with my college buddies. You see, I was a member of the fabled Animal House at Dartmouth College, and I was Giraffe. What a ride that was.

Actually, I was pretty square until Green Key Weekend of my junior year. I had a deal with my father. No booze until twenty-one and he would write me a check for five hundred bucks. But my frat brothers told me a great drink was grapefruit juice and vodka. So, emboldened with the idea of the moment, I dove into my first drink. It was a hot day, and about five drinks later, I declared there wasn't much to this drinking thing, stood up from the sofa, took one step, and passed out.

Of course, the real lesson was about changing the normal conscious state of a twenty-year-old. Why do we love to change our consciousness,

our appreciation and feelings about the world around us? We drink, we smoke, we do lattes, we seek painkillers, we may even get runner's high. We are always tampering with an aspect of our existence we still can't define: phenomenal conscious experience.

Consciousness comes in many flavors. Anyone who has taught an introductory college class, or attended one at eight o'clock Friday morning, has seen them all. There may be a couple of party-hearty frat boys in the back row, dozing after a long night spent celebrating the upcoming weekend. These two are not conscious. Up a couple of rows is the scammer checking out the hot babe across the aisle and wondering if he can get a date. He is conscious, but not of you; nor are the three girls down the way who are passing notes to each other and suppressing their merriment. Another has a tape recorder going and is finishing up a paper for another class, and will be conscious of you later. The front-row kids are sippin' their coffee, taking notes furiously and occasionally nodding in agreement; at least they are conscious of you. Although most people don't sit around and ponder the question of consciousness, they talk about it a lot. After class you may overhear: "I finally *realized* [was conscious of] what a jerk he was, like, he totally didn't even pay any *attention* to what I was saying and was only *conscious* of the sports channel. Great if you are into football stats, but if you want him to [be conscious of and] *remember* your birthday, forget about it. I, like, totally dumped him."

We have talked a lot about two aspects of brain function: the nonconscious goings on and the conscious goings on, the latter being what researcher Michael Posner at the University of Oregon calls alertness. We have already seen that a considerable amount of processing, one might even want to say most of it, occurs without our being aware of it: undercover. It hasn't been easy figuring out the content of all the nonconscious goings on that have been elucidated so far, for the simple reason that it doesn't bubble up to our consciousness. Researchers have had to devise tricky experiments to reveal their presence.

This might lead one to think that studying consciousness may be a little easier. Yet, as French neuroscientists Stan Dehaene and Lionel Naccache point out, the object of our study is now introspective and not

an objectively measurable response.[1] Oddly enough, subjective reports of introspection themselves give us some clues. My studies with split-brain patients have revealed that introspection can be wrong.[2] We actually unwittingly make up stories to fit the observable phenomenon, but this very fact is also a clue, which we will look into a bit later. Our very dualistic nature has also been a stumbling block on the road to unlocking the mechanisms of consciousness.[3] There are those who feel that the essence of consciousness cannot have a physical explanation, that it is so wondrous that it can't be explained by modules and neurons and synapses and neurotransmitters. We will soldier on without them. There are others who think that it can be. I find that being able to explain consciousness with modules, neurons, synapses, and neurotransmitters is even more wondrous and fascinating. It may not be glamorous and transcendent, but it sure is captivating.

THE UNSOLVED MYSTERY

One of the mysteries of consciousness is how a perception or information enters into consciousness from the nonconscious depths. Is there a gatekeeper that lets only some information through? What information is allowed through? What determines that? What happens after that? How do new ideas form? What processes are contributing to consciousness? Are all animals equally conscious or are there degrees of consciousness? Is our consciousness unique? The question of consciousness has been rather like the holy grail of neuroscience. If you tell me you are interested in knowing just exactly what parts of the brain are active when you are conscious of something—a flower, a thought, a song—what you are asking about is known as the *neural correlates of consciousness* (NCC). You are not the lone coyote on this quest. No one knows exactly what is going on, but there are plenty of suggestions. So let's see how many of those questions have been answered and what the theories are about the rest.

Many researchers have proposed definitions and criteria for different levels of consciousness, to the point where it has gotten rather confusing.[4, 5] Progressive levels of consciousness are commonly named

unconsciousness, consciousness, self-awareness, and meta-self-awareness, which means you know that you are self-aware.

Antonio Damasio[6] takes out his scalpel and slices consciousness down even further to only two choices: core consciousness and extended consciousness. Core consciousness is what goes on when the on-off switch is flipped on and an organism is awake and aware of one moment, now, and one place, here. It is alert and not concerned with the future or the past. This consciousness is not aware of self and is not uniquely human. It is, however, the foundation that is necessary to build increasingly complex levels of consciousness, which Damasio calls extended consciousness. Extended consciousness is what we normally think of when we think of being conscious. Extended consciousness is complex and is made up of many levels. For instance, one level of consciousness is being aware of one's surroundings and the chocolate cake on the table. Another is being aware of them and knowing they are different from yesterday and may be different tomorrow. (The cake wasn't there yesterday, and most likely will be gone tomorrow, so dig in now!) These aspects of consciousness have to do with *content*, the components of conscious experience. The highest level is knowing that one is aware of one's surroundings and, I might add, what that cake will do to your waistline, and caring. I know for sure that dogs do not care about their waistlines. This involves the autobiographical self.

What we want to know is whether there is a systematic way that information processing reaches consciousness, and if so, what it is, how it works, and what aspects of this system may be uniquely human. To figure this out, we are going to start with some rough neuroanatomy, including what has been learned from persons with different brain lesions and from neuroimaging studies. Then we are going to look at some theories.

THE PHYSICAL BASIS OF CONSCIOUS EXPERIENCE

First, we need to know what brain areas are needed for core consciousness—the "on" switch. It begins in the brain stem. The brain

stem* is the lower part of the brain, structurally continuous with the spinal cord, the first station on the way to the cortex. It is a structure that is evolutionarily old. All vertebrate animals have a brain stem, but they are not all made up of the same types of neurons. The brain stem is a complicated place. It is like all those subbasements in skyscrapers, full of pipes, vents, wires, and gauges, which are connected to the rest of the building. They keep everything running smoothly, but no one up on the thirty-fourth floor even thinks about them. If you were to disconnect some of the wiring, then the thirty-fourth floor would know something was amiss, whether it was the lights, the AC, or the telephones. If you were to disconnect all the wires, everything would shut down.

Just like the guy on the thirty-fourth floor, you have no idea what is going on in your brain stem. You are not conscious that different groups of neurons, known as nuclei, are relaying signals from your entire body related to the current state of your guts, heart, lung, balance, and musculoskeletal frame to parts of the brain higher up, with connections that are both sending and receiving information in the form of impulses. The main job of these brain-stem nuclei is the homeostatic regulation of both body and brain. They are fundamental for cardiovascular, respiratory, and intestinal control. Disconnect the brain stem, and the body dies. This is true for all mammals.

These groups of neurons have their dendrites in many pies. Some are *required* for consciousness, and those are connected with the intralaminar nuclei (ILN) of the thalamus. Others are required to *modulate* consciousness, like a rheostat; they make up part of the arousal system. These are connected to the basal forebrain,† the hypothalamus, and di-

*The brain stem is involved in the modulation of autonomic activities, hunger and body weight regulation, neuroendocrine functions, reproductive behavior, aggression, and suicidality; in mechanisms underlying attention and learning; in motor control and reward mechanisms underlying motivation; and in subserving the rewarding effect of opiates. It is essential for homeostatic control in general.

†The basal forebrain is located where the name implies: It is a group of structures that lie near the base of the front of the brain. These structures are important in the brain's production of a chemical widely distributed in the brain called acetylcholine, which affects the ability of brain cells to transmit information to one another. Basal

rectly to the cortex.[7] Our party-hearty boys are not irreversibly uncon-
scious. We can pinch them or throw cold water on them, and they will
wake up. Their consciousness was being modulated by the arousal sys-
tem via the connections that pass on to the basal forebrain and the hy-
pothalamus.

Core consciousness is the first step to extended consciousness. If the
wiring for core consciousness is disconnected, the pinch or the cold
water will not bring anyone back to wakefulness. This is where the neu-
rons that connect the brain stem with the intralaminar nuclei of the
thalamus are the stars. There are two ILNs in the thalamus, one in the
right side and one in the left. The thalamus itself is about the size of a
walnut and sits astride the midline, smack dab in the center of the
brain. Small, strategically placed bilateral lesions to the ILN in the tha-
lamus turn consciousness off forever, although a lesion in one alone will
not.[8] If the ILNs of the thalamus don't get their input from the connec-
tions to the brain stem, they are likewise kaput. So we have the first
step on the road to consciousness: The connection of the brain stem to
the thalamus must be active, and at least one of the ILNs must be up
and running.

Where do the pathways from the brain stem go beyond the ILNs?
Wherever they go, some must be involved with consciousness also. Now
the thalamus, of which the ILNs are a part, is a well-connected dude.
Neuronal connections link it to specific regions all over the cortex, and
those regions send connections straight back to the thalamus. It has *con-
nection loops*, which will become important a little later on in our discus-
sion. The ILNs themselves connect to the anterior portion of the

forebrain neurons that use acetylcholine as their neurotransmitter chemical at the syn-
apse (cholinergic neurons) are involved in attention and memory. Inhibiting these
chemicals is one of the mechanisms that causes sleep. Recently it has been shown that
the posterior hypothalamus also plays a major role in arousal and sleep, and has neu-
rons that act like a toggle switch [J. G. Sutcliffe and I. De Lecea, "The hypocretins:
Setting the arousal threshold," *Nature Reviews Neuroscience* 3 (2002): 339–49] or a
"flip-flop" circuit between wakefulness and sleep [C. B. Saper, T. E. Scammell, and L.
Jun, "Hypothalamic regulation of sleep and circadian rhythms," *Nature* 437 (2005):
1257–63].

cingulate cortex. Lesions anywhere from the brain stem to the cingulate cortex can disrupt core consciousness.

It appears that the cingulate cortex is where core consciousness and extended consciousness overlap. The cingulate cortex sits on top of the corpus callosum, the great bundle of neurons that connects the right and left hemispheres. Damasio reports that patients with lesions in their cingulate cortex have disruptions in both core and extended consciousness, but oftentimes can recover core consciousness.

Well then, if the cingulate cortex is involved with extended consciousness, is it well connected too? During the performance of conscious tasks, connections from the cingulate cortex to brain areas supporting the five neural networks for memory, perception, motor action, evaluation, and attention activate. Something else is happening, too. While engaging in a wide assortment of conscious tasks that require different types of brain activity, another area of the brain also is always activated, along with the anterior cingulate cortex (ACC). That was the dorsal lateral prefrontal cortex (dlPFC). And it is no coincidence that these two areas have reciprocal connections—more loops. Moreover, in the ACC there is a particular type of long-distance spindle cell that is present only in the great apes.[9] And, as you may have guessed, the dlPFC is also a hotbed of connections to the same five neural networks mentioned above.* Way back in chapter 1, we discussed the different layers of the cortex. These long-distance neurons originate mostly from the pyramidal cells of layers II and III. These layers are actually thicker in the dlPFC and inferior parietal cortex.

Extended Consciousness and Modularity

We are now getting to areas in the brain that are more specialized. If they become damaged, the result is the loss of a specific ability, not con-

*Through connections to the posterior aspect of the cingulate cortex, the inferior parietal cortex, and the superior temporal cortex (all involved with attention), the parahippocampal cortex (memory), the neostriatal cortex (sensory processing), and the premotor cortex.

sciousness itself. Throughout this book, there has been much talk about modules in the brain and how each has its specific contribution. The idea of a module of neurons dedicated for such specific duties such as reciprocity or cheater detection is fascinating, and the modularity of the brain becomes even more apparent when lesions in the same specific part of different brains cause the same specific deficit, such as the inability to recognize familiar faces. The odd thing is, we don't feel that fractionated. That is one of the reasons why we find these modules so fascinating (and why the very idea of a modular brain can be difficult to believe). "My brain is doing *that*? Crazy!" No, you didn't have any idea, because these modules are all working automatically, under cover, below the level of consciousness. For instance, if certain stimuli trick your visual system into constructing an illusion, consciously knowing that you have been tricked does not make the illusion disappear. That part of the visual system is not accessible to conscious control. We need to remember that all that nonconscious stuff is also contributing to and shaping what comes to the conscious surface. Another thing to keep in mind is that some stuff just cannot be processed nonconsciously. Unfortunately, your high school trig exam may have been an early reminder of this.

If consciousness requires the input of several modules, then the other problem we have to remember is connectivity. We learned in the first chapter that there are only a limited number of connections per neuron, and the more modules there are, the less they are interconnected. Even keeping this in mind, the sheer number of neurons and their connections, ah, well, boggles the mind. The human brain has approximately one hundred billion neurons, and each, on average, connects to about one thousand other neurons. A quick little conscious multiplication reveals that there are one hundred trillion synaptical connections. So how is all this input getting spliced and integrated into a coherent package? To put it anthropomorphically, how does one module know what all the other ones are doing? Or does it? How do we get order out of this chaos of connections? Even though it may not always seem so, our consciousness is rather kicked back and relaxed when you think about all the input with which the brain is being bombarded and all the processing that is going on. In fact, it is as if our consciousness is out on the golf course

like the CEO of a big company while all the underlings are working. It occasionally listens to some chatter, makes a decision, and then is out sunning itself. Ah . . . is that why they call some types of brain processing executive functions?*

Beyond Modularity

The modular crowd recognizes that not all mental activities can be explained by modules. Sometimes you have to step out of that cubicle and communicate with other cubicles. At some point along the processing route, the input from the modules needs to be synthesized, spliced together, and packaged—or ignored, suppressed, and inhibited. Here is the big mystery. How does it happen? Some controlled processing is going on, and there must be a mechanism that supports flexible links among these processing modules. Many theoretical models of this mechanism have been proposed, including the central executive,[10] the supervisory attention system,[11] the anterior attention system,[12, 13] the global workspace,[14] and the dynamic core.[15]

What processes need to be brought together? There are certain components to human consciousness, which we can figure out simply by thinking about what general mental tools we are using. By doing this we are accessing our consciousness and are able to identify what we are conscious of. Let's just pretend you are still conscious while reading this paragraph, and I haven't flipped your arousal switch off. Or maybe your mind has begun to wander, wondering where you should go on vacation next summer or what color to paint the kitchen. Your conscious thoughts require some form of *attention,* either to these words or visions of the Côte d'Azur. You may be using *short-term memory* (working memory) to keep track of what you have read, or *long-term memory* to call into mind past vacations or the color of your friend's kitchen. You also are using your visual *perceptions* and *language* ability while reading this, and most likely while you are formulating your presentation of sun-drenched afternoons sipping pastis. You may be silently talking to yourself (known

*Coined by Alan Baddeley in *Working Memory* (Oxford: Clavendon Press, 1986).

as *inner speech*), listing the reasons why this vacation is a good idea. Not only is all that contributing to your consciousness, but so are your *emotions* and *desires*. Once all these mechanisms are running, you end up being able to *reason* about what I have written and fit it in with what you already know, or to figure out how to talk your spouse into renting that villa. The good thing is, you are not thinking about your income taxes or picking up your dry cleaning . . . uh-oh, now you are. That is an example of top-down attention.

There are two phenomena we have to explain. One is that we feel like smoothly running, coherently thinking beings who are usually in control of our thoughts. We usually don't feel like police dispatchers with reports coming in from hundreds or thousands of different sources, deciding what is important or useful or not, or like triage nurses lining up incoming information in order of its importance, but somehow this *is* happening in our brains. Look around the room you are in and then close your eyes. Was it dusty? How many pencils and pens were on the table or desk? Were there any birds or flowers out the window? How about any dust on the screen? How many other books were in the room? Who wrote them? All this information is going in through your eyes, being perceived and processed and sorted unconsciously, but it is not all making it up to the level of consciousness (luckily) until you direct your attention to it. We also have to explain how we come out with a feeling of ourselves, with our own autobiography; and why, although our consciousness changes from minute to minute, our conscious sense of self does not. Somehow, information is being integrated into a nice package.

THE GATEKEEPER TO CONSCIOUSNESS: ATTENTION

Only certain information makes it through to consciousness. It is a dog-eat-dog world in our brains. Experiments have shown that in order for a stimulus to reach consciousness, it needs a minimal amount of time to be present, and it needs to have a certain degree of clarity. However, this is not quite enough. The stimulus has to have an interaction with the

attentional state of the observer. This can occur in two ways, which are referred to as either top-down or bottom-up processing. Just exactly what is going on here is not known, but Stan Dehaene, Jean-Paul Changeux, a neuroscientist at the Pasteur Institute in Paris, and various collaborators suggest that the top-down mode, when you consciously direct your attention, may be a result of activity in the thalamocortical neurons, those loops that I mentioned earlier. In the bottom-up mode, they suggest, the sensory signals coming from nonconscious activity have so much strength that they can reorient top-down amplification to themselves.[16] This is when your attention may be captured without conscious control. For example, you may be concentrating on a project at work, when all of a sudden you realize you are hearing the fire alarm.

You should note here an important point: Attention and consciousness are two separate animals. First off, cortical processors control the orientation of attention. Although there may be top-down voluntary control, there may also be bottom-up *nonconscious* signals of such strength that they can co-opt attention. We experience this all the time. You may be consciously thinking about the project that you are working on, when off go your thoughts to somewhere else, seemingly beyond your control. Second, although attention may be present, it may not be enough for a stimulus to make it to consciousness.[17] You are reading that article about string theory, your eyes are focused, you are mouthing the words to yourself, and none of it is making it to your conscious brain, and maybe it never will.

SELECTIVE DISRUPTIONS OF CONSCIOUSNESS

Brain lesions in the parietal lobe that affect attention can also affect consciousness. This is shown in a dramatic way in people who have lesions, usually caused by a stroke in the right parietal lobe, that cause disruptions of attention and spatial awareness. These people often behave as if the left side of their world, including the left side of their body, does not exist. If you were to visit such a person, and entered the room on the left, he would not realize you were there. If you served him dinner, he

would eat from only the right side of the plate! He would have shaved only the right side of his face, (or if a woman, would have put makeup on only the right side), would read to you only the right page of a book or newspaper, and would draw only the right side of a clock, or half of a bicycle. But what is truly odd, they don't think there is anything wrong! They are not *conscious* of their problem.

This syndrome is known as *hemineglect*. It includes a lack of awareness for sensory events located toward the side opposite the side where the lesion is (e.g., toward the left following a right-hemisphere lesion), as well as a loss of other actions that would normally be directed toward that side.[18] Some patients may neglect half their body, attempting to climb out of bed without moving their left arm or leg, even though they have no motor weakness on that side. Neglect can also be present in memory and imagination. One patient, when asked to describe the view from one end of a piazza from memory, described only the right half, but when asked to describe it from the other end looking back, described the other half with no reference to what had just been described from the other direction.[19] This phenomenon indicates that our autobiographical self is derived from our conscious musings. If we are not conscious of it, it doesn't exist.

Many patients with hemineglect do not realize that they are missing any information. This is known as *anosognosia*. If their lesion has also caused paralysis, they remain unaware of it. They will tell you the limp arm next to them belongs to someone else. They can be aware that they have been diagnosed with a deficit, but may refuse to believe it. One patient stated, "I knew the word 'neglect' was a sort of medical term for whatever was wrong, but the word bothered me because you only neglect something that is actually there, don't you? If it's not there, how can you neglect it? It doesn't seem right to me that the word 'neglect' should be used to describe it. I think concentrating is a better word than neglect. It's definitely concentration. If I am walking anywhere and there's something in my way, if I'm concentrating on what I'm doing, I will see it and avoid it. The slightest distraction and I won't see it."[20]

As this patient hints, the odd thing about hemineglect is that although it can occur when there is actual loss of sensation or motor systems, it can also occur when all the sensory modalities and musculoskeletal

systems are working. Neglect seems to be a loss of conscious *awareness* of these stimuli. Indeed, if you present a visual stimulus to both the right and left side at once, patients with left hemineglect report seeing only the right stimulus, and appear unconscious of the left stimulus. However, if you present the same left visual stimulus *in isolation,* so that it hits the same exact place on the retina, with no right visual stimulus at all, the left stimulus would be perceived normally. If there is no competition from the normal side, then the neglected side will be noticed.

We were the first to study this phenomenon in a controlled study, over twenty-five years ago. Bruce Volpe, Joseph LeDoux, and I asked the question, "Can information in the neglected field be used at a nonconscious level?" We presented pictures or words, one to each visual field. The only thing the patient suffering from hemineglect had to do was say if the two words or pictures were the same or different. Now remember, because they had neglect, when some sort of stimulus was presented to each visual field, they always verbally stated they consciously saw only the one stimulus, the one that was presented to their left (language) hemisphere. Nonetheless, when they were asked to judge if the words or pictures were the same or different, they responded very well. In short, somehow, somewhere in the brain, the information was combined, and a correct decision was possible, even though the patient was unable to say what the different stimulus was that had been presented to the right hemisphere. Needless to say, if they had guessed "same," they would have concluded in a post-hoc sort of way that the stimuli had been the same.

This experiment started a small cottage industry of experiments exploring what kinds of processes could go on subconsciously. For example, word-priming studies have also shown that even when a word is presented to the neglected field and the patient denies its presence, the information is still being processed unconsciously and would be used for word identification.[21]

So even if the information is there at the nonconscious level, in order for it to make it to consciousness, and for the person to become aware it is there, attention has to be directed to it. Furthermore, neglect is most apparent in *competitive* situations, in which information on or closest to the "good" side comes to dominate information on the "bad" side.[18]

Another odd thing is that when a patient is asked about the presence of the limp arm, instead of saying that he doesn't feel it, he goes so far as to say that it belongs to someone else. What's up with that? If asked to do something that requires the use of both hands, instead of replying that he is unable to, he will reply simply that he doesn't want to. And why don't these patients complain about the problem? If you couldn't see the left half of the room, wouldn't you complain?

This is where split-brain patients are going to help out with explaining this phenomenon and also shed some light on consciousness. The largest tract of neurons in the brain is called the corpus callosum, (CC), and it connects the two hemispheres, along with a smaller tract of neurons in the front part of the brain called the anterior commissure. The corpus callosum contains about two hundred million neurons that originate in which cortical layers? You guessed it: II and III,[22] the layers where most of the long-distance neurons originate. The corpus callosum has not been the focus of much attention in the past, but in light of the growing significance of the modularity and lateral specializations of the brain, this connectivity can be seen in an evolutionary light, as we touched on in chapter 1.

SPLITTING THE BRAIN

The surgical procedure to cut the corpus callosum is a last-ditch treatment effort for patients with severe intractable epilepsy for whom no other treatments have worked. Very few patients have had this surgery, and it is done even more rarely now because of improved medications and other modes of treatment. In fact, there have been only ten split-brain patients that have been well tested. William Van Wagenen, a Rochester, New York, neurosurgeon, performed the procedure for the first time in 1940, following the observation that one of his patients with severe seizures got relief after developing a tumor in his corpus callosum.[23]

Epileptic seizures are caused by abnormal electrical discharges that in some people spread from one hemisphere to the other. It was thought that if the connection between the two sides of the brain was cut, then

the electrical impulses causing the seizures wouldn't spread from one side of the brain to the other. The great fear was what the side effects of the surgery might be. Would it create a split personality, with two brains in one head? In fact, the treatment was a great success. Most patients' seizure activity decreased 60 to 70 percent, and they felt just fine: no split personality, no split consciousness.[24, 25] Most seemed completely unaware of any changes in their mental processes. This was great, but puzzling nonetheless. Why don't split-brain patients have dual consciousness? Why aren't the two halves of the brain conflicting over which half is in charge? *Is* one half in charge? Is consciousness and the sense of self actually located in one half of the brain?

Split-brain patients will do subtle things to compensate for their loss of brain connectivity. They may move their heads to feed visual information to both hemispheres, or talk out loud for the same purpose, or make symbolic hand movements. Only under experimental conditions, when we eliminate cross-cuing, does the disconnection between the two hemispheres become apparent. We are then able to demonstrate the different abilities of the two hemispheres.

Before we see what is separated after this surgery, we need to understand what continues to be shared. There are subcortical pathways that remain intact. Both hemispheres of the split-brain patient are still connected to a common brain stem, so both sides receive much of the same sensory and proprioceptive information automatically coding the body's position in space. Both hemispheres can initiate eye movements, and the brain stem supports similar arousal levels, so both sides sleep and wake up at the same time.[26] There also appears to be only one integrated spatial attention system, which continues to be unifocal after the brain has been split. Attention cannot be distributed to two spatially disparate locations.[27] The left brain does not pay attention to the blackboard while the right brain is checking out the hot dude in the next row. Emotional stimuli presented to one hemisphere will still affect the judgment of the other hemisphere.

You may have been taught in anatomy lectures that the right hemisphere of the brain controls the left half of the body and left hemisphere controls the right half of the body. Of course, things are not quite that simple. For instance both hemispheres can guide the facial and proximal

muscles, such as the upper arms and legs, but the separate hemispheres have control over the distal muscles (those farthest from the center of the body), so that, for example, the left hemisphere controls the right hand.[28] While both hemispheres can generate spontaneous facial expressions, only the dominant left hemisphere can generate voluntary facial expressions.*[29] Because half the optic nerve crosses from one side of the brain to the other at the optic chiasm, the parts of both eyes that attend to the right visual field are processed in the left hemisphere, and vice versa. This information does *not* cross over from one disconnected hemisphere to the other. If the left visual field sees something in isolation from the right, only the right side of the brain has access to that visual information. This is why these patients will move their heads to input visual information to both hemispheres.

It has also been known since the first studies of Paul Broca† that our language areas are usually located in the left hemisphere (with the exception of a few left-handed people). A split-brain patient's left hemisphere and language center have no access to the information that is being fed to the right brain. Bearing these things in mind, we have designed ways of testing split-brain patients to better understand what is going on in the separate hemispheres. We have verified that the left hemisphere is specialized for language, speech, and intelligent behavior, while the right is specialized for such tasks as recognizing upright faces, focusing attention, and making perceptual distinctions.

*It was also shown that when the left hemisphere carried out a command to smile or frown, the right side of the face responded about 180 milliseconds before the left side. This latter finding is consistent with the fact that the corpus callosum is involved in the execution of voluntary facial commands.

†Paul Broca was a French neuroanatomist who has garnered fame for his discovery, published in 1865, of the speech center in the left hemisphere, which has been named Broca's area. However, earlier reports were made to the French Academy of Sciences in 1837 and later posthumously published in 1863 of the same discovery made by the French neurologist Marc Dax. Some authors suggest that "the theory of the left hemisphere dominance for speech must be attributed equally to Dax and Broca, and henceforth should be called *the theory of Dax-Broca.*" R. Cubelli and C. G. Montagna, "A reappraisal of the controversy of Dax and Broca," *Journal of the History of Neuroscience* 3 (1994): 215–26.

Where attention is concerned, the hemispheres interact quite differently in their control of reflexive versus voluntary attention processes.[30, 31, 32] There is a limited amount of overall available attention.[33] The evidence suggests that reflexive (bottom-up) attention orienting happens independently in the two hemispheres, while voluntary attention orienting involves hemispheric competition, with control preferentially lateralized to the left hemisphere. The right hemisphere, however, attends to the entire visual field, whereas the left hemisphere attends only to the right field.[34, 35, 36] This can explain part of the problem of our hemineglect patients. When the right inferior parietal lobe is damaged, the left parietal lobe remains intact. However, the left parietal lobe directs its visual attention only to the right side of the body. There is no brain area paying attention to what is going on in the left visual field. The question that remains is, why doesn't this bother the patient? I'm getting there.

Breaking Up Is Not So Hard to Do

The left hemisphere is specialized for intelligent behavior. Don't leave home without it!

After the human cerebral hemispheres have been disconnected, the verbal IQ of a patient remains intact,[37, 38] and so does his problem-solving capacity. There may be some deficits in free-recall capacity and in other performance measures, but isolating essentially half of the cortex from the dominant left hemisphere causes no major change in cognitive functions. The left remains unchanged from its preoperative capacity, and the largely disconnected, same-size right hemisphere is seriously impoverished in cognitive tasks. Although the right hemisphere remains superior to the isolated left hemisphere for some perceptual* and attentional skills, and perhaps also emotions, it is poor at problem solving and many other mental activities. A brain system (the right hemisphere) with roughly the same number of neurons as one that easily cogitates (the left

*The right hemisphere outperforms the left in tests of spatial ability, such as determining alignment and orientation. Some processes are done only by the right hemisphere, such as inferring hidden contours or extrapolating cause from colliding objects that involve time and space.

hemisphere) is incapable of higher-order cognition—convincing evidence that cortical cell number by itself cannot fully explain human intelligence.[39]

The difference between the two hemispheres in problem solving is captured in a probability-guessing experiment. We have subjects try to guess which of two events will happen next: Will it be a red light or a green light? Each event has a different probability of occurrence (e.g., a red light appears 75 percent of the time and a green 25 percent of the time), but the order of occurrence of the events is entirely random. There are two possible strategies one can use: frequency matching or maximizing. Frequency matching would involve guessing red 75 percent of the time and guessing green 25 percent of the time. The problem with that strategy is that since the order of occurrence is entirely random, it can result in a great deal of error, often being correct only 50 percent of the time, although it *could* result in being correct 100 percent of the time also, but it is fully dependent upon luck. The second strategy, maximizing, involves simply guessing red every time. That ensures an accuracy rate of 75 percent, since red appears 75 percent of the time. Animals such as rats and goldfish maximize. In Vegas, the house maximizes. Humans, on the other hand, match. The result is that nonhuman animals perform better than humans in this task.

The human's use of this suboptimal strategy has been attributed to a propensity to try to find patterns in sequences of events, even when told the sequences are random. George Wolford, Michael Miller, and I tested the two hemispheres of split-brain patients to see if the different sides used the same or different strategies.[40] We found that the left hemisphere used the frequency-matching strategy, whereas the right hemisphere maximized! Our interpretation was that the right hemisphere's accuracy was higher than the left's because the right hemisphere approaches the task in the simplest possible manner with no attempt to form complicated hypotheses about the task.

However, more recent tests have yielded even more interesting findings. They have shown that the right hemisphere uses frequency matching when presented with stimuli for which it is specialized, such as facial recognition, and the left hemisphere, which is not a specialist in this task, responds randomly.[41] This suggests that one hemisphere

cedes control of a task to the other if the other hemisphere specializes in that task.[42] The left hemisphere, on the other hand, engages in the human tendency to find order in chaos. The left hemisphere persists in forming hypotheses about the sequence of events even in the face of evidence that no pattern exists—in playing slot machines, for instance. Why would the left hemisphere do this, even when it can be nonadaptive?

The Left Hemisphere Is a Know-It-All

Several years ago, we observed something about the left hemisphere that was very interesting: how it deals with behaviors we had elicited from the disconnected right hemisphere about which it had no information. We showed a split-brain patient two pictures: a chicken claw was shown to his right visual field, so the left hemisphere saw only that, and a snow scene was shown to the left visual field, so the right hemisphere saw only that. He was then asked to choose from an array of pictures placed in full view in front of him. From the array of pictures, the shovel was chosen with the left hand and the chicken with the right. When asked why he chose these items, his left-hemisphere speech center replied, "Oh, that's simple. The chicken claw goes with the chicken, and you need a shovel to clean out the chicken shed." Here the left brain, observing the left hand's response without knowing why it has picked that item, had to explain it. It will not say, "I don't know." Instead it interprets that response in a context consistent with what it knows, and all it knows is: chicken claw. It knows nothing about the snow scene, but it has to explain pointing to the shovel with the left hand. It has to find reasons for the behavior. We called this left-hemisphere process *the interpreter*.

We also tried the same type of test with mood shifts. We showed a command to the right hemisphere to laugh. The patient began to laugh. Then we asked the patient why she was laughing. The speech center in the left hemisphere had no knowledge of why its person was laughing, but out would come an answer anyway: "You guys are so funny!" When we triggered a negative mood in the right hemisphere by a visual stimulus, the patient denied seeing anything but suddenly said that she was upset

and that it was the experimenter that was upsetting her. She *felt* the emotional response to the stimulus, all the autonomic results, but had no idea what caused them. Ah, lack of knowledge is of no importance, the left brain will find a solution! Order must be made. The first makes-sense explanation will do—the experimenter did it! The left-brain inter-preter makes sense out of all the other processes. It takes all the input that is coming in and puts it together in a story that makes sense, even though it may be completely wrong.

THE RELATIONSHIP BETWEEN THE INTERPRETER AND CONSCIOUS EXPERIENCE

So here we are, back to the main question of the chapter: How come we feel unified when we are made up of a gazillion modules? Decades of split-brain research have revealed the specialized functions of the two hemispheres, as well as providing insights into specialization *within* each hemisphere. Our big human brains have countless capacities. If we are merely a collection of specialized modules, how does that powerful, al-most self-evident feeling of unity come about? The answer may lie in the left-hemisphere interpreter and its drive to seek explanations for why events occur.

In 1962, Stanley Schachter and Jerry Singer at Columbia University injected epinephrine into subjects participating in a research experi-ment.[43] Epinephrine activates the sympathetic nervous system, and the result is an increased heart rate, hand tremors, and facial flushing. The subjects were then put into contact with a confederate who behaved in either a euphoric or an angry manner. The subjects who were informed about the effects of the epinephrine attributed symptoms such as a rac-ing heart to the drug. The subjects who were not informed, however, at-tributed their autonomic arousal to the environment. Those who were with the euphoric confederate reported being elated and those with the angry confederate reported being angry. This finding illustrates the hu-man tendency to generate explanations for events. When aroused, we are

driven to explain why. If there is an obvious explanation, we accept it, as did the group informed about the effects of epinephrine. When there is not an obvious explanation, we generate one. The subjects recognized that they were aroused and immediately assigned some cause to it. We talked about this in the last chapter when we discussed looking over the edge of the Grand Canyon. This is a powerful mechanism; once seen, it makes one wonder how often we are victims of spurious emotional-cognitive correlations. (I am feeling good! I must really like this guy! As he is thinking, *Ah, the chocolate is working!*) Split brain research has shown us that this tendency to generate explanations and hypotheses—to interpret—lies within the left hemisphere.

Although the left hemisphere seems driven to interpret events, the right hemisphere shows no such tendency. A reconsideration of hemispheric memory differences suggests why this dichotomy might be adaptive. When asked to decide whether a series of items appeared in a study set or not, the right hemisphere is able to identify correctly items that have been seen previously and to reject new items. "Yes, there was the plastic fork, the pencil, the can opener, and the orange." The left hemisphere, however, tends to falsely recognize new items when they are similar to previously presented items, presumably because they fit into the schema it has constructed.[44, 45] "Yes, the fork [but it is a silver one and not plastic], the pencil [although this one is mechanical and the other was not], the can opener, and the orange." This finding is consistent with the hypothesis that the left-hemisphere interpreter constructs theories to assimilate perceived information into a comprehensible whole. By going beyond simply observing events to asking why they happened, a brain can cope with such events more effectively if they happen again. In doing so, however, the process of elaborating (story making) has a deleterious effect on the accuracy of perceptual recognition, as it does with verbal and visual material. Accuracy remains high in the right hemisphere, however, because it does not engage in these interpretive processes. The advantage of having such a dual system is obvious. The right hemisphere maintains an accurate record of events, leaving the left hemisphere free to elaborate and make inferences about the material presented. In an intact brain, the two systems complement each other, allowing elaborative processing without sacrificing veracity.

The probability-guessing paradigm also demonstrates why having an interpreter in one hemisphere and not the other would be adaptive. The two hemispheres approach problem-solving situations in two different ways. The right hemisphere bases its judgments on simple frequency information, whereas the left relies on the formation of elaborate hypotheses. Sometimes it is just a random coincidence. In the case of random events, the right hemisphere's strategy is clearly advantageous, and the left hemisphere's tendency to create nonsensical theories about random sequences is detrimental to performance. This is what happens when you build a theory on a single anecdotal situation. "I vomited all night. It must have been the food was bad at that new restaurant where I ate dinner." This would be a good hypothesis if everyone who ate what you ate became ill, but not just one person. It may have been the flu, or your lunch. In many situations, however, there is an underlying pattern, and in these situations the left hemisphere's drive to create order from apparent chaos would be the best strategy. Coincidences do happen, but sometimes there really is a conspiracy. In an intact brain, both of these cognitive styles are available and can be implemented, depending on the situation.

The difference in the way the two hemispheres approach the world can be seen as adaptive. It might also provide some clues about the nature of human consciousness. In the media, split-brain patients have been described as having two brains. The patients themselves, however, claim that they do not feel any different after the surgery than they did before. They do not have any sense of the dual consciousness implied by the notion of having two brains. How is it that two isolated hemispheres give rise to a single consciousness? The left-hemisphere interpreter may be the answer. The interpreter is driven to generate explanations and hypotheses regardless of circumstances. The left hemisphere of split-brain patients does not hesitate to offer explanations for behaviors that are generated by the right hemisphere. In neurologically intact individuals, the interpreter does not hesitate to generate spurious explanations for sympathetic nervous system arousal. In these ways, the left-hemisphere interpreter may generate a feeling in all of us that we are integrated and unified.

In his masterpiece, *The Alexandria Quartet,* Lawrence Durrell tells a

story in four books, *Justine, Balthazar, Mountolive,* and *Clea.* Each of the first three books tells the story of a group of people living in Alexandria, Egypt, just before World War II, from the viewpoint of a different character. If you were to read only the first book, *Justine,* you would have a distorted idea of all that was going on. The second book, *Balthazar,* gives you more information, and the third even more. In all three, however, the reader is at the mercy of the narrators. Your interpretation of the story is dependent upon what they tell you: Your interpretation is dependent upon the supplied information. This is true for the interpretive system in the brain, also. The conclusions of an interpretive system are only as good as the information it receives.

Now, finally, we can consider our patients with hemineglect. First, let's start with an easy case. If a person has a lesion in the optic nerve that carries information about vision to the visual cortex, the damaged nerve ceases to carry that information; the patient complains that he is blind in the relevant part of his visual field. For example, such a patient might have a huge blind spot to the left of center in his visual field. No wonder he complains. However, if another patient has a lesion not in the optic tract but in the visual cortex (the area where the visual information is processed after it is received), and it creates a blind spot of the same size in the same place, he usually does not complain at all. The reason is, the cortical lesion is in the place in his brain that represents an exact part of the visual world, the place that ordinarily asks, "What is going on to the left of visual center?" With a lesion on the optic nerve, this brain area was functioning; when it could not get any information from the nerve, it squawked—"something is wrong, I am not getting any input!" When that same brain area is itself damaged and no longer does its job, the patient's brain no longer has an area responsible for what is going on in that part of the visual field; for that patient, that part of the visual field no longer exists, so there is no squawk at all. The patient with the central lesion does not have a complaint because the part of the brain that might complain has been incapacitated, and no other takes over.

As we move further down the line into the brain's processing centers, we see the same pattern, but now the problem is with the interpretive function. The parietal cortex is constantly seeking information on the arm's position in three-dimensional space, and it also monitors the arm's

existence in relation to everything else. If there is a lesion in the sensory nerves that bring information to the brain about where the arm is, what is in its hand, or whether it is in pain or feels hot or cold, the brain communicates that something is wrong: "I am not getting any input! Where's the left hand? I can't feel a thing!" But if the lesion is in the parietal cortex, that monitoring function is gone with no squawk raised, because the squawker is damaged. Consider our case of anosognosia and the disowned left hand. A patient with a right parietal lesion suffers damage to the area that represents the body's left half. It is as if that part of the body has lost its representative in the brain and left no trace. There is no brain area that knows about the left half of the body and whether it is working or not. When a neurologist holds a patient's left hand up to the patient's face, the patient gives a reasonable response: "That's not my hand." The interpreter, which is intact and working, cannot get news from the parietal lobe; in fact, it does not even know that there should be news from the parietal lobe, since the flow of information has been disrupted by the lesion. For the interpreter, which is dependent upon the information it receives, the left hand simply does not exist anymore, just as seeing behind the head or wagging a tail is not something the interpreter is supposed to worry about. It is true, then, that the hand held in front of him cannot be his. In this light, the claims of the patient are more reasonable.

Reduplicative paramnesia is another odd syndrome, in which there is the delusional belief that a place has been duplicated, or exists in more than one spot at the same time, or has been moved to a different location. One such patient I had was a woman who, although she was being examined in my office at New York Hospital, claimed we were in her home in Freeport, Maine. The standard interpretation of this syndrome is that she made a duplicate copy of a place (or person) and insisted there were two.

This woman was intelligent; before the interview she was biding her time reading the *New York Times*. I started with the "So, where are you?" question. "I am in Freeport, Maine. I know you don't believe it. Dr. Posner told me this morning when he came to see me that I was in Memorial Sloan-Kettering Hospital and that when the residents come on rounds to say that to them. Well, that is fine, but I know I am in my house on Main Street in Freeport, Maine!"

I asked, "Well, if you are in Freeport and in your house, how come there are elevators outside the door here?" The grand lady peered at me and calmly responded, "Doctor, do you know how much it cost me to have those put in?"

This patient's interpreter tried to make sense of what she knew and felt and did. Because of her lesion, the part of the brain that represents locality was overactive and sending out an erroneous message about her location. The interpreter is only as good as the information it receives, and in this instance it was getting a wacky piece of information. Yet the interpreter still has to field questions and make sense of other incoming information—information that to the interpreter is self-evident. The result? A lot of imaginative stories.

In Capgras' syndrome, patients will recognize a familiar person but will insist that the person is an imposter and has been replaced by an identical double. For instance, a woman will say Jack (who really is her husband) looks like her husband, but he really isn't her husband, he's a double, or an alien. In this syndrome, it appears that the emotional feelings for the familiar person are disconnected from the representation of that person.[46] The patient feels no emotion when they see the familiar person. The interpreter has to explain this phenomenon. It is receiving the information from the face identification module: "That's Jack." However, it is not receiving any emotional information. Therefore in order to explain the situation, the interpreter comes up with a solution: "It must not really be Jack, because if it really were Jack I'd feel some emotion, so he is an imposter!"

I JUST GOTTA BE ME!
SELF-AWARENESS

The interpreter also has other duties. This system that started out making sense of all the information bombarding the brain—interpreting our cognitive and emotional responses to what we encounter in our environment, asking how one thing relates to another, making hypotheses, bringing order out of chaos—also creates a running narrative of our actions, emotions, thoughts, and dreams. The interpreter is the glue that

keeps our story unified and creates our sense of being a coherent, rational agent. Insertion of an interpreter into an otherwise functioning brain creates many by-products. A device that begins by asking how one thing relates to another, a device that asks about an infinite number of things, in fact, and that can get productive answers to its questions, cannot help but give birth to the concept of self. Surely one big question the device would ask is, "Who is solving all these problems? Hmm . . . Let's call it *me*"—and away it goes!*

"My sense of self is a by-product?"

Yes, sorry. Now at this point we could get all philosophical or Freudian about what is self or I, but we aren't going there. We are going to cognitive psychology instead.

It is generally agreed that self-cognition is constructed from several distinct processes, and several different proposals have been made as to what processes make up self-cognition. John Kihlstrom and my colleague Stan Klein[47] at the University of California, Santa Barbara, emphasize that the self is a knowledge structure, not a mystical entity. They have suggested that there are four categories of self-knowledge that are stored and cataloged in different formats in the brain.

1. The conceptual self: a fuzzy set of context-specific selves united by a *theory* of how we got to be the person that we are. "I am a generous (or stingy), happy (or taciturn), and swell (or jerky) guy because my parents (or church or society or Bacchus) taught me (or made me) to be that way." According to Pascal Boyer and colleagues[48] this would include the domain of social systems: The self-concept includes notions of social identity or moral status and also includes the capacities for theory of mind and empathy.

2. The self as a *narrative,* which we have constructed, rehearsed to ourselves, and told to others about the past, present, and future. "I was born on a ranch, grew up breaking horses, and knew rodeo was my life."

*Those other big questions are, Why are we here? What is the purpose of life? How did we get here? and How are humans unique?

3. The self viewed as an image, with details about face, body, and gestures. "I am slender, graceful, and quite striking. You gotta see me tango!"

4. An associative network with information about personality traits, memories, and experiences, stored separately in episodic and semantic memory. "I am confident and outgoing and always have a great tan. I was born in Tahiti, moved to Hawaii, had a great time there, and won the state surfing championships on a totally gnarly surf day. Chicks dig me."

This is sounding suspiciously familiar. I submit that it is the left-brain interpreter that is coming up with the theory, the narrative, and the self-image, taking the information from various inputs, from the "neuronal workspace," and from the knowledge structures, and gluing it together, thus creating the self, the autobiography, out of the chaos of input.

Do these knowledge structures about self differ from other knowledge structures? Some neuropsychologists think not much. James Gilligan and Martha Farah at the University of Pennsylvania think that most structures are probably not distinct from processes involving persons in general.[49] This actually makes a lot of sense in terms of brain economy. I propose that the left-brain interpreter is uniquely human. It can take information from a wide variety of sources, the same sources that are available to other animals, but it integrates that information in a unique way to create our self-conscious self. There has been a phase shift. The degree to which humans are self-aware is unique.

However, there may be some specialized knowledge structures that we will consider that give our interpreter an edge. First we are going to learn a bit about memory, and then we are going back to patients with lesions that affect the sense of self, to see if we can learn anything more. Remember that the interpreter can use only information that it has available.

Consider the trip to the Côte d'Azur. In proposing such a trip, you are using information that you know about yourself that indicates that you will enjoy the trip. Where is this information coming from? How about your travel partner? Is the same information available about another

person, and is it stored as memory in the same place? One fascinating aspect of memory that was noticed several years ago was that if you asked a person if a certain word was self-descriptive, that word would later be remembered better than if you asked about the word in a more general sense. For instance a person would remember the word *kind* better if he had been asked, "Are you kind?" than if he had been asked, "What does *kind* mean?"[50] This led researchers to believe that self-knowledge might be stored in a different manner than other information.

Memory stores two basic types of information: procedural and declarative.[51] Procedural memory allows one to retain perceptual, motor, and cognitive skills and express them nonconsciously, such as driving a car, riding a bicycle, tying a shoelace, braiding one's hair, and, eventually, playing the piano. Declarative memory is made up of facts and beliefs about the world, such as, the desert is hot in the summer, and orange blossoms are fragrant. Neuroscientist Endel Tulving, professor emeritus at the University of Toronto, proposes that there are two types of declarative memory: semantic and episodic.[51, 52, 53]

Semantic memory is generic: "Just the facts ma'am, just the facts," not necessarily associated with the source or where or when they were learned. Cairo is the capital of Egypt, 12 squared is 144, and most wine is made from grapes. Semantic memory makes no subjective reference to the self, although it can have facts about the self: "I have green eyes. I was born in Timbuctoo." Semantic memory provides knowledge from the point of view of an observer of the world rather than that of a participant. Episodic memory retains events that were experienced by the self at a particular place and time. "I had a great time at the party last night, and the food was delicious!"

Tulving is continually sculpting the definition of episodic memory as more is known about it. Because he considers episodic memory uniquely human, and since it will be important in our discussion of animal consciousness later, I will quote his most recent sculpting.

> Episodic memory is a recently evolved, late developing, and early deteriorating brain/mind (neurocognitive) memory system. It is oriented to the past, more vulnerable than other memory systems to neuronal dysfunction, and probably unique to humans. It makes possible mental time

travel through subjective time—past, present, and future. This mental time travel allows one, as an "owner" of episodic memory ("self"), through the medium of autonoetic awareness,* to remember one's own previous "thought-about" experiences, as well as to "think about" one's own possible future experiences. The operations of episodic memory require, but go beyond the semantic memory system. Retrieving information from episodic memory ("remembering") requires the establishment and maintenance of a special mental set, dubbed episodic "retrieval mode." The neural components of episodic memory comprise a widely distributed network of cortical and subcortical brain regions that overlap with and extend beyond the networks subserving other memory systems. The essence of episodic memory lies in the conjunction of three concepts—self, autonoetic awareness, and subjective time.[54]

By definition, episodic memory always includes the self as the agent or recipient of some action. When a person—let's call her Sarah—remembers an event, she reexperiences it with the awareness that it happened to her: "I remember seeing the Stones last year. They were great!" The major distinction between episodic and semantic memory is not the type of information they encode, but *the subjective experience that accompanies the operations of the systems at encoding and retrieval.* Sarah could say, "I saw the Stones last year," as a fact, even if she was too drunk to actually remember having done so. Episodic memory is rooted in autonoetic awareness and in the belief that the self having the experience now is the same self that had it originally. Semantic memory requires only noetic awareness, which is experienced when one thinks objectively about something that one knows. Tulving emphasizes that it is "possible to be noetically aware of one's self, including body position in space, traits, and characteristics, and even autobiographical facts that are not accompanied by a feeling of re-experiencing or reliving the past."

It is looking as though semantic memory appears earlier in development than episodic memory. Although very young children appear to be able to remember facts and can think about things that are not physically present (that is, they have semantic memory), it is difficult to determine

*The ability to focus attention directly on one's own subjective experiences.

whether they can consciously recollect the past in a way that engages a developed episodic system. Babies who are two years old have been able to demonstrate recall of things that they had witnessed at age thirteen months.[55] However, several pieces of evidence support the idea that it isn't until children are at least eighteen months old that they actually include themselves as part of the memory, although this ability tends to be more reliably present in three- to four-year-olds.[56, 57] In fact, it appears that children less than four years old have no knowledge of time scales,[58, 59] which is why it is never a good idea to tell them that you will be going to Disneyland in two weeks. This later-developing episodic memory explains why there is scant autobiographical memory from our very early years.

Evolutionary psychology theory, however, is not going to be happy with only episodic memory doing all the autobiographical work. It would take way too long when you need "quick and dirty" answers. If our ancestor was presented with the question of whether to chase a prey or not, he needed a fast answer about his capabilities. He couldn't wait around while he remembered every gazelle and warthog that he had ever run after and whether his speed and endurance matched theirs, and calculate the probabilities; he needed precomputed and stored answers: "I am fast, strong, and have endurance. Go for it!" or "I am slow, wimpy, and tire easily, and besides that, warthogs are gross. I'll just tell Cronos where it is."

Well, guess what? The semantic system, that "Just the facts, ma'am" system, appears to have a subsystem for *personality trait summaries*. Stan Klein and Judith Loftus did some tests to tease out whether personality trait summaries were stored separately from episodic memory. Subjects were given pairs of tasks, the first serving as a prime for the second. The first task varied among answering if a trait was self-descriptive ("Are you generous?"), doing a filler task ("Define the word table"), or a control task (which was either looking at a blank screen or defining a trait word: "What does selfish mean?"). Next, if the first task had been answering whether a trait was self-descriptive, the second task was to remember an episode in which the subject had displayed that trait. The experimenters measured the amount of time it took to come up with the remembered episode. If the subjects had seen only a blank screen, they were presented

with a new trait and asked to come up with an episode in which they had displayed that trait. The researchers reasoned that if subjects had used episodic memory to come up with an answer about whether a trait was self-descriptive (yes, I'm generous), then they should be faster at describing an episode when they displayed that trait, because they would already have thought of it to answer the first question. However, this isn't what happened. It took subjects just as long to remember an episode of a trait that they had already been asked about as they did to remember an episode of a different trait of which no previous mention had been made. The experimenters concluded that people can answer questions about their personality traits by accessing trait summaries without invoking memories of specific episodes.[60]

Other research Klein and Loftus have done has shown that episodic memory is called in only when there is no trait summary available—for instance, when experience is extremely limited in regard to a specific trait. This also holds true when making judgments of other people. Episodic memory is called upon only when no trait summary exists.[61] One patient with total amnesia who could not remember a single thing he had done or experienced in his life has been extensively studied. Not only does he have no episodic memory, but his semantic memory has also been partially lost. Although he could not accurately describe the personality of his daughter, he could accurately describe his own personality. He knew some facts about his life, but was missing others. He knew some well-known facts about history, but not others. This patient's pattern of deficits strongly suggests that there is specific memory architecture for storage and retrieval of self personality traits.

The general trend from studies that have been done on self-referential traits points to left-hemisphere involvement.[62] How about the autobiographical episodic memories? Can they be located? The answer to this question has been elusive; some evidence points to one side, some to the other. The picture that is emerging is that aspects of self-knowledge are distributed throughout the cortex, a little here, a little there. There is some evidence that the frontal regions of the left hemisphere play a pivotal role in setting the goal for retrieval and reconstruction of autobiographical knowledge.[63, 64, 65]

Do split-brain patients help us out at all with locating where self

processing is located? Severing the corpus callosum in humans has raised a fundamental question about the nature of the self: Does each disconnected half brain have its own sense of self? Could it be that each hemisphere has its own point of view, its own self-referential system that is truly separate and different from that of the other hemisphere?[66]

Early observations of split-brain patients indicated that this could be the case.[67] There were moments when one hemisphere seemed to be belligerent while the other was calm. There were times when the left hand (controlled by the right hemisphere) behaved playfully with an object that was held out of view while the left hemisphere seemed perplexed about why. However, of the dozens of instances recorded over the years, none allowed for a clear-cut claim that each hemisphere has a full sense of self. Although it has been difficult to study the self per se, there have been intriguing observations about perceptual and cognitive processing relating to the self.

Research has revealed much about the processes and brain structures that support the recognition of familiar others (for example, friends, family members, and movie stars). Both functional imaging and patient studies show that face recognition is typically reliant on structures in the right cerebral hemisphere. For example, we have shown that split-brain patients perform significantly better on tests of face recognition when *familiar* faces are presented to the right hemisphere rather than the left hemisphere.[68] Similarly, damage to specific cortical areas in the right hemisphere impairs the ability to recognize others.[69, 70, 71, 72, 73]

But is the right hemisphere similarly specialized for *self*-recognition? Although some support has been garnered for this idea,[74, 75, 76] the available evidence is inconclusive. Neuroimaging studies have revealed that highly self-relevant material (for example, autobiographical memories) activates a range of cortical networks in the left hemisphere that could, potentially, support self-recognition and a host of related cognitive functions.[77, 78, 79] Therefore, whereas the recognition of familiar others relies primarily on structures in the right hemisphere, self-recognition might be supported by additional left-lateralized cognitive processes. To investigate this possibility, David Turk and colleagues assessed face recognition of self versus a familiar other in a split-brain patient.[80]

Patient J.W. viewed a series of facial photographs that ranged from 0 percent to 100 percent self-images. A photograph of me (M.G.), a long-time associate of J.W. (that is, a highly familiar other), was used to represent 0 percent self, and a photograph of J.W. was used to represent 100 percent self. Nine additional images were generated using computer-morphing software, each image representing a 10 percent incremental shift from M.G. to J.W. In one condition (self-recognition), J.W. was asked to indicate whether the presented image was he; in the other condition (familiar-other recognition), he was asked to indicate whether the image was M.G. The only difference across the two conditions was the judgment that was required (Is it me? versus Is it Mike?).

The results revealed a double dissociation in J.W.'s face-recognition performance. His left hemisphere showed a bias toward recognizing morphed faces as self, whereas his right hemisphere showed the opposite pattern; that is, biased recognition in favor of a familiar other. In short, the left hemisphere is quick to detect a partial self-image, even one that is only slightly reminiscent of the self, whereas the right brain needs an essentially full and complete picture of the self before it recognizes the image as such. In the left hemisphere, there was, essentially, a linear relationship between the amount of self in the image and the probability of detecting self. The right hemisphere, on the other hand, did not recognize the image as self until the image contained more than 80 percent self. The finding that the left hemisphere requires less self in the image for self-recognition might reflect a key role of the left hemisphere in the retrieval of self-knowledge, or might depend on the left-brain interpreter taking whatever information is available and making a judgment call on the basis of that information. This also goes along with the right brain's being more accurate and maximizing information, not forming a hypothesis—"Wait a minute, that is not me. That nose is not quite right," while the left brain will frequency-match and hypothesize, "Yep that's me!"

Overall, the data indicate that a sense of self arises out of distributed networks in both hemispheres.[80, 81] It is likely that both hemispheres have processing specializations that contribute to a sense of self, and that sense of self is constructed by the left-hemisphere interpreter on the basis of the input from these distributed networks.

ANIMALS AND CONSCIOUSNESS: TO WHAT DEGREE?

This is the question that intrigues many animal researchers. The answer has been elusive. If only they could talk, they would be so much easier to study. To paraphrase Steve Martin,* "Boy, those animals! They don't have a different word for anything!" As I mentioned earlier, there are many levels of consciousness, defined differently by different researchers. It is well accepted that mammals are conscious to the here and now, but the debate begins with the degree of extended consciousness that they possess. The problem is, how can one design an experiment that could demonstrate degrees of consciousness in a nonverbal animal? Come up with the answer to that problem and you have yourself a big fat PhD dissertation.

In order to determine degrees of extended consciousness an animal possesses, one needs to know what is considered to be extended consciousness. The basic step that is made into extended consciousness is becoming self-aware to some degree. Self-awareness means being the object of one's own attention. Various scientists describe this as ranging from merely being aware of the products of self-perception or environmental stimuli ("I hear a noise," "I feel a thorn") to the ability of conceptualizing information about the self, which needs to be determined abstractly ("I am hip.")[82] This has led animal researchers to concentrate in two areas: animal self-awareness and animal metacognition (thinking about thinking).

Animal Self-Awareness

In discussing animal self-awareness, Marc Hauser makes the point that when it would pay, in evolutionary terms, to treat some members of your own species differently from others is when the discrimination leads to fitness payoffs. Thus it may pay to be able to recognize the opposite sex, or the age of another individual (if they were sexually mature . . . no use

*"Boy, those French! They have a different word for everything."

wasting time on courting an immature individual), or your own mother, or kin versus non-kin, or other members of your own pack or hive. He tells us, "All social, sexually reproducing organisms seem to be equipped with neural machinery for discriminating males from females, juveniles from adults, and relatives from nonrelatives."[83]

Many different systems have evolved to help identify kin from non-kin. One system that many birds have is imprinting. The first individual they see is Ma. This usually works, but glitches in this system have been the basis of many cartoons. Sweat bees and paper wasps recognize their colony by odor, ground squirrels also use odor for recognition,[84] and Mexican free-tail bats recognize their own pup out of thousands through vocal and olfactory communication. These recognition systems use some sensory perception to clue recognition, a match to a specified neural template, but they do not require any self-awareness, any "knowing of self" to work.

Trying to design a test to demonstrate self-awareness in animals has proven difficult. In the past it has been approached from two angles. One is mirror self-recognition and the other is through imitation. Gordon Gallup approached the problem by developing a mirror test, in which he anesthetized chimpanzees, put a red mark on one ear and eyebrow, and then, after they had recovered from the anesthesia, presented them with a full-length mirror. Prior to exposure to the mirror, the chimps didn't touch the red marks, but once the mirror was presented, they did. After being left with the mirror, a while later they began to look at visibly inaccessible parts of their bodies.[85] Not all chimps exhibit mirror self-recognition (MSR), however.[86] Later experiments have shown that MSR develops in some, but not all, chimps around puberty, but is present to a lesser degree in older chimps,[87] and in fact may deteriorate over time.[88] Orangutans also show MSR, but only a rare gorilla possesses it.[89, 90] Two dolphins[91] (with a few questions still to be addressed concerning differences in testing procedures[92]) and one out of the five Asian elephants that have been tested in two different studies have also passed the mark test.[93, 94] That's it, folks.

No other animal species has yet been found that exhibits MSR. This is why your dog isn't all that interested when you try to get him to look in the mirror. Children have MSR and pass the mark test by age two.[95]

Gallup has suggested that mirror self-recognition implies the presence of a self-concept and self-awareness.[96] This sounds like a reasonable test until Robert Mitchell, a psychologist at Eastern Kentucky University, chimes in by asking, What degree of self-awareness is demonstrated by recognizing oneself in the mirror? Mitchell points out that MSR requires only an awareness of the body, rather than any abstract concept of self.[97] There is no need to invoke anything more than matching sensation to visual perception; attitudes, values, intentions, emotion, and episodic memory are not required to recognize one's body in the mirror. A chimp looks down and sees his arm and wills it to move. It moves. He sees it move in the mirror. No grand concept of self is needed. Mitchell divides the self into three levels:

1. The implicit self, a point of view that experiences, acts, and in the case of mammals and birds, has emotions and feelings. A hamster is hungry, and can experience eating and can like eating, but it probably doesn't know that it likes to eat.
2. The self built upon kinesthetic visual matching, which leads to MSR, the first step to imitation, pretense, planning, self-conscious emotion, and imaginative experience.
3. The self built on symbols, language, and artifacts, which provides support for shared cultural beliefs, social norms, inner speech, dissociation, and evaluation by others, as well as self-evaluation.[98]

Another problem with the MSR test is that some patients with prosopagnosia (inability to recognize faces) cannot recognize themselves in a mirror. They think they are seeing someone else. However, they do have a sense of self, which is why the problem is so distressing to them. The absence of MSR, then, doesn't necessarily mean the absence of self-awareness. So although the MSR test can indicate a degree of self-awareness, it is of limited value in evaluating just how self-aware an animal is. It does not answer the question of whether an animal is aware only of its visible self or if it is aware of unobservable features. Povinelli and Cant have suggested that a sense of physical self-awareness in nonhuman primates may have evolved in large arboreal primates to meet the challenges of crossing between gaps in trees,

where their weight was an issue in selecting their route.[99] Knowing that they had a body and that only certain structures could support it provided a survival advantage.

If one can imitate another's actions, then one is capable of distinguishing between one's own actions and the other's. The ability to imitate is used as evidence for self-recognition in developmental studies of children. We have seen in chapter 5 that there is sparse evidence for imitation in the animal world. Josep Call has summarized the research, concluding that most of the evidence in primates points to the ability to reproduce the result of an action, not imitate the action itself.[100]

Tulving's suggestion that episodic memory—which includes an awareness of self in its definition and the ability to project oneself into the past or future—is uniquely human has also been a field of focus to identify self-awareness. If an animal can demonstrate its capacity for episodic memory, then it must have a concept of self. Tulving outlines the challenges and pitfalls of identifying episodic memory in animals. Much research on animal memory has been concerned with perceptual memory, which doesn't require declarative memory. Even when some tests require more than perceptual memory, they can be successfully performed using declarative semantic memory without episodic memory.

Many previous studies have assumed that animals have episodic memory when they demonstrated some behaviors. These studies, however, did not separate memory for *facts*, which would be semantic memory, from memory for *events*. Episodic memory tests require the subject to answer what, where, when (the *when* has been lacking in most tests), and then one final question that is the most difficult to study. Is the animal remembering the experience with an attached emotional component, or does it merely know that it happened? (This is the difference between knowing when you born versus remembering the experience of your birth, or knowing that one eats every day versus remembering the experience of a particular meal.) The problem has been figuring out how to approach that experiential aspect. In humans, we can just ask, although even this does not always give accurate information, because we have the know-it-all interpreter providing the answers. Animal studies have had to focus on behavior criteria. It has taken years to understand that much of what we do is not under conscious control, even though we

thought that it was, so attributing conscious action to animals is also going to be tempting but needs to be rigorously evaluated.

Povinelli and his colleagues did an interesting study with children that revealed a developmental difference in semantic and episodic memory.[101] First he unobtrusively put stickers on the foreheads of two-, three-, and four-year-olds while they were playing a game. Three minutes later, he showed them either a video of this action or a Polaroid picture of it to find out whether what a child learned about a past experience could be assimilated into the present. About 75 percent of the four-year-olds had immediately reached up and pulled the sticker off, while none of the two-year-olds and only 25 percent of the three-year-olds had done so. However, when he handed the two- and three-year-olds a mirror and they glimpsed themselves, they all immediately pulled off the stickers. The researchers suggested that the difference in reaction to live versus delayed feedback in the different age groups indicated a developmental lag between the development of a self-concept and a self-concept that includes temporal continuity. Specifically, children may not assume that their currently experienced state is determined by previous states. The two- to three-year-olds were not yet able to project themselves into the past, not yet able to time-travel. This is further indication that possessing MSR is not evidence for the possession of episodic memory and full self-awareness, and that semantic and episodic memory develop separately.

Thomas Suddendorf, a psychologist at the University of Queensland, Australia, and Michael Corballis, from the University of Auckland, New Zealand, make the interesting point that in order to have episodic memory and to time-travel, many cognitive abilities are involved. It is not just a single module doing its thing. Thus in order to establish if episodic memory is present in other species, they need to possess all the cognitive abilities required. What are these? Beyond some level of self-awareness, they must have an imagination able to reconstruct the order of events, must be able to metarepresent their knowledge (to be able to think about thinking), and must be able to dissociate from their current mental state (I am not hungry now, but I may be in the future). Episodic memory also requires that an animal understand the perception-knowledge contingency, that is, that seeing is knowing: *I know that because Susan has her*

eyes covered, she cannot see me; or *I know that because Ann is not in the room, she did not see Sally move the ball to a new place*. It also requires the ability to attribute past mental states to one's earlier self: *I used to think the candy was in the blue box, but now I know that it is in the red one*. These systems aren't up and running in children until age four. Included in these cognitive abilities is a concept derived from the Bischof-Kohler hypothesis, which states, "Animals other than humans cannot anticipate future needs or drive states and are therefore bound to a present that is defined by their current motivational state."[102] That means that if an animal is not hungry now, it is unable to plan for actions in the near future that involve eating; it cannot uncouple or dissociate from its current motivation (to lie down, perhaps) to plan for something that would be the result of a different motivational state.

The idea that "animals may be stuck in time," as suggested by a comprehensive review of animal memory studies done by William Roberts,[103] a psychologist at the University of Western Ontario, seems a little far-fetched when you think about how your dog "knows" it is 7:00 P.M. and time for his walk, or waits at the door for you to get home from work every day at 5:30. Or how about all those dang birds that have the intelligence to head south for the winter while you are crazy enough to stay in Buffalo, or bears eating their fill all summer and holing up for the winter? They seem to understand time and are planning ahead. These abilities turn out to be regulated by internal cues that have to do with circadian rhythms rather than a concept of time. A bear that hibernates for the first time cannot be planning ahead for the long cold winter: It doesn't even know that there *are* long cold winters.

The Search for Episodic Memory in Animals

Some of the most tantalizing sets of animal studies looking for episodic memory have been done by Nicola Clayton and Anthony Dickinson, professors at the University of Cambridge, studying scrub jays.[104, 105, 106, 107, 108] What was different about their studies was that they designed them to determine if the jays were answering the what, where, *and when* questions about multiple episodes that were unique in time and flexibly recalled. The jays more recently are even answering the *who* question.

Thus they are using multiple components of an event, not just a single bit of information.

You may have been inadvertently using a misguided epithet when you referred to the annoying person on the phone or in traffic as a birdbrain. While most of us have been going about our daily lives, working, enjoying our vacations, and worrying about our taxes, there has been a revolution going on in the study of bird brains. I am not kidding! There has been a major change in the understanding of bird-brain anatomy and their neural connections, which has led to new ideas about the structure and function of parts of the avian brain.[109] While birds lack the neocortical structure of mammals, they have many brain structures that serve the same purpose as mammalian brain structures, and have similar thalamic-cortical loop connections.[110] This has led to the realization that some species of birds have a lot more going on upstairs than had previously been thought. The presence of loop connections similar to the loop connections proposed to allow extended consciousness in humans leads to the hypothesis that they are performing the same operation in birds and providing them with some level of extended consciousness. This actually should come as no surprise to anyone who has spent much time watching ravens, crows, jays, or some species of parrots.

So, back to the scrub jays: Clayton, a former colleague of mine when we were both at the University of California, Davis, found that Florida scrub jays (*Aphelocoma coerulescens*) will cache different types of food in different places, at different times, and will selectively retrieve food that degrades, and eat that before retrieving and eating food that stores well. Her birds fulfill the when, what, and where questions, and are flexible. What is still not answered is if it is semantic knowledge or experiential. All the jay really is demonstrating is that it can update its knowledge, as psychologist Bennett Schwartz maintains; it is like the memory of where one's keys are. Clayton calls it episode-like memory because of this problem.[111]

Another tantalizing finding is that jays adjust their caching strategies to minimize potential stealing by other birds. If an individual jay (let's call him Buzz) had stolen food from another's cache in the past, and if while Buzz was caching his food he was observed by another jay, then after that other bird was removed, Buzz would recache his food in private. Not only that, Buzz also keeps track of who is observing him

cache. If it is a dominant bird, he is more likely to rehide his food in private than if it is his mate or a subordinate bird. He is also less likely to recache his food if a new jay appears who had not watched him hide food previously.[112] However, if Buzz had never stolen food from another jay in the past, then he would not recache his food even though his caching had been observed. These results indicate that recaching depended on previous experience as a thief.[113] Walking on the wild side, Clayton and her coworkers suggest that maybe these scrub jays are showing evidence of knowing what another jay knows: theory of mind.

You may recall from chapter 2 the studies that revealed planning behavior in orangutans and bonobos, done by Mulcahy and Call.[114] These are the best evidence so far that imaginary time travel is not unique to humans. These were the studies that demonstrated future planning of tool use when the subject carried a tool from one room to another for use up to fourteen hours later. These authors concluded:

> Because traditional learning mechanisms or certain biological predispositions appear insufficient to explain our current results, we propose that they represent a genuine case of future planning. Subjects executed a response (tool transport) that had not been reinforced during training, in the absence of the apparatus or the reward, that produced no consequences or reduced any present needs but was crucial to meet future ones. The presence of future planning in both bonobos and orangutans suggests that its precursors may have evolved before 14 Ma* in the great apes. Together with recent evidence from scrub jays our results suggest that future planning is not a uniquely human ability.

Suddendorf agrees that these findings are very suggestive, but points out that the researchers did not measure or control subjects' motivational states. He thinks, "Although the data suggest anticipation of the future need for a tool, they do not necessarily imply anticipation of a future state of mind."[115] It seems that the quest for nonhuman episodic memory is still afoot, and designing tests that can demonstrate it is the current stumbling block, although they are slowly being improved upon.

*Million years ago.

Do Animals Think About What They Know?

While most research on animals has been concentrating on the theory-of-mind question and what an animal knows about another's knowledge, little has been done on what an animal knows about its own knowledge. A newer approach in looking for self-reflective consciousness has been to look for metacognition, or thinking about thinking, which is awareness of one's own mental operations. Do animals think about what they know? This is another difficult question to study.

One approach has been through the testing of uncertainty. Humans know when they don't know something, or when they are unsure of something. J. David Smith, a psychologist at the State University of New York at Buffalo, thought that designing a test that included uncertainty might demonstrate metacognition in animals. He designed a visual density test in which rhesus monkeys and humans used a joystick to move a cursor to one of three objects on a computer screen.[116] They were to judge if a box was densely lit (exactly 2,950 pixels) or sparsely lit if it had fewer. They could pick the "dense" response, the "sparse" response, or the "uncertain" response, which was represented by a star on the screen. If they picked the star, they went automatically to a new guaranteed-win trial. The difficulty of making the discrimination gradually increased, until most faltered at about the 2,600-pixel level. Interestingly, the monkeys' and the humans' responses were much the same. After the test, the humans verbally reported that when they had guessed that the screen was either sparse or dense, their answers were dependent on the visual stimulus; however when they chose the uncertain response, it was because they had personal feelings of uncertainty and doubt: "I was uncertain," "I didn't know," or "I couldn't tell." Smith concluded that the "uncertain" response in humans might reveal not only metacognitive monitoring but also a reflexive awareness of the self as cognitive monitor.

A similar study has been done with a male bottlenose dolphin using an auditory discrimination test. The dolphin had to press a high paddle for the high-pitched tone (2100 Hz), a low paddle for any other tone, and a third paddle if he was uncertain. This paddle was picked when the tone approached 2085 Hz or greater. The dolphin, when responding with

certainty, also swam quickly to the paddle; however, when he was not, he swam more slowly and wavered between the paddles.[117] The demonstration that animals had an uncertainty response and used it in situations similar to those when humans demonstrated uncertainty was interpreted to mean that monkeys and dolphins have metacognition.

Reactions to this suggestion have been varied, with some agreement and some skepticism.[118] The problem is in the original assumption that the humans were thinking about thinking when they made their uncertain response. I don't think metacognition came into the picture until they were *asked* about their response. That is when the left-hemisphere interpreter revved up to explain their response. The choice was powered by emotional responses to the stimuli, the old approach–don't approach response. The problem comes from the assumption that humans were using higher cognition when they may not have been. Philosopher Derek Browne, from the University of Canterbury, Christchurch, New Zealand, has a similar take in discussing the results of the dolphin study. He suggests that it isn't until the postexperimental probe (or question) is applied that human subjects apply psychological concepts to their own earlier performances.[119]

The latest tests have been done with rats by Allison Foote and Jonathon Crystal at the University of Georgia. First their rats heard either a short sound or a long one. Next, for a reward, the rats had to pick whether the recent noise had been short or long. This was easy unless they were given sounds that were intermediate in length. If the rat was correct, it got a big food reward, and if it was wrong, zilch. However, before it was given the choice, the rat could opt out of the test and get a small food reward. Sometimes, however, it was not allowed to opt out but was forced to make a choice. Two interesting things happened. The more difficult it was to distinguish the sounds, the more frequently the rats opted out of the test if they could. And second, as you would expect, test accuracy declined as the difficulty of the time-discrimination task increased, but this decline in accuracy was greater when rats were forced to do the test. The findings suggest that rats could assess whether they were going to pass a test on a trial-by-trial basis.[120] They knew what they knew about the length of the sound.

Josep Call has approached metacognition from a different angle. He

has provided his subjects with incomplete information to solve a problem, in order to find out whether they would seek additional information: Would they know that they did not know enough to solve a problem? He tested orangutans, gorillas, chimps, bonobos—and children two and one-half years old.[121, 122] He had two opaque tubes. He put a treat in one, either while the subject could see him do it or while he was hidden behind a screen. Then he let the subject pick the tube they wanted, either right away or with a time delay. The question was, when they didn't have enough information as to which tube had the treat inside, would they seek more information before choosing a tube? They did! In fact, in many of the trials, after the apes looked in one tube and saw that it was empty, they chose the second tube without checking it out first. They inferred that the other tube had the treat. They were better at this than the children. Preventing the apes from immediately choosing increased the looking behavior and obviously their success. However, this did not change the behavior of the children. Call suggested that it "is likely that apes were more successful in the delayed situation because they did not have to inhibit the powerful responses elicited by the prospect of getting the reward."[122] As we have learned before, inhibition is not high on the list of chimpanzee behavioral traits.

Call is very cautious about his conclusions as to what this study reveals about the cognition of great apes and whether metacognition is involved. The debate is whether they are using a fixed hardwired rule, such as "Search until you find food," or perhaps a fixed rule learned from a specific experience, like "Bend down in the presence of a barrier," or whether they are using a flexible rule based on knowledge accumulation created through multiple experiences, none of which were the same as the one that is now being presented, such as "When my visual access is blocked, then do something appropriate to gain visual access." Call is inclined toward the latter explanation in his current pursuit of this question.

Can anatomy help us at all? Maybe. If we knew exactly what the neural correlates of human consciousness were, which we don't, then we could see if their equivalent exists in other species. It appears that long-range connection loops are necessary. As I said before, these have been identified in bird brains, and also in other primates. Although much

more work in comparative anatomy still needs to be done, we have a problem when we compare anatomy. It is not the same thing as comparing function. There may be more than one way to skin a cat—that is, there may be neural solutions or routes to consciousness other than those in the human brain, which could result in different types of consciousness.

So, currently we are left with Antonio Damasio's conclusions. Some animals have some degrees of extended consciousness, but what animals possess it and to what extent is still unknown. There appears to be some degree of body self-awareness in a very limited number of species, but even as new ways for testing such abilities are designed, the many brains that evaluate the tests continue to poke holes in their validity and also their interpretation. Current evidence suggests that animals do not have episodic memory and do not time-travel, but we are going to have to keep our eyes on Nicola Clayton and her scrub jays. The latest studies looking for evidence of animal metacognition in rats are tantalizing but still need refining before definite conclusions can be drawn.

CONCLUSION

I was recently asked by a *Time* magazine reporter, "If we could build a robot or an android that duplicated the processes behind human consciousness, would it actually be conscious?" It is a provocative question and it is one that persists, especially as one tries to capture the differences between the spheres of consciousness of animals and also those that exist between separated left and right brains. Much of what I have written here about bisected brains has appeared before. Yet, I find that the way we all nuance our understanding of complex topics is ever changing, since none of us hold the true answers in our hip pocket. I found myself answering the reporter with what I feel is a new twist.

Underlying this question is the assumption that consciousness reflects some kind of process that brings all of our zillions of thoughts into a special energy and reality called personal or phenomenal consciousness. That is not how it works. Consciousness is an emergent property and not a process in and of itself. When one tastes salt, for example, the consciousness

of taste is an emergent property of the sensory system, not of the combination of elements that make up table salt. Our cognitive capacities, memories, dreams, and so on reflect distributed processes throughout the brain, and each of those entities produces its own emergent states of consciousness.

In closing, remember this one fact. A split-brain patient, a human who has had the two halves of his brain disconnected from each other, does not find one side of the brain missing the other. The left brain has lost all consciousness about the mental processes managed by the right brain, and vice versa. It is just as with aging or with focal neurologic disease. We don't miss what we no longer have access to. The emergent conscious state arises out of each capacity and probably through neural circuits local to the capacity in question. If they are disconnected or damaged, there is no underlying circuitry from which the emergent property arises.

The thousands or millions of conscious moments that we each have reflect one of our networks being "up for duty." These networks are all over the place, not in one specific location. When one finishes, the next one pops up. The pipe organ–like device plays its tune all day long. What makes emergent human consciousness so vibrant is that our pipe organ has lots of tunes to play, whereas the rat's has few. And the more we know, the richer the concert.

Part 4

BEYOND CURRENT CONSTRAINTS

Chapter 9

WHO NEEDS FLESH?

The principles now being discovered at work in the brain may provide, in the future, machines even more powerful than those we can at present foresee.

—*J. Z. Young*, Doubt and Certainty in Science:
A Biologist's Reflections on the Brain, *1960*

Men ought to know that from the brain, and from the brain only, arise our pleasures, joy, laughter and jests, as well as our sorrows, pains, griefs, and tears.

—*Hippocrates, c. 400 B.C.*

I AM A FYBORG, AND SO ARE YOU. FYBORGS, OR FUNCTIONAL cyborgs, are biological organisms functionally supplemented with technological extensions.[1] For instance, shoes. Wearing shoes has not been a problem for most people. In fact, it has solved many problems, such as walking on gravelly surfaces, avoiding thorns in the foot, walking at high noon across an asphalt parking lot on a June day in Phoenix, or a January day in Duluth, and shoes have prevented over one million stubbed toes in the last month. In general, no one is going to get upset about the existence and use of shoes. Man's ingenuity came up with a tool to make life easier and more pleasant. After the inventors and engineers were done with the concept, the basic design, and product development, the aesthetics department took over, cranked it around a bit, and came up with high

heels. Perhaps not so utilitarian, but they serve a different, more specific purpose: to get across that parking lot looking sexy.

Wearing clothes has also been well accepted. They provide protection both from the cold and the sun, from thorns and brush, and can cover up years' worth of unsightly intake errors. Watches, a handy tool, are used by quite a few people without any complaint, and are now usually run by a small computer worn on the wrist. Eyeglasses and contact lenses are common. There was no big revolution when those were introduced. Cell phones seem to be surgically attached to the palms of teenagers and, for that matter, most everyone else. Fashioning tools that make life easier is what humans have always done. For thousands of years, we humans have been fyborgs, a term coined by Alexander Chislenko, who was an artificial-intelligence theorist, researcher, and software designer for various private companies and MIT. The first caveman that slapped a piece of animal hide across the bottom of his foot and refused to leave home without it became a fyborg to a limited degree. Chislenko devised a self-test for functional cyborgization:

> Are you dependent on technology to the extent that you could not survive without it?
>
> Would you reject a lifestyle free of any technology even if you could endure it?
>
> Would you feel embarrassed and "dehumanized" if somebody removed your artificial covers (clothing) and exposed your natural biological body in public?
>
> Do you consider your bank deposits a more important personal resource storage system than your fat deposits?
>
> Do you identify yourself and judge other people more by possessions, ability to manipulate tools and positions in the technological and social systems than primary biological features?
>
> Do you spend more time thinking about—and discussing—your external "possessions" and "accessories" than your internal "parts"?[1]

I don't know about you, but I would much rather hear about my friend's new Maserati than his liver. Call me a fyborg any day.

Cyborgs, on the other hand, have a *physical* integration of biological

and technological structures. And we now have a few in our midst. Going beyond the manufacture of tools, humans have gotten into the business of aftermarket body parts. Want to upgrade that hip or knee? Hop up on this table. Lost an arm? Let's see what we can do to help you out. But things start getting a little bit dicier when we get to the world of implants. Replacement hips and knees are OK, but start a discussion about breast implants, and you may end up with a lively or heated debate about a silicon upgrade. Enhancement gets the ire up in some people. Why is that? What is wrong with a body upgrade?

We get into even choppier waters when we start talking about neural implants. Some people fear that tinkering with the brain by use of neural prostheses may threaten personal identity. What is a neural prosthesis? It's a device implanted to restore a lost or altered neural function. It may be either on the input side (sensory input coming into the brain) or the output side (translating neuronal signals into actions). Currently the most successful neural implant has been used to restore auditory sensory perception: the cochlear implant.

Until recently, "artifacts" or tools that man has created have been directed to the external world. More recently, therapeutic implants—such as artificial joints, cardiac pacemakers, drugs, and physical enhancements—have been used either below the neck or for facial cosmetic purposes (that would include hair transplants). Today, we are using therapeutic implants above the neck. We are using them in the brain. We also are using therapeutic medications that affect the brain to treat mental illness, anxiety, and mood disorders. Things are changing, and they are changing rapidly. Technological and scientific advances in many areas, including genetics, robotics, and computer technology, are predicted to set about a revolution of change such as humans have never experienced before, change that may well affect what it means to be human—changes that we hope will improve our lives, our societies, and the world.

Ray Kurzweil, a researcher in artificial intelligence, makes the point that knowledge in these areas is increasing at an exponential rate, not at a linear rate.[2] This is what you would like your stock price to do. The classic example of exponential growth is the story about the smart peasant of whom we learned in math class—the guy who worked a deal with a math-challenged king for a grain of rice on the first square of a chessboard, and to have it

doubled on the second, and so on, until by the time the king had reached the end of the chessboard, he had lost his kingdom and then some. Across the first row or two of the chessboard things progressed rather slowly, but there came a point where the doubling was a hefty change.

In 1965, Gordon Moore, one of the cofounders of Intel, the world's largest semiconductor manufacturing company, made the observation that the number of transistors on an integrated circuit for minimum component cost doubles every twenty-four months. That means that every twenty-four months they could double the number of transistors on a circuit without increasing the cost. That is exponential growth. Carver Mead, a professor at Caltech, dubbed this observation Moore's law, and it has been viewed both as a prediction and a goal for growth in the technology industry. It continues to be fulfilled. In the last sixty years, computation speed, measured in what are known as floating point operations per second (FLOPS), has increased from 1 FLOPS to over 250 trillion FLOPS! As Henry Markram, project director of IBM's Blue Brain project (which we will talk about later), states, this is "by far the largest man-made growth rate of any kind in the ~10,000 years of human civilization."[3] The graph of exponential change, instead of gradually increasing continually as a linear graph would, gradually increases until a critical point is reached and then there is an upturn such that the line becomes almost vertical. This "knee" in the graph is where Kurzweil thinks we currently are in the rate of change that will occur owing to the knowledge gained in these areas. He thinks we are not aware of it or prepared for it because we have been in the more slowly progressing earlier stage of the graph and have been lulled into thinking that the rate of change is linear.

What are the big changes that we aren't prepared for? What do they have to do with the unique qualities of being human? You aren't going to believe them if we don't work up to them slowly, so that is what we are going to do.

SILICON-BASED AIDS: THE COCHLEAR IMPLANT STORY

Cochlear implants have helped hundreds of thousands of people with severe hearing problems (due to the loss of hair cells in the inner ear,

which are responsible for transmitting but also augmenting or decreasing auditory stimuli) for whom a typical hearing aid does not help. In fact, a child who has been born deaf and has the implants placed at an early enough age (eighteen to twenty-four months being optimal) will be able to learn to speak normally, and although his hearing may not be perfect, it will be quite functional. Wonderful as this may sound, in the 1990s, many people in the deaf community worried that cochlear implants might adversely affect deaf culture and that, rather than a therapeutic intervention, the devices were a weapon being wielded by the medical community to commit cultural genocide against the deaf community. Some considered hearing an *enhancement*, an additional capability on top of what other members of the community had, gained by artificial means. Although people with cochlear implants can still use sign language, apparently they are not always welcome.[4] Could this reaction be a manifestation of Richard Wragham's theory, which we learned about in chapter 2, that humans are a party-gang species with in-group/out-group bias? This attitude has slowly been changing but is still held by many.

To understand cochlear implants, and all neuroprosthetics, it is important to also understand that the body runs on electricity. David Bodanis, in his book *Electric Universe*, gives us a vivid description: "Our entire body operates by electricity. Gnarled living electrical cables extend into the depths of our brains; intense electric and magnetic force fields stretch into our cells, flinging food or neurotransmitters across microscopic barrier membranes; even our DNA is controlled by potent electrical forces."[5]

A DIGRESSION ON ELECTRIC CITY

The physiology of the brain and central nervous system has been a challenge to understand. We haven't talked much about physiology, but it is the structure underneath all that occurs in the body and brain. All theories of the brain's mechanisms must have an understanding of the physiology as their foundation. The electrical nature of the body and brain is perhaps most easily digested bit by bit and, luckily for our digestion, the

continuing unfolding story began in one of the most tasty cities of the world, Bologna, Italy. In 1791, Luigi Galvani, a physician and physicist, hung a frog's leg out on his iron balcony rail. He had hung it with a copper wire. The dang thing started twitching. Something was going on between those two metals. He zapped another frog's leg with a bit of electricity, and it twitched. After further investigation, he suggested that nerve and muscle could generate their own electrical current, and that was what caused them to twitch. Galvani thought the electricity came from the muscle, but his intellectual sparring partner, physicist Alessandro Volta, who hailed from the southern reaches of Lake Como, was more on the mark, thinking that electricity inside and outside the body was much the same type of electrochemical reaction occurring between metals.

Nearly a hundred years go by, and another physician and physicist, from Germany, Hermann von Helmholtz, who was into everything from visual and auditory perception to chemical thermodynamics and the philosophy of science, figured out a bit more. That electrical current was no by-product of cellular activity; it was what was actually carrying messages along the axon of the nerve cell. He also figured out that even though the speed at which those electrical messages (signals) were conducted was far slower than in a copper wire, the nerve signals maintained their strength, but those in the copper did not. What was going on? Well, in wire, signals are propagated passively, so that must not be what is going on with nerve cells. Von Helmholtz found that the signals were being propagated by a wavelike action that went as fast as ninety feet per second. Well, Helmholtz had done his bit and passed the problem on.

How did those signals get propagated? Helmholtz's former assistant, Julius Bernstein, was all over this problem and came up with the membrane theory, published in 1902. Half of it has proven true; the other half, not quite.

When a nerve axon is at rest, there is a 70-millivolt voltage difference between the inside and the outside of the membrane surrounding it, with the inside having a greater negative charge. This voltage difference across the membrane is known as the resting membrane potential.

When you get a blood panel done, part of what is being checked are

your electrolyte levels. Electrolytes are electrically charged atoms (ions) of sodium, potassium, and chlorine. Your cells are sitting in a bath of this stuff, but ions are also inside the cells, and it is the difference in their concentrations inside and outside of the cell that constitutes the voltage difference.

Outside the cell are positively charged sodium ions (atoms that are short an electron) balanced by negatively charged chloride ions (chlorine atoms carrying an extra electron). Inside the cell, there is a lot of protein, which is negatively charged, balanced by positively charged potassium ions. However, since the inside of the cell has an overall negative charge, not all the protein is being balanced by potassium. What's up with that? Bernstein flung caution to the wind and suggested that there were selectively permeable pores (now called ion channels), which allowed only potassium to flow in and out. The potassium flows out of the cell and remains near the outside of the cell membrane, making it more positively charged, while the excess of negatively charged protein ions make the inside surface of the membrane negatively charged. This creates the voltage difference at rest.

But what happens when the neuron fires off a signal (which is called an action potential)? Bernstein proposed that for a fraction of a second the membrane loses its selective permeability, letting any ion cross it. Ions would then flow into and out of the cell, neutralizing the charge and bringing the resting potential to zero. No big fancy biochemical reactions were needed, just ion concentration gradients. This second part later needed to be tweaked a bit, but first we encounter another physician and scientist, Keith Lucas.

In 1905, Lucas demonstrated that nerve impulses worked on an all-or-none basis. There is a certain threshold of stimulation that is needed for a nerve to respond, and once that threshold is reached, the nerve cell gives its all. It either fires fully, or it does not fire: all or nothin,' baby. Increasing the stimulus does not increase the intensity of the nerve impulse. With one of his students, Baron Edgar Adrian, he discussed trying to record action potentials from nerves, but World War I intervened, and Lucas died in an airplane accident.

Adrian spent World War I treating soldiers for nerve damage and shell

shock, and when it ended, he returned to his alma mater, Cambridge, to take over Lucas's lab and study nerve impulses. Adrian set out to record those propagated signals, the action potentials, and in doing so, found out a wealth of information and bagged a Nobel Prize along the way.

Adrian found that all action potentials produced by a nerve cell are the same. If the threshold has been reached for generating the signal, it fires with the same intensity, no matter what the location, strength, or duration of the stimulus is. So an action potential is an action potential is an action potential. You've seen one, you've seen them all. Now this was a bit puzzling. If the action potentials were always the same, how could different messages be sent? How were stimuli distinguished? How could you tell the difference between a flaccid and a firm hand-shake, between a sunny day and a moonlit night, between a dog bark and a dog bite?

Baron Adrian discovered that the *frequency* of the action potentials is determined by the intensity of the stimulus. If it is a mild stimulus, such as a feather touching your skin, you get only a couple of action poten-tials, but if it is a hard pinch, you can get hundreds. The duration of a stimulus determines how long the potentials are generated. If, however, the stimulus is constant, although the action potentials remain constant in strength, they gradually reduce in frequency, and the sensation is di-minished. And the subject of the stimulus, whether it is perceptual (visual, olfactory, etc.) or motor, is determined by the type of nerve fiber that is stimulated, its pathway, and its final destination in the brain. Adrian also figured out something cool about the somatosensory cortex, the destination of all those perception neurons. Different mammals have different amounts of somatosensory cortex for different perceptions: Dif-ferent species do not have equal sensory abilities; it all depends on how big an area in their somatosensory cortex is for a specific ability.

This also applies to the motor cortex. Pigs, for instance, have most of their somatosensory cortex dedicated to their snout. Ponies and sheep also have a big nostril area; it is as large as the area for the entire rest of their bodies. Mice have a huge whisker area, and raccoons have 60 per-cent of their neocortex devoted to their fingers and palm. We primates have big hand and face areas, for both sensation and motor movement.

You get more bang for your buck when you touch something with your index finger than when you use other parts of your body. This is why when you touch an object with your finger in the dark, you are more likely to be able to determine what it is than if you touch it with your back. It is also why you have such dexterous hands and such an expressive face. However, we will never know what it is like to have the perceptions of a pig. Although the basic physiology is the same, the hookups and the motor and somatosensory areas are different among mammalian species. Part of our unique abilities and experiences, and the uniqueness of every animal species, lies in the makeup of the motor and somatosensory cortex.

Next, Alan Hodgkin, one of Adrian's students, figured out that the current generated by the action potential was more than enough to excite an action potential in the next segment of an axon. Each action potential had more power than it needed to spark the next one. So they could perpetuate themselves forever. This was why, once generated, they didn't lose their strength. Later, Hodgkin and one of *his* students (are you following the genealogy?), Andrew Huxley, tweaked Bernstein's membrane theory, and also received a Nobel Prize for their work. Studying the gigantic squid neuron, the largest of all neurons (picture a strand of spaghettini), they were able to record action potentials from inside and outside the cell. They confirmed the −70-millivolt difference that Bernstein had proposed, but found that in the action potential, there was actually a 110-millivolt change, and the inside of the cell ended up with a positive charge of 40 millivolts, not the neutral state that Bernstein had supposed.

Somehow, excess positive ions were getting in and staying in the cell. Hodgkin and Huxley suggested that the selectively permeable membrane was also selectively permeable in a second way. It turns out that there is another set of pores, which they called voltage-gated channels, that selectively let in sodium ions when the membrane is stimulated enough, but they let them in for only a thousandth of a second. Then they slam closed, and the other set opens, letting potassium out, and then they slam closed too—all regulated by the changing ion voltage gradients across the cell membrane. Then, since the inside of the cell

now has excess sodium, a protein binds to it and carries it out of the cell. This propagating action potential gets passed along from one end of an axon to the other. With the advent of molecular biology, more has been learned. Those ion channels are actually proteins that surround the cell membrane; they have fluid-filled pores that allow the ions to pass through.

So it is electrical current that conducts an impulse along the length of a nerve axon. However, no electricity passes from one neuron to the next, although this had been thought to be the case for many years. Rather, it is chemicals that transmit a signal from one neuron to the next across a tiny gap, called the synapse. These chemicals are now known as neuro-transmitters. The neurotransmitter chemical binds to the protein on the synaptic membrane, the binding causes the protein to open its ion chan-nel, and that sets in motion the action potential along the next nerve axon. OK, back to our story of neural implants.

THE RAGING BULL

Electrical stimulation of the brain was pioneered by José Delgado, a neu-roscientist who in 1963 put his money where his mouth was. In a reac-tion against the increasing practice of lobotomy and "psychosurgery" in the late 1940s and early 1950s, he determined to find a more conserva-tive way of treating mental illness, and decided to investigate electrical stimulation. Luckily he was technologically gifted. He developed the first electronic brain implant, which he placed in different brain regions of various animals. By pressing a button that controlled the implanted electrical stimulator, he would get different reactions, depending on where it was implanted. Quite sure of his technology and the informa-tion that he had learned from it, he stood in a bull ring at a ranch in Córdoba, Spain, one day in 1963 facing a charging bull with only the stimulator button in his hand and an itchy trigger finger. The electrical stimulator itself was implanted into a part of the charging bull's brain known as the caudate nucleus. A gentle tap brought the bull to a skid-ding stop just feet in front of him.[6] The button and his theories worked! He had turned off the bull's aggression, and it stood placidly

in front of him. With this demonstration, Delgado put neural implants on the map.

Back to the Cochlear Implant

So far, the cochlear implant is the most successful neural implant. A tiny microphone about the size of a small button is worn externally, usually behind the ear. This attaches magnetically to an internal processor that is surgically implanted under the scalp. A tunnel is drilled through the skull to the cochlea, and a wire is fed from the processor through the tunnel and into the cochlea, which is shaped like one of those twisty seashells. The microphone, made of metal backed by a plastic plate, acts like the eardrum. When the metal vibrates from incoming sound waves, it creates an electrical charge in the plastic, thus converting the sound to electricity, which then travels down a wire to a small portable computer that is worn on the belt. This computer converts the electrical charges to digital representations of what the electrical charges represent acoustically; it runs on software that is continually being fine-tuned and improved. The software can adjust audio frequency ranges and volume to personal preferences.

Let's just say this software is very complex and is the result of years of research in sound waves and frequencies and how to code them, as well as the physiology of the cochlea. The processed signal is then sent back up the wire to the external button containing the microphone. But the microphone is not home alone. There is also a tiny radio transmitter, which transmits the signal as radio waves through the skin to the internal processor, where it is reconverted back to electricity by a diode. In the processor are up to twenty-two electrodes that correspond to different audio frequencies. The electrical signal fires up the electrodes in different combinations according to the message that the software has encoded, and the end result is then signaled down the wire into the cochlea, where it electrically stimulates the auditory nerve. This whole process takes four milliseconds!* It does not provide perfect hearing;

*The cochlear implant has been made possible by the gradual accumulation of scientific knowledge that began with the boys tinkering with electricity in the 1700s. It

voices sound mechanical. The brain has to learn that certain sounds may not correspond to what they sounded like in the past. Also, after a sound has been learned, a software upgrade may change that sound to actually become more realistic, but the wearer now has to readjust to the sound and its significance.

Why am I telling you all this? Because here we have the first successful neuroprosthetic in a human: a merging of silicon with carbon, forming what many consider is the first truly cybernetic organism.

Manfred Clynes and Nathan Cline coined the word *cyborg* to describe the interaction of artificial and biological components in a single "cybernetic organism." Their aim was to describe an organism built for space travel. Viewing space as an environment that humans were not adapted for, they suggested, "The task of adapting man's body to any environment he may choose will be made easier by increased knowledge of homeostatic functioning, the cybernetic aspects of which are just beginning to be understood and investigated. In the past, evolution brought about the altering of bodily functions to suit different environments. Starting as of now, it will be possible to achieve this to some degree *without alteration of heredity* by suitable biochemical, physiological, and electronic modifications of man's existing modus vivendi."[7]

That was 1960, and this is now, and it is happening. To some extent, we can change man's existing state without changing his heredity. We have been doing this with drugs to treat physical and mental states that occur in our adapted environment, and now, sophisticated physical apparatuses are also being used. If you were born deaf, that can be changed. And some researchers predict that it may be in the not so far future (less than forty years), if you were born not so swift, mentally or physically, that will be able to be changed. There is even the possibility that if you were born a psychopath, that could be changed, too. Just how much we

brings together knowledge from the fields of physics, computer engineering, neurophysiology, chemistry, medicine . . . you name it. It is also refined in the ears of many courageous volunteers who allowed untested devices to be used on them with the understanding they would most likely provide them little or no benefit. For an interesting read about the history of neuroprosthetics, read V. D. Chase, *Shattered Nerves* (Baltimore: Johns Hopkins University Press, 2006).

will be able to tinker with such matters and how extensive the possible changes to one's current physical and mental states will be are currently matters of intense speculation.

With a cochlear implant, a mechanical device has taken over one of the brain's functions. Silicon has been substituted for carbon. It is a little different from a heart pacemaker, which stimulates the cardiac muscle to contract. This is directly connected to the brain, and the software determines what is heard. The conspiracy crowd may get a little agitated by this, because the software developer determines what is being heard. Is it ethical to use cochlear implants? Most people do not have a problem with them. Although the wearer may depend on a computer for part of his brain processing, Michael Chorost has written that although he is now a cyborg, his cochlear implant has made him more human,[8] allowing him to be more social and participate in a community. People with normal hearing do not think of the cochlear implant as an enhancement. They think of it as a therapeutic intervention. One ethical question that arises is, What if in the future such implants or other devices allow you to have superhuman hearing, hearing enhancement? What if such an implant allows one to hear frequencies the human ear cannot hear? Is that OK too? Would hearing more frequencies provide a survival advantage? Would you be less of a person or less successful if everyone around you had one and you didn't? Will you have to upgrade to silicon to survive? These are the questions we are going to be facing, and they don't concern only sensory enhancements.

Artificial Retinas

Progress toward retinal implants has been slower. There are two questions that remain unanswered: How many electrodes will be necessary for the retinal implant to provide useful vision? And how much sight must they generate for it to be useful? Is being able to navigate enough, or must one be able to see well enough to read? Experimental retinal implants that have been tested on humans have only sixteen electrodes, and the vision they provide is only spots of light. A second implant that is not yet ready for human testing has sixty-four electrodes. No one knows how many electrodes will be necessary to provide adequate vision. It may

well be that for vision, hundreds or thousands of electrodes will be needed, and their development will be dependent on the continuing advancements in nanotechnology and the miniaturizing of the electrode arrays. Rodney Brooks, a leader in the robotics world, sees the possibility of retinal implants being adapted for night vision, infrared vision, or ultraviolet vision.[9] One day you may be able to trade in one good eye for one of these implants to enhance your vision beyond that of natural humans.

Locked-In Syndrome

One of the most terrifying brain injuries that a person can sustain is a lesion to the ventral part of the pons in the brain stem. These people are awake and conscious and intelligent but can't move any skeletal muscles. That also means that they can't talk or eat or drink. This is known as locked-in syndrome. The ones who are lucky, if you can call it that, can voluntarily blink or move their eyes, and this is how they communicate. Lou Gehrig's disease (amyotrophic lateral sclerosis, or ALS) can also result in this syndrome. Phil Kennedy, a neurologist at Emory University, came up with a technology he felt could help these people. After successful trials in rats and monkeys, he was given the OK to try it in humans.

In 1998, for the first time, Kennedy implanted an electrode made up of a tiny hollow glass cone attached to two gold wires. The electrode is coated with neurotrophic factor, which encourages brain cells to grow into the tube and hold it stable in the brain. The electrode is implanted in the left-hand motor region of the brain and picks up the electrical impulses the brain generates. The patient imagines moving his left hand, and the electrode picks up the electrical impulse that this thought produces. The electrical impulse travels down the two wires, which are connected to an amplifier and an FM transmitter outside the skull but under the scalp. The transmitter signals to a receiver external to the scalp. These signals are routed to the patient's computer, interpreted and converted by software, and end by moving the cursor on the computer screen. Kennedy's first patients were able, after extensive training, to

imagine moving their left hand and thereby move the cursor on the computer screen![10, 11] This was and still is truly amazing. He had captured electrical impulses generated by thinking about a movement and translated them into movement by a computer cursor. It requires huge processing power.[12] A myriad of neural signals must be sorted through to remove "noise," the remaining electrical activity must be digitized, and decoding algorithms must process the neural activity into a command signal—all in a few milliseconds. The result is a command that the computer can respond to.

This is all based upon an implant that can survive in the salty sea-like environment inside the body without corroding, transmit electrical signals without producing toxic by-products, and remain cool enough to avoid cooking the nearby neurons. This was not an easy assignment. This is an incredible first step, which actually, of course, was not the first step but one based on hundreds of thousands of other steps. And one electrode doesn't provide a lot of information. It took the patient months to learn how to use it, and the cursor could only move horizontally, but the concept worked. There are several groups approaching this drawing board from different angles.[13]

This type of device is known as a brain-computer interface (BCI). Unlike the cochlear implant, which is supplying sensory input information *to* the brain, BCIs work on the output *from* the brain. They pick up electrical potentials generated in the brain as a by-product of neuronal activity and translate the neuronal signals into electrical impulses that can control the computer cursor—or, in the future, other devices.

BASIC-SCIENCE BREAKTHROUGHS

In 1991, Peter Fromherz of the Max Planck Institute in Germany succeeded in developing a neuron-silicon junction. This was between an insulated transistor and a Retzius cell of a leech,[14] and was the beginning of actual brain-computer interfaces. The problem that had to be surmounted was that although computers and brains both work electrically, their charge carriers are different. It's roughly like trying to hook up your gas

stove to an electric line. Electrons carry the charge in the solid silicon of the chip, and *ions* (atoms or molecules that have gained or lost an electron) do the job in liquid water for the biological brain. Semiconductor chips also have to be protected from corrosion in the body's saltwater environment, as anyone who has ever worked or lived by the ocean knows. Fromherz's "intellectual and technological challenge" was to join these different systems directly at the level of electronic and ionic signals.[15]

This technology has allowed another lab more recently to implant a different system, called the BrainGate system, developed by John P. Donoghue at Brown University, using a neural implant developed by Richard Normann at the University of Utah. The implant, known as the Utah electrode array, was originally designed to be used in the visual cortex, but Donoghue thought it would work as well in the motor cortex. In 2004, an implant with ninety-six electrodes was surgically inserted into Matthew Nagle, a quadriplegic patient who had been stabbed in the neck at a Fourth of July celebration three years before while coming to the aid of a friend. Since this patient had been quadriplegic for a few years, no one knew if the part of his brain that controlled his motor system would still respond or whether it would have atrophied from disuse. However, he began to respond right away.

It was also easier to use than Kennedy's implant. Nagle didn't need several months of training before he was able to control it. Just by thinking about it, he was able to open simulated e-mail and draw an approximately circular figure on the computer screen using a paint program. He could adjust the volume, channel, and power on his television, and play video games, such as Pong. After a few trials, he was also able to open and close a robotic prosthetic hand by just looking at the hand, and he used a simple multijointed robotic limb to grasp an object and transport it from one location to another.[16] This was not done easily or smoothly, but it was possible. Obviously this is huge. Anything that gives such people any degree of control over their environment is momentous. The system still has many bugs to be worked out. When the patient wants to use the system, a cable that leads to the bulky external processing equipment must be attached to a connecter on his skull. Each time it is turned on, a technician has to recalibrate the system. And, of course, the electrode array in the brain is no small potatoes. The risk of infection is ever

present, as are the probability of scar tissue eventually causing the implant to lose function, the risk of causing more damage with insertion or movement of the array, and its possible malfunction.

How can a chip with only ninety-six electrodes code for the movement of an arm? The idea that recording the firing of just a few neurons could accomplish a motor activity came from Apostolos Georgopoulos, a neurophysiologist currently at the University of Minnesota. He had observed that an individual nerve cell performs more than one function. A single neuron fires for more than one direction of movement, but has a preferred direction of movement.[17] It turned out that the frequency that it was firing determined the direction of the muscle's movement: If more frequently, it was moving in one direction; less, in another—a bit like Morse code of the brain. Georgopoulos found that through a vector analysis (not everyone has forgotten their high school trig class) of the firing frequency and preferred direction of firing, he could accurately predict the direction of muscular movement.[18] He also suggested that recording only a few neurons, between 100 and 150, would produce fairly accurate predictions of movement in three-dimensional space.[19] This made using a small electrode panel feasible in recording neuronal intentions.

For a locked-in patient, or a paralyzed patient, more autonomy would include feeding himself and being able to get a glass of water without calling for assistance. Controlling a robotic arm to perform these tasks would be great. However, there are still many limiting factors to these systems. Without enumerating all the bugs, one obvious factor is that they are open-loop systems. Information goes out, but none comes back in. In order for a person to be able to control a prosthetic arm to drink a cup of coffee or feed himself at his own pace, sensory information needs to be sent back to the brain to prevent the many a slip 'twixt cup and lip. Anyone who has done the Mr. Small skit knows about this problem.*

*This involves two people. To assemble Mr. Small, one person stands behind a table that comes to his chest, with his arms at his side. A drape is placed around his neck so that his arms are covered, and placed on the table in front of him are a small pair of jeans with stuffed legs and shoes that protrude from the bottom. Another person in a large jacket stands directly behind the first person and extends his jacketed arms

The input problem is a complicated business. No one quite knows all the ins and outs of how proprioception works. In addition, there is the need for sensory information, such as how firmly one is grasping a cup, its weight, temperature, and whether it is following a smooth trajectory to the mouth. There is hope that if this information can be programmed into a prosthetic arm, perhaps the real arm could be programmed and directed too. The arm would have its nerves connected to chips that receive signals from the implants in the brain directing its movement, but also incoming sensory signals would be decoded by the chip and sent to the brain to give it feedback. In this way, the implant would serve as a bridge to bypass the severed nerves.

The human arm, however, which we take for granted as we reach for a cup of java or twist a little pasta onto a fork, that whole shoulder-elbow-wrist-hand with all its fingers and network of bones, nerves, tendons, muscles, and ligaments, is immensely complicated. Muscles are flexing and extending together, being stimulated and inhibited, twisting and adjusting their movement constantly, all at varying velocities, all with sensory, proprioceptive, cognitive, and pain feedbacks to the brain telling it the muscles' position, force, stretch, and velocity. The sensory system actually is sending back to the brain about ten times the information the motor system is sending out. The current implants are obviously still quite crude, but they are being improved every year, being reduced in size and given more capacity, just as personal computers have gotten smaller and faster with more memory. But the idea works. Neurons in your brain can grow onto a computer chip and transfer neuronal signals to it. There can be silicon replacement parts for the brain.

Richard Andersen, a professor of neuroscience at Caltech, has another idea. He thinks instead of using the motor cortex as the site to

around him, with the lapels of the jacket covering the other's chest. Mr. Small's arms are those of the second person, whose body is hidden behind the first. Then a third person gives commands to Mr. Small, such as to drink some soda, eat a cupcake, or scratch his nose. The person maneuvering Mr. Small's arms and hands has his own sensory input from them, but does not get sensory or visual input about Mr. Small's face. The end result is soda being poured down his front, and a cupcake crammed into his nose or cheeks.

capture neuronal firings, it would be better and easier to go back up to a higher cortical area where the visual feedback is processed and the planning for the movement is made—the parietal cortex.[20] The posterior parietal cortex is situated between the sensory and the motor regions and serves as a bridge from sensation to action. His lab has found that an anatomical map of plans exists within this area, with one part devoted to planning eye movements and another part to planning arm movements.[21, 22] The action plans in the arm-movement area exist in a cognitive form, specifying the goal of the intended movement rather than particular signals for all the biomechanical movements. The parietal lobe says, "Get that piece of chocolate into my mouth," but does not detail all the motions that are necessary: "First extend the shoulder joint, by flexing the blah blah blah. . . ." All these detailed movements are encoded in the motor cortex. Andersen and his colleagues are working on a neural prosthesis for paralyzed patients that records the electrical activity of nerve cells in the posterior parietal cortex. Such an implant would interpret and transmit the patients' intentions: "Get the coffee to my mouth." They think this will be much easier for software programmers. These neural signals are decoded using computer algorithms, and are converted into electrical control signals to operate external devices such as a robot arm, an autonomous vehicle, or a computer. The robotic arm or vehicle would simply receive the input as a goal—chocolate in mouth—leaving the determination of how to accomplish the goal to the other systems, such as smart robotic controllers. Smart robots? We'll get there soon. This bypasses the need for a closed-loop system. This system also needs relatively few neurons to send a signal.[23]

Brain surgery, implants, infection—can't they figure out something that doesn't require going inside the head? Can't they use EEGs?

Jonathan Wolpaw, chief of the Laboratory of Nervous System Disorders of the New York State Department of Health and State University of New York, thinks so. He has been working on this problem for the last twenty years. When he first began, he had to figure out if the idea of using brain waves captured externally was possible. He made a headset with a series of external electrodes positioned over the motor cortex, where neurons fire to initiate movement. These neurons give off weak electrical signals that the electrodes pick up. Getting useful signals from

"a few amplitudes of scalp-recorded EEG rhythms that reflect in a noisy and degraded fashion the combined activity of many millions of neurons and synapses"[24] was difficult. After several years, he was able to show that people could learn to control their brain waves to move a computer cursor. The software for this system has been many years in development. The headset electrodes pick up the signals, and because the strength of the signals varies from person to person, and from one part of the cortex to another, the software is constantly surveying the different electrodes for the strongest signals, giving those the greatest influence in the decision-making process as to which way a cursor should move.

Scott Hamel, one of the subjects who test Wolpaw's system, says it is easiest to use when he is fully relaxed. If he tries too hard, has other things on his mind, or gets frustrated and tense, things don't go as well.[4] Too many neurons are competing for attention. Wolpaw and his group, and others who have taken up the challenge, have found that "a variety of different brain signals, recorded in a variety of different ways and analyzed with a variety of different algorithms, can support some degree of real-time communication and control."[25]

However, there is a big problem, and it is not just with externally controlled BCIs. It is also true of the implants. Even in controlled conditions, the results are variable. Users are better on some days than others, and performance can vary widely even within a single session and from trial to trial. Cursor movements are slow and jerky, described by some as ataxic.[24] Wolpaw thinks this problem is going to persist unless researchers take into account the fact that *BCIs ask the brain to do something entirely new.*

This becomes clear if you look at what the brain normally does to produce movement and how it normally does it. The job of the central nervous system (CNS) is to convert sensory inputs into appropriate motor outputs. This job of creating motor outputs is a concerted effort of the entire CNS from the cerebral cortex to the spinal cord. No single area is wholly responsible for an action. Whether you walk, talk, high jump, or bronco bust, there is a collaboration among areas, from the sensory neurons up the spinal cord to the brain stem and eventually to the cortex and back down through the basal ganglia, thalamic nuclei, cerebellum, brain-stem nuclei, and spinal cord to the interneu-

rons and motor neurons. And even though the motor action is smooth and consistent from one time to the next, the activity in all those different brain areas may not be. However, when a BCI is being used, it is a whole new ball game. Motor actions, which are normally produced by spinal motor neurons, are now being produced by the neurons that normally just *contribute* to the control of the motor neurons. Now they are putting on the whole show. They have to do their own job *and* assume the role normally performed by spinal motor neurons; their activity becomes the final product, the output, of the entire CNS. They are doing it all.

The brain has some plasticity, but there are limits. Wolpaw makes the point that BCIs provide new output pathways for the brain, but the brain has to learn them. The brain has to change the way it normally functions. He thinks that in order to make BCIs perform better, researchers have to make it easier for the brain to implement these new output pathways. An output pathway can either control a process or select a goal. He also thinks that outputting a goal is easier. Just tell the software the goal, and let it do all the work. Wolpaw is walking into Andersen's camp.

This technology has not been overlooked by the business world. There are companies that have come up with their own versions that are being developed for playing computer games. One company, Emotiv, has a sixteen-sensor strap-on headset that they claim reads emotions, thoughts, and facial expressions. According to the company, it is the first brain-computer interface that can detect human conscious thoughts and non-conscious emotions. Its current gaming application allows for 3-D characters to reflect the player's expressions: You wink, it winks; you smile, it smiles. It also allows the manipulation of virtual objects using the player's thoughts.

Another company, NeuroSky, has come up with a single-electrode device that they claim will read emotions as its software translates them to commands to control a game. Other companies are developing NeuroSky's technology to use in cell-phone headsets and MP3 players. The sensor will sense your emotional state and pick music that is compatible with it. No downer songs while you are feeling fine, or for those slow-to-wake-up folks; no heavy metal until after 11:00 A.M. Just exactly what is being recorded and used is, of course, not being revealed by either company.

Aiding Faulty Memories with Silicon

Another problem begging for a solution has to do with the increasing elderly population: memory loss. The normal slow loss of memory is annoying enough without the devastating problem of Alzheimer's disease. Although the neuronal implants that we have discussed have to do with sensory or motor functions, other researchers are concerned with restoring cognitive loss of higher-level thought processes. Theodore Berger at USC has been interested in memory and the hippocampus for years, and more recently he has been working toward creating a prosthesis that will perform the services that Alzheimer's disease plays havoc with: the transfer of information from immediate memory to long-term memory. The hippocampus has a star role in the formation of new memories about experienced events, as evidenced by the fact that damage to the hippocampus usually results in profound difficulties in forming new memories and also affects retrieval of memories formed prior to the damage. It doesn't look as if procedural memory, such as learning how to play an instrument, is part of the hippocampus's job description, for it is not affected by damage to the hippocampus.

The hippocampus is located deep in the brain and is evolutionarily old, which means that it is present in less-evolved animals. Its connections, however, are less complicated than other parts of the brain, and this makes Berger's goal a tad (and only a tad) easier. Just what the damaged cells in the hippocampus did is still up to conjecture, but that doesn't slow down Berger and his big plan to develop a chip for people with this type of memory loss. He doesn't think he needs to know exactly what they did. He thinks all he has to do is provide the bridge between the input of cells on one side and the output of cells on the other side of the damaged cells.

Not that that is a walk in the park. He has to figure out from an electrical input pattern what the output pattern should be. For instance, let's say that you were a telegraph operator who translates Morse code from one language to another. The problem is, you don't know or understand either of the languages or codes. You receive a code tapped out in Romanian and then have to translate it and tap it out in Swedish. You have no dictionaries or codebooks to help you. You just have to figure it out. That

is what his job has been like, but harder. This has taken several years and the help of researchers from many different disciplines. In Berger's system, the damaged CNS neurons would be replaced with silicon neurons that mimic their biologic function. The silicon neurons would receive electrical activity as inputs from, and send it as outputs to, regions of the brain with which the damaged region previously was connected. This prosthesis would replace the computational function of the damaged brain and restore the transmission of that computational result to other regions of the nervous system.[26] So far his tests on rats and monkeys "worked extremely well," but tests on humans are still a few years away.[4]

Caveats and Concerns

Futurists like Ray Kurzweil envision this technology being able to do far more. He foresees enhancement chips: chips that will increase your intelligence, chips that will increase your memory, chips that can have information downloaded into them. Learn French, Japanese, Farsi? No problem, just download it. Do advanced calculus? Download it. Increase your memory? Sure, just get another five-terabyte chip implanted. Mary Fisher Polito, a friend who occasionally suffers from a "senior moment" memory lapse, says, "I hope they hurry up with those chips. I could use some more RAM now." Kurzweil also envisions the world being populated with such intelligent people that the major problems facing us will be easily solved. "Greenhouse gases? Oh, I know how to fix that. Famine? Who's hungry? There have been no reports of hunger for the last fifty years. War? That is so retro." But then, Chris von Ruedon, one of my students, points out, "It's often the most intelligent people who cause such problems." Others are concerned about such scenarios as: "Honey, I know that we were saving this money for a vacation, but maybe we should get the twins neural chips instead. It is hard for them in school when so many of the other kids have them and are so much smarter. I know you wanted them to stay natural, but they just can't keep up, and their friends think they are odd." Artifact-driven evolution!

But in a sense, the story of human evolution has been artifact-driven ever since the first stone ax was chipped, and perhaps even earlier. Merlin

Donald, a cognitive neuroscientist at Case Western Reserve University, thinks that although humanity is greatly concerned about changes in the physical ecology of the external world, we should be paying more attention to what has been going on inside our heads. Information storage and transfer went from the internally stored memory and experience of a single individual to being internally stored and transferred by many individuals as storytellers, to external memory storage on papyrus, then to books and libraries, then to computers and the Internet. He thinks that there have been equally massive changes in the cognitive ecology, due to the advent of these huge banks of external memory storage, and we are not done yet. He predicts that this runaway proliferation of information will probably set our future direction as a species.[27] Perhaps that next step in this evolution of information storage may be to store it internally, again with the help of implanted silicon: just another tool.

Or not. The idea that we are messin' with our innards is disturbing to many. And just what would we do with expanded intelligence? Are we going to use it for solving problems, or will it just allow us to have longer Christmas card lists and bigger social groups? If we spend 90 percent of our time talking about each other, will we solve the world problems or just have more stories to tell? But there is another major problem with Kurzweil's scenario: No one knows what it is that the brain is doing that makes a person intelligent. Just having a lot of information available doesn't necessarily make a person more intelligent. And being intelligent does not necessarily make a person wise. As David Gelernter, a computer scientist at Yale, wonders, "What are people well informed about in the information age? . . . Video games?" He isn't impressed; in fact, he seems to think people are *less* informed.[28] So what about intelligence? What were those smart robots all about?

SMART ROBOTS?

My desires in a personal robot are rather mundane. I just want it to do all the things I *don't* want to do. I want it to get the mail, hand me any personal handwritten letters and invitations, and take everything else and deal with it. I want it to check my e-mail and throw out all the spam and

pay my bills. I want it to keep track of finances, fund my retirement, do the taxes, and hand me a net profit at the end of the year. I want it to clean the house (including the windows), and it might as well do all the car maintenance. Ditto with weeding, trapping gophers, and . . . well, it might as well do the cooking, too, except when I want to. I would like my robot to look like Sophia Loren in *Marriage Italian Style,* not R2D2. I may have trouble with that one, because my wife wants Johnny Depp doing all the chores. Maybe R2D2 isn't such a bad idea. As I said, my needs are mundane. I can do all these things, but I'd rather spend my time doing something else. For disabled persons who cannot do any of these things, a personalized robot would allow far more autonomy than they have.

The thing is, this may not be so far off, or at least some of it, and that would be great. But maybe, if we aren't careful, the smart robot won't be grumbling about cat hair as it is cleaning the floor. It may be discussing quantum physics or, worse yet, its "feelings." And if it is intelligent, will it still do all our chores? Just like you and your kids, won't it figure out a way not to do them? That would mean it would have desires. Once it has feelings, will we feel guilty about making it do all the scut work, and start cleaning up before the robot comes in, and apologizing for the mess? Once it is conscious, will we have to go to court to get it decommissioned so we can get the latest model? Will a robot have rights? As Clynes and Kline pointed out in their original description of a cyborg in space, "The purpose of the Cyborg . . . is to provide an organizational system in which [such] robot-like problems are taken care of automatically and unconsciously, leaving man free to explore, create, think, and feel."[7] Without my actually merging physically with silicon, without actually becoming a cyborg, a separate silicon assistant could just as easily give me more time to explore, create, think, and feel (and, I might add, gain weight). So I am going to be careful which model I order. I do not want a robot with emotions. I don't want to feel guilty that my robot is vacuuming while I am out on the deck in the sun eating a now mandatory calorie-reduced lunch and thinking deep thoughts, like maybe I should get up and weed.

How close are we to my idea of a personal robot? If you haven't been keeping up with what is going on in the world of robotics, you will be amazed. There are currently robots doing plenty of the jobs that are

repetitive and/or require precision, from automobile assembly to surgery. Currently the domain of robots is the three Ds—dull, dangerous, or dirty. The dirty category includes toxic waste cleanups. Surgery is none of those three; it is just being done on a microscopic level. Currently Pack Bots that weigh eighteen kilograms are being used as emergency and military robots. They can negotiate rough terrain and obstacles such as rocks, logs, rubble, and debris; they can survive a drop of two meters onto a concrete surface and land upright; and they can function in water up to two meters deep. They can perform search and rescue, and disarm bombs. They are being used to detect roadside bombs and reconnoiter caves. However, these robots do not look like your dream of a handsome search-and-rescue guy (like my brother-in-law) as you are lying at the base of some cliff you foolishly tried to climb. They look like something your kid would build with an erector set.

There are also unmanned robotic aircraft. A robot has driven most of the way across the United States. Driving in an urban setting is still the most difficult test and has yet to be perfected. The Urban Challenge, a sixty-mile competition for autonomous vehicles sponsored by the Defense Advanced Research Projects Agency (DARPA), was held in November 2007. Vehicles had to be able to negotiate city streets, intersections, and the parking lot, including finding a spot, parking legally, and then leaving the lot without a fender bender, while avoiding shopping carts and other random objects. This is not remote control. These cars controlled by software, driving on their own. It may not be too long before computer programs will drive *all* cars. We will recline, read the paper, munch a doughnut (I'll take jelly), and drink a latte on the way to work.

But so far, on the home-cleaning front, all we have is a floor cleaner and vacuum cleaner that looks like a CD player, and a lawn mower. But what these robots have, and what my dream does not have, are wheels. No robot yet can move through the room like Sophia Loren or Johnny Depp. Half the neurons in the human brain are at work in the cerebellum. Part of their job is motivating, not in the sense of "come on, you can do it," but in the sense of Chuck Berry and Maybelline in the Coupe de Ville motivatin' up the hill—that is, timing and coordinating muscles and skills.

Developing a robot with animal-like motion is incredibly difficult and

has yet to be accomplished, but engineers at Shadow Robot Company in England, under founder Richard Greenhill, think they are getting close. Since 1987, they have been working to build a bipedal robot. Greenhill says, "The need for anthropomorphism in domestic robotics is classically illustrated by the problem of staircases. It is not feasible to alter houses or to remove the staircases. It is possible to design robots with stair-climbing attachments, but these are usually weak spots in the design. Providing a robot with the same locomotive structures as a human will ensure that it can certainly operate in any environment a human can operate in."[29] They are getting there, and along the way they have developed many innovations, one of them being the Shadow Hand, a state-of-the-art robotic hand that can do twenty-four out of the twenty-five movements that a human hand can perform. It has forty "air muscles," another invention. The shadow hand has touch sensors on its fingertips and can pick up a coin. Many other laboratories are working on other aspects of the anthropomorphic robot. David Hanson, at the University of Texas, has made a substance he has called Flubber, which is very much like human skin and allows lifelike facial expressions.* So it is possible to have a robotic Johnny Depp sitting in your living room, but he isn't up to doing the tango yet.

Japan Takes the Lead

Japan is a hot spot for robotic research. They have a problem that they are hoping robots will help solve. Japan has the lowest birth rate in the world, and 21 percent of the population is over sixty-five, the highest proportion of elderly in any nation. The population actually started declining in 2005, when births were exceeded by deaths. The government discourages immigration; the population is over 99 percent pure Japanese. Any economist will tell you this is a problem. There aren't enough young people to do all the work; shortages are already being felt in many areas, including nursing. So if the Japanese don't want to increase immigration, then they are going to have to figure out a way to take care of their elders. They are looking to robotics.

*Check out his Web site: www.hansonrobotics.com.

At Waseda University, researchers have been working on creating facial expressions and upper-body movements that correlate with the emotions of fear, anger, surprise, joy, disgust, sadness, and, because it is Japan, a Zen-like neutral state. Their robot has been created with sensors: It can hear, smell, see, and touch. They are studying how senses translate into emotions and want to develop a mathematical model for this.[30] Their robot will then react to external stimuli with humanlike emotions. It is also programmed with instinctual drives and needs. Its needs are driven by appetite (energy consumption), the need for security (if it senses it is in a dangerous situation, it will withdraw), and the need for exploration in a new environment. (I will not order one of these.) The Waseda engineers have also made a talking bot that has lungs, vocal cords, articulators, a tongue, lips, a jaw, a nasal cavity, and a soft palate. It can reproduce a humanlike voice with a pitch control mechanism. They have even built a robot that plays the flute.

At Meiji University, designers have set their sights on making a conscious robot. It may be that from this intersection of robotic technology, computer technology, and the desire to make humanlike robots, a greater understanding of human brain processing will emerge. Building a robot to act and think as a human does means testing the theories of brain processing with software and seeing if the result corresponds to what the human brain is actually doing. As Cynthia Breazeal, who leads a group at MIT, points out, "While many researchers have proposed models of specific components of social referencing, these models and theories are rarely integrated with one another into a coherent, testable instance of the full behavior. A computational implementation allows researchers to bring together these disparate models into a functioning whole."[31] Tohru Suzuki, Keita Inaba, and Junichi Takeno lament that no one yet has presented a good integrated model to explain consciousness. Yak yak yak, but how do you actually hook it all up? So instead of shrugging their shoulders, they went about making their own model and then built a robot using this design.

Actually they built two, and you will see why. They believe that consciousness arises from the consistency of cognition and behavior.[32] What does that remind you of? How about mirror neurons? Those same neurons that are firing when you cogitate a behavior and when you perform

it. You can't get more consistent than that. Next they turn to a theory by Merlin Donald—that the ability to imitate motor action is the foundation of communication, language, the human level of consciousness, and human culture in general. This is known as mimesis theory. Donald has been thinking a lot about the origins of language, and he just does not see it happening without fine motor skills, and in particular, the ability to self-program motor skills. After all, language and gesture require the refined movements of muscles. And while other animal species have genetically determined rigid types of behavior, human language is not rigid but flexible. Thus the motor skills required for language must also be flexible. There just had to be voluntary, flexible control of muscles before language could develop. He sees this flexibility coming from one of the fundamentals of motor skill—procedural learning. To vary or refine a motor movement, one needs to rehearse the action, observe its consequences, remember them, and then alter what needs to be altered. Donald calls this a rehearsal loop, something we are all familiar with. He notes that other animals do not do this. They do not initiate and rehearse actions entirely on their own for the purpose of refining their skill.[33] Your dog is not practicing shaking hands all day while you are at the office. Merlin thinks that this rehearsal-loop ability is uniquely human and forms the basis for all human culture, including language.

So, Suzuki and pals drew up a plan for a robot that had consistency of behavior and cognition. They built two, to see if they would show imitative behavior. One robot was programmed to make some specific movements, and the second robot copied them! Imitative behavior implies that the robot can distinguish itself from another robot: It is self-aware. They believe that this is the first step on the road to consciousness. Unlike other designs but like many models of human consciousness, this one had feedback loops for both internal and external information. External information (somatic sensation) feedback is needed for a robot to imitate and learn. The external result of action must come back to the interior in order to modify it if need be: Action must be connected to cognition. Internal feedback loops are what connect the cognition to the action. However, these robots don't look like what I'm pretty sure you are visualizing. They look like something that a mechanic would pull out from under the hood of a Mercedes and charge an arm and a leg to replace.

Meanwhile, Back at MIT

The problem with robots is, they still mostly act like machines. Cynthia Breazeal at MIT sums it up: "Robots today interact with us either as other objects in the environment, or at best in a manner characteristic of socially impaired people. They generally do not understand or interact with people as people. They are not aware of our goals and intentions."[34] She wants to give her robots theory of mind! She wants her robot to understand her thoughts, needs, and desires. If one is building a robot to help the elderly, she continues, "Such a robot should be persuasive in ways that are sensitive to the person, such as helping to remind them when to take medication, without being annoying or upsetting. It must understand what the person's changing needs are and the urgency for satisfying them so that it can set appropriate priorities. It needs to understand when the person is distressed or in trouble so that it can get help."

Kismet, the second-generation Cog, is a sociable robot that was built in the lab of Rodney Brooks, director of the MIT Computer Science and Artificial Intelligence Laboratory, predominantly by Cynthia Breazeal when she was Brooks's graduate student. Part of what makes Kismet a sociable robot is that it has large eyes that look at what it is paying attention to. It is programmed to pay attention to three types of things: moving things, things with saturated color, and things with skin color. It is programmed to look at skin color if it is lonely, and bright colors if it is bored. If it is paying attention to something that moves, it will follow the movement with its eyes. It has a set of programmed internal drives that increase until they release certain behaviors. Thus if its lonely drive is high, it will look around until it finds a person. Then, since that drive is satisfied, another drive will kick in, perhaps boredom, which will increase, and it will start searching for a bright color; this makes it appear to be looking for something specific. It may then find a toy, giving an observer the impression that it was looking specifically for the toy. It also has an auditory system that detects prosody in speech. With this mechanism it has a program that matches certain prosody with specific emotions. Thus it can detect certain emotions such as approval, prohibition, attention getting, and soothing—just like your dog. Incoming perceptions affect Kismet's "mood" or emotional state, which is a combination of three variables:

valence (positive or negative), arousal (how tired or stimulated it is), and novelty. Responding to various motion and prosody cues, Kismet will proceed among different emotional states, which are expressed through its eyes, eyebrows, lips, ears, and the prosody of its voice. Kismet is controlled by the interaction of fifteen different computers running various operating systems—a distributed system with no central control. It does not understand what you say to it, and it speaks only gibberish, though gibberish with the proper prosody for the situation. Because this robot simulates human emotions and reactions, many people relate to it on an emotional level and will speak to it as if it were alive. Here we are back to anthropomorphism.

Rodney Brooks wonders if simulated, hard-coded emotions in a robot are the same as real emotions. He presents the argument that most people and artificial intelligence researchers are willing to say that computers with the right software and the right problem can reason about facts, can make decisions, and can have goals; but although they may say that a computer may *act as if, behave as if, seem as if, or simulate* that it is afraid, it is hard to find anyone who will say that it is viscerally afraid. Brooks sees the body as a compilation of biomolecules that follow specific, well-defined physical laws. The end result is a machine that acts according to a set of specific rules. He thinks that although our physiology and constituent materials may be vastly different, we are much like robots. We are not special or unique. He thinks that we overanthropomorphize humans, "who are after all mere machines."[9] I'm not sure that, by definition, it is possible to overanthropomorphize humans. Perhaps it is better to say we underanthropomorphize machines or undermechanomorphize humans.

Breazeal's group's next attempt at developing TOM in a robot is Leonardo. Leo looks like a puckish cross between a Yorkshire terrier and a squirrel that is two and a half feet tall.* He can do everything that Kismet can do and more. They wanted Leo to be able to identify another's emotional state and why that person is experiencing it. They also want him (they refer to Leo as "he" and "him," so I will, too) to know the emotional content of an object to another person. They don't want Leo

*Check him out at http://robotic.media.mit.edu/projects/Leonardo/Leo-intro.html.

tramping on the Gucci shoes or throwing out your child's latest painting that looks like trash to anyone but a parent. They also want people to find Leo easy to teach. Instead of your having to read an instruction manual and learn a whole new form of communication when you get your first robot, they want Leo to be able to learn as we do. You'll just say, "Leo, water the tomatoes on Thursdays" and show him how to do it, and that's it. No small ambitions!

They are banking on the neuroscience theory that humans are sociable, and we learn through using our social skills. So first, in order to be responsive in a social way, Leonardo has to be able to figure out the emotional state of the person with whom he is interacting. They approached designing Leo using evidence from neuroscience that "the ability to learn by watching others (and in particular the ability to imitate) could be a crucial precursor to the development of appropriate social behavior—and ultimately the ability to reason about the thoughts, intents, beliefs, and desires of others." This is the first step on the road to TOM. The design was inspired by the work done on newborns' facial imitation and simulation ability by Andrew Metzoff and M. Keith Moore, whom we read about in chapter 5. They needed Leonardo to be able to do the five things that we talked about that a baby could do when it was hours old:

1. Locate and recognize the facial features of a demonstrator.
2. Find the correspondence between the perceived features and its own.
3. Identify a desired expression from this correspondence.
4. Move its features into the desired configuration.
5. Use the perceived configuration to judge its own success.[35]

So they built an imitation mechanism into Leonardo. Like Kismet, he has visual inputs, but they do more. Leo can recognize facial expressions. Leo has a computational system that allows him to imitate the expression he sees. He also has a built-in emotional system that is matched to facial expression. Once this system imitates a person's expression, it takes on the emotion associated with it.

The visual system also recognizes pointing gestures and uses spatial reasoning to associate the gesture with the object that is indicated.

Leonardo also tracks the head pose of another. Together these two abilities allow him to understand the object of attention and share it. He makes and keeps eye contact.

Like Kismet, he has an auditory system, and he can recognize prosody, pitch, and the energy of vocalization to assign a positive or negative emotional value. And he will react emotionally to what he hears. But unlike Kismet, Leo can recognize some words. His verbal tracking system matches words to their emotional appraisal. For instance the word *friend* has a positive appraisal, and the word *bad* has a negative one, and he will respond with the emotional expression that matches the words.

Breazeal's group also incorporated the neuroscience findings that memory is enhanced by body posture and affect.[36] As Leo stores information in long-term memory, the memory can be linked with affect. His ability to share attention also allows him to associate emotional messages of others with things in the world. You smile as you look at the painting your kid did; Leo looks at it too, and he files it away in memory as a good thing—he doesn't toss it with the trash. Shared attention also provides a basis for learning.

So we are reasonably close to a robot that is physically humanlike in appearance and movement, one that can simulate emotions and is sociable. However, you'd better not be doing the rumba with your robot, because it most likely would break your foot if it accidentally trod on it (these puppies are not lightweight). You should also consider its energy requirements (there goes the electric bill). But what about intelligence? Social intelligence is not all my robot will need. It is going to have to outfox gophers, and it is going to have to be pretty dang intelligent to outfox the gophers in my yard, which, I am sure, have the same genetic code as the *Caddyshack* survivors.

Ray Kurzweil is not worried so much about the physical vehicle. It is the intelligence that interests him. He thinks that once computers are smart enough, that is, smarter than we are, they will be able to design their own vehicles. Others think that humanlike intelligence and all that contributes to it cannot exist without a human body: I think therefore my brain *and* my body am. Alun Anderson, editor in chief of *New Scientist* magazine, put it this way when asked what his most dangerous idea

was: "Brains cannot become minds without bodies."[37] No brain-in-a-box will ever have humanlike intelligence. We have seen how emotion and simulation affect our thinking, and, without those inputs, we would be, well, a whole 'nother animal. And Jeff Hawkins, creator of the Palm Pilot, thinks since we don't even know what intelligence is and what processes in the brain produce it, we have a lot of work still to do before we can have intelligent machines.[38]

ARTIFICIAL INTELLIGENCE

The term *artificial intelligence* (AI) originated in 1956, when John McCarthy from Dartmouth College, Marvin Minsky from Harvard University, Nathaniel Rochester of the IBM Corporation, and Claude Shannon from the Bell Telephone Laboratories proposed that "a 2 month, 10 man study of artificial intelligence be carried out during the summer of 1956 at Dartmouth College in Hanover, New Hampshire. The study is to proceed on the basis of the conjecture that every aspect of learning or any other feature of intelligence can in principle be so precisely described that a machine can be made to simulate it. An attempt will be made to find how to make machines use language, form abstractions and concepts, solve kinds of problems now reserved for humans, and improve themselves. We think that a significant advance can be made in one or more of these problems if a carefully selected group of scientists work on it together for a summer."[39]

Looking back at that statement made over half a century ago, it seems as if it was a little optimistic. Today the American Association for Artificial Intelligence defines AI as "the scientific understanding of the mechanisms underlying thought and intelligent behavior and their embodiment in machines."[40] However, despite all the computing power and effort that have gone into making computers intelligent, they still can't do what a three-year-old child can do: They can't tell a cat from a dog. They can't do what any surviving husband can do: They don't understand the nuances of language. For instance, they don't know that the question "Have the trash barrels been taken out?" actually means, "Take the trash

barrels out," and that it also has a hidden implication: "If you don't take the trash out, then. . . ." Use any search engine, and as you gaze at what pops up, you think, "Where did that come from? That is so not what I'm looking for." Language translation programs are wacky. It is obvious the program has no clue as to the meaning of the words it is translating. Attempts are continually being made, but even with all the processing power, memory, and miniaturization, creating a machine with human intelligence is still a dream. Why?

Artificial intelligence comes in two strengths: weak and strong. Weak AI is what we are used to when we think about computers. It refers to the use of software for problem-solving or reasoning tasks. Weak AI does not include the full range of human cognitive abilities, but it may also have abilities that humans do not have. Weak AI has slowly permeated our lives. AI programs are directing our cell-phone calls, e-mails, and Web searches. They are used by banks to detect fraudulent transactions, by doctors to help diagnose and treat patients, and by lifeguards to scan beaches to spot swimmers in need of help. AI is responsible for the fact that we never encounter a real person when we make a call to any large organization or even many small ones, and for the voice recognition that allows us to answer vocally rather than press a number. Weak AI beat the world champion chess player, and can actually pick stocks better than most analysts. But Jeff Hawkins points out that Deep Blue, IBM's computer that beat the world chess champion, Garry Kasparov, at chess in 1997, didn't win by being smarter than a human. It won because it was millions of times faster than a human: It could evaluate two hundred million positions per second. "Deep Blue had no sense of the history of the game, and didn't know anything about its opponent. It played chess yet didn't understand chess, in the same way that a calculator performs arithmetic but doesn't understand mathematics."[38]

Strong AI is what flips many people out. *Strong AI* is a term coined by John Searle, a philosopher at the University of California, Berkeley. The definition presupposes, although he does not, that it is possible for machines to comprehend and to become self-aware. "According to strong AI, the computer is not merely a tool in the study of the mind; rather, the appropriately programmed computer really is a mind, in the sense that

computers given the right programs can be literally said to *understand* and have other cognitive states."[41] Searle maintains that all conscious states are caused by lower level brain processes,[42] thus consciousness is an emergent phenomenon, a physical property—the sum of the input from the entire body. Consciousness does not just arise from banter back and forth in the brain. Consciousness is not the result of computation. You have to have a body, and the physiology of the body and its input, to create a mind that thinks and has the intelligence of the human mind.

IS A CONSCIOUS MACHINE POSSIBLE?

The logic behind believing a machine can be conscious is the same logic that is behind creating AI. Because human thought processes are the result of electrical activity, if you can simulate that same electrical activity in a machine, then the result will be a machine with humanlike intelligence and consciousness. And just as with AI, there are some who think that this does not mean that the machine's thought processes need necessarily be the same as a human's to produce consciousness. Then there are those who agree with Hawkins and think that it must have the same processes, and that to have those, it has to be hooked up the same way. And there are those who are on the fence.

The quest for artificial intelligence was not originally based on reverse-engineering the brain, because in 1956, when AI was a glimmer of an idea, very little was known about how the brain works. Those early engineers had to wing it when they began to design AI. They initially came up with their own solutions for creating the various components of artificial intelligence, and some of these methods have actually supplied clues to how parts of the brain work. Some of these approaches are based on mathematical rules, such as Bayesian logic, which determines the likeliness of a future event based on similar events in the past, or Markov models, which evaluate the chance that a specific sequence of events will happen and are used in some voice-recognition software. The engineers built "neural nets," set up to run in parallel and loosely simulating neurons and their connections; they actually learn responses that are not preprogrammed in. These systems have also been used in voice-

recognition software. They are also used to detect fraud in credit-card charges, and in face and handwriting recognition. Some are based on inference—the old "if this, then that" logic. There are programs that search through large numbers of possibilities, such as the chess program Deep Blue. Some are planning programs that start with general facts about the world, rules about cause and effect, facts germane to particular situations, and the intended goal—just like the direction finder in your car that plans routes and tells you how to get to the closest Chinese takeout.

But the human brain is different in many ways from a computer. In his book *The Singularity Is Near,* Kurzweil enumerates the differences.

* The brain's circuits are slower but more massively parallel. The brain has about one hundred trillion interneuronal connections. This is more than any computer yet has.
* The brain is constantly rewiring itself and self-organizing.
* The brain uses emergent properties, which means that intelligent behavior is rather an *unpredictable* result of chaos and complexity.
* The brain is only as good as it has to be, in terms of evolution. There's no need to be ten times smarter than everyone else; you need only be a *little* smarter.
* The brain is democratic. We contradict ourselves: We have internal conflicts that *may* result in a superior solution.
* The brain uses evolution. The developing brain of a baby six to eight months old forms many random synapses. The patterns of connections that best make sense of the world are the ones that survive. Certain patterns of brain connections are crucial, whereas some are random. As a result, an adult has far fewer synapses than the toddler.
* The brain is a distributed network. There is no dictator or central processor calling the shots. It is also deeply connected: Information has many ways to navigate through the network.
* The brain has architectural regions that perform specific functions and have specific patterns of connections.
* The overall design of the brain is simpler than the design of a neuron.[2]

It's interesting, however, that Kurzweil leaves out something rather major. He ignores the fact that the brain is hooked up to a biological body. So far, AI programs are good only at the thing they are specifically designed for. They don't generalize and aren't flexible.[2] Deep Blue, with all its connections, massive memory, and power, does not know that it better take the trash out . . . or else.

Although human-level intelligence has not been achieved, computers surpass some of our abilities. They are better at symbolic algebra and calculus, scheduling complex tasks or sequences of events, laying out circuits for fabrication, and many other mathematically involved processes.[9] They are not good at that elusive quality, common sense. They can't critique a play. As I said before, they are not good at translating from one language to another, nor at nuances within a language. Oddly, it is many of the things that a four-year-old can do, rather than what a physicist or a mathematician can do, that are the hang-ups.

No computer yet has passed the Turing Test, proposed in 1950 by Alan Turing,[43] the father of computer science, to answer the question, Can machines think? In the Turing Test, a human judge engages in a natural language conversation with two other parties, one a human and the other a machine, both trying to appear human. If the judge cannot reliably tell which is which, then the machine has passed the test. The conversation is usually limited to written text, so that voice is not a prejudicial factor. Many researchers have a problem with the Turing Test. They do not think that it will indicate whether a machine is intelligent. Behavior isn't a test of intelligence. A computer may be able to act as if it were intelligent, but that does not mean it is.

PALM PILOT TO THE RESCUE

Jeff Hawkins thinks he knows why no truly intelligent machines have been made. It is not because computers just need to be more powerful and have more memory, as some researchers think. He thinks everyone working on artificial intelligence has been barking up the wrong tree. They have been working under the wrong premise[38] and should be paying more attention to how the human brain works. Although John

McCarthy and most other AI researchers think that "AI does not have to confine itself to methods that are biologically observable,"[44] Hawkins thinks this notion is what has led AI research astray. And he isn't so happy with neuroscientists, either. Slogging through neuroscience literature to answer the question of just how the brain works, he found that although mounds of research have been done, and tons of data accumulated, no one yet has put it all together and come up with a theory to explain how humans think. He was tired of the failed attempts at AI and concluded that if we don't know how humans think, then we can't create a machine that can think like a human. He also concluded that if no one else was going to come up with a theory, he'd just have to do it himself. So he founded the Redwood Center for Theoretical Neuroscience and set about the business. Jeff is no slouch. Or maybe he is. He leaned back, put his feet up on the desk, cogitated, and came up with the memory-prediction theory,[38] which presents a large-scale framework of the processes in the human brain. He hopes other computer scientists will take it out for a spin, tweak it, and see if it works.

Hawkins was fascinated when he read a paper written in 1978 by the distinguished neuroscientist Vernon Mountcastle, who had made the observation that the neocortex is remarkably similar throughout, and therefore all regions of the cortex must be performing the same job. Why the end result of that job is different for different areas—that is, vision is the result of processing in the visual cortex, hearing in the auditory cortex, etc.—is not because they have different processing methods. It is because the input signals are different, and because of how the different regions are connected to each other.

One piece of evidence that backs up this conclusion was the demonstration of the plasticity (an ability to change its wiring) of the cortex done by Mriganka Sur at MIT. To see what effect the input to a cortical area had on its structure and function, he rewired visual input in newborn ferrets so that it went to the auditory cortex instead of the visual cortex.[45, 46] Would a ferret be able to use another portion of the somatosensory cortex, such as the auditory cortex tissue, to see? It turns out that the input has a big effect. The ferrets could see to some extent. This means that they were seeing with the brain area that normally hears sounds. The new "visual cortical tissue" isn't wired exactly as it would

have been in the normal visual cortex, leading Sur and his colleagues to conclude that input activity can remodel the cortical networks, but it is not the only determinant of cortical structure; there are probably intrinsic cues (genetically determined) that also provide a scaffold of connectivity.[47] That means specific areas of the cortex have evolved to process certain types of information and have been wired in a certain way to better accommodate it, but if need be, because the actual mode of processing is the same in all the neurons, any part of the cortex can process it.

This idea that the brain uses the same mechanism to process all information made a lot of sense to Hawkins. It united all the capabilities of the brain into one tidy package. The brain didn't have to reinvent the wheel every time it expanded its abilities: It has one solution for thousands of problems. If the brain uses a single processing method, then a computer could too, if he could figure out what that method was.

Hawkins is a self-declared neocortical chauvinist. He looks on the neocortex as the seat of our intelligence: It was the last to develop and is larger and better connected than any other mammal's. However, he fully keeps in mind that all the input that goes into it has been processed by lower-level brain regions: those regions that are evolutionarily older, which we share with other animals. So using his big neocortex, Hawkins came up with his memory-prediction theory, and we are going to check it out.

All the inputs into the neocortex come from our senses, just as in all animals. One surprising thing is that no matter what sense we are talking about, the input into the brain is in the same format: neural signals that are partly electrical and partly chemical. It is the pattern of these signals that determines what sense you experience; it doesn't matter where they come from. This can be illustrated by the phenomenon of sensory substitution.

Paul Bach y Rita, who was a physician and neuroscientist at the University of Wisconsin, became interested in the plasticity of the brain after caring for his father, who was recovering from a stroke. He understood that the brain is plastic and that it is the brain that sees, not the eyes. He wondered if he could restore vision to a blind person by providing the correct electrical signal but through a different input pathway, that is, not

through the eyes, which were no longer functioning and providing input. He created a device that displays visual patterns on the tongue, so that a blind person would be able to wear the device and "see" via sensations on the tongue.[48] Visual images from a small TV camera worn on the forehead are delivered to arrays of stimulators in a disc worn on the tongue. (He tried several parts of the body, including the abdomen, back, thigh, forehead, and fingertip, and found the tongue to be the best.) The images from the camera are translated into a neural code, which the stimulator implements by creating specific pressure patterns on the tongue. The nerve impulses created by the pressure patterns are sent to the brain via the intact sensory pathway from the tongue, and the brain quickly learns to interpret these impulses as vision. Wacky, huh? With this system, a congenitally blind person was able to perform assembly and inspection tasks on an electronic assembly line of miniature diodes, and totally blind persons can catch a ball rolling across a table and identify faces.

Hawkins says that an important aspect of all this sensory information is that no matter what sense's input is being processed, it is arriving in the form of spatial and temporal patterns. When we hear something, it is not only the timing between sounds that is important, the temporal pattern, but also the actual spatial position of the receptor cells in the cochlea is important. With vision, obviously there are spatial patterns, but what we don't realize is that with every image that we perceive, the eye is actually jumping three times a second to fixate on different points. These movements are known as saccades. Although what we perceive is a stable picture, it actually is not. The visual system automatically deals with these continuously changing images and you perceive them as stable. Touch is also spatial, but Hawkins points out that just one single sensation is not enough to identify an object; it has to be touched in more than one spot, which adds a temporal aspect.

So with this understanding of the input, we go to the six-layered dish towel, the neocortex. Following Mountcastle's theory, Hawkins assumes that each cell in a particular layer of the dish towel performs the same type of process. So all the neurons in layer I do the same process, then the result is sent to layer II and the layer II cells all do their thing, and so on. However, the information is not just being sent up through

the levels, it is also sent laterally to other regions and back down. Each one of those pyramidal neurons may have up to ten thousand synapses. Talk about an information superhighway!

The neocortex is also divided into regions that process different information. Now we come to the notion of hierarchy. The brain treats information in a hierarchical manner. This is not a physical hierarchy such that higher-level cortical areas sit on top of each other, but a hierarchy of information processing, a hierarchy of connectivity. The region at the bottom of the hierarchy is the biggest and receives tons of sensory information, each neuron a specialist in a bit of minutiae. For instance, at the bottom of the hierarchy for visual processing is an area known as V1. Each neuron in V1 specializes in a tiny patch of an image, like a pixel in a camera, but not only that, it has a specific job within the pixel. It fires only with a specific input pattern, such as a 45-degree line slanted down to the left. It makes no difference whether you are looking at a dog or a Pontiac; if there is a 45-degree downward slant to the left, this neuron will fire. Area V2, the next region up the hierarchy, starts putting the information from V1 together. Then it sends what it has pieced together to V4. V4 does its thing, and then the information goes to an area called IT. IT specializes in entire objects. So if all the incoming info matches a face pattern, then a group of neurons specific for face patterns in IT start firing away as long as they are receiving their info from below. "I'm getting a face code, still there, still there, ahh . . . , OK, it's gone. I'm out."

But don't get the idea that this is a one-way system. Just as much information is going down the hierarchy as coming up. Why?

Computer scientists have been modeling intelligence as if it were the result of computations—a one-way process. They think of the brain as if it, too, were a computer doing tons of computations. They attribute human intelligence to our massively parallel connections, all running at the same time and spitting out an answer. They reason that once computers can match the amount of parallel connections in the brain, they will have the equivalent of human intelligence. But Hawkins points out a fallacy in this reasoning, which he calls the hundred-step rule. He gives this example: When a human is shown a picture and asked to press a button if a cat is in the picture, it takes about a half second or less. This task is either very difficult or impossible for a computer to do. We already

know that neurons are much slower than a computer, and in that half second, information entering the brain can traverse only a chain of one hundred neurons. You can come up with the answer with only one hundred steps. A digital computer would take billions of steps to come up with the answer. So how do we do it?

And here is the crux of Hawkins's hypothesis: "The brain doesn't 'compute' the answers to problems; it retrieves the answers from memory. In essence, the answers were stored in memory a long time ago. It only takes a few steps to retrieve something from memory. Slow neurons are not only fast enough [to] do this, but they constitute the memory themselves. The entire cortex is a memory system. It isn't a computer at all."[38] And this memory system differs from computer memory in four ways:

1. The neocortex stores sequences of patterns.
2. It recalls patterns autoassociatively, which means it can recall a complete pattern when given only a partial one. You see a head above a wall and know that there is a body connected to it.
3. It stores patterns in invariant form. It can handle variations in a pattern automatically: When you look at your friend from different angles and different distances, although the visual input is completely different, you still recognize her. A computer would not. Each change in input does not cause you to recalculate whom you are looking at.
4. The neocortex stores memory in a hierarchy.

Hawkins proposes that the brain uses its stored memory to make predictions constantly. When you enter your house, your brain is making predictions from past experience: where the door is, where the door handle is, how heavy the door it is, where the light switch is, which furniture is where, etc. When something is brought to your attention, it is because the prediction failed. Your wife painted the back door pink without telling you of her intentions, so you notice it. ("What the heck . . . ?") It didn't match the predicted pattern. (In fact, it didn't match anything.) Thrill seeker that he is, Hawkins proposes that *prediction* "is the primary function of the neocortex, and the foundation of intelligence."[38] That means that prediction is going on all the time in everything that you do,

because all those neocortical cells process in the same manner. Hawkins states, "The human brain is more intelligent than that of other animals because it can make predictions about more abstract kinds of patterns and longer temporal pattern sequences."[38]

Rita Rudner, in a comedy routine occasioned by her wedding anniversary, says you have to be very careful about what household activities you perform during the first two weeks of marriage, because those are going to be the ones that you will be stuck doing for the duration. You don't want to set up a predictable pattern that you will regret! Hawkins sees intelligence as measuring just how well you remember and predict patterns, whether they are patterns of words, numbers, social situations, or physical objects. So this is what is going on when cortical areas are sending information down the cortical hierarchy:

> For many years most scientists ignored these feedback connections. If your understanding of the brain focused on how the cortex took input, processed it, and then acted on it, you didn't need feedback. All you needed were feed forward connections leading from sensory to motor sections of the cortex. But when you begin to realize that the cortex's core function is to make predictions, then you have to put feedback into the model: the brain has to send information flowing back toward the region that first receives the inputs. Prediction requires a comparison between what is happening and what you expect to happen. What is actually happening flows up, and what you expect to happen flows down.[38]

So back to the visual processing of the face that we started with: IT is firing away about identifying a face pattern, sending this info forward to the frontal lobes, but also back down the hierarchy. "I'm getting a face code, still there, still there, ahh . . . , OK, it's gone, I'm out." But V4 had already put most of the info together, and while it sent it up to IT, it also yelled back down to V2, "I betcha that's a face. I got it almost pieced together, and the last ninety-five out of one hundred times the pieces were like this, it was a face, so I betcha that's what we got now, too!" And V2 is yelling, "I knew it! It seemed so familiar. I was so guessing the same damn thing. I told V1 as soon as it started sending me stuff. Like I am *so* hot!" This is a simplified rendition, but you get the idea.

The neocortex of mammals got tacked onto the lower-functioning reptilian-type brain (with some modifications). That brain, however, was no small potatoes. It could and still can do a lot. Crocodiles can see, hear, touch, run, swim, maintain all their homeostatic mechanisms, catch prey, have sex, and get a shoe company named after them. We can do most of these same things without our neocortex, although Michael Jordan needed his to get shoes named after him. Having this addition made mammals smarter, and Hawkins says it is because it added memory. Memory allowed an animal to predict the future, by being able to recall previous sensory and behavioral information. The neurons receive their input and recognize it from the day before. "Gee, we got similar signals yesterday, and it turned out to be a delicious thing to eat. Well, hey, all our input is just like yesterday. Let's predict that it is the same thing as yesterday, a delicious tidbit. Let's eat it."

Memory and prediction allow a mammal to take the rigid behaviors that the evolutionarily old brain structures developed and use them more intelligently. Your dog predicts that if he sits, puts his paw on your lap, and cocks his head, you will pet him, just as you did all those other times. He did not have to invent any new movement. Even without his neocortex, he could sit, lift his paw, and cock his head, but now he can remember the past and predict the future. However, animals depend on the environment to access their memory. Your dog sees you, and that gives him his cue. There is no evidence that he is out on the lawn ruminating about what to do to get petted. Merlin Donald maintains that humans have the unique ability to autocue. We can voluntarily recall specific memory items independent of the environment.[49] Hawkins thinks that human intelligence is unique because the neocortex of humans is bigger, which allows us to learn more complex models of the world and make more complex predictions. "We see deeper analogy, more structure on structure, than other mammals." We also have language, which he sees as fitting nicely into the memory prediction framework. After all, language is pure analogy and is just patterns set in a hierarchical structure (semantics and syntax), which is the meat and potatoes of what his framework recognizes. And, just as Merlin Donald suggested, language needed motor coordination.

Humans have also taken their motor behavior to the extreme. Hawkins makes the point that our ability to execute complex movements is due to the fact that our neocortex has taken over most of our motor functions. Knock out the motor cortex of a rat, and you may not notice any change, but knock it out in a human, and the result is paralysis. Our motor cortex is much more connected to our muscles than that of any other species. This is why Michael Jordan needed his neocortex to become the king of basketball. Hawkins thinks our movements are the result of predictions, and predictions cause the motor command to move: "Instead of just making predictions based on the behavior of the old brain, the human neocortex directs behavior to satisfy its predictions."[38]

Hawkins doesn't really foresee my getting a personal robot. He thinks that in order for a robot to act like a human or interact in humanlike ways, it will need all the same sensory and emotional input, and it will need to have had human experiences. To behave as a human, you need to experience life as a human biological entity. This would be extremely difficult to program, and he doesn't see the point. He projects that such robots would be more expensive and higher maintenance than a real human and couldn't relate to a human on the level of shared experience. He thinks that we can build an intelligent machine by giving it senses (not necessarily the same as we have; it could have infrared vision, for instance) so that it can learn from observation of the world (rather than having everything programmed in), and a heck of a lot of memory, but it isn't going to look like Sophia or Johnny.

Hawkins is not worried that an intelligent machine is going to be malevolent or want to take over the world or be concerned that it is a slave to its human oppressor. These fears are based on a false analogy: confusing intelligence with "thinking like a human," which as we have seen, is often dominated by the emotional drives of the evolutionarily old part of our brain. An intelligent machine would not have the drives and desires of a human. There is a difference between the neocortical intelligence measured by the predictive ability of a hierarchical memory, and what happens to that when input from the rest of the brain is added. He doubts that we will be able to download our minds onto a chip and pop it into a robot, as Ray Kurzweil predicts will be possible. He foresees no way that the trillions of unique connections in the nervous system can

be copied and duplicated, and then popped into a robotic body just like yours. All those years of sensory input from the exact dimensions of a specific body have honed the predictions of each brain. Pop it into a different body, and the predictions will be off. Michael Jordan's timing would be totally off in Danny DeVito's body, and vice versa.

The Blue Brain Project

Henry Markram, director of the Brain and Mind Institute at the École Polytechnique Fédérale de Lausanne (EPFL), in Switzerland, is a big advocate of the view that in order to understand how the brain works, the biology of the brain is of the utmost importance. He agrees with Hawkins about the problems in modeling artificial intelligence: "'The main problem in computational neuroscience is that theoreticians [who] do not have a profound knowledge of neuroscience build models of the brain.' Current models 'may capture some elements of biological realism, but are generally far from biological.' What the field needs, he says, is 'computational neuroscientists [who are] willing to work closely with the neuroscientists to follow faithfully and learn from the biology.'"[50] Markram is a detail man. He's no theoretical windbag. He mucks around at the ion channel, neurotransmitter, dendritic, synaptic level and works his way up.

Markram and his institute, collaborating with IBM and their Blue Gene/L supercomputer, have now taken on the task of reverse engineering the mammalian brain. This project has been dubbed the Blue Brain Project, and it rivals the human genome project in its complexity. To begin with, they are creating a 3-D replica of a rat brain with the intention of eventually being able to create one of a human brain. "The aims of this ambitious initiative are to simulate the brains of mammals with a high degree of biological accuracy and, ultimately, to study the steps involved in the emergence of biological intelligence."[3] It is not an attempt to create a brain or artificial intelligence, but an attempt to *represent* the biological system. From this, insights about intelligence and even consciousness may be drawn.

Markram makes the fundamental point that there are "quantum leaps in the 'quality' of intelligence between different levels of an

organism." Thus the intelligence of an atom is less than that of a DNA molecule, which has less intelligence than the protein it codes, which alone is nothing compared to combinations of proteins that produce different cell types. These different cell types combine to produce different brain areas, which contain and process different types of input. You get the picture. The brain as a whole makes the next quantum leap in the quality of intelligence beyond its physical structures, the separate brain areas, and the neurons. The question is whether it is the interaction between the neurons, that whole thing about being well connected, that is driving that last qualitative leap. So this 3-D model is no flim-flam replica that has ever been done before. In fact, it never *could* have been done before. It requires the huge computational power of the Blue Gene computer, the biggest, baddest, fastest computer in the world.

They are building the replica specific neuron by specific neuron, because every neuron is anatomically and electrically unique, with unique dendritic connections. The project is founded on an immense amount of research that has been going on for the last hundred years in neuroanatomy, beginning with the unraveling of the microstructure of the neocortical column, and in physiology, beginning with the model of ionic currents and the idea that dendritic branches of neurons affect their processing. The first goal of the project has been accomplished. That was to construct a single neocortical column (NCC) of a two-week-old rat. In preparation for this project, the researchers at EPFL, over the last ten years, have been performing paired recordings of the morphology and physiology of thousands of individual neurons and their synaptic connections in the somatosensory cortex of two-week-old rats. The replica NCC, the "blue column,"* is made up of ten thousand neocortical neurons within the dimensions of an NCC, which is about half a millimeter in diameter and one and a half millimeters tall.[3]

*The blue column is made up of the "different types of neuron in layer 1, multiple subtypes of pyramidal neuron in layers 2–6, spiny stellate neurons in layer 4, and more than 30 anatomical-electrical types of interneuron with variations in each of layers 2–6." H. Markram, "The Blue Brain Project," *Nature Reviews Neuroscience* 7 (2006): 153–60.

At the end of 2006, the first column was completed; the model included thirty million synapses in precise 3-D locations! The next step is to compare simulation results of the model with experimental data from the rat brain. Areas where more info is needed can then be identified, and more research will be done to fill in these gaps. This is not a one-shot deal. The circuit will have to be rebuilt over and over again every time a section gets tweaked by new data, and the replica of the real biological circuit will become progressively more accurate.

What's the Point of Building This Model?

Markram has a whole laundry list of information that will be gleaned from these models. Just as Breazeal thinks her robots will be useful for verifying neuroscientific theories, so Markram thinks of the blue column the same way: "Detailed, biologically accurate brain simulations offer the opportunity to answer some fundamental questions about the brain that cannot be addressed with any current experimental or theoretical approaches."[3] First, he sees it as a way to gather all the random puzzle pieces of information that have been learned about cortical columns, and put them all together in one place. Current experimental methods allow only glimpses at small parts of the structure. This would allow the puzzle to be completed. You jigsaw fans know how satisfying that can be.

Markram has hopes the continual tweaking of the details of the model will allow us to understand the fine control of ion channels, receptors, neurons, and synaptic pathways. He hopes to answer questions about the exact computational function of each element, and their contribution to emergent behavior. He also foresees insight into the mystery of how the emergent properties of these circuits—such as memory storage and retrieval, and intelligence—come about. A detailed model will also aid in disease diagnosis and treatment. Besides identifying weak points in circuits that can cause dysfunction and targeting them for treatment, simulations of neurological or psychiatric disease could also be used to check hypotheses about their origins, to design tests to diagnose them, and to find treatments. It will also provide circuit designs that can be used for silicon chips. Not too shabby!

CHANGING YOUR GENES

Gregory Stock, director of the Program on Medicine, Technology and Society at UCLA, doesn't think the fields of technology and robotics are going to change what it means to be human. He thinks being a fyborg is where it is at. Machines will stay machines, bodies will remain carbon. The idea of hopping up onto the operating table for a bit of neurosurgery when he feels just fine doesn't much appeal to him, and he doesn't think it will appeal to many people, especially when everything you would gain could be had by wearing an external device. I know neurosurgery is not on the top of *my* to-do list. Why risk it, when you could strap on a watch-like device or clip something on your belt? Why give up a good eye when you could slip on a pair of glasses for night vision? Stock thinks our world is going to be rocked by the fields of genetics and genetic engineering—tinkering with DNA, man directing his own evolution. These changes aren't going to be the result of some mad scientist cooking up ideas about modifying the human race to his specifications; they are going to creep in slowly as the result of work done to treat genetic diseases and to avoid passing them on to our children. They are also going to come from the realization that much of our temperament is due to our genes (just like the domesticated Siberian foxes we talked about) and that those genes will be modifiable. "We have already used technology to transform the world around us. The canyons of glass, concrete, and stainless steel in any major city are not the stomping ground of our Pleistocene ancestors. Now our technology is becoming so potent and so precise that we are turning it back on our own selves. And before we're done, we are likely to transform our own biology as much as we have already changed the world around us."[51]

Biology-Based Aids—The Ways to Change Your DNA

You can change your biology by taking medications, or you can change the instruction manual that coded how to build your body. That manual is DNA. There are two ways to tinker with DNA: somatic gene therapy

and germ-line therapy. Somatic gene therapy is tinkering with the DNA a person already has in nonreproductive cells; it affects only the current individual. Germ-line therapy is tinkering with the DNA in sperm, egg, or an embryo, so that every cell in the future adult organism has the new DNA, including the reproductive cells. That means the change is passed on to future generations.

Stanley Cohen of Stanford University and Herbert Boyer, then at the University of California, San Francisco, worked only thirty miles apart, but they met in Hawaii. They attended a conference on bacterial plasmids in 1972. A plasmid is a DNA molecule, usually in the shape of a ring. It is separate from the chromosomal DNA but is also able to replicate. It is usually found floating around in bacterial cells. One reason they are important is that these strands of DNA can carry information that makes bacteria resistant to antibiotics. Cohen had been working on ways to isolate specific genes in plasmids and clone them individually by putting them in *Escherichia coli* bacteria and letting them replicate. Boyer had discovered an enzyme that cut DNA strands at specific DNA sequences, leaving "cohesive ends" that could stick to other pieces of DNA. Shop-talking over lunch, they wondered if Boyer's enzyme would cut Cohen's plasmid DNA into specific, rather than random, segments, then bind those segments to new plasmids. They decided to collaborate, and in a matter of months succeeded in splicing a piece of foreign DNA into a plasmid.[52] The plasmid acted as a vehicle to carry this new DNA, which then inserted new genetic information into a bacterium. When the bacterium reproduced, it copied the foreign DNA into its offspring. This created a bacterium that was a natural factory, cranking out the new DNA strands. Boyer and Cohen, now considered to be the fathers of biotechnology, understood that they had invented a quick and easy way to make biological chemicals. Boyer went on to cofound the first biotech company, Genentech. Today, people all around the world enjoy the benefits of Boyer and Cohen's "cellular factories." Genetically engineered bacteria produce human growth hormone, synthetic insulin, factor VIII for hemophilia, somatostatin for acromegaly, and the clot-dissolving agent called tissue plasminogen activator. This line of research suggested that perhaps custom DNA could be added to human cells, but the problem was how to get it into the cell.

The goal of somatic therapy is to replace a defective gene that is causing a disease or dysfunction by the insertion of a good gene into an individual's cells. In somatic gene therapy, the recipient's genome is changed, but not in every cell in the body, and the change is not passed along to the next generation. This has not been an easy assignment. Although there has been a lot of research done in this area, and a lot of money spent, the successes have been few and far between.

First of all, there is the problem of just exactly how one inserts genes into a cell. Researchers finally figured out that they should use the experts in cell invasion and replication: viruses. Unlike bacteria, viruses cannot replicate on their own. In reality, a virus is merely a vehicle for DNA or RNA. It consists of DNA or RNA surrounded by a protective coat of protein: That's it. They are the quintessential houseguests from hell.

Viruses actually sneak their way inside a host cell and then use the cell's replication apparatus to make copies of their own DNA. However, if you could make that DNA a good copy of a defective gene, and direct it to cells that have a defective copy, well then, you can see the possibilities of a virus acting as the agent of somatic gene therapy: Take the virus's DNA out, add the DNA that you want, and turn it loose.

To begin with, research has concentrated on diseases that are caused by only a single defective gene in accessible cells, such as blood or lung cells, rather than diseases caused by a host of defects that work in concert with each other. But of course, nothing is as easy as first envisioned. The protein coats of the viruses are foreign to the body, and sometimes they have triggered host reactions that have caused rejection, a problem that recently may have been solved by researchers in Italy.[53] Because of the problems with rejection, different DNA vehicles are being explored. Inserting strands of DNA on a chromosome is also tricky, because it matters where it is put. If spliced next to a DNA sequence that regulates the expression of the sequences next to it, it can result in unexpected consequences, such as tumors.[54] Moreover, most genetic diseases, such as diabetes, Alzheimer's disease, heart disease, and various cancers, arise from a host of genes, not just one. Also, the effects of the therapy may not last. The cells that have been modified may not be long-lived, so that the therapy has to be repeated.

Gene therapy has had a few successes, including the treatment of severe combined immunodeficiency disease (also known as bubble-boy disease)[55, 56, 57] and X-linked chronic granulomatous disease,[58] which is another type of immune deficiency. As I am writing this, the BBC reports that a team at London's Moorfields Eye Hospital made the first attempt to treat blindness caused by a faulty gene called RPE65 using gene therapy.[59] Whether this worked or not will not be known for months. The trouble is, somatic therapy is really a quick fix. The people who have been treated still carry the mutant gene and can pass it on to their offspring. This is the problem that prompts research in germ-line therapy.

In germ-line gene therapy, the embryo's DNA is changed, including the DNA in its reproductive cells. When it comes time for it to reproduce, its egg or sperm cells carry the new DNA, and the changes are passed on to their offspring. The disease-producing gene or genes are eliminated for good in a particular individual's genome. This idea could not even have been considered until 1978, when the first test-tube baby was born. In vitro fertilization involves harvesting egg cells from the woman's ovary, and mixing them on a petri dish with sperm. The resultant embryo is then accessible to manipulation. Very controversial at the time, in vitro fertilization (IVF) is now casual cocktail-party talk. That is not to say the process is enjoyable. It is difficult and both physically and emotionally arduous. Notwithstanding the difficulties, many infertile couples benefit from the technology, to the extent that 1 percent of the babies born in the United States are the result of in vitro fertilization.

Not all in vitro fertilization is done for infertile couples. Some is done for couples who have had a child with a genetic disease, such as cystic fibrosis. It is also done when one or both of the prospective parents know they carry a copy of a defective gene. Embryos conceived in vitro, when they reach the eight-cell stage, can now be screened with the genetic tests that are currently available. Up until 2006, there were just a small handful of diseases that could be tested for. However, a new procedure known as preimplantation genetic haplotyping (PGH),[60] developed at Guy's Hospital in London, has changed that. It is now possible to take a single cell from the early embryo, extract the DNA, replicate it, and then use it for DNA fingerprinting. This not only increases the number of genetic defects that can be detected in preimplantation embryos, now

ranging into the thousands, but also increases the number of usable embryos and their survival rate. Before this test was available, if the concern was for X-linked disease, none of the male embryos could be tested, so they were eliminated. Now they too can be screened. Humans are the only animal that can tinker with their chromosomes (and those of other species, too) and guide their genetic reproduction.

The future implications of PGH are huge. There is a Web site called BetterHumans.com. The first page of comments about PGH seems to cover the territory pretty well:

"It's pretty important considering how much it will affect the lifelong happiness of an individual and how well they can contribute to the world."

"It is wonderful that this is not illegal yet. Do you not love incrementalism?"

"But once again, we need to define disease. I consider the average lifespan to be a disease."

"Perhaps it will be possible to extrapolate the genetic tendency for longer life, in which case we can engineer longer lifespans into the populace."

"When we can clearly say that a given DNA pattern has an unacceptably high propensity for a specific disease—it would be unethical to propagate it."

"You're right, it's not a simple process to weed out disease from socially desirable traits. . . . Diversity will be important to maintain."

"However, for public policy: an international ethical board should decide which genetic options lead to medical disorders."

Those less enthusiastic may agree with Josephine Quintavalle, member of the pro-life activist organization Comment on Reproductive Ethics, who said: "I am horrified to think of these people sitting in judgment on these embryos and saying who should live and who should die."[61]

Even before the advent of this type of testing, an earlier version that allowed screening for only a handful of diseases caused different countries to take very different approaches to legislating and regulating its use, giving rise to the phenomenon of reproductive tourism—the one vacation from which you won't appear so well rested on your return. Obviously this even more exhaustive testing will bring more ethical questions with it.[62]

Currently if a couple does such testing, they may be concerned only with genetic disease that causes a lifelong affliction or an early death. But the truth is, no embryo is going to be perfect. It may not have the genes coding for childhood-onset diseases like cystic fibrosis or muscular dystrophy, but suppose it had genes that indicated a high probability of developing diabetes in middle age, or heart disease, or Alzheimer's disease? Are you going to toss it, start all over again, and try for a better one? How about depression? And this is where the future of germ-line therapy and all of those headache-provoking ethical questions may come into play: Don't toss 'em, change 'em!

Changing the DNA of an embryo changes the DNA in all its future cells, from the brain to the eyeballs to the reproductive organs. It changes the DNA in the future egg and sperm cells also. That means the altered DNA is passed on to all the future offspring, which would therefore be "genetically modified organisms." In a sense, every organism is genetically modified just by the recombining of genes. Humans have already been guiding their evolution more than they realize, from raising crops to modern medicine. Although modern medicine has found ways to treat such things as infectious disease, diabetes, and asthma, allowing people to live longer, it has also allowed some people—who normally would not have lived to reproductive age—to reproduce and pass those genes on. Inadvertently, this affects evolution, increasing the prevalence of genes coding for these diseases. However, the term *genetically modified organisms* has come to mean tinkering with DNA by man for the purpose of selecting for or against specific traits. This has been done in plants and on laboratory animals, but not with humans.

Today, in 2007, when you have a child without IVF, you really can't be held responsible for his or her DNA: You get what you get. That is, unless you know that you carry a defective gene that can produce a disease, and you choose to reproduce anyway. It is a matter of opinion how ethical that is. Now that the human genome has been sequenced, and you will soon be able to get your own personal sequencing done for a few bucks, this laissez-faire attitude about the future DNA of your offspring may not be acceptable.

I can imagine the courtroom scene:

"Mr. Smith, I see here that you had your gene sequencing done in
February of 2010. Is that correct?"

"Ah, yeah, I thought it would be cool to get it done."

"I also see that you received a printout of the results and an explana-
tion of what they meant."

"Well, yeah, they gave me that paper."

"Yes, but you signed this paper that said you understood you carried
a gene that could cause any of your offspring to have. . . ."

"Yeah, I guess so."

"And you went ahead and had a child without first doing PGH? You
did nothing to prevent this disease in your child?"

"Well, you know, we just got caught up in the moment, and, well, it
just happened."

"Did you tell your partner you knew you were the carrier of these
defective genes?"

"Ah, well, I kinda forgot about it."

*"You kinda forgot about it? When we have the technology to prevent
this sort of thing?"*

But then there is the other side of the coin. Your future teenager
may hold you responsible for all that she doesn't like about herself.
"Gee Dad, couldn't you have been a little more original? Like, every-
one has curly blond hair and blue eyes. And maybe you could have
made me more athletic. I mean, I can't even run a marathon without
training."

No one is tinkering with the human germ line just yet. Too much is
still unknown about the properties of various genes and how they affect
and control each other. It may turn out that it will be too complicated to
mess with. Genes that control the expression of certain traits may be so
linked with the expression and control of other genes that they may not
be able to be isolated. Certain traits may be the result of a constellation
of genes that can't be altered without affecting many other traits. Parents
are going to be reluctant to interfere with their children's genes, and well
they should be. Europeans and people in Marin County don't even want
them altering the genes of their vegetables. That is why a different idea
is being pursued: an artificial chromosome.

Artificial Chromosomes

The first version of an artificial human chromosome was made by a group at Case Western Reserve University in 1997.[63] It was to be used to help illuminate the structure and function of human chromosomes, and possibly to avoid some of the problems of viral and nonviral gene therapy. You will recall that we have twenty-three pairs of chromosomes. The idea is to add an "empty" (and, we hope, inert) chromosome, which can be modified. The artificial chromosome is put into the embryo, and then whatever you order up will be tacked on to it. Some of what is tacked on may have on-and-off switches that would be under the individual's control when they are older. For instance, there could be a gene for cancer-fighting cells that wouldn't express itself except in the presence of a particular chemical. That chemical would be given as an injection. A person finds out he has cancer, he gets the injection that turns on the gene that produces the cancer-fighting cells, and voilà, the body cleans up the mess without any further ado. Another type of injection would turn the gene off. And if better sequences are discovered, then when it comes time for your offspring to reproduce, they can replace whatever is on the artificial chromosome with the newer, better version. Some of the genes would have to be able to suppress the expression of genes on the original chromosomes, if they control the trait you want modified.

Of course, this all presupposes IVF. Will humans control their reproduction to this extent? Our current genetically coded sexual urges lead to a great deal of willy-nilly reproduction. In the United States, abortion eliminates half of these unplanned pregnancies. However, if this urge is suppressed by selecting for a population of people that plan everything, will we survive as a species? How much will all this cost? Will only wealthy countries, or the wealthy in each country, be able to afford it? Does that matter?

You may find this disconcerting and think we should be pulling in the reins a bit, but you also need to remember what is driving our behavior. Our genes are programmed to reproduce. Besides urging reproductive behavior, they also make us safeguard our children to ensure that they survive to reproduce themselves. Stock predicts that this safeguarding will include routine PGH, that those who can afford to will no longer

reproduce that old-fashioned, rather haphazard way, but will resort to IVF and embryo selection.

And of course, next up after disease prevention will be embryo modification or enhancement. As more is learned about how our brain activity is controlled by our personal genetic code, how mental illness results from specific sequences of DNA, and how different temperaments are coded for, the temptation to tinker may prove irresistible. At first, the motivation will be to prevent disease, but while you're at it . . . , how about . . . ? Stock quotes a comment made by James Watson, codiscoverer of DNA's double-helix structure, at a conference on human germ-line engineering in 1998: "No one really has the guts to say it, but if we could make better human beings by knowing how to add genes, why shouldn't we?"[64] Modification and enhancement will be a fuzzy zone, depending on your point of view. "If you are really stupid, I would call that a disease," Watson said on a British documentary. "The lower 10 percent who really have difficulty, even in elementary school, what's the cause of it? A lot of people would like to say, 'Well, poverty, things like that.' It probably isn't. So I'd like to get rid of that, to help the lower 10 percent."[65] Both Watson and Stock realize we are going to have to understand that many of the psychological differences between people (and the similarities) have biological roots.

These technologies will originally be explored for the treatment and prevention of disease, for developing genetically tailored drugs, and for genetic counseling. But obviously they will have applicability to modification and enhancement of the human genome. "OK, I got a couple of embryos here. What did you guys want added? Oh, yeah, here is your order form. I see you have checked tall, symmetrical, blue eyes, happy, male. Hmm, are you sure about that? Everyone is ordering tall males. Jeez, there goes horse racing. Oh, you want the athletic package, and the anticancer, antiaging, antidiabetes, anti–heart disease package. That's standard. Comes with the chromosome now."

So humans may soon be taking a hands-on approach to their own evolution. However, tincture of time will not be an aspect of this type of change. Selected-for traits will not be honed by hundreds of thousands of years of physiological, emotional, social, and environmental interactions. Our track record for preserving finely balanced interactions has

not been so stellar. Think rabbits in Australia: Introduced in 1859 for hunting on an estate, within ten years the twenty-four original rabbits had multiplied to such an extent that two million could be shot or trapped annually with no noticeable effect on the population. Rabbits have contributed to the demise of one-eighth of all mammalian species in Australia, and an unknown number of plant species. They also munch on plants to the point where plant loss has contributed to massive amounts of erosion. All that to be able to bag a few on the manor. You don't even want to know how much money has been spent dealing with those rabbits.

Apparently the rabbit lesson wasn't enough. Another supposedly good idea gone bad was the one hundred cane toads that were introduced to Australia in 1935 because they were thought to be good for controlling beetles in the sugarcane fields of Central and South America. Now there are more than one hundred million across New South Wales and the Northern Territory. They are not popular. Loud and ugly with a voracious appetite and ducts full of poisonous bile, they eat more than beetles. They have had a disastrous effect on indigenous fauna in Australia. Or consider the Indian mongoose, brought to Hawaii to control the rats that had come to Hawaii as stowaways. Not only did they not control the rats, they killed all the land fowl. Or how about the recent introduction of zebra mussels, native to the Black, Caspian, and Azov seas, which were dumped into the Great Lakes in the mid-1980s in the ballast water of vessels from Europe. They are now one of the most injurious invasive species to affect the United States, and have been found as far as Louisiana and Washington. Zebra mussels have altered the ecosystems of the Great Lakes by reducing phytoplankton, the foundation of the local food chain. They have other negative economic impacts, causing damage to the hulls of ships, docks, and other structures and clogging water-intake pipes and irrigation ditches. Need I go on? And these finely balanced systems were visible ones.

What will come of all this genetics research? Exuberant technological scenarios have us becoming so intelligent that we will be capable of solving the entire world's problems, eradicating disease, and living for hundreds of years. Are the things that we consider problems really problems, or are they solutions for larger problems that we haven't considered? If a

deer had the capacity to enumerate some of the problems it faces, we might hear, "I feel anxious all the time, I always think there is a puma watching me. I can't get a restful night's sleep. If I just could get those damn pumas to become vegans, half my problems would be solved." We have seen what happens when the puma populations wane: forests become overpopulated with deer, which wreak havoc on the vegetation, leading to erosion . . . on and on. Problems for the individual may be solutions in the big picture. Would animal-rights activists want to tinker with the genomes of carnivores to change them into herbivores? If they think it is wrong for a human to kill and eat a deer, what about a puma?

Genetic enhancement will certainly involve tweaking personality traits. Those that may be considered undesirable, if possessed by no one, may unwittingly cause havoc. Richard Wrangham thinks pride has caused many of society's problems. But perhaps pride is what motivates us to do a job well. Perhaps shaving the capacity for pride out of the genome would result in people not caring about the quality of their work and hearing the word "whatever" even more, if that is possible. Anxiety is often listed as another undesirable. Maybe the world would be better off without the anxious, but maybe not. Perhaps the anxious are the canaries of the world. So who is going to define what is desirable and not? Will it be well-meaning parents, who think that a perfectly designed child will live a perfect life? Will the result be the same game of Russian roulette that we already have?

CONCLUSION

Being human is interesting, that's for sure, and it seems that it is getting more so. In a mad frenzy of utilizing our uniquely human abilities, such as our arching and opposing thumbs, which allow us finely tuned movements, and our abilities to question, reason, and explain imperceptible causes and effects, using language, abstract thinking, imagination, autocuing, planning, reciprocity, combinatorial mathematics, and so on, science is beginning to model what is going on in that brain of ours and in the brains of other species. We have come across a few more uniquely human abilities as we looked at researchers trying to create smart robots.

One is Merlin's rehearsal loop, and another is his suggestion that humans are the only animals that can autocue. We also learned that each species has unique somatosensory and motor specialties that give each its unique way of perceiving, and moving in, the world.

Some of the motivation for this research is pure curiosity, which is not a uniquely human characteristic; some is from a desire to help relieve suffering from injury or disease, driven by empathy and compassion, which arguably is uniquely human; and some is done to improve the human condition in general, a goal that definitely is uniquely human. Some of the research is driven by desires that we share with all other animals, to reproduce healthy and fit offspring. It remains to be seen whether our desires will drive us to manipulate our chromosomes to the point where we will no longer be *Homo sapiens,* whether we will be trading up to silicon. Maybe we will be referred to in the future as *Homo buttinski.*

AFTERWORD

This is my simple religion. There is no need for temples; no need for complicated philosophy. Our own brain, our own heart is our temple; the philosophy is kindness.

—Tenzin Gyatso, the fourteenth Dalai Lama

As long as our brain is a mystery, the universe, the reflection of the structure of the brain, will also be a mystery.

—Santiago Ramón y Cajal,
Spanish physician and Nobel laureate

LONG BEFORE I BEGAN THIS BOOK, AS I WORKED MY WAY UP through my classes, I posed the question to various family members and friends, "In what ways do you think humans are unique?" Years ago, I did a more formal version of this tactic. I wrote many of the leading thinkers of America and asked them, since they made decisions every day about worldly matters, what was their theory about the nature of man? This was done in preparation for my book *The Social Brain*. It was a fascinating exercise and proved productive. So why not try it again, this time with family and friends of both sexes and all ages?

Naturally, I thought I might actually start the book with these suggestions and either verify them or shoot holes in them. Most people told me they would think about it and get back to me. I filed away the few responses I received. I haven't looked at them again until now, wondering how they matched up with the various ideas and facts I had come across.

It seems, even though the responses were few, I received a rather good cross section. Although they weren't all written in the same lingo, in one way or another, several of our unique abilities were identified. Leave it to a therapist to identify the moral emotions of guilt and shame. A teacher suggested that humans are the only animal to actively teach their young. An accountant mentioned mathematical abilities, and a five-year-told me, "Animals don't have birthday parties for themselves, you have to give them one." A teenager, fresh out of high school, said other animals don't starve themselves by dieting, don't accessorize, and don't have tummy tucks. Other unique abilities mentioned were that humans could voluntarily recall an enormous amount of stored information, could play and write music, had language and religion, believed in an afterlife, played team sports, and were disgusted by feces.

There were also the people who weren't altogether impressed with humans. Some said that humans were not unique. One response from the obstetrics clinic was, "I think at the core humans are no different from animals. We all have the bestial urges of expanding our hunting range, controlling resources, and spreading our DNA. The need to ask the question separates us, but the reality of our behavior is not so very different from our animal counterparts." Or from an ornithologist after a hard day: "Humans are self-centered egotists who take advantage of other humans, other animals, and the lands they inhabit for what they think suits them and without considering how their actions affect other living things—plant and animal." Of course this describes all the animals that she loves, too. A hawk is not concerned about the mouse's family when it swoops in for lunch. A beaver is not concerned about the effects of the dam it is building on the creek.

I was also given some suggestions that sounded promising but then later proved to be a bit off. An anthropologist suggested that humans were the only animal with incest taboos. As we saw, there is some of this going on with chimpanzees. That surprised me, too. A marine biologist suggested that humans were the only animals that can change natural selection. I didn't discuss something known as niche-construction theory, which suggests that animals actually do cause changes to their niche that affect natural selection. However, humans are the only animals consciously tinkering with their DNA via technology. Along these lines,

another observation was that humans have been able to separate sex from reproduction through technology.

Obviously, people were looking at the question from their own perspectives, the jobs they did, and their personal interests. I guess I should have quizzed a chef, because no one mentioned cooking. It was interesting that no one brought up the basic question concerning whether animals understood that other individuals had thoughts, beliefs, and desires, or thought about their own thoughts. No one wondered if other animals' consciousness was different from our own, which is indicative of how strongly we humans anthropomorphize, lavishing theory of mind on other animals. Also, no one mentioned that humans alone thought abstractly, had imagination, or thought about, reasoned about, and explained imperceptible forces, causes, and effects. Nor did anyone suggest that we are the only animal that could separate pretense from reality, use contingently true information, time-travel in our imaginations, or manifest episodic memory. And no one realized that we are the only animal that can delay gratification by inhibiting our impulses over time. It was not surprising that no one mentioned we were the only animal that frequency matched. Irritatingly enough, however, not one person in my family mentioned the left-brain interpreter. What is up with that?

On the evolutionary tree, we humans are sitting at the tip of our lonely branch. The chimps have their own branch with the bonobos sprouting off it, and a common ancestor links us. We have the same roots as all living organisms. That is why those who don't see much difference between humans and animals have a strong footing. All those similarities are there. Our cellular processes depend upon the same biology, and we are subject to the same properties of physics and chemistry. We are all carbon-based creatures. Yet every species is unique, and we are too. Every species has answered the problem of survival with a different solution, filling a different niche.

One other comment that I received was that humans don't have a built-in defense mechanism, like fangs or claws. We do pack a punch with our fists, but we also have, as Inspector Poirot likes to point out, the little gray cells. We *Homo sapiens* entered a cognitive niche. We have done all too well without the fangs and claws. Without the changes to

our physical structure, we could not have developed the abilities that we have. We needed to have free hands and fully opposable thumbs and a larynx and all the other changes to our body before we could acquire many of our unique abilities. Yet there were more than just the physical changes.

As we have seen, we do have physically big brains, but that is not the whole story. The Neanderthals had a bigger brain than we but did not develop the same advanced artifacts as the upstart *Homo sapiens*. Will we ever know what happened and how the change came about? This question haunts paleontologists such as Ian Tattersall. He just wants to know: unrequited curiosity. Many try to define our uniqueness in terms of quantity versus quality. Are we on a continuum, as Darwin thought, or was there some big leap? By studying our closest living relatives, the chimps, we have learned that our brains are both quantitatively and qualitatively different. We have a bigger brain, and some of the parts are different. But I think the crucial difference is that we aren't hooked up the same. Everything has been tweaked and interconnected. Feedback loops have been formed that allow rumination and inhibition and may be the basis for our self-awareness and consciousness. The corpus callosum has allowed more punch per cubic inch of brain, eliminating redundancy and allowing the two hemispheres to specialize and increase efficiency. Specialization appears to have run rampant, creating various modular pathways. Our mirror-neuron systems seem to be into everything, providing us with imitative abilities that may be the basis of our social abilities, our learning, our empathy, and perhaps our language. And the story of those connections is continuing to unfold.

Humans are actually just getting a toehold on understanding their abilities. Whether we have the brain capacity to assimilate all the information that is being collected is questionable. Maybe those people who see humans as only slightly different from the rest of the animals are right. Just like other animals, we are constrained by our biology. We may not have the capacity to be any better than their worst appraisal. But the ability to wish or imagine that we can be better is notable. No other species aspires to be more than it is. Perhaps we can be. Sure, we may be only slightly different, but then, some ice is only one degree colder than liquid water. Ice and water are both constrained by their chemical composition,

but they are very different because of a phase shift. My brother closed his list of differences by saying, "Humans will sit behind a computer and try to figure out the meaning of life. Animals live life. The question is: Who is better off, the human or the animal?"

That's enough! I am going out to tend to my vineyard. My pinot grapes will soon be producing a fine wine. Am I ever glad I am not a chimp!

NOTES

Chapter 1: ARE HUMAN BRAINS UNIQUE?

1. Preuss, T.M. (2001). The discovery of cerebral diversity: An unwelcome scientific revolution. In Falk, D., and Gibson, K. (eds.), *Evolutionary Anatomy of the Primate Cerebral Cortex* (pp. 138–64). Cambridge: Cambridge University Press.

2. Darwin, C. (1871). *The Descent of Man, and Selection in Relation to Sex.* London: John Murray (Facsimile edition, Princeton, NJ: Princeton University Press, 1981). In Preuss (2001).

3. Huxley, T.H. (1863). *Evidence as to Man's Place in Nature.* London: Williams and Morgate (Reissued 1959, Ann Arbor: University of Michigan Press). In Preuss (2001).

4. Holloway, R.L., Jr. (1966). Cranial capacity and neuron number: A critique and proposal. *American Journal of Anthropology* 25: 305–14.

5. Preuss, T.M. (2006). Who's afraid of *Homo sapiens*? *Journal of Biomedical Discovery and Collaboration* 1, www.j-biomed-discovery.com/content/1/1/17.

6. Striedter, G.F. (2005). *Principles of Brain Evolution.* Sunderland, MA: Sinauer Associates.

7. Jerrison, H.J. (1991). *Brain Size and the Evolution of Mind.* New York: Academic Press.

8. Roth, G. (2002). Is the human brain unique? In Stamenov, M.I., and Gallese, V. (eds.), *Mirror Neurons and the Evolution of Brain and Language* (pp. 64–76). Philadelphia: John Benjamin.

9. Klein, R.G. (1999). *The Human Career.* Chicago: University of Chicago Press.

10. Simek, J. (1992). Neanderthal cognition and the Middle to Upper Paleolithic transition. In Brauer, G., and Smith, G.H. (eds.), *Continuity or Replacement? Controversies in* Homo sapiens *Evolution* (pp. 231–35) Rotterdam: Balkema.

11. Smirnov, Y. (1989). Intentional human burial: Middle Paleolithic (last glaciation) beginnings. *Journal of World Prehistory* 3: 199–233.

12. Deacon, T.W. (1997). *The Symbolic Species.* London: Penguin.

13. Gilead, I. (1991). The Upper Paleolithic period in the Levant. *Journal of World Prehistory* 5: 105–54.

14. Hublin, J.J., and Bailey, S.E. (2006). Revisiting the last Neanderthals. In Conard, N.J. (ed.), *When Neanderthals and Modern Humans Met* (pp. 105–28). Tübingen: Kerns Verlag.

15. Dorus, S., Vallender, E.J., Evans, P.D., Anderson, J.R., Gilbert, S.L., Mahowald, M., Wyckoff, G.J., Malcom, C.M., and Lahn, B.T. (2004). Accelerated evolution of nervous system genes in the origin of *Homo sapiens*. *Cell* 119: 1027–40.

16. Jackson, A.P., Eastwood, H., Bell, S.M., Adu, J., Toomes, C., Carr, I.M., Roberts, E., et al. (2002). Identification of microcephalin, a protein implicated in determining the size of the human brain. *American Journal of Human Genetics* 71: 136–42.

17. Bond, J., Roberts, E., Mochida, G.H., Hampshire, D.J., Scott, S., Askham, J.M., Springell, K., et al. (2002). ASPM is a major determinant of cerebral cortical size. *Nature Genetics* 32: 316–20.

18. Ponting, C., and Jackson, A. (2005). Evolution of primary microcephaly genes and the enlargement of primate brains. *Current Opinion in Genetics & Development* 15: 241–48.

19. Evans, P.D., Anderson, J.R., Vallender, E.J., Choi, S.S., and Lahn, B.T. (2004). Reconstructing the evolutionary history of microcephalin, a gene controlling human brain size. *Human Molecular Genetics* 13: 1139–45.

20. Evans, P.D., Anderson, J.R., Vallender, E.J., Gilbert, S.L., Malcom, C.M., Dorus, S., and Lahn, B.T. (2004). Adaptive evolution of ASPM, a major determinant of cerebral cortical size in humans. *Human Molecular Genetics* 13: 489–94.

21. Evans, P.D., Gilbert, S.L., Mekel-Bobrov, N., Ballender, E.J., Anderson, J.R., Baez-Azizi, L.M., Tishkoff, S.A., Hudson, R.R., and Lahn, B.T. (2005). Microcephalin, a gene regulating brain size, continues to evolve adaptively in humans. *Science* 309: 1717–20.

22. Mekel-Bobrov, N., Gilbert, S.L., Evans, P.D., Ballender, E.J., Anderson, J.R., Hudson, R.R., Tishkoff, S.A., and Lahn, B.T. (2005). Ongoing adaptive evolution of ASPM, a brain size determinant in *Homo sapiens*. *Science* 309: 1720–22.

23. Lahn, B.T., www.hhmi.org/news/lahn4.html.

24. Deacon, T.W. (1990). Rethinking mammalian brain evolution. *American Zoology* 30: 629–705.

25. Semendeferi, K., Lu, A., Schenker, N., and Damasio, H. (2002). Humans and great apes share a large frontal cortex. *Nature Neuroscience* 5: 272–76.

26. Semendeferi, K., Damasio, H., Frank, R., and Van Hoesen, G.W. (1997). The evolution of the frontal lobes: A volumetric analysis based on three-dimensional reconstructions of magnetic resonance scans of human and ape brains. *Journal of Human Evolution* 32: 375–88.

27. Semendeferi, K., Armstrong, E., Schleicher, A., Zilles, K., and Van Hoesen, G.W. (2001). Prefrontal cortex in humans and apes: A comparative study of area 10. *American Journal of Physical Anthropology* 114: 224–41.

28. Schoenemann, P.T., Sheehan, M.J., and Glotzer, L.D. (2005). Prefrontal white matter volume is disproportionately larger in humans than in other primates. *Nature Neuroscience* 8: 242–52.

29. Damasio, A. (1994). *Descartes' Error*. New York: Putnam.

30. Johnson-Frey, S.H. (2003). What's so special about human tool use? *Neuron* 39: 201–4.

31. Johnson-Frey, S.H. (2003). Cortical mechanisms of tool use. In Johnson-Frey, S.H. (ed.), *Taking Action: Cognitive Neuroscience Perspectives on the Problem of Intentional Movements* (pp.185–217). Cambridge, MA: MIT Press.

32. Johnson-Frey, S.H., Newman-Morland, R., and Grafton, S.T. (2005). A distributed left hemisphere network active during planning of everyday tool use skills. *Cerebral Cortex* 15: 681–95.

33. Buxhoeveden, D.P., Switala, A.E., Roy, E., Litaker, M., and Casanova, M.F. (2001). Morphological differences between minicolumns in human and nonhuman primate cortex. *American Journal of Physical Anthropology* 115: 361–71.

34. Casanova, M.F., Buxhoeveden, D., and Soha, G.S. (2000). Brain development and evolution. In Ernst, M., and Rumse, J.M. (eds.), *Functional Neuroimaging in Child Psychiatry* (pp. 113–36). Cambridge: Cambridge University Press.

35. Goodhill, G.J., and Carreira-Perpinan, M.A. (2002). Cortical columns. In *Encyclopedia of Cognitive Science*. Basingstoke, UK: Macmillan.

36. Marcus, J.A. (2003). *Radial Neuron Number and Mammalian Brain Evolution: Reassessing the Neocortical Uniformity Hypothesis*. Boston: Doctoral dissertation, Department of Anthropology, Harvard University.

37. Mountcastle, V.B. (1957). Modality and topographic properties of single neurons of cat's somatic sensory cortex. *Journal of Neurophysiology* 20: 408–34.

38. Buxhoeveden, D.P., and Casanova, M.F. (2002). The minicolumn hypothesis in neuroscience. *Brain* 125: 935–51.

39. Jones, E.G. (2000). Microcolumns in the cerebral cortex. *Proceedings of the National Academy of Sciences* 97: 5019–21.

40. Mountcastle, V.B. (1997). The columnar organization of the neocortex. *Brain* 120: 701–22.

41. Barone, P., and Kennedy, H. (2000). Non-uniformity of neocortex: Areal heterogeneity of NADPH-diaphorase reactive neurons in adult macaque monkeys. *Cerebral Cortex* 10: 160–74.

42. Beaulieu, C. (1993). Numerical data on neocortical neurons in adult rat, with special reference to the GABA population. *Brain Research* 609: 284–92.

43. Elston, G.N. (2003). Cortex, cognition and the cell: New insights into the pyramidal neuron and prefrontal function. *Cerebral Cortex* 13: 1124–38.

44. Preuss, T. (2000a). Preface: From basic uniformity to diversity in cortical organization. *Brain Behavior and Evolution* 55: 283–86.

45. Preuss, T. (2000b). Taking the measure of diversity: Comparative alternatives to the model-animal paradigm in cortical neuroscience. *Brain Behavior and Evolution* 55: 287–99.

46. Marin-Padilla, M. (1992). Ontogenesis of the pyramidal cell of the mammalian neocortex and developmental cytoarchitectonics: A unifying theory. *Journal of Comparative Neurology* 321: 223–40.

47. Caviness, V.S.J., Takahashi, T., and Nowakowski, R.S. (1995). Numbers, time and neocortical neurogenesis: A general developmental and evolutionary model. *Trends in Neuroscience* 18: 379–83.

48. Fuster, J.M. (2003). Neurobiology of cortical networks. In *Cortex and Mind* (pp. 17–53). New York: Oxford University Press.

49. Jones, E.G. (1981). Anatomy of cerebral cortex: Columnar input-output organization. In Schmitt, F.O., Worden, F.G., Adelman, G., and Dennis, S.G. (eds.), *The Organization of the Cerebral Cortex* (pp. 199–235). Cambridge, MA: MIT Press.

50. Hutsler, J.J., and Galuske, R.A.W. (2003). Hemispheric asymmetries in cerebral cortical networks. *Trends in Neuroscience* 26: 429–35.

51. Ramón y Cajal, S. (1990). The cerebral cortex. In *New Ideas on the Structure of the Nervous System in Man and Vertebrates* (pp. 35–72). Cambridge, MA: MIT Press.

52. Elston, G.N., and Rosa, M.G.P. (2000). Pyramidal cells, patches and cortical columns: A comparative study of infragranular neurons in TEO, TE, and the superior temporal polysensory area of the macaque monkey. *Journal of Neuroscience* 20: RC117: 1–5.

53. Hutsler, J.J., Lee, D.-G., and Porter, K.K. (2005). Comparative analysis of cortical layering and supragranular layer enlargement in rodent, carnivore, and primate species. *Brain Research* 1052: 71–81.

54. Caviness, V.S.J., Takahashi, T., and Nowakowski, R.S. (1995). Numbers, time and neocortical neurogenesis: A general developmental and evolutionary model. *Trends in Neuroscience* 18: 379–83.

55. Hutsler, J.J., Lee, D.-G., and Porter, K.K. (2005). Comparative analysis of cortical layering and supragranular layer enlargement in rodent, carnivore, and primate species. *Brain Research* 1052: 71–81.

56. Darlington, R.B., Dunlop, S.A., and Finlay, B.L. (1999). Neural development in metatherian and eutherian mammals: Variation and constraint. *Journal of Comparative Neurology* 411: 359–68.

57. Finlay, B.L., and Darlington, R.B. (1995). Linked regularities in the development and evolution of mammalian brains. *Science* 268: 1578–84.

58. Rakic, P. (1981). Developmental events leading to laminar and areal organization of the neocortex. In Schmitt, F.O., Worden, F.G., Adelman, G., and Dennis, S.G. (eds.), *The Organization of the Cerebral Cortex* (pp. 7–28). Cambridge, MA: MIT Press.

59. Rakic, P. (1988). Specification of cerebral cortical areas. *Science* 241: 170–76.

60. Ringo, J.L., Doty, R.W., Demeter, S., and Simard, P.Y. (1994). Time is of the essence: A conjecture that hemispheric specialization arises from interhemispheric conduction delay. *Cerebral Cortex* 4: 331–34.

61. Hamilton, C.R., and Vermeire, B.A. (1988). Complementary hemisphere specialization in monkeys. *Science* 242: 1691–94.

62. Cherniak, C. (1994). Component placement optimization in the brain. *Journal of Neuroscience* 14: 2418–27.

63. Allman, J.M. (1999). Evolving brains. *Scientific American Library Series*, No. 68. New York: Scientific American Library.

64. Hauser, M., and Carey, S. (1998). Building a cognitive creature from a set of primitives: Evolutionary and developmental insights. In Cummins, D., and Allen, C. (eds.), *The Evolution of the Mind* (pp. 51–106). New York: Oxford University Press.

65. Funnell, M.G., and Gazzaniga, M.S. (2000). Right hemisphere deficits in reasoning processes. *Cognitive Neuroscience Society Abstracts Supplements* 12: 110.

66. Rilling, J.K., and Insel, T.R. (1999). Differential expansion of neural projection systems in primate brain evolution. *NeuroReport* 10: 1453–59.

67. Rizzolatti, G., Fadiga, L., Gallese, V., and Fogassi, L. (1996). Premotor cortex and the recognition of motor actions. *Cognitive Brain Research* 3: 131–41.

68. Rizzolatti, G. (1998). Mirror neurons. In Gazzaniga, M.S., and Altman, J.S. (eds.), *Brain and Mind: Evolutionary Perspectives* (pp. 102–10). HFSP workshop reports 5. Strasbourg: Human Frontier Science Program.

69. Baron-Cohen, S. (1995). *Mindblindness. An Essay on Autism and Theory of Mind*. Cambridge, MA: MIT Press.

70. Watanabe, H., et al. (2004). DNA sequence and comparative analysis of chimpanzee chromosome 22. *Nature* 429: 382–88.

71. Vargha-Khadem, F., et al. (1995). Praxic and nonverbal cognitive deficits in a large family with a genetically transmitted speech and language disorder. *Proceedings of the National Academy of Sciences* 92: 930–33.

72. Fisher, S.E., et al. (1998). Localization of a gene implicated in a severe speech and language disorder. *Nature Genetics* 18: 168–70.

73. Lai, C.S., et al. (2001). A novel forkhead-domain gene is mutated in a severe speech and language disorder. *Nature* 413: 519–23.

74. Shu, W., et al. (2001). Characterization of a new subfamily of winged-helix/forkhead (Fox) genes that are expressed in the lung and act as transcriptional repressors. *Journal of Biological Chemistry* 276: 27488–97.

75. Enard, W., et al. (2002). Molecular evolution of FOXP2, a gene involved in speech and language. *Nature* 418: 869–72.

76. Fisher, S.E. (2005). Dissection of molecular mechanisms underlying speech and language disorders. *Applied Psycholinguistics* 26: 111–28.

77. Caceres, M., et al. (2003). Elevated gene expression levels distinguish human from non-human primate brains. *Proceedings of the National Academy of Sciences* 100: 13030–35.

78. Bystron, I., Rakic, P., Molnár, Z., and Blakemore, C. (2006). The first neurons of the human cerebral cortex. *Nature Neuroscience* 9: 880–86.

Chapter 2: WOULD A CHIMP MAKE A GOOD DATE?

1. Evans, E.P. (1906). *The Criminal Prosecution and Capital Punishment of Animals*. New York: E.P. Dutton.

2. International Human Genome Sequencing Consortium. (2001). Initial sequencing and analysis of the human genome. *Nature* 409: 860–921; Errata 411: 720; 412: 565.

3. Venter, J.C., et al. (2001). The sequence of the human genome. *Science* 291: 1304–51. Erratum 292: 1838.

4. Watanabe, H., et al. (2004). DNA sequence and comparative analysis of chimpanzee chromosome 22. *Nature* 429: 382–438.

5. Provine, R. (2004). Laughing, tickling, and the evolution of speech and self. *Current Directions in Psychological Science*. 13: 215–18.

6. Benes, F.M. (1998). Brain development, VII: Human brain growth spans decades. *American Journal of Psychiatry* 155:1489.

7. Wikipedia.

8. Markl, H. (1985). Manipulation, modulation, information, cognition: Some of the riddles of communication. In Holldobler, B., and Lindauer, M. (eds.), *Experimental Behavioral Ecology and Sociobiology* (pp. 163–94). Sunderland, MA: Sinauer Associates.

9. Povinelli, D.J. (2004). Behind the ape's appearance: Escaping anthropocentrism in the study of other minds. *Daedalus: The Journal of the American Academy of Arts and Sciences* 133 (Winter).

10. Povinelli, D.J., and Bering, J.M. (2002). The mentality of apes revisited. *Current Directions in Psychological Science* 11: 115–19.

11. Holmes, J. (1978). *The Farmer's Dog*. London: Popular Dogs.

12. Leslie, A.M. (1987). Pretense and representation: The origins of "theory of mind." *Psychological Review* 94: 412–26.

13. Bloom. P., and German, T. (2000). Two reasons to abandon the false belief task as a test of theory of mind. *Cognition* 77: B25–B31.

14. Baron-Cohen, S. (1995). *Mindblindness: An Essay on Autism and Theory of Mind*. Cambridge, MA: MIT Press.

15. Baron-Cohen, S., Leslie, A.M., and Frith, U. (1985). Does the autistic child have a theory of mind? *Cognition* 21: 37–46.

16. Heyes, C.M. (1998). Theory of mind in nonhuman primates. *Behavioral and Brain Sciences* 21: 101–34.

17. Povinelli, D.J., and Vonk, J. (2004). We don't need a microscope to explore the chimpanzee's mind. *Mind & Language* 19: 1–28.

18. Tomasello, M., Call, J., and Hare, B. (2003). Chimpanzees versus humans: It's not that simple. *Trends in Cognitive Science* 7: 239–40.

19. White, A., and Byrne, R. (1988). Tactical deception in primates. *Behavioral and Brain Sciences* 11: 233–44.

20. Hare, B., Call, J., Agnetta, B., and Tomasello, M. (2000). Chimpanzees know what conspecifics do and do not see. *Animal Behaviour* 59: 771–85.

21. Call, J., and Tomasello, M. (1998). Distinguishing intentional from accidental actions in orangutans (*Pongo pygmaeus*), chimpanzees (*Pan troglodytes*), and human children (*Homo sapiens*). *Journal of Comparative Psychology* 112: 192–206.

22. Hare, B., and Tomasello, M. (2004). Chimpanzees are more skilful in competitive than in cooperative cognitive tasks. *Animal Behaviour* 68: 571–81.

23. Melis, A., Hare, B., and Tomasello, M. (2006). Chimpanzees recruit the best collaborators. *Science* 313: 1297–1300.

24. Bloom, P., and German, T. (2000). Two reasons to abandon the false belief task as a test of theory of mind. *Cognition* 77: B25–B31.

25. Call, J., and Tomasello, M. (1999). A nonverbal false belief task: The performance of children and great apes. *Child Development* 70: 381–95.

26. Onishi, K.H., and Baillargeon, R. (2005). Do 15-month-old infants understand false beliefs? *Science* 308: 255–58.

27. Wellman, H.M., Cross, D., and Watson, J. (2001). Meta-analysis of theory of mind development: The truth about false-belief. *Child Development* 72: 655–84.

28. Gopnik, A. (1993). How we know our minds: The illusion of first-person knowledge of intentionality. *Behavioral and Brain Sciences* 16: 1–14.

29. Leslie, A.M., Friedman, O., and German, T.P. (2004). Core mechanisms in "theory of mind." *Trends in Cognitive Sciences* 8: 528–33.

30. Leslie, A.M., German, T.P., and Polizzi, P. (2005). Belief-desire reasoning as a process of selection. *Cognitive Psychology* 50: 45–85.

31. German, T.P., and Leslie, A.M. (2001). Children's inferences from "knowing" to "pretending" and "believing." *British Journal of Developmental Psychology* 19: 59–83.

32. German, T.P., and Leslie, A.M. (2004). No (social) construction without (meta) representation: Modular mechanisms as the basis for the acquisition of an understanding of mind. *Behavioral and Brain Sciences* 27:106–7.

33. Tomasello, M., Call, J., and Hare, B. (2003). Chimpanzees understand psychological states—the question is which ones and to what extent. *Trends in Cognitive Science* 7: 154–56.

34. Povinelli, D.J., Bering, J.M., and Giambrone, S. (2000). Toward a science of other minds: Escaping the argument by analogy. *Cognitive Science* 24: 509–41.

35. Mulcahy, N., and Call, J. (2006). Apes save tools for future use. *Science* 312: 1038–40.

36. Anderson, S.R. (2004). A telling difference. *Natural History* 113 (November): 38–43.

37. Chomsky, N. (1980). Human language and other semiotic systems. In Sebeokand, T.A., and Umiker-Sebeok, J. (eds.), *Speaking of Apes: A Critical Anthology of Two-Way Communication with Man* (pp. 429–40). New York: Plenum Press.

38. Savage-Rumbaugh, S., and Lewin, R. (1994). *Kanzi: The Ape at the Brink of the Human Mind*. New York: Wiley.

39. Savage-Rumbaugh, S., Romski, M.A., Hopkins, W.D., and Sevcik, R.A. (1988). Symbol acquisition and use by *Pan troglodytes, Pan paniscus,* and *Homo sapiens*. In Heltne, P.G., and Marquandt, L.A. (eds.), *Understanding Chimpanzees* (pp. 266–95). Cambridge, MA: Harvard University Press.

40. Seyfarth, R.M., Cheney, D.L., and Marler, P. (1980). Vervet monkey alarm calls: Semantic communication in a free-ranging primate. *Animal Behaviour* 28: 1070–94.

41. Premack, D. (1972). Concordant preferences as a precondition for affective but not for symbolic communication (or how to do experimental anthropology). *Cognition* 1: 251–64.

42. Seyfarth, R.M., and Cheney, D.L. (2003). Meaning and emotion in animal vocalizations. *Annals of the New York Academy of Sciences* 1000: 32–55.

43. Seyfarth, R.M., and Cheney, D.L. (2003). Signalers and receivers in animal communication. *Annual Review of Psychology* 54: 145–73.

44. Fitch, W.T., Neubauer, J., Herzel, H. (2002). Calls out of chaos: The adaptive significance of nonlinear phenomena in mammalian vocal production. *Animal Behaviour* 63: 407–18.

45. Mitani, J., and Nishida, T. (1993). Contexts and social correlates of long-distance calling by male chimpanzees. *Animal Behaviour* 45: 735–46.

46. Corballis, M.C. (1999). The gestural origins of language. *American Scientist* 87: 138–45.

47. Rizzolatti, G., and Arbib, M.A. (1998). Language within our grasp. *Trends in Neurosciences* 21: 188–94.

48. Hopkins, W.D., and Cantero, M. (2003). From hand to mouth in the evolution of language: The influence of vocal behavior on lateralized hand use in manual gestures by chimpanzees (*Pan troglodytes*). *Developmental Science* 6: 55–61.

49. Meguerditchian, A., and Vauclair, J. (2006). Baboons communicate with their right hand. *Behavioral Brain Research* 171: 170–74.

50. Iverson, J.M., and Goldin-Meadow, S. (1998). Why people gesture when they speak. *Nature* 396: 228.

51. Senghas, A. (1995). The development of Nicaraguan sign language via the language acquisition process. In MacLaughlin, D., and McEwen, S. (eds.), *Proceedings of the 19th Annual Boston University Conference on Language Development* (pp. 543–52). Boston: Cascadilla Press.

52. Neville, H.J., Bavalier, D., Corina, D., Rauschecker, J., Karni, A., Lalwani, A., Braun, A., Clark, V., Jezzard, P., and Turner, R. (1998). Cerebral organization for language in deaf and hearing subjects: Biological constraints and effects of experience. *Proceedings of the National Academy of Sciences* 95: 922–29.

53. Rizzolatti, G., Fogassi, L., and Gallese, V. (2004). Cortical mechanisms subserving object grasping, action understanding, and imitation. In Gazzaniga, M.S. (ed.), *The Cognitive Neurosciences,* vol. 3 (pp. 427–40). Cambridge, MA: MIT Press.

54. Kurata, K., and Tanji, J. (1986). Premotor cortex neurons in macaques: Activity before distal and proximal forelimb movements. *Journal of Neuroscience* 6: 403–11.

55. Rizzolatti, G., et al. (1988). Functional organization of inferior area 6 in the macaque monkey, II: Area F5 and the control of distal movements. *Experimental Brain Research* 71: 491–507.

56. Gentillucci, M., et al. (1988). Functional organization of inferior area 6 in the macaque monkey, I: Somatotopy and the control of proximal movements. *Experimental Brain Research* 71: 475–90.

57. Hast, M.H., et al. (1974). Cortical motor representation of the laryngeal muscles in *Macaca mulatta. Brain Research* 73: 229–40.

58. For a review, see: Rizzolatti, G., Fogassi, L., and Gallese, V. (2001). Neurophysiological mechanisms underlying the understanding and imitation of action. *Nature Reviews Neuroscience* 2: 661–70.

59. Goodall, J. (1986). *The Chimpanzees of Gombe: Patterns of Behavior.* Cambridge, MA: Belknap Press of Harvard University.

60. Crockford, C., and Boesch, C. (2003). Context-specific calls in wild chimpanzees, *Pan troglodytes verus:* Analysis of barks. *Animal Behaviour* 66: 115–25.

61. Barzini, L. (1964). *The Italians.* New York: Atheneum.

62. LeDoux, J.E. (2000). Emotion circuits in the brain. *Annual Review of Neuroscience* 23: 155–84.

63. LeDoux, J.E. (2003). The self: Clues from the brain. *Annals of the New York Academy of Sciences* 1001: 295–304.

64. Wrangham, R., and Peterson, D. (1996). *Demonic Males: Apes and the Origins of Human Violence.* Boston: Houghton Mifflin.

65. McPhee, J. (1984). *La Place de la Concorde Suisse*. New York: Farrar, Straus & Giroux.

66. Damasio, A.R. (1994). *Descartes' Error*. New York: Putnam.

67. Ridley, M. (1993). *The Red Queen* (p. 244). New York: Macmillan.

Chapter 3: BIG BRAINS AND EXPANDING SOCIAL RELATIONSHIPS

1. Roes, F. (1998). A conversation with George C. Williams. *Natural History* 107 (May): 10–13.

2. Hamilton, W.D. (1964). The genetical evolution of social behaviour, I and II. *Journal of Theoretical Biology* 7: 1–16 and 17–52.

3. Wilson, D.S., and Wilson, E.O. (2008). Rethinking the theoretical foundation of sociobiology. *Quarterly Review of Biology,* in press.

4. Trivers, R. (1971). The evolution of reciprocal altruism. *Quarterly Review of Biology* 46: 35–37.

5. Tooby, J., Cosmides, L., and Barrett, H.C. (2005). Resolving the debate on innate ideas: Learnability constraints and the evolved interpenetration of motivational and conceptual functions. In Carruthers, P., Laurence, S., and Stich, S. (eds.), *The Innate Mind: Structure and Content*. New York: Oxford University Press.

6. Trivers, R.L., and Willard, D. (1973). Natural selection of parental ability to vary the sex ratio. *Science* 7: 90–92.

7. Clutton-Brock, T.H., and Vincent, A.C.J. (1991). Sexual selection and the potential reproductive rates of males and females. *Nature* 351: 58–60.

8. Clutton-Brock, T.H. (1989) Mammalian mating systems. *Proceedings of the Royal Society of London, Series B: Biological Sciences* 236: 339–72.

9. Clutton-Brock, T.H. (1991). *The Evolution of Parental Care*. Princeton, NJ: Princeton University Press.

10. Trivers, R.L. (1972). Parental investment and sexual selection. In Campbell, B. (ed.), *Sexual Selection and the Descent of Man 1871–1971* (pp. 136–79). Chicago: Aldine.

11. Geary, D.C. (2004). *The Origin of Mind*. Washington, DC: American Psychological Association.

12. Jerrison, H.J. (1973). *Evolution of the Brain and Intelligence*. New York: Academic Press.

13. Wynn, T. (1988). Tools and the evolution of human intelligence. In Byrne, W.B., and White, A. (eds.), *Machiavellian Intelligence*. Oxford: Clarendon Press.

14. Pinker, S. (1997). *How the Mind Works* (p. 195). New York: W.W. Norton.

15. Wrangham, R.W., and Conklin-Brittain, N. (2003). Cooking as a biological trait. *Comparative Biochemistry and Physiology: Part A* 136: 35–46.

16. Boback, S.M., Cox, C.L., Ott, B.D., Carmody, R., Wrangham, R.W., and Secor, S.M. (2007). Cooking and grinding reduces the cost of meat digestion. *Comparative Biochemistry and Physiology: Part A* 148: 651–56.

17. Lucas, P. (2004). *Dental Functional Morphology: How Teeth Work*. Cambridge: Cambridge University Press.

18. Oka, K., Sakuarae, A., Fujise, T., Yoshimatsu, H., Sakata, T., and Nakata,

M. (2003). Food texture differences affect energy metabolism in rats. *Journal of Dental Research* 82: 491–94.

19. Broadhurst, C.L., Wang, Y., Crawford, M.A., Cunnane, S.C., Parkington, J.E., and Schmidt, W.F. (2002). Brain-specific lipids from marine, lacustrine, or terrestrial food resources: Potential impact on early African *Homo sapiens*. *Comparative Biochemistry and Physiology* 131B: 653–73.

20. Crawford, M.A., Bloom, M., Broadhurst, C.L., Schmidt, W.F., Cunnane, S.C., Galli, C., Gehbremeskel, K., Linseisen, F., Lloyd-Smith, J., and Parkington, J. (1999). Evidence for the unique function of docosahexaenoic acid during the evolution of the modern hominid brain. *Lipids* 34 Suppl: S39–47.

21. Broadhurst, C.L., Cunnane, S.C., and Crawford, M.A. (1998). Rift Valley lake fish and shellfish provided brain-specific nutrition for early *Homo*. *British Journal of Nutrition* 79: 3–21.

22. Carlson, B.A., and Kingston, J.D. (2007). Docosahexaenoic acid, the aquatic diet, and hominid encephalization: Difficulties in establishing evolutionary links. *American Journal of Human Biology* 19: 132–41.

23. Byrne, R.W., and Corp, N. (2004). Neocortex size predicts deception rate in primates. *Proceedings of the Royal Society of London, Series B: Biological Sciences* 271: 1693–99.

24. Jolly, A. (1966). Lemur social behaviour and primate intelligence. *Science* 153: 501–6.

25. Humphrey, N.K. (1976). The social function of intellect. In Bateson, P.P.G., and Hinde, R.A. (eds.), *Growing Points in Ethology*. Cambridge: Cambridge University Press.

26. Byrne, R.B., and Whiten, A. (1988). *Machiavellian Intelligence*. Oxford: Clarendon Press.

27. Alexander, R.D. (1990). *How Did Humans Evolve? Reflections on the Uniquely Unique Species*. Ann Arbor: Museum of Zoology, University of Michigan Special Publication No. 1.

28. Dunbar, R.I.M. (1998). The social brain hypothesis. *Evolutionary Anthropology* 6: 178–90.

29. Sawaguchi, T., and Kudo, H. (1990). Neocortical development and social structure in primates. *Primate* 31: 283–90.

30. Dunbar, R.I.M. (1992). Neocortex size as a constraint on group size in primates. *Journal of Human Evolution* 22: 469–93.

31. Kudo, H., and Dunbar, R.I.M. (2001). Neocortex size and social network size in primates. *Animal Behaviour* 62: 711–22.

32. Pawlowski, B.P., Lowen, C.B., and Dunbar, R.I.M. (1998). Neocortex size, social skills and mating success in primates. *Behaviour* 135: 357–68.

33. Lewis, K. (2001). A comparative study of primate play behaviour: Implications for the study of cognition. *Folia Primatica* 71: 417–21.

34. Dunbar, R.I.M. (2003). The social brain: Mind, language, and society in evolutionary perspective. *Annual Review of Anthropology* 32: 163–81.

35. Hill, R.A., and Dunbar, R.I.M. (2003). Social network size in humans. *Human Nature* 14: 53–72.

36. Dunbar, R.I.M. (1996). *Grooming, Gossip and the Evolution of Language*. Cambridge, MA: Harvard University Press.

37. Ben-Ze'ev, A. (1994). The vindication of gossip. In Goodman, R.F., and Ben-Ze'ev, A. (eds.), *Good Gossip* (pp. 11–24). Lawrence: University of Kansas Press.

38. Iwamoto, T., and Dunbar, R.I.M. (1983). Thermoregulation, habitat quality and the behavioural ecology of gelada baboons. *Journal of Animal Ecology* 52: 357–66.

39. Dunbar, R.I.M. (1993). Coevolution of neocortical size, group size and language in humans. *Behavioral and Brain Sciences* 16 : 681–735.

40. Enquist, M., and Leimar, O. (1993). The evolution of cooperation in mobile organisms. *Animal Behaviour* 45: 747–57.

41. Kniffin, K., and Wilson, D. (2005). Utilities of gossip across organizational levels. *Human Nature* 16 (Autumn): 278–92.

42. Emler, N. (1994). Gossip, reputation and adaptation. In Goodman, R.F., and Ben-Ze'ev, A. (eds.), *Good Gossip* (pp.117–38). Lawrence: University of Kansas Press.

43. Taylor, G. (1994). Gossip as moral talk. In Goodman, R.F., and Ben-Ze'ev, A. (eds.), *Good Gossip* (pp. 34–46). Lawrence: University of Kansas Press.

44. Ayim, M. (1994). Knowledge through the grapevine: Gossip as inquiry. In Goodman, R.F., and Ben-Ze'ev, A. (eds.), *Good Gossip* (pp. 85–99). Lawrence: University of Kansas Press.

45. Schoeman, F. (1994). Gossip and privacy. In Goodman, R.F., and Ben-Ze'ev, A. (eds.), *Good Gossip* (pp. 72–84). Lawrence: University of Kansas Press.

46. Jaeger, M.E., Skleder, A., Rind, B., and Rosnow, R.L. (1994). Gossip, gossipers and gossipees. In Goodman, R.F., and Ben-Ze'ev, A. (eds.), *Good Gossip* (pp. 154–68). Lawrence: University of Kansas Press.

47. Haidt, J. (2006). *The Happiness Hypothesis.* New York: Basic Books.

48. Dunbar, R.I.M. (1996). *Grooming, Gossip and the Evolution of Language.* Cambridge, MA: Harvard University Press.

49. Brown, D.E. (1991). *Human Universals.* New York: McGraw-Hill.

50. Cosmides, L. (2001). *El Mercurio,* October 28.

51. Cosmides, L., and Tooby, J. (2004). Social exchange: The evolutionary design of a neurocognitive system. In Gazzaniga, M.S. (ed.), *Cognitive Neurosciences,* vol. 3 (pp. 1295–1308). Cambridge, MA: MIT Press.

52. Stone, V.E., Cosmides, L., Tooby, J., Kroll, N., and Knight, R.T. (2002). Selective impairment of reasoning about social exchange in a patient with bilateral limbic system damage. *Proceedings of the National Academy of Sciences* 99: 11531–36.

53. Brosnan, S.F., and de Waal, F.B.M. (2003). Monkeys reject unequal pay. *Nature* 425: 297–99.

54. Hauser, M.D. (2000). *Wild Minds: What Animals Really Think.* New York: Henry Holt.

55. Chiappe, D. (2004). Cheaters are looked at longer and remembered better than cooperators in social exchange situations. *Evolutionary Psychology* 2: 108–20.

56. Barclay, P. (2006). Reputational benefits for altruistic behavior. *Evolution and Human Behavior* 27: 325–44.

57. Ristau, C. (1991). Aspects of the cognitive ethology of an injury-feigning bird, the piping plover. In Ristau, C.A. (ed.), *Cognitive Ethology: The Minds of Other Animals.* Hillsdale, NJ: Lawrence Erlbaum.

58. Hare, B., Call, J., and Tomasello, M. (2006). Chimpanzees deceive a human by hiding. *Cognition* 101: 495–514.

59. Dangerfield, R., in *Caddyshack,* Orion Pictures, 1980.

60. Tyler, J.M., and Feldman, R.S. (2004). Truth, lies, and self-presentation: How gender and anticipated future interaction relate to deceptive behavior. *Journal of Applied Social Psychology* 34: 2602–15.

61. Gilovich, T. (1991). *How We Know What Isn't So.* New York: Macmillan.

62. Morton, J., and Johnson, M. (1991). CONSPEC and CONLEARN: A two-process theory of infant face recognition. *Psychology Reviews* 98: 164–81.

63. Nelson, C.A. (1987). The recognition of facial expressions in the first two years of life: Mechanisms and development. *Child Development* 58: 899–909.

64. Parr, L.A., Winslow, J.T., Hopkins, W.D., and de Waal, F.B.M. (2000). Recognizing facial cues: Individual recognition in chimpanzees (*Pan troglodytes*) and rhesus monkeys (*Macaca mulatta*). *Journal of Comparative Psychology* 114: 47–60.

65. Burrows, A.M., Waller, B.M., Parr, L.A., and Bonar, C.J. (2006). Muscles of facial expression in the chimpanzee (*Pan troglodytes*): Descriptive, ecological and phylogenetic contexts. *Journal of Anatomy* 208: 153–67.

66. Parr, L.A. (2001). Cognitive and physiological markers of emotional awareness in chimpanzees, *Pan troglodytes. Animal Cognition* 4: 223–29.

67. For a review, see: Ekman, P. (1999) Facial expressions. In Dalgleish, T., and Power, T. (eds.), *The Handbook of Cognition and Emotion* (pp. 301–20). Sussex, UK: Wiley.

68. Ekman, P. (2002). *Telling Lies: Clues to Deceit in the Marketplace, Marriage, and Politics,* 3rd ed. New York: W.W. Norton.

69. Ekman, P., Friesen, W.V., and O'Sullivan, M. (1988). Smiles when lying. *Journal of Personality and Social Psychology* 54: 414–20.

70. Ekman, P., Friesen, W.V., and Scherer, K. (1976). Body movement and voice pitch in deceptive interaction. *Semiotica* 16: 23–27.

71. Ekman, P. (2004). Face to face: The science of reading faces. *Conversations with History* (January 14). http://globetrotter.berkeley.edu/conversations/e.html.

72. De Becker, G. (1997). *The Gift of Fear.* New York: Dell.

73. Batson, C.D., Thompson, E.R., Seuferling, G., Whitney, H., and Strongman, J.A. (1999). Moral hypocrisy: Appearing moral to oneself without being so. *Journal of Personality and Social Psychology* 77: 525–37.

74. Batson, C.D., Thompson, E.R., and Chen, H. (2002). Moral hypocrisy: Addressing some alternatives. *Journal of Personality and Social Psychology* 83: 330–39.

75. Miller, G. (2000). *The Mating Mind: How Sexual Choice Shaped the Evolution of Human Nature.* New York: Doubleday.

76. Burling, R. (1986). The selective advantage of complex language. *Ethology and Sociobiology* 7: 1–16.

77. Smith, P.K. (1982). Does play matter? Functional and evolutionary aspects of animal and human play. *Behavioral Brain Science* 5: 139–84.

78. Byers, J.A., and Walker, C. (1995). Refining the motor training hypothesis for the evolution of play. *American Naturalist* 146: 25–40.

79. Dolhinow, P. (1999). Play: A critical process in the developmental system. In Dolhinow, P., and Fuentes, A. (eds.), *The Non-Human Primates* (pp. 231–36). Mountain View, CA: Mayfield Publishing.

80. Pellis, S.M., and Iwaniuk, A.N. (1999). The problem of adult play-fighting: A comparative analysis of play and courtship in primates. *Ethology* 105: 783–806.

81. Pellis, S.M., and Iwaniuk, A.N. (2000). Adult-adult play in primates: Comparative analyses of its origin, distribution and evolution. *Ethology* 106: 1083–1104.

82. Špinka, M., Newberry, R.C., and Bekoff, M. (2001). Mammalian play: Training for the unexpected. *Quarterly Review of Biology* 76: 141–67.

83. Palagi, E., Cordoni, G., and Borgognini Tarli, S.M. (2004). Immediate and delayed benefits of play behaviour: New evidence from chimpanzees (*Pan troglodytes*). *Ethology* 110: 949–62.

84. Keverne, E.B., Martensz, N.D., and Tuite, B. (1989). Beta-endorphin concentrations in cerebrospinal fluid of monkeys are influenced by grooming relationships. *Psychoneuroendocrinology* 14: 155–61.

85. Henzi, S.P., and Barrett, L. (1999). The value of grooming to female primates. *Primates* 40: 47–59.

Chapter 4: THE MORAL COMPASS WITHIN

1. Haidt, J. (2001). The emotional dog and its rational tail: A social intuitionist approach to moral judgment. *Psychological Review* 108: 814–34.

2. Westermarck, E.A. (1891). *The History of Human Marriage*. New York: Macmillan.

3. Shepher, J. (1983). *Incest: A Biosocial View*. Orlando, FL: Academic Press.

4. Wolf, A.P. (1966). Childhood association and sexual attraction: A further test of the Westermarck hypothesis. *American Anthropologist* 70: 864–74.

5. Lieberman, D., Tooby, J., and Cosmides, L. (2002). Does morality have a biological basis? An empirical test of the factors governing moral sentiments relating to incest. *Proceedings of the Royal Society of London, Series B: Biological Sciences* 270: 819–26.

6. Nunez, M., and Harris, P. (1998). Psychological and deontic concepts: Separate domains or intimate connection? *Mind and Language* 13: 153–70.

7. Call, J., and Tomasello, M. (1998). Distinguishing intentional from accidental actions in orangutans (*Pongo pygmaeus*), chimpanzees (*Pan troglodytes*), and human children (*Homo sapiens*). *Journal of Comparative Psychology* 112: 192–206.

8. Fiddick, L. (2004). Domains of deontic reasoning: Resolving the discrepancy between the cognitive and moral reasoning literature. *Quarterly Journal of Experimental Psychology* 5A: 447–74.

9. *Free Soil Union*. Ludlow, VT, September 14, 1848.

10. Macmillan, M., www.deakin.edu.au/hmnbs/psychology/gagepage/Pgstory.php.

11. Damasio, A.J. (1994). *Descartes' Error: Emotion, Reason, and the Human Brain*. New York: Avon Books.

12. Bargh, J.A., Chaiken, S., Raymond, P., and Hymes, C. (1996). The automatic evaluation effect: Unconditionally automatic activation with a pronunciation task. *Journal of Experimental Social Psychology* 32: 185–210.

13. Bargh, J.A., and Chartrand, T.L. (1999). The unbearable automaticity of being. *American Psychologist* 54: 462–79.

14. Haselton, M.G., and Buss, D.M. (2000). Error management theory: A new perspective on biases in cross-sex mind reading. *Journal of Personality and Social Psychology* 78: 81–91.

15. Hansen, C.H., and Hansen, R.D. (1988). Finding the face in the crowd: An anger superiority effect. *Journal of Personality and Social Psychology* 54: 917–24.

16. Rozin, P., and Royzman, E.B. (2001). Negativity bias, negativity dominance, and contagion. *Personality and Social Psychology Review* 5: 296–320.

17. Cacioppo, J.T., Gardner, W.L., and Berntson, G.G. (1999). The affect system has parallel and integrative processing components: Form follows function. *Journal of Personality and Social Psychology* 76: 839–55.

18. Chartrand, T.L, and Bargh, J.A. (1999). The chameleon effect: The perception-behavior link and social interaction. *Journal of Personality and Social Psychology* 76: 893–910.

19. Ambady, M., and Rosenthal, R. (1992). Thin slices of expressive behavior as predictors of interpersonal consequences: A meta-analysis. *Psychological Bulletin* 111: 256–74.

20. Albright, L., Kenny, D.A., and Malloy, T.E. (1988). Consensus in personality judgments at zero acquaintance. *Journal of Personality and Social Psychology* 55: 387–95.

21. Chailen, S. (1980). Heuristic versus systematic information processing and the use of source versus message cures in persuasion. *Journal of Personality and Social Psychology* 39: 752–66.

22. Cacioppo, J.T., Priester, J.R., and Berntson, G.G. (1993). Rudimentary determinants of attitudes, II: Arm flexion and extension have differential effects on attitudes. *Journal of Personality and Social Psychology* 65: 5–17.

23. Chen, M., and Bargh, J.A. (1999). Nonconscious approach and avoidance: Behavioral consequences of the automatic evaluation effect. *Personality and Social Psychology Bulletin* 25: 215–24.

24. Thomson, J.J. (1986). *Rights, Restitution, and Risk: Essays in Moral Theory.* Cambridge, MA: Harvard University Press.

25. Greene, J., et al. (2001). An fMRI investigation of emotional engagement in moral judgment. *Science* 293: 2105–8.

26. Hauser, M. (2006). *Moral Minds.* New York: HarperCollins.

27. Borg, J.S., Hynes, C., Horn, J.V., Grafton, S., and Sinnott-Armstrong, W. (2006). Consequences, action and intention as factors in moral judgments: An fMRI investigation. *Journal of Cognitive Neuroscience* 18: 803–17.

28. Amati, D., and Shallice, T. (2007). On the emergence of modern humans. *Cognition* 103: 358–85.

29. Haidt, J., and Joseph, C. (2004). Intuitive ethics: How innately prepared intuitions generate culturally variable virtues. *Daedalus* 138 (Autumn): 55–66.

30. Haidt, J., and Bjorklund, F. (in press). Social intuitionists answer six questions about moral psychology. In Sinnott-Armstrong, W. (ed.), *Moral Psychology.* Cambridge, MA: MIT Press.

31. Shweder, R.A., Much, N.C., Mahapatra, M., and Park, L. (1997). The "big three" of morality (autonomy, community, and divinity), and the "big three" explanations of suffering. In Brandt, A., and Rozin, P. (eds.), *Morality and Health* (pp. 119–69). New York: Routledge.

32. Haidt, J. (2003). The moral emotions. In Davidson, R.J., Scherer, K.R., and Goldsmith, H.H. (eds.), *Handbook of Affective Sciences* (pp. 852–70). Oxford: Oxford University Press.

33. Frank, R.H. (1987). If Homo economicus could choose his own utility function, would he want one with a conscience? *American Economic Review* 77: 593–604.

34. Kunz, P.R., and Woolcott, M. (1976). Season's greetings: From my status to yours. *Social Science Research* 5: 269–78.

35. Hoffman, E., McCabe, K., Shachat, J., and Smith, V. (1994). Preferences, property rights and anonymity in bargaining games. *Games and Economic Behavior* 7: 346–80.

36. Hoffman, E., McCabe, K., and Smith, V. (1996). Social distance and other-regarding behavior in dictator games. *American Economic Review* 86: 653–60.

37. McCabe, K., Rassenti, S., and Smith, V. (1996). Game theory and reciprocity in some extensive form experimental games. *Proceedings of the National Academy of Sciences* 93: 13421–28.

38. Henrich, J., et al. (2005). "Economic man" in cross-cultural perspective: Behavioral experiments in 15 small-scale societies. *Behavioral and Brain Sciences* 28: 795–815.

39. Kurzban, R., Tooby, J., and Cosmides, L. (2001). Can race be erased? Coalitional computation and social categorization. *Proceedings of the National Academy of Sciences* 98:15387–92.

40. Ridley, M. (1993). *The Red Queen*. New York: Macmillan.

41. Haidt, J., Rozin, P., McCauley, C., and Imada, S. (1997). Body, psyche, and culture: The relationship of disgust to morality. *Psychology and Developing Societies* 9: 107–31.

42. Reported in: Haidt, J., and Bjorklund, F. (2008). Social intuitionists answer six questions about moral psychology. In Sinnott-Armstrong, W. (ed.), *Moral Psychology*, vol. 3 (in press).

43. Balzac, H. de (1898). *Modeste Mignon*. Trans. Bell, C. Philadelphia: Gebbie Publishing.

44. Perkins, D.N., Farady, M., and Bushey, B. (1991). Everyday reasoning and the roots of intelligence. In Voss, J.F., Perkins, D.N., and Segal, J.W. (eds.), *Informal Reasoning and Education*. Hillsdale, NJ: Lawrence Erlbaum.

45. Kuhn, D. (1991). *The Skills of Argument*. New York: Cambridge University Press.

46. Kuhn, D. (2001). How do people know? *Psychological Science* 12: 1–8.

47. Kuhn, D., and Felton, M. (2000). Developing appreciation of the relevance of evidence to argument. Paper presented at the Winter Conference on Discourse, Text, and Cognition, Jackson Hole, WY.

48. Wright, R. (1994). *The Moral Animal*. New York: Random House/Pantheon.

49. Asch, S. (1956). Studies of independence and conformity: A minority of one against a unanimous majority. *Psychological Monographs* 70: 1–70.

50. Milgram, S. (1963). Behavioral study of obedience. *Journal of Abnormal and Social Psychology* 67: 371–78.

51. Milgram, S. (1974). *Obedience to Authority: An Experimental View*. New York: Harper & Row.

52. Baumeister, R.F., and Newman, L.S. (1994). Self-regulation of cognitive inference and decision processes. *Personality and Social Psychology Bulletin* 20: 3–19.

53. Hirschi, T., and Hindelang, M.F. (1977). Intelligence and delinquency: A revisionist view. *American Sociological Review* 42: 571–87.

54. Blasi, A. (1980). Bridging moral cognition and moral action: A critical review of the literature. *Psychological Bulletin* 88: 1–45.

55. Shoda, Y., Mischel, W., and Peake, P.K. (1990). Predicting adolescent cognitive and self-regulatory behavior competencies from preschool delay of gratification: Identifying diagnostic conditions. *Developmental Psychology* 26: 978–86.

56. Metcalfe, J., and Mischel, W. (1999). A hot/cool-system analysis of delay of gratification: Dynamics of willpower. *Psychological Review* 106: 3–19.

57. Harpur, T.J., and Hare, R.D. (1994). The assessment of psychopathy as a function of age. *Journal of Abnormal Psychology* 103: 604–9.

58. Raine, A. (1998). Antisocial behavior and psychophysiology: A biosocial perspective and a prefrontal dysfunction hypothesis. In Stroff, D., Brieling, J., and Maser, J. (eds.), *Handbook of Antisocial Behavior* (pp. 289–304). New York: Wiley.

59. Blair, R.J. (1995). A cognitive developmental approach to morality: Investigating the psychopath. *Cognition* 57: 1–29.

60. Hare, R.D., and Quinn, M.J. (1971). Psychopathy and autonomic conditioning. *Journal of Abnormal Psychology* 77: 223–35.

61. Blair, R.J., Jones, L., Clark, F., and Smith, M. (1997). The psychopathic individual: A lack of responsiveness to distress cues? *Psychophysiology* 342: 192–98.

62. Hart, D., and Fegley, S. (1995). Prosocial behavior and caring in adolescence: Relations to self-understanding and social judgment. *Child Development* 66: 1346–59.

63. Colby, A., and Damon, W. (1992). *Some Do Care: Contemporary Lives of Moral Commitment.* New York: Free Press.

64. Matsuba, K.M., and Walker, L.J. (2004). Extraordinary moral commitment: Young adults involved in social organizations. *Journal of Personality* 72: 413–36.

65. Oliner, S., and Oliner, P.M. (1988). *The Altruistic Personality: Rescuers of Jews in Nazi Europe.* New York: Free Press.

66. Boyer, P. (2003). Religious thought and behavior as by-products of brain function. *Trends in Cognitive Sciences* 7: 119–24.

67. Barrett, J.L., and Keil, F.C. (1996). Conceptualizing a nonnatural entity: Anthropomorphism in God concepts. *Cognitive Psychology* 31: 219–47.

68. Boyer, P. (2004). Why is religion natural? *Skeptical Inquirer* 28, no. 2 (March/April).

69. Wilson, D.S. (2007). Why Richard Dawkins is wrong about religion. *eSkeptic* July 4, www.eskeptic.com/eskeptic/07-07-04.html.

70. Ridley, M. (1996). *The Origins of Virtue.* New York: Penguin.

71. Ostrom, E., Walker, J., and Gardner, T. (1992). Covenants without a sword: Self-governance is possible. *American Political Science Review* 886: 404–17.

Chapter 5: I FEEL YOUR PAIN

1. Pegna, A.J., Khateb, A., Lazeyras, F., and Seghier, M.L. (2004). Discriminating emotional faces without primary visual cortices involves the right amygdala. *Nature Neuroscience* 8: 24–25.

2. Goldman, A.I., and Sripada, C.S. (2005). Simulationist models of face-based emotion recognition. *Cognition* 94: 193–213.

3. Gallese, V. (2003). The manifold nature of interpersonal relations: The quest for a common mechanism. *Philosophical Transactions of the Royal Society of London, Series B: Biological Sciences* 358: 517–28.

4. Meltzoff, A.N., and Moore, M.K. (1977). Imitation of facial and manual gestures by human neonates. *Science* 198: 75–78.

5. For a review, see: Meltzoff, A.N., and Moore, M.K. (1997). Explaining facial imitation: A theoretical model. *Early Development and Parenting* 6: 179–92.

6. Meltzoff, A.N., and Moore, M.K. (1983). Newborn infants imitate adult facial gestures. *Child Development* 54: 702–9.

7. Meltzoff, A.N., and Moore, M.K. (1989). Imitation in newborn infants: Exploring the range of gestures imitated and the underlying mechanisms. *Developmental Psychology* 25: 954–62.

8. Meltzoff, A.N., and Decety, J. (2003). What imitation tells us about social cognition: A rapprochement between developmental psychology and cognitive neuroscience. *Philosophical Transactions of the Royal Society of London, Series B: Biological Sciences* 358: 491–500.

9. Legerstee, M. (1991). The role of person and object in eliciting early imitation. *Journal of Experimental Child Psychology* 5: 423–33.

10. For a review, see: Puce, A., and Perrett, D. (2005). Electrophysiology and brain imaging of biological motion. In Cacioppo, J.T., and Berntson, G.G. (eds.), *Social Neuroscience* (pp. 115–29). New York: Psychology Press.

11. Meltzoff, A.N., and Moore, M.K. (1994). Imitation, memory, and the representation of persons. *Infant Behavior and Development* 17: 83–99.

12. Meltzoff, A.N., and Moore, M.K. (1998). Object representation, identity, and the paradox of early permanence: Steps toward a new framework. *Infant Behavior and Development* 21: 210–35.

13. Nadel, J. (2002). Imitation and imitation recognition: Funcional use in preverbal infants and nonverbal children with autism. In Meltzoff, A., and Prinz, W. (eds.), *The Imitative Mind*. Cambridge: Cambridge University Press.

14. de Waal, F. (2002). *The Ape and the Sushi Master: Cultural Reflections of a Primatologist*. New York: Basic Books.

15. Visalberghi, E., and Fragaszy, D.M. (1990). Do monkeys ape? In Parker, S.T., and Gibson, K.R. (eds.), *Language and Intelligence in Monkeys and Apes* (pp. 247–73). New York: Cambridge University Press.

16. Whiten, A., and Ham, R. (1992). On the nature and evolution of imitation in the animal kingdom: Reappraisal of a century of research. In Slater, P.J.B., Rosenblatt, J.S., Beer, C., and Milinski, M. (eds.), *Advances in the Study of Behavior* (pp. 239–83). New York: Academic Press.

17. Kumashiro, M., Ishibashi, H., Uchiyama, Y., Itakura, S., Murata, A., and Iriki, A. (2003). Natural imitation induced by joint attention in Japanese monkeys. *International Journal of Psychophysiology* 50: 81–99.

18. Zentall, T. (2006). Imitation: Definitions, evidence, and mechanisms. *Animal Cognition* 9: 335–53.

19. See review in: Bauer, B.B., and Harley, H. (2001). The mimetic dolphin. *Behavior and Brain Science* 24: 326–27. Commentary in: Rendell, L., and Whitehead, H. (2001). Culture in whales and dolphins. *Behavioral and Brain Sciences* 24: 309–82.

20. Giles, H., and Powesland, P.F. (1975). *Speech Style and Social Evaluation.* London: Academic Press.

21. For a review, see: Chartrand, T., Maddux, W., and Lakin, J. (2005). Beyond the perception-behavior link: The ubiquitous utility and motivational moderators of nonconscious mimicry. In Hassin, T., Uleman, J.J., and Bargh, J.A. (eds.), *Unintended Thoughts,* vol. 2: *The New Unconscious.* New York: Oxford University Press.

22. Dimberg, U., Thunberg, M., and Elmehed, K. (2000). Unconscious facial reactions to emotional facial expressions. *Psychological Science* 11: 86–89.

23. Bavelas, J.B., Black, A., Chovil, N., Lemery, C., and Mullett, J. (1988). Form and function in motor mimicry: Topographic evidence that the primary function is communication. *Human Communication Research* 14: 275–300.

24. Cappella, J.M., and Panalp, S. (1981). Talk and silence sequences in informal conversations, III: Interspeaker influence. *Human Communication Research* 7: 117–32.

25. Van Baaren, R.B., Holland, R.W., Kawakami, K., and van Knippenberg, A. (2004). Mimicry and prosocial behavior. *Psychological Science* 15: 71–74.

26. Decety, J., and Jackson, P.L. (2004). The functional architecture of human empathy. *Behavioral and Cognitive Neuroscience Reviews* 3: 71–100.

27. Hatfield, E., Cacioppo, J.T., and Rapson, R.L. (1993). Emotional contagion. *Current Directions in Psychological Sciences* 2: 96–99.

28. Gazzaniga, M.S., and Smylie, C.S. (1990). Hemispheric mechanisms controlling voluntary and spontaneous facial expressions. *Journal of Cognitive Neuroscience* 2: 239–45.

29. Damasio, A. (2003). *Looking for Spinoza.* New York: Harcourt.

30. Dondi, M., Simion, F., and Caltran, G. (1999). Can newborns discriminate between their own cry and the cry of another newborn infant? *Developmental Psychology* 35: 418–26.

31. Martin, G.B., and Clark, R.D. (1982). Distress crying in neonates: Species and peer specificity. *Developmental Psychology* 18: 3–9.

32. Neumann, R., and Strack, F. (2000). "Mood contagion": The automatic transfer of mood between persons. *Journal of Personality and Social Psychology* 79: 211–23.

33. Field, T. (1984). Early interactions between infants and their postpartum depressed mothers. *Infant Behavior and Development* 7: 517–22.

34. Field, T. (1985). Attachment as psychobiological attunement: Being on the same wavelength. In Reite, M., and Field, T. (eds.), *Psychobiology of Attachment and Separation* (pp. 415–54). New York: Academic Press.

35. Field, T., Healy, B., Goldstein, S., Perry, S., Bendell, D., Schanberg, S., Zimmerman, E.A., and Kuhn, C. (1988). Infants of depressed mothers show "depressed" behavior even with nondepressed adults. *Child Development* 59: 1569–79.

36. Cohn, J.F., Matias, R., Tronick, E.Z., Connell, D., and Lyons-Ruth, K. (1986). Face-to-face interactions of depressed mothers and their infants. In Tronick, E.Z., and Field, T. (eds.), *Maternal Depression and Infant Disturbance* (pp. 31–45). San Francisco: Jossey-Bass.

37. Penfield, W., and Faulk, M.E. (1955). The insula: Further observations on its function. *Brain* 78: 445–70.

38. Krolak-Salmon, P., Henaff, M.A., Isnard, J., Tallon-Baudry, C., Guenot, M., Vighetto, A., Bertrand, O., and Mauguiere, F. (2003). An attention modulated response to disgust in human ventral anterior insula. *Annals of Neurology* 53: 446–53.

39. Wicker, B., Keysers, C., Plailly, J., Royet, J.P., Gallese, V., and Rizzolatti , G. (2003). Both of us disgusted in *my* insula: The common neural basis of seeing and feeling disgust. *Neuron* 400: 655–64.

40. Singer, T., Seymour, B., O'Doherty, J., Kaube, H., Dolan, R.J., and Frithe, C.D. (2004). Empathy for pain involves the affective but no sensory components of pain. *Science* 303: 1157–62.

41. Jackson, P.L., Meltzoff, A.N., and Decety, J. (2005). How do we perceive the pain of others? A window into the neural processes involved in empathy. *Neuroimage* 24: 771–79.

42. Hutchison, W.D., Davis, K.D., Lozano, A.M., Tasker, R.R., and Dostrovsky, J.O. (1999). Pain-related neurons in the human cingulate cortex. *Nature Neuroscience* 2: 403–5.

43. Ekman, P., Levenson, R.W., and Freisen, W.V. (1983). Autonomic nervous system activity distinguishes among emotions. *Science* 221: 1208–10.

44. Ekman, P., and Davidson, R.J. (1993). Voluntary smiling changes regional brain activity. *Psychological Science* 4: 342–45.

45. Levenson, R.W., and Ruef, A.M. (1992). Empathy: A physiological substrate. *Journal of Personality and Social Psychology* 663: 234–46.

46. Critchley, H.D., Wiens, S., Rotshtein, P., Öhman, A., and Dolan, R.J. (2004). Neural systems supporting interoceptive awareness. *Nature Neuroscience* 7: 189–95.

47. Craig, A.D. (2004). Human feelings: Why are some more aware than others? *Trends in Cognitive Sciences* 8: 239–41.

48. Calder, A.J., Keane, J., Manes, F., Antoun, N., and Young, A. (2000). Impaired recognition and experience of disgust following brain injury. *Nature Neuroscience* 3: 1077–78.

49. Adolphs, R., Tranel, D., and Damasio, A.R. (2003). Dissociable neural systems for recognizing emotions. *Brain and Cognition* 52: 61–69.

50. Adolphs, R., Tranel, D., Damasio, H., and Damasio, A. (1994). Impaired recognition of emotion in facial expressions following bilateral damage to the human amygdala. *Nature* 372: 669–72.

51. Broks, P., et al. (1998). Face processing impairments after encephalitis: Amygdala damage and recognition of fear. *Neuropsychologia* 36: 59–70.

52. Adolphs, R., Damasio, H., Tranel, D., and Damasio, A.R. (1996). Cortical

systems for the recognition of emotion in facial expressions. *Journal of Neuroscience* 16: 7678–87.

53. Adolphs, R., et al. (1999). Recognition of facial emotion in nine individuals with bilateral amygdala damage. *Neuropsychologia* 37: 1111–17.

54. Sprengelmeyer, R., et al. (1999). Knowing no fear. *Proceedings of the Royal Society of London, Series B: Biological Sciences* 266: 2451–56.

55. Lawrence, A.D., Calder, A.J., McGowan, S.W., and Grasby, P.M. (2002). Selective disruption of the recognition of facial expressions of anger. *NeuroReport* 13: 881–84.

56. Meunier, M., Bachevalier, J., Murray, E.A., Málková, L., Mishkin, M. (1999). Effects of aspiration versus neurotoxic lesions of the amygdala on emotional responses in monkeys. *European Journal of Neuroscience* 11: 4403–18.

57. Church, R.M. (1959). Emotional reactions of rats to the pain of others. *Journal of Comparative and Physiologcal Psychology* 52: 132–34.

58. Anderson, J.R., Myowa-Yamakoshi, M., and Matsuzawa, T. (2004). Contagious yawning in chimpanzees. *Proceedings of the Royal Society of London, Series B: Biological Sciences* 27: 468–70.

59. Platek, S.M., Critton, S.R., Myers, T.E., and Gallup, G.G., Jr. (2003). Contagious yawning: The role of self-awareness and mental state attribution. *Cognitive Brain Research* 17:223–27.

60. Platek, S., Mohamed, F., and Gallup, G.G., Jr. (2005). Contagious yawning and the brain. *Cognitive Brain Research* 23: 448–53.

61. Kohler, E., Keysers, C., Umilta, M.A., Fogassi, L, Gallese, B., and Rizzolatti, G. (2002). Hearing sounds, understanding actions: Action representation in mirror neurons. *Science* 297: 846–48.

62. Iacoboni, M., Woods, R.P., Brass, M., Bekkering, H., Mazziotta, J.C., and Rizzolatti, G. (1999). Cortical mechanisms of human imitation. *Science* 286: 2526–28.

63. Buccino, G., Binkofski, F., Fink, G.R., Fadiga, L., Fogassi, L., Gallese, V., Seitz, R.J., Zilles, K., Rizzolatti, G., and Freund, H.J. (2005). Action observation activates premotor and parietal areas in a somatotopic manner: An fMRI study. In Cacioppo, J.T., and Berntson, G.G. (eds.), *Social Neuroscience*. New York: Psychology Press.

64. Fadiga, L., Fogassi, L., Pavesi, G., and Rizzolatti, G. (1995). Motor facilitation during action observation: A magnetic stimulation study. *Journal of Neurophysiology* 73: 2608–11.

65. Rizzolatti, G., and Craighero, L. (2004). The mirror neuron system. *Annual Review of Neuroscience* 27: 169–92.

66. Buccino, G., Vogt, S., Ritzl, A., Fink, G.R., Zilles, K., Freund, H.J., and Rizzolatti, G. (2004). Neural circuits underlying imitation of hand action: An event-related fMRI study. *Neuron* 42: 323–34.

67. Iacoboni, M., Molnar-Szakacs, I., Gallese, V., Buccino, G., Mazziotta, J.C., and Rizzolatti, G. (2005). Grasping the intentions of others with one's own mirror neuron system. *Public Library of Science: Biology* 3: 1–7.

68. Gallese, V., Keysers, C., and Rizzolatti, G. (2004). A unifying view of the basis of social cognition. *Trends in Cognitive Sciences* 8: 396–403.

69. Oberman, L.M., Hubbard, E.M., McCleery, J.P., Altschuler, E.L., Rama-chandran, V.S., and Pineda, J.A. (2005). EEG evidence for mirror neuron dysfunction in autism spectrum disorders. *Cognitive Brain Research* 24: 190–98.

70. Dapretto, M., Davies, M.S., Pfeifer, J.H., Scott, A.A., Sigman, M., Bookheimer, S.Y., and Iacoboni, M. (2006). Understanding emotions in others: Mirror neuron dysfunction in children with autism spectrum disorder. *Nature Neuroscience* 9: 28–30.

71. Eastwood, C. (1973), from the movie *Magnum Force*. Burbank, CA: Malpaso Productions.

72. Calder, A.J., Keane, J., Cole, J., Campbell, R., and Young, A.W. (2000). Facial expression recognition by people with Mobius syndrome. *Cognitive Neuropsychology* 17: 73–87.

73. Danziger, N., Prkachin, K.M., and Willer, J.C. (2006). Is pain the price of empathy? The perception of others' pain in patients with congenital insensitivity to pain. *Brain* 129: 2494–2507.

74. Hess, U., and Blairy, S. (2001). Facial mimicry and emotional contagion to dynamic facial expressions and their influence on decoding accuracy. *International Journal of Psychophysiology* 40: 129–41.

75. Lanzetta, J.T., and Englis, B.G. (1989). Expectations of cooperation and competition and their effects on observers' vicarious emotional responses. *Journal of Personality and Social Psychology* 33: 354–70.

76. Bourgeois, P., and Hess, U. (1999). Emotional reactions to political leaders' facial displays: A replication. *Psychophysiology* 36: S36.

77. Balzac, H. de (1898). *Modeste Mignon*. Philadelphia: Gebbie Publishing.

78. Ochsner, K.N., Bunge, S.A., Gross, J.J., and Gabrieli, J.D.E. (2002). Rethinking feelings: An fMRI study of the cognitive regulation of emotion. *Journal of Cognitive Neuroscience* 14: 1215–29.

79. Canli, T., Desmond, J.E., Zhao, Z., Glover, G., and Gavrielli, J.D.E. (1998). Hemispheric asymmetry for emotional stimuli detected with fMRI. *NeuroReport* 9: 3233–39.

80. Gross, J.J. (2002). Emotion regulation: Affective, cognitive, and social consequences. *Psychophysiology* 39: 281–91.

81. Uchno, B.N., Cacioppo, J.T., and Kiecolt-Glaser, J.K. (1996). The relationship between social support and physiological processes: A review with emphasis on underlying mechanisms and implications for health. *Psychological Bulletin* 119: 488–531.

82. Butler, E.A., Egloff, B., Wilhelm, F.H., Smith, N.C., Erickson, E.A., and Gross, J.J. (2003). The social consequences of expressive suppression. *Emotion* 3: 48–67.

83. For a review, see: Niedenthal, P., Barsalou, L., Ric, F., and Krauth-Graub, S. (2005). Embodiment in the acquisition and use of emotion knowledge. In Barret, L., Niedenthal, P., and Winkielman, P. (eds.), *Emotion and Consciousness*. New York: Guilford Press.

84. Osaka, N., Osaka, M., Morishita, M., Kondo, H., and Fukuyama, H. (2004). A word expressing affective pain activates the anterior cingulate cortex in the human brain: An fMRI study. *Behavioural Brain Research* 153: 123–27.

85. Meister, I.G., Krings, T., Foltys, H., Müller, M., Töpper, R., and Thron, A. (2004). Playing piano in the mind—an fMRI study on music imagery and performance in pianists. *Cognitive Brain Research* 19: 219–28.

86. Phelps, E., O'Conner, K., Gatenby, J., Grillon, C., Gore, J., and Davis, M. (2001). Activation of the left amygdala to a cognitive representation of fear. *Nature Neuroscience* 4: 437–41.

87. Repacholi, B.M., and Gopnik, A. (1997). Early reasoning about desires: Evidence from 14- and 18-month-olds. *Developmental Psychology* 33: 12–21.

88. Keysar, B., Lin, S., and Barr, D.J. (2003). Limits on theory of mind in adults. *Cognition* 89: 25–41.

89. Nickerson, R.S. (1999). How we know and sometimes misjudge what others know: Imputing one's own knowledge to others. *Psychological Bulletin* 126: 737–59.

90. Vorauer, J.D., and Ross, M. (1999). Self-awareness and feeling transparent: Failing to suppress one's self. *Journal of Experimental Social Psychology* 35: 414–40.

91. Ruby, P., and Decety, J. (2001). Effect of subjective perspective taking during simulation of action: A PET investigation of agency. *Nature Neuroscience* 4: 546–50.

92. Ruby, P., and Decety, J. (2003). What you believe versus what you think they believe: A neuroimaging study of conceptual perspective taking. *European Journal of Neuroscience* 17: 2475–80.

93. Ruby, P., and Decety, J. (2004). How would you feel versus how do you think she would feel? A neuroimaging study of perspective taking with social emotions. *Journal of Cognitive Neuroscience* 16: 988–99.

94. Blanke, O., Ortigue, S., Landis, T., and Seeck, M. (2002). Neuropsychology: Stimulating illusory own-body perceptions. *Nature* 419: 269–70.

95. Blanke, O., and Arzy, S. (2005). The out-of-body experience: Disturbed self-processing at the temporo-parietal junction. *Neuroscientist* 11: 16–24.

96. Saxe, R., and Kanwisher, N. (2005). People thinking about thinking people: The role of the temporo-parietal junction in "theory of mind." In Cacioppo, J.T., and Berntson, G.G. (eds.), *Social Neuroscience*. New York: Psychology Press.

97. Price, B.H., Daffner, K.R., Stowe, R.M., and Mesulam, M.M. (1990). The compartmental learning disabilities of early frontal lobe damage. *Brain* 113: 1383–93.

98. Anderson, S.W., Bechara, A., Damasio, H., Tranel, D., and Damasio, A.R. (1999). Impairment of social and moral behavior related to early damage in human prefrontal cortex. *Nature Neuroscience* 2: 1032–37.

99. Jackson, P.L., Brunet, E., Meltzoff, A.N., and Decety, J. (2006). Empathy examined through the neural mechanisms involved in imagining how I feel versus how you feel pain. *Neuropsychologia* 44: 752–61.

100. Mitchell, J.P., Macrae, C.N., and Banaji, M.R. (2006). Dissociable medial prefrontal contributions to judgments of similar and dissimilar others. *Neuron* 50: 655–63.

101. Demoulin, S., Torres, R.R., Perez, A.R., Vaes, J., Paladino, M.P., Gaunt, R., Pozo, B.C., and Leyens, J.P. (2004). Emotional prejudice can lead to infra-humanisation. In Stroebe, W., and Hewstone, M. (eds.), *European Review of Social Psychology* (pp. 259–96). Hove, UK: Psychology Press.

102. Ames, D.R. (2004). Inside the mind reader's tool kit: Projection and stereotyping in mental state inference. *Journal of Personality and Social Psychology* 87: 340–53.

103. Hare, B., Call, J., and Tomasello, M. (2006). Chimpanzees deceive a human competitor by hiding. *Cognition* 101: 495–514.

104. Hauser, M.D. (1990). Do chimpanzee copulatory calls incite male–male competition? *Animal Behaviour* 39: 596–97.

105. Watts, D., and Mitani, J. (2001). Boundary patrols and intergroup encounters in wild chimpanzees. *Behaviour* 138: 299–327.

106. Wilson, M., Hauser, M.D., and Wrangham, R. (2001). Does participation in intergroup conflict depend on numerical assessment, range location, or rank for wild chimpanzees? *Animal Behaviour* 61: 1203–16.

107. Parr, L.A. (2001). Cognitive and physiological markers of emotional awareness in chimpanzees, *Pan troglodytes*. *Animal Cognition* 4: 223–29.

108. Flombaum, J.I., and Santos, L.R. (2005). Rhesus monkeys attribute perceptions to others. *Current Biology* 15: 447–52.

109. Santos, L.R., Flombaum, J.I., and Phillips, W. (2007). The evolution of human mindreading: How nonhuman primates can inform social cognitive neuroscience. In Platek, S.M., Keenan, J.P., and Shackelford, T.K. (eds.), *Cognitive Neuroscience*. Cambridge MA: MIT Press.

110. Miklósi, A., Topál, J., and Csányi, V. (2004). Comparative social cognition: What can dogs teach us? *Animal Behaviour* 67: 995–1004.

111. For a review, see: Hare, B., and Tomasello, M. (2005). Human-like social skills in dogs? *Trends in Cognitive Sciences* 9: 439–44.

112. Belyaev, D. (1979). Destabilizing selection as a factor in domestication. *Journal of Heredity* 70: 301–8.

Chapter 6: WHAT'S UP WITH THE ARTS?

1. Dissanayake, E. (1988). *What Is Art For?* Seattle: University of Washington Press.

2. Pinker, S. (1997). *How the Mind Works*. New York: W.W. Norton.

3. Cela-Conde, C.C.J., Marty, G., Maestu, F., Ortiz, T., Munar, E., Fernandez, A., Roca, M., Rossello, J., and Quesney, F. (2004). Activation of the prefrontal cortex in the human visual aesthetic perception. *Proceedings of the National Academy of Sciences* 101: 6321–25.

4. *American Heritage College Dictionary*, 3rd ed. Boston: Houghton Mifflin.

5. Aiken, N.E. (1998). *The Biological Origins of Art*. Westport, CT: Praeger.

6. Kawabata, H., and Zeki, S. (2003). Neural correlates of beauty. *Journal of Neurophysiology* 91: 1699–1705.

7. Lindgaard, G., and Whitfield, T.W. (2004). Integrating aesthetics within an evolutionary and psychological framework. *Theoretical Issues in Ergonomics Science* 5: 73–90.

8. Norman, D.A. (2004). Introduction to this special section on beauty, goodness, and usability. *Human-Computer Interaction* 19: 311–18.

9. Humphrey, N.K. (1973). The illusion of beauty. *Perception* 2: 429–39.

10. Reber, R., Schwarz, N., and Winkielman, P. (2004). Processing fluency and aesthetic pleasure: Is beauty in the perceiver's processing experience? *Personality and Social Psychology Review* 8: 364–82.

11. Her description can be heard at http://cdbaby.com/cd/lyonsgoodall.

12. Morris, D. (1962). *The Biology of Art: A Study of the Picture-Making Behaviour of the Great Apes and Its Relationship to Human Art.* New York: Alfred A. Knopf.

13. BBC News, June 20, 2005.

14. Shick, K.D., and Toth, N. (1993). *Making Silent Stones Speak: Human Evolution and the Dawn of Technology.* New York: Simon & Schuster.

15. Mithen, S. (2004). The evolution of imagination: An archeological perspective. *Substance* 94/95: 28–54.

16. Wynn, T. (1995). Handaxe enigmas. *World Archaeology* 27: 10–24.

17. Mithen, S. (2001). The evolution of imagination: An archaeological perspective. *Substance* 30: 28–54.

18. Miller, G. (2000). *The Mating Mind.* New York: Doubleday.

19. Tooby, J., and Cosmides, L. (2001). Does beauty build adapted minds? Toward an evolutionary theory of aesthetics, fiction and the arts. *Substance* 30: 6–27.

20. Leslie, A. (1987). Pretense and representation: The origins of "theory of mind." *Psychological Review* 94: 412–26.

21. Thorpe, W. (1958). The learning of song patterns by birds, with special reference to the song of the chaffinch, *Fringilla coelebs. Ibis* 100: 535–70.

22. Almli, C.R., and Stanley, F. (1987). Neural insult and critical period concepts. In Bornstein, M.H. (ed.), *Sensitive Periods in Development: Interdisciplinary Perspectives* (pp. 123–43). Hillsdale, NJ: Lawrence Erlbaum.

23. Boyer, P. (in press 2007). Specialised inference engines as precursors of creative imagination? Forthcoming in Roth, I. (ed.), *Imaginative Minds.* London: British Academy.

24. Carroll, J. (2007). The adaptive function of literature. In Petrov, V., Martindale, C., Locher, P., and Petrov, V.M. (eds.), *Evolutionary and Neurocognitive Approaches to Aesthetics, Creativity and the Arts.* Amityville, NY: Baywood Publishing.

25. Haidt, J. (2006). *The Happiness Hypothesis: Finding Modern Truth in Ancient Wisdom.* New York: Basic Books.

26. Tractinsky, N., Cokhavi, A., Kirschenbaum, M. (2004). Using ratings and response latencies to evaluate the consistency of immediate aesthetic perceptions of web pages. *Proceedings of the Third Annual Workshop on HC I Research in MIS.* Washington, DC, December 10–11.

27. Uduehi, J. (1995). A cross cultural assessment of the Maitland-Graves design judgment test using U.S. and Nigerian subjects. *Visual Arts Research* 13: 11–18.

28. Humphrey, D. (1997). Preferences in symmetries and symmetries in drawings: asymmetries between ages and sexes. *Empirical Studies of the Arts* 15: 41–60.

29. Møller, A.P., and Thornhill, R. (1998). Bilateral symmetry and sexual selection: A meta-analysis. *American Naturalist* 15: 174–92.

30. Thornhill, R., and Møller, A.P. (1997). Developmental stability, disease and medicine. *Biological Reviews* 72: 497–548.

31. Perrett, D.I., Burt, D.M., Penton-Voak, I.S., Lee, K.J., Rowland, D.A., and Edwards, R. (1999). Symmetry and human facial attractiveness. *Evolution and Human Behavior* 20: 295–307.

32. Manning, J.T., Koukourakis, K., and Brodie, D.A. (1997). Fluctuating asymmetry, metabolic rate and sexual selection in human males. *Evolution and Human Behavior* 18: 15–21.

33. Thornhill, R., and Gangestad, S.W. (1994). Human fluctuating asymmetry and sexual behavior. *Psychological Science* 5: 297–302.

34. Gangestad, S.W., and Thornhill, R. (1997). The evolutionary psychology of extra-pair sex: The role of fluctuating asymmetry. *Evolution and Human Behavior* 18: 69–88.

35. Scutt, D., Manning, J.T., Whitehouse, G.H., Leinster, S.J., and Massey, C.P. (1997). The relationship between breast asymmetry, breast size and occurrence of breast cancer. *British Journal of Radiology* 70: 1017–21.

36. Manning, J.T., Scutt, D., Whitehouse, G.H., and Leinster, S.J. (1997). Breast asymmetry and phenotypic quality in women. *Evolution and Human Behavior* 18: 223–36.

37. Møller, A.P., Soler, M., and Thornhill, R. (1995). Breast asymmetry, sexual selection, and human reproductive success. *Evolution and Human Behavior* 16: 207–19.

38. Perrett, D.I., Burt, D.M., Penton-Voak, I.S., Lee, K.J., Rowland, D.A., and Edwards, R. (1999). Symmetry and human facial attractiveness. *Evolution and Human Behavior* 20: 295–307.

39. Thornhill, R., and Gangestad, S.W. (1999). The scent of symmetry: A human sex pheromone that signals fitness. *Evolution and Human Behavior* 20: 175–201.

40. Hughes, S.M., Harrison, M.A., and Gallup, G.G., Jr. (2002). The sound of symmetry: Voice as a marker of developmental instability. *Evolution and Human Behavior* 23: 173–78.

41. Cunningham, M.R. (1986). Measuring the physical in physical attractiveness: Quasi-experiments on the sociobiology of female facial beauty. *Journal of Personality and Social Psychology* 50: 923–35.

42. Perrett, D.I., May, K.A., and Yoshikawa, S. (1994). Facial shape and judgements of female attractiveness. *Nature* 368: 239–42.

43. Langlois, J.H., Ritter, J.M., Roggman, L.A., and Vaughn, L.S. (1991). Facial diversity and infant preferences for attractive faces. *Developmental Psychology* 27: 79–84.

44. Lawsmith, M.J., Perrett, D.I., Jones, B.C., Cornwell, R.E., Moore, F.R., Feinberg, D.R., Boothroyd, L.G., et al. (2006). Facial appearance is a cue to oestrogen levels in women. *Proceedings of the Royal Society of London, Series B: Biological Sciences* 273: 1435–40.

45. Moshe, B., and Neta, M. (2006). Humans prefer curved visual objects. *Psychological Science* 17: 645–48.

46. Latto, R. (1995). The brain of the beholder. In Gregory, R., Harris, J., Heard, P., and Rose, D. (eds.), *The Artful Eye* (pp. 66–94). Oxford: Oxford University Press.

47. Jastrow, J. (1892). On the judgment of angles and positions of lines. *American Journal of Psychology* 5: 214–48.

48. Latto, R. (2004). Do we like what we see? In Malcolm, G. (ed.), *Multidisciplinary Approaches to Visual Representations and Interpretations* (pp. 343–56). Amsterdam: Elsevier.

49. Ulrich, R.S. (1986). Human responses to vegetation and landscapes. *Landscape and Urban Planning* 13: 29–44.

50. Ulrich, R.S. (1993). Biophilia, biophobia and natural landscapes. In Kellert, S., and Wilson, E.O. (eds.), *The Biophilia Hypothesis* (pp. 73–137). Washington, DC: Island Press.

51. Ulrich, R.S. (1984). View through window may influence recovery from surgery. *Science* 224: 420–21.

52. Balling, J.D., and Falk, J.H. (1982). Development of visual preference for natural environments. *Environment and Behavior* 14: 5–28.

53. Lohr, V.I., and Pearson-Mims, C.H. (2006). Responses to scenes with spreading, rounded, and conical tree forms. *Environment and Behavior* 38: 667–88.

54. Orians, G.H. (1980). Habitat selection: General theory and applications to human behavior. In Lockard, J.S. (ed.), *The Evolution of Human Social Behavior*. Amsterdam: Elsevier.

55. Taylor, R.P. (1998). Splashdown. *New Scientist* 2144:30–31.

56. Sprott, J. (2004). Can a monkey with a computer create art? *Nonlinear Dynamics, Psychology, and Life Sciences* 8: 103–14.

57. Aks, D.J., and Sprott, J.C. (1996). Quantifying aesthetic preference for chaotic patterns. *Empirical Studies of the Arts* 14: 1–19.

58. Wise, J.A., and Rosenberg, E. (1986). The effects of interior treatments on performance stress in three types of mental tasks. *Technical Report Space*. Sunnyvale, CA: Human Factors Office, NASA-ARC.

59. Wise, J.A., and Taylor, R.P. (2002). Fractal design strategies for enhancement of knowledge work environments. *Proceedings of the Human Factors and Ergonomics Society Meeting*, Baltimore.

60. Spehar, B., Clifford, C., Newell, B., and Taylor, R.P. (2004). Universal aesthetic of fractals. *Chaos and Graphics* 37: 813–20.

61. Mandelbrot, B.B. (2001). Fractals and art for the sake of science. In Emmer, M. (ed.), *The Visual Mind*. Cambridge, MA: MIT Press.

62. Taylor, R.P. (2006). Reduction of physiological stress using fractal art and architecture. *Leonardo* 39: 245–51.

63. Hagerhall, C., Purcell, T., and Taylor, R.P. (2004). Fractal dimension of landscape silhouette as a predictor for landscape preference. *Journal of Environmental Psychology* 24: 247–55.

64. Hauser, M.D., and McDermott, J. (2006). Thoughts on an empirical approach to the evolutionary origins of music. *Music Perception* 24: 111–16.

65. Marler, P. (1990). Song learning: The interface between behaviour and neuroethology. *Philosophical Transactions of the Royal Society of London, Series B: Biological Sciences* 329: 109–14.

66. Brown, D. (1991). *Human Universals*. New York: McGraw-Hill.

67. Blacking, J. (1995). *Music, Culture and Experience*. Chicago: University of Chicago Press.

68. Merriam, A.P. (1964). *The Anthropology of Music*. Chicago: Northwestern University Press.

69. Huron, D. (2001). Is music an evolutionary adaptation? *Annals of the New York Academy of Sciences* 930: 43–61.

70. Zhang, J., Haarottle, G., Wang, C., and Kong, Z. (1999). Oldest playable music instruments found at Jiahua early Neolithic site in China. *Nature* 401: 366–68.

71. Hagen, E.H., and Bryant, G.A. (2003). Music and dance as a coalition signaling system. *Human Nature* 14: 21–51.

72. Fitch, T. (2006). On the biology and evolution of music. *Music Perception* 24: 85–88.

73. Levitin, D.J. (1994). Absolute memory for musical pitch: Evidence from the production of learned melodies. *Perception & Psychophysics* 56: 414–23.

74. Levitin, D.J., and Cook, P.R. (1996). Memory for musical tempo: Additional evidence that auditory memory is absolute. *Perception & Psychophysics* 58: 927–35.

75. Trehub, S.E. (2003). Toward a developmental psychology of music. *Annals of the New York Academy of Sciences* 999: 402–13.

76. Wright, A.A., Rivera, J.J., Hulse, S.H., et al. (2000). Music perception and octave generalization in rhesus monkeys. *Journal of Experimental Psychology: General* 129: 291–307.

77. Gagnon, T., Hunse, C., Carmichael, L., Fellows, F., and Patrick, J. (1987). Human fetal responses to vibratory acoustic stimulation from twenty-six weeks to term. *American Journal of Obstetrics and Gynecology* 157: 1375–84.

78. Koelsch, S., and Siebel, W.A. (2005). Towards a neural basis of music perception. *Trends in Cognitive Science* 9:578–84.

79. Koelsch, S., Kasper, E., Sammler, D., Schulze, K., Gunter, T., and Friederici, A.D. (2004). Music, language and meaning: Brain signatures of semantic processing. *Nature Neuroscience* 7: 302–7.

80. Fitch, W.T., and Hauser, M.D. (2004). Computational constraints on syntactic processing in a nonhuman primate. *Science* 303: 377–80.

81. Levitin, D.J., and Menon, V. (2003). Musical structure is processed in "language" areas of the brain: A possible role for Brodmann area 47 in temporal coherence. *NeuroImage* 20: 2142–52.

82. Tillmann, B., Janata, P., and Bharucha, J.J. (2003). Activation of the inferior frontal cortex in musical priming. *Cognitive Brain Research* 16: 145–61.

83. Koelsch, S., Gunter, T.C., von Cramon, D.Y., Zysset, S., Lohmann, G., and Friederici, A.D. (2002). Bach speaks: A cortical "language-network" serves the processing of music. *NeuroImage* 17: 956–66.

84. Voss, R.F., and Clarke, J. (1978). 1/f noise in music and speech. *Nature* 258: 317–18.

85. De Coensel, B., Botterdooren, D., and De Muer, T. (2003). 1/f noise in rural and urban soundscapes. *Acta Acoustica* 89: 287–95.

86. Garcia-Lazaro, J.A., Ahmed, B., and Schnupp, J.W.H. (2006). Tuning to natural stimulus dynamics in primary auditory cortex. *Current Biology* 7: 264–71.

87. Rieke, F., Bodnar, D.A., and Bialek, W. (1995). Naturalistic stimuli increase the rate and efficiency of information transmission by primary auditory afferents. *Proceedings of the Royal Society of London, Series B: Biological Sciences* 262: 259–65.

88. Krumhansl, C.L. (1997). An exploratory study of musical emotions and psychophysiology. *Canadian Journal of Experimental Psychology* 51: 336–53.

89. Pancept, J. (1995). The emotional sources of "chills" induced by music. *Music Perception* 13: 171–207.

90. Goldstein, A. (1980). Thrills in response to music and other stimuli. *Physiological Psychology* 8: 126–29.

91. Blood, A.J., and Zatorre, R.J. (2001). Intensely pleasurable responses to music

correlate with activity in brain regions implicated in reward and emotion. *Proceedings of the National Academy of Sciences* 98: 11818–23.

92. Ashby, F.G., Isen, A.M., and Turken, A.U. (1999). A neuropsychological theory of positive affect and its influence on cognition. *Psychology Review* 106: 529–50.

93. Rauscher, F.H., Shaw, G.L., and Ky, K.N. (1993). Music and spatial task performance. *Nature* 365: 611.

94. For a review, see: Schellenberg, E.G. (2005). Music and cognitive abilities. *Current Directions in Psychological Science* 14: 317–20.

95. Barnett, S.M., and Ceci, S.J. (2002). When and where do we apply what we learn? A taxonomy for transfer. *Psychological Bulletin* 128: 612–37.

96. Schellenberg, E.G. (2004). Music lessons enhance IQ. *Psychological Science* 15: 511–14.

97. Elbert, T., Pantev, C., Wienbruch, C., Rockstroh, B., and Taub, E. (1995). Increased cortical representation of the fingers of the left hand in string players. *Science* 270: 305–7.

98. Gaser, C., and Schlaug, G. (2003). Brain structures differ between musicians and nonmusicians. *Journal of Neuroscience* 23: 9240–45.

99. Neville, H.J., unpublished data, personal communication.

100. Rueda, M.R., Rothbart, M.K., McCandliss, B.D., Saccomanno, L., and Posner, M.I. (2005). Training, maturation, and genetic influences on the development of executive attention. *Proceedings of the National Academy of Sciences* 102: 14931–36.

101. Norton, A., Winner, E., Cronin, K., et al. (2005). Are there pre-existing neural, cognitive, or motoric markers for musical ability? *Brain and Cognition* 59: 124–34.

102. Schlaug, G., Norton, A., Overy, K., and Winner, E. (2005). Effects of music training on the child's brain and cognitive development. *Annals of the New York Academy of Sciences* 1060: 219–30.

103. Personal communication.

Chapter 7: WE ALL ACT LIKE DUALISTS: THE CONVERTER FUNCTION

1. Barrett, J.L. (2004). *Why Would Anyone Believe in God?* Walnut Creek, CA: Altamira Press.

2. Atran, S. (1990). *Cognitive Foundations of Natural History: Towards an Anthropology of Science.* Cambridge: Cambridge University Press.

3. Pinker, S. (1997). *How the Mind Works.* New York: W.W. Norton.

4. Gelman, S.A., and Wellman, H.M. (1991). Insides and essences: Early understandings of the non-obvious. *Cognition* 38: 213–44.

5. Atran, S. (1998). Folk biology and the anthropology of science: Cognitive universals and cultural particulars. *Behavioral and Brain Sciences* 21: 547–609.

6. Caramazza, A., and Shelton, J.R. (1998). Domain-specific knowledge systems

in the brain: The animate-inanimate distinction. *Journal of Cognitive Neuroscience* 10: 1–34.

7. Boyer, P., and Barrett, C. (2005). Evolved intuitive ontology: Integrating neural, behavioral and developmental aspects of domain-specificity. In Buss, D.M. (ed.), *The Handbook of Evolutionary Psychology* (pp. 200–23). New York: Wiley.

8. Barrett, H.C. (2005). Adaptations to predators and prey. In Buss (ed.), *The Handbook of Evolutionary Psychology* (pp. 200–23). New York: Wiley.

9. Coss, R.G., Guse, K.L., Poran, N.S., and Smith, D.G. (1993). Development of antisnake defenses in California ground squirrels (*Spermophilus beecheyi*), II: Microevolutionary effects of relaxed selection from rattlesnakes. *Behaviour* 124: 137–64.

10. Blumstein, D.T., Daniel, J.C., Griffin, A.S., and Evans, C.S. (2000). Insular tammar wallabies (*Macropus eugenii*) respond to visual but not acoustic cues from predators. *Behavioral Ecology* 11: 528–35.

11. Fox, R., and McDaniel, M. (1982). The perception of biological motion by human infants. *Science* 218: 486–87.

12. Schlottmann, A., and Surian, L. (1999). Do 9-month-olds perceive causation-at-a-distance? *Perception* 28: 1105–13.

13. Csibra, G., Gergely, G., Bíró, S., Koós, O., and Brockbank, M. (1999). Goal attribution without agency cues: The perception of "pure reason" in infancy. *Cognition* 72: 237–67.

14. Csibra, G., Bíró, S., Koós, O., and Gergely, G. (2003). One-year-old infants use teleological representations of actions productively. *Cognitive Psychology* 27: 111–33.

15. Gelman, S.A., Coley, J.D., Rosengren, K.S., Hartman, E., Pappas, A., and Keil, F.C. (1998). Beyond labeling: The role of maternal input in the acquisition of richly structured categories. *Monographs of the Society for Research in Child Development* 63: 1–157.

16. Bloom, P. (2004). *Descartes' Baby*. New York: Basic Books.

17. Vonk, J., and Povinelli, D.J. (2006). Similarity and difference in the conceptual systems of primates: The unobservability hypothesis. In Wasserman, E., and Zentall, T. (eds.), *Comparative Cognition: Experimental Explorations of Animal Intelligence* (pp. 363–87). Oxford: Oxford University Press.

18. Baillargeon, R.E., Spelke, E., and Wasserman, S. (1985). Object permanence in five-month-old infants. *Cognition* 20: 191–208.

19. Spelke, E.S. (1991). Physical knowledge in infancy: Reflections on Piaget's theory. In Carey, S., and Gelman, R. (eds.), *The Epigenesis of Mind: Essays on Biology and Cognition* (pp. 133–69). Hillsdale, NJ: Lawrence Erlbaum.

20. Spelke, E.S. (1994). Initial knowledge: Six suggestions. *Cognition* 50: 443–47.

21. Baillargeon. R. (2002). The acquisition of physical knowledge in infancy: A summary in eight lessons. In Goswami, U. (ed.), *Blackwell Handbook of Childhood Cognitive Development*. Malden, MA: Blackwell.

22. Shultz, T.R., Altmann, E., and Asselin, J. (1986). Judging causal priority. *British Journal of Developmental Psychology* 4: 67–74.

23. Kohler, W. (1925). *The Mentality of Apes*. New York: Liveright.

24. Tomasello, M. (1998). Uniquely primate, uniquely human. *Developmental Science* 1: 1–16.

25. Povinelli, D.J. (2000). *Folk Physics for Apes: The Chimpanzee's Theory of How the World Works,* rev. ed. 2003. Oxford: Oxford University Press.

26. Bloom, P. (1996). Intention, history and artifact concepts. *Cognition* 60: 1–29.

27. Moore, C.J., and Price, C.J. (1999). A functional neuroimaging study of the variables that generate category-specific object processing differences. *Brain* 122: 943–62.

28. Mecklinger, A., Gruenewald, C., Besson, M., Magnié, M.-N., and Von Cramon, D.Y. (2002). Separable neuronal circuitries for manipulable and non-manipulable objects in working memory. *Cerebral Cortex* 12: 1115–23.

29. Heider, F., and Simmel, M. (1944). An experimental study of apparent behavior. *American Journal of Psychology* 57: 243–59.

30. Kelemen, D. (1999). The scope of teleological thinking in preschool children. *Cognition* 70: 241–72.

31. Kelemen, D. (1999). Why are rocks pointy? Children's preference for teleological explanations of the natural world. *Developmental Psychology* 35: 1440–53.

32. Kelemen, D. (2003). British and American children's preference for teleo-functional explanations of the natural world. *Cognition.* 88: 201–21.

33. Kelemen, D. (1999). Function, goals, and intention: Children's teleological reasoning about objects. *Trends in Cognitive Sciences* 3: 461–68.

34. Gergely, G., and Csibra, G. (2003). Teleological reasoning in infancy: The naïve theory of rational action. *Trends in Cognitive Sciences* 7: 287–92.

35. Povinelli, D.J. (2004). Behind the ape's appearance: Escaping anthropocentrism in the study of other minds. *Daedalus* 133 (Winter): 29–41.

36. Povinelli, D.J., and Dunphy-Lelii, S. (2001). Do chimpanzees seek explanations? Preliminary comparative investigations. *Canadian Journal of Experimental Psychology* 52: 93–101.

37. Povinelli, D.J., Bering, J., and Giambrone, S. (2001). Toward a science of other minds: Escaping the argument by analogy. *Cognitive Science* 24: 509–41.

38. Wynn, K. (1992). Addition and subtraction by human infants. *Nature* 358: 749–50.

39. Klin, A. (2000). Attributing social meaning to ambiguous visual stimuli in higher-functioning autism and Asperger syndrome: The social attribution task. *Journal of Child Psychology and Psychiatry* 41: 831–46.

40. Pierce, K., Muller, R.A., Ambrose, J., Allen, G., and Courchesne, E. (2001). Face processing occurs outside the fusiform "face area" in autism: Evidence from functional MRI. *Brain* 124: 2059–73.

41. Schultz, R.T., Gauthier, I., Klin, A., Fulbright, R.K., Anderson, A.W., Volkmar, F., et al. (2000). Abnormal ventral temporal cortical activity during face discrimination among individuals with autism and Asperger syndrome. *Archives of General Psychiatry* 57: 331–40.

42. Tattersall, I. (1998). *Becoming Human.* New York: Harcourt Brace.

43. McComb, K., Baker, L., and Moss, C. (2006). African elephants show high levels of interest in the skulls and ivory of their own species. *Biology Letters* 2: 26–28.

44. Moss, C. (1988). *Elephant Memories: Thirteen Years of Life in an Elephant Family*. New York: William Morrow.

45. Evans, J., and Curtis-Holmes, J. (2005). Rapid responding increases belief bias: Evidence for the dual-process theory of reasoning. *Thinking and Reasoning* 11: 382–89.

Chapter 8: IS ANYBODY THERE?

1. Dehaene, S., and Naccache, L. (2001). Towards a cognitive neuroscience of consciousness: Basic evidence and a workspace framework. *Cognition* 79: 1–37.

2. Gazzaniga, M.S., Le Doux, J.E., and Wilson, D.H. (1977). Language, praxis, and the right hemisphere: Clues to some mechanisms of consciousness. *Neurology* 27: 1144–47.

3. Searle, J.R. (1998). How to study consciousness scientifically. *Philosophical Transactions of the Royal Society of London, Series B*: Biological Sciences 353: 1935–42.

4. Zeman, A. (2001). Consciousness. *Brain* 124: 1263–89.

5. Moran, A. (2006). Levels of consciousness and self-awareness: A comparison and integration of various neurocognitive views. *Consciousness and Cognition* 15: 358–71.

6. Damasio, A. (1999). *The Feeling of What Happens*. New York: Harcourt Brace.

7. Parvizi, J., and Damasio, A. (2001). Consciousness and the brainstem. *Cognition* 79: 135–60.

8. Bogen, J. (1995). On the neurophysiology of consciousness, I: An overview. *Consciousness and Cognition* 4: 52–62.

9. Allman, J.M., Hakeem, A., Erwin, E.N., and Hof, P. (2001). The anterior cingulate cortex: The evolution of an interface between emotion and cognition. *Annals of the New York Academy of Science* 935: 107–17.

10. Baddeley, A.D. (1986). *Working Memory*. Oxford: Clarendon Press.

11. Shallice, T. (1988). *From Neurospsychology to Mental Structure*. Cambridge: Cambridge University Press.

12. Posner, M.I. (1994). Attention: The mechanisms of consciousness. *Proceedings of the National Academy of Sciences* 91: 7398–7403.

13. Posner, M.I., and Dehaene, S. (1994). Attentional networks. *Trends in Neuroscience* 17: 75–79.

14. Baars, B.J. (1989). *A Cognitive Theory of Consciousness*. Cambridge: Cambridge University Press.

15. Tonini, G., and Edelman, G.M. (1998). Consciousness and complexity. *Science* 282: 1846–51.

16. Dehaene, S., and Changeux, J.-P. (2005). Ongoing spontaneous activity controls access to consciousness: A neuronal model for inattentional blindness. *Public Library of Science: Biology* 3: e141.

17. Dehaene, S., and Changeux, J.-P. (2004). Neural mechanisms for access to consciousness. In Gazzaniga, M.S. (ed.), *The Cognitive Neurosciences*, vol. 3. Cambridge, MA: MIT Press.

18. Driver, J., and Vuilleumier, P. (2001). Perceptual awareness and its loss in unilateral neglect and extinction. *Cognition* 79: 39–88.

19. Bisiach, E., and Luzzatti, B. (1978). Unilateral neglect of representational space. *Cortex* 14: 129–33.

20. Halligan, P.W., and Marshall, J.C. (1998). Neglect of awareness. *Consciousness and Cognition* 7: 356–80.

21. McGlinchey-Berroth, R., Milberg, W.P., Verfaellie, M., Alexander, M., and Kilduff, P. (1993). Semantic priming in the neglected field: Evidence from a lexical decision task. *Cognitive Neuropsychology* 10: 79–108.

22. Aboitiz, F., Scheibel, A.B., Fisher, R.S., and Zaidel, E. (1992). Fiber composition of the human corpus callosum. *Brain Research* 598: 143–53.

23. Van Wagenen, W.P., and Herren, R.Y. (1940). Surgical division of commissural pathways in the corpus callosum: Relation to spread of an epileptic seizure. *Archives of Neurology and Psychiatry* 44: 740–59.

24. Akelatis, A.J. (1941). Studies on the corpus callosum: Higher visual functions in each homonymous field following complete section of the corpus callosum. *Archives of Neurology and Psychiatry* 45: 788.

25. Gazzaniga, M.S., Bogen, J.E., and Sperry, R. (1962). Some functional effects of sectioning the cerebral commissures in man. *Proceedings of the National Academy of Sciences* 48: 1756–69.

26. Sperry, R. (1984). Consciousness, personal identity and the divided brain. *Neuropsychologia* 22: 661–73.

27. Kutas, M., Hillyard, S.A., Volpe, B.T., and Gazzaniga, M.S. (1990). Late positive event-related potentials after commissural section in humans. *Journal of Cognitive Neuroscience* 2: 258–71.

28. Gazzaniga, M.S., Bogen, J.E., and Sperry, R. (1967). Dyspraxia following division of the cerebral commissures. *Archives of Neurology* 16: 606–12.

29. Gazzaniga, M.S., and Smylie, C.S. (1990). Hemispheric mechanisms controlling voluntary and spontaneous facial expressions. *Journal of Cognitive Neuroscience* 2: 239–45.

30. Enns, J.T., and Kingstone, A. (1997). Hemispheric cooperation in visual search: Evidence from normal and split-brain observers. In Christman, S., (ed.), *Cerebral Asymmetries in Sensory and Perceptual Processes* (pp. 197–231). Amsterdam: North-Holland.

31. Kingstone, A., Grabowecky, M., Mangun, G.R., Valsangkar, M.A., and Gazzaniga, M.S. (1997). Paying attention to the brain: The study of selective visual attention in cognitive neuroscience. In Burak, J., and Enns, J.T. (eds.), *Attention, Development, and Psychopathology* (pp. 263–87). New York: Guilford Press.

32. Kingstone, A., Friesen, C.K., and Gazzaniga, M.S. (2000). Reflexive joint attention depends on lateralized cortical connections. *Psychological Science* 11: 159–66.

33. Holtzman, J.D., and Gazzaniga, M.S. (1982). Dual task interactions due exclusively to limits in processing resources. *Science* 218: 1325–27.

34. Mangun, G.R., Luck, S.J., Plager, R., Loftus, W., Hillyard, S.A., Clark, V.P., et al. (1994). Monitoring the visual world: Hemispheric asymmetries and subcortical processes in attention. *Journal of Cognitive Neuroscience* 6: 267–75.

35. Berlucchi, G., Mangun, G.R., and Gazzaniga, M.S. (1997). Visuospatial attention and the split brain. *News in Physiological Sciences* 12: 226–31.

36. Corballis, M.C. (1995). Visual integration in the split brain [review]. *Neuropsychologia* 33: 937–59.

37. Nass, R.D., and Gazzaniga, M.S. (1987). Cerebral lateralization and specialization of human central nervous system. In Mountcastle, V.B., Plum, F., and Geiger, S.R. (eds.), *Handbook of Physiology*, section 1, vol. 5, part 2 (pp. 701–61). Bethesda, MD: American Physiological Society.

38. Zaidel, E. (1991). Language functions in the two hemispheres following complete cerebral commissurotomy and hemispherectomy. In Boller, F., and Grafman, J. (eds.), *Handbook of Neuropsychology*, vol. 4 (pp. 115–50). Amsterdam: Elsevier.

39. Gazzaniga, M.S. (1995). On neural circuits and cognition [review]. *Neural Computation* 7: 1–12.

40. Wolford, G., Miller, M.B., and Gazzaniga, M.S. (2000). The left hemisphere's role in hypothesis formation. *Journal of Neuroscience* 20: RC64.

41. Miller, M.B., and Valsangkar-Smyth, M. (2005). Probability matching in the right hemisphere. *Brain and Cognition* 57(2): 165–67.

42. Wolford, G., Miller, M.B., and Gazzaniga, M.S. (2004). Split decisions. In Gazzaniga, M.S. (ed.), *The Cognitive Neurosciences*, vol. 3 (pp. 1189–99). Cambridge, MA: MIT Press.

43. Schachter, S., and Singer, J.E. (1962). Cognitive, social, and physiological determinants of emotional state. *Psychology Review* 69: 379–99.

44. Phelps, E.A., and Gazzaniga, M.S. (1992). Hemispheric differences in mnemonic processing: The effects of left hemisphere interpretation. *Neuropsychologia* 30: 293–97.

45. Metcalfe, J., Funnell, M., and Gazzaniga, M.S. (1995). Right-hemisphere memory superiority: Studies of a split-brain patient. *Psychological Science* 6: 157–64.

46. Doran, J.M. (1990). The Capgras syndrome: Neurological/neuropsychological perspectives. *Neuropsychology* 4: 29–42.

47. Kihlstrom, J.F., and Klein, S.B. (1997). Self-knowledge and self-awareness. In Snodgrass, J.D., and Thompson, R.L. (eds.), The self across psychology: Self-recognition, self-awareness, and the self concept. *Annals of the New York Academy of Sciences* 818: 5–17.

48. Boyer, P., Robbins, P., and Jack, A.I. (2005). Varieties of self-systems worth having: Introduction to a special issue on "the brain and its self." *Consciousness and Cognition* 14: 647–60.

49. Gillihan, S.J., and Farah, M.J. (2005). Is self special? A critical review of evidence from experimental psychology and cognitive neuroscience. *Psychological Bulletin* 131: 76–97.

50. Rogers, T.B., Kuiper, N.A., and Kirker, W.S. (1977). Self-reference and the encoding of personal information. *Journal of Personality and Social Psychology* 35: 677–88.

51. Tulving, E. (1983). *Elements of Episodic Memory*. New York: Oxford University Press.

52. Tulving, E. (1985). Memory and consciousness. *Canadian Psychology* 26: 1–12.

53. Tulving, E. (1993). What is episodic memory? *Current Directions in Psychological Science* 2: 67–70.

54. Tulving, E. (2005). Episodic memory and autonoesis: Uniquely human? In Terrace, H.S., and Metcalfe, J. (eds.), *The Missing Link in Cognition* (pp. 3–56). New York: Oxford University Press.

55. Bauer, P.J., and Wewerka, S.S. (1995). One- to two-year-olds' recall of events: The more expressed, the more impressed. *Journal of Experimental Child Psychology* 59: 475–96.

56. Perner, J., and Ruffman, T. (1995). Episodic memory and autonoetic consciousness: Developmental evidence and a theory of childhood amnesia. *Journal of Experimental Child Psychology* 59: 516–48.

57. Wheeler, M.A., Stussl, D.T., and Tulving, E. (1997). Toward a theory of episodic memory: The frontal lobes and autonoetic consciousness. *Psychological Bulletin* 121: 331–54.

58. Friedman, W.J. (1991). The development of children's memory for the time of past events. *Child Development* 62: 139–55.

59. Friedman, W.J., Gardner, A.G., and Zubin, N.R. (1995). Children's comparisons of the recency of two events from the past year. *Child Development* 66: 970–83.

60. For a summary, see: Klein, S. (2004). Knowing one's self. In Gazzaniga, M.S. (ed.), *The Cognitive Neurosciences*, vol. 3 (pp. 1077–89). Cambridge, MA: MIT Press.

61. Babey, S.H., Queller, S., and Klein, S.B. (1998). The role of expectancy violating behaviors in the representation of trait-knowledge: A summary-plus-exception model of social memory. *Social Cognition* 16: 287–339.

62. Morin, A. (2002). Right hemispheric self-awareness: A critical assessment. *Consciousness and Cognition* 11: 396–401.

63. Conway, M.A., Pleydell-Pearce, C.W., and Whitecross, S.E. (2001). The neuroanatomy of autobiographical memory: A slow cortical potential study of autobiographical memory retrieval. *Journal of Memory and Language* 45: 493–524.

64. Conway, M.A., Pleydell-Pearce, C.W., Whitecross, S., and Sharpe, H. (2002). Brain imaging autobiographical memory. *Psychology of Learning and Motivation* 41: 229–64.

65. Conway, M.A., Pleydell-Pearce, C.W., Whitecross, S.E., and Sharpe, H. (2003). Neurophysiological correlates of memory for experienced and imagined events. *Neuropsychologia* 41: 334–40.

66. Turk, D.J., Heatherton, T.F., Macrae, C.N., Kelley, W.M., and Gazzaniga, M.S. (2003). Out of contact, out of mind: The distributed nature of self. *Annals of the New York Academy of Sciences* 1001: 65–78.

67. Gazzaniga, M.S. (1972). One brain—two minds? *American Scientist* 60: 311–17.

68. Gazzaniga, M.S., and Smylie, C.S. (1983). Facial recognition and brain asymmetries: Clues to underlying mechanisms. *Annals of Neurology* 13: 536–40.

69. DeRenzi, E. (1986). Prosopagnosia in two patients with CT scan evidence of damage confined to the right hemisphere. *Neuropsychologia* 24: 385–89.

70. Landis, T., Cummings, J.L., Christen, L., Bogen, J.E., and Imhof, H.G. (1986). Are unilateral right posterior cerebral lesions sufficient to cause prosopagnosia? Clinical and radiological findings in six additional patients. *Cortex* 22: 243–52.

71. Michel, F., Poncet, M., and Signoret, J.L. (1989). Les lesions responsables de la prosopagnosie sont-elles toujours bilateral. *Revue Neurologique* (Paris) 145: 764–70.

72. Wada, Y., and Yamamoto, T. (2001). Selective impairment of facial recognition due to a haematoma restricted to the right fusiform and lateral occipital region. *Journal of Neurology, Neurosurgery and Psychiatry* 71: 254–57.

73. Whiteley, A.M., and Warrington, E.K. (1977). Prosopagnosia: A clinical, psychological, and anatomical study of three patients. *Journal of Neurology, Neurosurgery and Psychiatry* 40: 395–403.

74. Keenan, J.P., Nelson, A., O'Connor, M., and Pascual-Leone, A. (2001) Neurology: Self recognition and the right hemisphere. *Nature* 409: 305.

75. Keenan, J.P., et al. (1999). Left hand advantage in a self-face recognition task. *Neuropsychologia* 37: 1421–25.

76. Keenan, J.P., Ganis, G., Freund, S., and Pascual-Leone, A. (2000). Self-face identification is increased with left hand responses. *Laterality* 5: 259–68.

77. Maguire, E.A., and Mummery, C.J. (1999). Differential modulation of a common memory retrieval network revealed by positron emission tomography. *Hippocampus* 9: 54–61.

78. Conway, M.A., et al. (1999). A positron emission tomography (PET) study of autobiographical memory retrieval. *Memory* 7: 679–702.

79. Conway, M.A., and Pleydell-Pearce, C.W. (2000). The construction of autobiographical memories in the self-memory system. *Psychology Review* 107: 261–88.

80. Turk, D.J. (2002). Mike or me? Self-recognition in a split-brain patient. *Nature Neuroscience* 5: 841–42.

81. Cooney, J.W., and Gazzaniga, M.S. (2003). Neurologic disorders and the structure of human consciousness. *Trends in Cognitive Science* 7: 161–64.

82. For a review of different theories of components of consciousness, see: Morin, A. (2006). Levels of consciousness and self-awareness: A comparison and integration of various neurocognitive views. *Consciousness and Cognition* 15: 358–71.

83. Hauser, M. (2000). *Wild Minds* (p. 93). New York: Henry Holt.

84. Mateo, J.M. (2006). The nature and representation of individual recognition cues in Belding's ground squirrels. *Animal Behaviour* 71: 141–54.

85. Gallup, G.G., Jr. (1970). Chimpanzees: Self-recognition. *Science* 2: 86–87.

86. Swartz, K.B., and Evans, S. (1991). Not all chimpanzees (*Pan troglodytes*) show self-recognition. *Primates* 32: 583–96.

87. Povinelli, D.J., Rulf, A.R., Landau, K., and Bierschwale, D.T. (1993). Self-recognition in chimpanzees (*Pan troglodytes*): Distribution, ontogeny, and patterns of emergence. *Journal of Comparative Psychology* 107: 347–72.

88. de Veer, M.W., Gallup, G.G., Jr., Theall, L.A., van den Bos, R., and Povinelli, D.J. (2003). An 8-year longitudinal study of mirror self-recognition in chimpanzees (*Pan troglodytes*). *Neuropsychologia* 41: 229–34.

89. Suarez, S.D., and Gallup, G.G., Jr. (1981). Self-recognition in chimpanzees and orangutans, but not gorillas. *Journal of Human Evolution* 10: 175–88.

90. Swartz, K.B. (1997). What is mirror self-recognition in nonhuman primates, and what is it not? *Annals of the New York Academy of Sciences* 818: 64–71.

91. Reiss, D., and Marino, L. (2001). Mirror self-recognition in the bottlenose

dolphin: A case of cognitive convergence. *Proceedings of the National Academy of Sciences* 98: 5937–42.

92. Barth, J., Povinelli, D.J., and Cant, J.G.H. (2004). Bodily origins of self. In Beike, D., Lampinen, J., and Behrend, D. (eds.), *Self and Memory*. New York: Psychology Press.

93. Povinelli, D.J. (1989). Failure to find self-recognition in Asian elephants (*Elephas maximus*) in contrast to their use of mirror cues to discover hidden food. *American Journal of Comparative Psychology* 103: 122–31.

94. Plotnik, J.M., de Waal, F.B.M., and Reiss, D. (2006). Self-recognition in an Asian elephant. *Proceedings of the National Academy of Sciences* 103: 17053–57.

95. Amsterdam, B.K. (1972). Mirror self-image reactions before age two. *Developmental Psychobiology* 5: 297–305.

96. Gallup, G.G., Jr. (1982). Self-awareness and the emergence of mind in primates. *American Journal of Primatology* 2: 237–48.

97. Mitchell, R.W. (1997). Kinesthetic-visual matching and the self-concept as explanations of mirror-self-recognition. *Journal for the Theory of Social Behavior* 27: 101–23.

98. Mitchell, R.W. (1994). Multiplicities of self. In Parker, S.T., Mitchell, R.W., and Boccia, M.L. (eds.), *Self-awareness in Animals and Humans*. Cambridge: Cambridge University Press.

99. Povinelli, D.J., and Cant, J.G.H. (1995). Arboreal clambering and the evolution of self-conception. *Quarterly Review of Biology* 70: 393–421.

100. Call, J. (2004). The self and other: A missing link in comparative social cognition. In Terrace, H.S., and Metcalfe, J. (eds.), *The Missing Link in Cognition*. Oxford: Oxford University Press.

101. Povinelli, D.J., Landau, K.R., and Perilloux, H.K. (1996). Self-recognition in young children using delayed versus live feedback: Evidence of a developmental asynchrony. *Child Development* 67: 1540–54.

102. Suddendorf, T., and Corballis, M.C. (1997). Mental time travel and the evolution of the human mind. *Genetic Psychology Monographs* 123: 133–67.

103. Roberts, W.A. (2002). Are animals stuck in time? *Psychological Bulletin* 128: 473–89.

104. Clayton, N.S., and Dickinson, A. (1998). Episodic-like memory during cache recovery by scrub jays. *Nature* 395: 272–74.

105. Clayton, N.S., and Dickinson, A. (1999). Memory for the content of caches by scrub jays (*Aphelocoma coerulescens*). *Journal of Experimental Psychology: Animal Behavior Processes* 25: 82–91.

106. Clayton, N.S., and Dickinson, A. (1999). Scrub jays (*Aphelocoma coerulescens*) remember the relative time of caching as well as the location and content of their caches. *Journal of Comparative Psychology* 113: 403–16.

107. Clayton, N.S., Yu, K.S., and Dickinson, A. (2001). Scrub jays (*Aphelocoma coerulescens*) form integrated memories of the multiple features of caching episodes. *Journal of Experimental Psychology: Animal Behavior Processes* 27: 17–29.

108. Clayton, N.S., Yu, K.S., and Dickinson, A. (2003). Interacting cache memories: Evidence for flexible memory use by western scrub-jays (*Aphelocoma californica*). *Journal of Experimental Psychology: Animal Behavior Processes* 29: 14–22.

109. Reiner, A., et al. (2004). The Avian Brain Nomenclature Forum: Terminology for a new century in comparative neuroanatomy. *Journal of Comparative Neuroanatomy* 473: E1–E6.

110. Butler, A.M., and Cotterill, R.M.J. (2006). Mammalian and avian neuroanatomy and the question of consciousness in birds. *Biological Bulletin* 211: 106–27.

111. Schwartz, B.L. (2004). Do nonhuman primates have episodic memory? In Terrace, H.S., and Metcalfe, J. (eds.), *The Missing Link in Cognition*. Oxford: Oxford University Press.

112. Dally, J.M., Emery, N.J., and Clayton, N.S. (2006). Food-caching western scrub-jays keep track of who was watching when. *Science* 312: 1662–65.

113. Emery, N.J., and Clayton, N.S. (2001). Effects of experience and social context on prospective caching strategies in scrub jays. *Nature* 414: 443–46.

114. Mulcahy, N.J., and Call, J. (2006). Apes save tools for future use. *Science* 312: 1038–40.

115. Suddendorf, T. (2006). Foresight and evolution of the human mind. *Science* 312: 1006–7.

116. Smith, J.D., Shields, W.E., Schull, J., and Washburn, D.A. (1997). The uncertain response in humans and animals. *Cognition* 62: 75–97.

117. Smith, J.D., Schull, J., Strote, J., McGee, K., Egnor, R., and Erb, L. (1995). The uncertain response in the bottlenosed dolphin (*Tursiops truncatus*). *Journal of Experimental Psychology: General* 124: 391–408.

118. Smith, J.D., Shields, W.E., and Washburn, D.A. (2003). The comparative psychology of uncertainty monitoring and metacognition. *Behavioral and Brain Sciences* 26:317–39; discussion 340–73.

119. Browne, D. (2004). Do dolphins know their own minds? *Biology and Philosophy* 19: 633–53.

120. Foote, A.L., and Crystal, J.D. (2007). Metacognition in the rat. *Current Biology* 17: 551–55.

121. Call, J. (2004). Inferences about the location of food in the great apes. *Journal of Comparative Psychology* 118: 232–41.

122. Call, J., and Carpenter, M. (2001). Do apes and children know what they have seen? *Animal Cognition* 4: 207–20.

Chapter 9: WHO NEEDS FLESH?

1. www.ethologic.com/sasha/articles/Cyborgs.rtf.

2. Kurzweil, R. (2005). *The Singularity Is Near*. New York: Viking.

3. Markram, H. (2006). The blue brain project. *Nature Reviews. Neuroscience* 7: 153–60.

4. Chase, V.D. (2006). *Shattered Nerves: How Science Is Solving Modern Medicine's Most Perplexing Problem* (pp. 266–68). Baltimore: Johns Hopkins University Press.

5. Bodanis, D. (2004). *Electric Universe: The Shocking True Story of Electricity* (p. 199). New York: Crown.

6. Horgan, H. (2005). The forgotten era of brain chips. *Scientific American* 290, no. 4 (October): 66–73.

7. Clynes, M.E., and Kline, N.S. (1960). Cyborgs and space. *Astronautics*. American Rocket Society: Sept.

8. Chorost, M. (2005). *Rebuilt: My Journey Back to the Hearing World*. New York: Houghton Mifflin.

9. Brooks, R.A. (2002). *Flesh and Machines*. New York: Pantheon.

10. Kennedy, P.R., and Bakay, R.A. (1998). Restoration of neural output from a paralyzed patient by a direct brain connection. *NeuroReport* 9: 1707–11.

11. Kennedy, P.R., Bakay, R.A.E., Moore, M.M., Adams, K., and Goldwaithe, J. (2000). Direct control of a computer from the human central nervous system. *IEEE Transactions on Rehabilitation Engineering* 8: 198–202.

12. Donoghue, J.P. (2002). Connecting cortex to machines: Recent advances in brain interfaces. *Nature Neuroscience* 5 (Suppl.): 1085–88.

13. Abbott, A. (2006). Neuroprosthetics: In search of the sixth sense. *Nature* 442: 125–27.

14. Fromherz, P., et al. (1991). A neuron-silicon junction: A Retzius cell of the leech on an insulated-gate field effect transistor. *Science* 252: 1290–92.

15. Fromherz, P. (2006). Three levels of neuroelectronic interfacing: Silicon chips with ion channels, nerve cells, and brain tissue. *Annals of the New York Academy of Sciences* 1093: 143–60.

16. Hochberg, L.R., Serruya, M.D., Friehs, G.M., Mukand, J.A., Saleh, M., Caplan, A.H., Branner, A., Chen, D., Penn, R.D., and Donoghue, J.P. (2006). Neuronal ensemble control of prosthetic devices by a human with tetraplegia. *Nature* 442: 164–71.

17. Georgopoulos, A.P., Kalaska, J.F., Caminiti, R., and Massey, J.T. (1982). On the relations between the direction of two-dimensional arm movements and cell discharge in primate motor cortex. *Journal of Neuroscience* 11:1527–37.

18. Georgopoulos, A.P., Caminiti, R., Kalaska, J.F., and Massey, J.T. (1983). Spatial coding of movement: A hypothesis concerning the coding of movement direction by motor cortical populations. *Experimental Brain Research* Supplement 7: 327–36.

19. Georgopoulos, A.P., Kettner, R.E., and Schwartz, A.B. (1988). Primate motor cortex and free arm movements to visual targets in three-dimensional space, II: Coding of the direction of movement by a neuronal population. *Journal of Neuroscience* 8: 2928–37.

20. Andersen, R.A., and Buneo, C.A. (2002). Intentional maps in posterior parietal cortex. *Annual Review of Neuroscience* 25: 189–220.

21. Batista, A.P., Buneo, C.A., Snyder, L.H., and Andersen, R.A. (1999). Reach plans in eye-centered coordinates. *Science* 285: 257–60.

22. Buneo, C.A., Jarvis, M.R., Batista, A.P., and Andersen, R.A. (2002). Direct visuomotor transformations for reaching. *Nature* 416: 632–36.

23. Musallam, S., Corneil, B.D., Greger, B., Scherberger, H., and Andersen, R.A. (2004). Cognitive control signals for neural prosthetics. *Science* 305(5681): 258–62.

24. Wolpaw, J.R. (2007). Brain-computer interfaces as new brain output pathways. *Journal of Physiology* 579: 613–19.

25. Vaughan, T.M., and Wolpaw, J.N. (2006). The third international meeting on brain-computer interface technology: Making a difference. *IEEE Transactions on Neural Systems and Rehabilitation Engineering* 14: 126–27.

26. Berger, T.W., Ahuja, A., Courellis, S.H., Deadwyler, S.A., Erinjippurath, G., Gerhardt, G.A., Gholmieh, G., et al. (2005). Restoring lost cognitive function. *IEEE Engineering in Medicine and Biology* 24, no. 5: 30–44.

27. http://www.case.edu/artsci/cogs/donald.html.

28. Gelernter, D. (2007). What are people well informed about in the information age? In Brockman, J. (ed.), *What Is Your Dangerous Idea?* New York: Harper.

29. www.shadow.org.uk/projects/biped.shtml#Anchor-Anthropomorphism-51540.

30. www.takanishi.mech.waseda.ac.jp/research/index.htm.

31. Thomaz, A.L., Berlin, M., and Breazeal, C. (2005). Robot science meets social science: An embodied computational model of social referencing. Cognitive Science Society workshop July 25–26: 7–17.

32. Suzuki, T., Inaba, K., and Takeno, J. (2005). Conscious robot that distinguishes between self and others and implements imitation behavior. Paper presented at: Innovations in Applied Artificial Intelligence, 18th International Conference on Industrial and Engineering Applications of Artificial Intelligence and Expert Systems, *Lecture Notes in Artificial Intelligence* 3533: 101–10.

33. Donald, M. (1999). Preconditions for the evolution of protolanguages. In Corballis, M.C., and Lea, S.E.G. (eds.), *The Descent of Mind*. New York: Oxford University Press.

34. Breazeal, C., Brooks, A., Gray, J., Hoffman, G., Kidd, C., Lee, H., Lieberman, J., Lockerd, A., and Mulanda, D. (2004). Humanoid robots as cooperative partners for people. *International Journal of Humanoid Robotics* 1 (2): 1–34.

35. Breazeal, C., Buchsbaum, D., Gray, J., Gatenby, D., and Blumberg, B. (2005). Learning from and about others: Towards using imitation to bootstrap the social understanding of others by robots. *Artificial Life* 11 (2): 31–62. Also in Rocha, L., and Almedía e Costa, F. (eds.), *Artificial Life X* (pp. 111–30). Cambridge, MA: MIT Press.

36. Barsalou, L.W., Niedenthal, P.M., Barbey, A., and Tuppert, J. (2003). Social embodiment. In Ross, B. (ed.), *The Psychology of Learning and Motivation* (pp. 43–92). Boston: Academic Press.

37. Anderson, A. (2007). Brains cannot become minds without bodies. In Brockman, J. (ed.), *What Is Your Dangerous Idea?* New York: Harper.

38. Hawkins, J., with Blakeslee, S. (2004). *On Intelligence*. New York: Henry Holt.

39. www-formal.stanford.edu/jmc/history/dartmouth/dartmouth.html.

40. www.aaai.org/AITopics/html/applications.html.

41. Searle, J. (1980). Minds, brains, and programs. *The Behavioral and Brain Sciences* 3: 417–57.

42. http://ist-socrates.berkeley.edu/~jsearle/BiologicalNaturalismOct04.doc.

43. Turing, A.M. (1950). Computing machinery and intelligence. *Mind* 59: 433–60.

44. www-formal.stanford.edu/jmc/whatisai/whatisai.html.

45. Sharma, J., Angelucci, A., and Sur, M. (2000). Induction of visual orientation modules in auditory cortex. *Nature* 404: 841–47.

46. Von Melchner, L., Pallas, S.L., and Sur, M. (2000). Visual behaviour mediated by retinal projections directed to the auditory pathway. *Nature* 404: 871–76.

47. Majewska, A., and Sur, M. (2006). Plasticity and specificity of cortical processing networks. *Trends in Neuroscience* 29: 323–29.

48. Bach y Rita, P. (2004). Tactile sensory substitution studies. *Annals of the New York Academy of Sciences* 1013: 83–91.

49. Donald, M. (1993). Human cognitive evolution: What we were, what we are becoming. *Social Research* 60: 143–70.

50. Pain, E. (2006). Leading the blue brain project. *Science Careers*. Oct. 6, http://sciencecareers.sciencemag.org/career_development/previous_issues/articles/2006_10_06/leading_the_blue_brain_project/(parent)/68.

51. Stock, G. (2003). From regenerative medicine to human design: What are we really afraid of? *DNA and Cell Biology* 22: 679–83.

52. Cohen, N.S., Chang, A., Boyer, H., and Helling, R. (1973). Construction of biologically functional bacterial plasmids in vitro. *Proceedings of the National Academy of Sciences* 70: 3240–44.

53. Brown, B.D., Venneri, M.A., Zingale, A., Sergi, L.S., and Naldini, L. (2006). Endogenous microRNA regulation suppresses transgene expression in hematopoietic lineages and enables stable gene transfer. *Nature Medicine* 12: 585–91.

54. Hacein-Bey-Abina, S., von Kalle, C., Schmidt, M., et al. (2003). LMO2-associated clonal T cell proliferation in two patients after gene therapy for SCID-X1. *Science* 302: 415–19.

55. Cavazzana-Calvo, M., Hacein-Bey, S., De Saint Basile, G., Gross, F., Yvon, E., Nusbaum, P., Selz, F., et al. (2000). Gene therapy of human severe combined immunodeficiency (SCID)-X1 disease. *Science* 288: 669–72.

56. Hacein-Bey-Abina, S., Le Deist, F., Carlier, F., et al. (2002). Sustained correction of X-linked severe combined immunodeficiency by ex vivo gene therapy. *New England Journal of Medicine* 346: 1185–93.

57. Gaspar, H.B., et al. (2004). Gene therapy of X-linked severe combined immunodeficiency by use of a pseudotyped gammaretroviral vector. *Lancet* 364: 2181–87.

58. Ott, M.G., Schmidt, M., Schwarzwaelder, K., Stein, S., Siler, U., Koehl, U., Glimm, H., et al. (2006). Correction of X-linked chronic granulomatous disease by gene therapy, augmented by insertional activation of MDS1-EVI1, PRDM16 or SETBP1. *Nature Medicine* 12: 401–9.

59. http://news.bbc.co.uk/1/hi/health/6609205.stm.

60. Renwick, P. J., Trussler, J., Ostad-Saffari, E., Fassihi, H., Black, C., Braude, P., Ogilvie, C.C., and Abbs, S. (2006). Proof of principle and first cases using preimplantation genetic haplotyping—a paradigm shift for embryo diagnosis. *Reproductive BioMedicine Online* 13:110–19.

61. http://news.bbc.co.uk/2/hi/health/5079802.stm.

62. Renwick, P., and Ogilvie, C.M. (2007). Preimplantation genetic diagnosis for monogenic diseases: Overview and emerging issues. *Expert Review of Molecular Diagnostics* 7: 33–43.

63. Harrington, J.J., Van Bokkelen, G., Mays, R.W., Gustashaw, K., and Willard, H.F. (1997). Formation of *de novo* centromeres and construction of first-generation human artificial microchromosomes. *Nature Genetics* 15: 345–55.

64. Stock, G. (2002). *Redesigning Humans*. Boston: Houghton Mifflin.

65. www.newscientist.com/article.ns?id=dn3451.

INDEX